# ICON AND WORD

Robin Cormack on Crete, 1995

# Icon and Word
## The Power of Images in Byzantium

Studies presented to Robin Cormack

*Edited by*

ANTONY EASTMOND AND LIZ JAMES

ASHGATE

Published by
Ashgate Publishing Limited
Gower House
Croft Road
Aldershot
Hants GU11 3HR
England

Ashgate Publishing Company
Suite 420
101 Cherry Street
Burlington, VT 05401-4405
USA

Ashgate website: http://www.ashgate.com

**British Library Cataloguing in Publication Data**
Icon and Word : the power of images in Byzantium
   1.Icons, Byzantine 2.Art and religion - Byzantine Empire
   3.Art and society - Byzantine Empire
   I. Eastmond, Antony, 1966- II.James, Liz III.Cormack, Robin
   704.9'482'09495'09021

**Library of Congress Cataloging-in-Publication Data**
Icon and word : the power of images in Byzantium / edited by Antony Eastmond and Liz James.
     p. cm.
   Essays by doctoral students of Robin Cormack and a bibliography of Robin Cormack's published works.
   Includes bibliographical references and index.
   ISBN 0-7546-3549-X (alk. paper)
     1. Icons, Byzantine. 2. Art, Byzantine. I. Eastmond, Antony, 1966- II. James, Liz. III. Cormack, Robin.

N8187.I24 2003
755'.2'094950902—dc21

2003045159

ISBN 0 7546 3549 X

Printed and bound in Great Britain by MPG Books Ltd, Bodmin, Cornwall

# Contents

## PART 1: ICONS AND MEANING

# Contributors

All contributors are former students of Robin Cormack

| | |
|---|---|
| Charles Barber | Associate Professor of the History of Art, University of Notre Dame, Indiana |
| Karen Boston | Independent Scholar, London |
| Antony Eastmond | Reader in the History of Art, University of Warwick |
| Jaś Elsner | Humfry Payne Senior Research Fellow in Classical Art and Archaeology, Corpus Christi College, Oxford |
| Maria Evangelatou | Independent scholar, Athens |
| Rico Franses | Assistant Professor, Department of History of Art, Pratt Institute, New York |
| John Hanson | Assistant Professor of Art History, Hope College, Michigan |
| Cecily Hennessy | Courtauld Institute of Art, University of London |
| Lucy-Anne Hunt | Professor and Head of School of the History of Art and Design, Manchester Metropolitan University |
| Liz James | Reader in the History of Art, University of Sussex |
| John Lowden | Professor of the History of Art, Courtauld Institute of Art, University of London |
| Robert Maniura | Lecturer in the History of Art, Birkbeck College, University of London |
| John Osborne | Professor of the History of Art, Queen's University, Kingston, Ontario |
| Maria Vassilaki | Associate Professor of Byzantine Art, University of Thessaly |
| Annabel Wharton | Professor of the History of Art at Duke University, NC |
| John Wilkinson | Independent scholar, London |
| Barbara Zeitler | Independent scholar and barrister, London |

# Abbreviations

| | |
|---|---|
| *ArtB* | *Art Bulletin* |
| *ArtH* | *Art History* |
| *BHG* | *Bibliotheca hagiographica graeca,* ed. F. Halkin, 3 vols (Brussels, 1957) |
| *BMGS* | *Byzantine and Modern Greek Studies* |
| *Byz* | *Byzantion* |
| *BZ* | *Byzantinische Zeitschrift* |
| *CahArch* | *Cahiers Archéologiques* |
| *DchAE* | *Deltion tes Christianikes Archaiologikes Hetaireias* |
| *DOP* | *Dumbarton Oaks Papers* |
| *IRAIK* | *Izvestiia russkogo arkheologicheskogo instituta v Konstantinopole* |
| *JWCI* | *Journal of the Warburg and Courtauld Institutes* |
| *JÖB* | *Jahrbuch der Österreichischen Byzantinistik* |
| Mansi | G.D. Mansi, *Sacrorum conciliorum nova et amplissima collectio* 53 vols (Paris, Leipzig, 1901-1927) |
| MGH | Monumenta Germaniae historica |
| *PG* | J.P. Migne ed., *Patrologia cursus completus. Series Graeca* (Paris, 1857-66) |
| *PL* | J.P. Migne ed., *Patrologia cursus completus. Series Latina* (Paris, 1844-80) |
| *REB* | *Revue des études byzantines* |
| SC | Sources chrétiennes |
| SPBS | Society for the Promotion of Byzantine Studies. Publications |
| *VizVrem* | *Vizantiiskii Vremennik* |

# Figures

## Colour Plates

## Black and White Figures

14.4 St Michael with St Mark, 1204/5. Vatican MS Copto 9 fol. 145v (© Biblioteca Apostolica Vaticana).

14.5 St Michael, 1232/3. Wallpainting, khurus arch, monastery church of St Antony at the Red Sea (after J. Leroy, 'Le programme decorative de l'église de Saint-Antoine du désert de la mer Rouge', *Bulletin de l'institut français d'archaéologie orientale* 76 (1976), 347-79).

14.6 St Michael, 13th century. Nave pier, Church of al 'Adra, Dayr al-Baramus, Wadi Natrun (L.-A. Hunt).

14.7 St Michael, detail, 13th century. Nave pier, Church of al 'Adra, Dayr al-Baramus, Wadi Natrun. (L.-A. Hunt).

14.8 Christ in Majesty. Drawing of wallpainting, eastern apse (north) of North church, Dayr al-Chohada', Esna (after drawing by P.-H. Lafferière in J. Leroy, *Les peintures des couvents du désert d'Esna* (Cairo, 1975), Fig. 3).

14.9 St Michael, AD 928. Funerary shroud from Antinoë. Coptic Museum, Old Cairo, no. 8452 (courtesy of the Coptic Musuem, Old Cairo).

14.10 Inscription of AD 928. Funerary shroud from Antinoupolis. Coptic Museum, Old Cairo (courtesy of the Coptic Museum, Old Cairo).

14.11 Christ in Majesty. Drawing of wallpainting, eastern apse (south) of North Church, Dayr al-Chohada', Esna. (after drawing by P.-H. Lafferière in J. Leroy, *Les peintures des couvents du désert d'Esna* (Cairo, 1975), pl. 31).

15.1 St Luke. Archimedes Palimpsest, fol. 21r.

15.2 St John. Archimedes Palimpsest, fol. 57r.

15.3 Archimedes Palimpsest, fol. 56v-57r, showing condition when photographed for Heiberg in 1906-8.

15.4 St Matthew. Archimedes Palimpsest, fol. 64v.

15.5 St Mark. Archimedes Palimpsest, fol. 81r.

15.6 H. Omont, *Miniatures des plus anciens manuscrits grecs de la Bibliothèque Nationale du VIe au XIVe siècle* (Paris, 1929), pl. LXXXIV.

15.7 Tailpiece. Archimedes Palimpsest, fol. 116v.

15.8 MS Paris gr. 550, fol. 116v, headpiece: H. Omont, *Miniatures des plus anciens manuscrits grecs de la Bibliothèque Nationale du VIe au XIVe siècle* (Paris, 1929), pl. CIV.7.

15.9 St Luke. Detached leaf from Duke University, MS Gk. 84.

15.10 H. Omont, *Miniatures des plus anciens manuscrits grecs de la Bibliothèque Nationale du VIe au XIVe siècle* (Paris, 1929), pl. LXXXIX.

15.11 Archimedes Palimpsest, interior of binding (removed from book) showing Canon Tables re-used as pastedowns.

15.12 St Mark. Dumbarton Oaks MS acc. 79.31.1 (Dumbarton Oaks, Byzantine collection, Washington, DC).

# Robin Cormack

## Jaś Elsner

Robin Cormack's art historical career spans the most radical period of change, indeed of crisis, in his chosen discipline in over a century. He has spent most of his working life at the Courtauld Institute of Art – the single institution that has been most abused in the last twenty years for being seen as the principal bastion of an old fashioned art history (much of that abuse being unfair, I might add) – but he was always associated (especially within the Courtauld) with the 'New Art History'. His work might be seen as a complex negotiation between what effectively became different paradigms in the academic study of art. I am not sure that Robin would have chosen to stand for so long at such a polarised epicentre of so many entrenched positions and so much academic bad temper over the years, if he had been given the option beforehand. But it has been – especially in retrospect – a significant place within which to engage in academic debate, and one that may be noticed in the future historiography of the subject.

After Greats at Oxford and brief spells at the Institute of Contemporary Arts and as a journalist in London in the heady days of the early sixties, Robin entered the Courtauld for postgraduate work and then a doctorate during the heyday of empirical positivism in art history. He studied with some of the princes of the discipline – Anthony Blunt, Johannes Wilde, John Shearman – apostles of that empathetic connoisseurship for which the Courtauld was not only so celebrated then but remains famous now (even when there is virtually no connoisseurship as traditionally understood actually taught there!). His medievalist teachers in the area where he was to specialize included George Zarnecki, Peter Kidson, Christopher Hohler and, at the Warburg Institute, especially Hugo Buchthal, who taught him Byzantine art. Since Robin was one of the first within the Courtauld to reject the dominance of the positivist paradigm and to show sympathy with the interests and claims of the new

From *Icon and Word: the Power of Images in Byzantium. Studies presented to Robin Cormack*, eds Antony Eastmond and Liz James. © 2003 by contributors. Published by Ashgate Publishing Ltd, Gower House, Croft Road, Aldershot, Hampshire, GU11 3HR, England, pp. xvii-xxi.

brigade of post-structuralist art historians who emerged in Britain and America in the early 1980s (of his Courtauld colleagues, he was intellectually closest to David Freedberg, before the latter went to New York), it is easy to forget the heritage within which he was educated. But no one in my experience has so rigorously set themselves the task of seeing at first hand 'everything' within the purview of their discipline, and few have been so successful in achieving that aim. This particular commitment, never easy given the scattered dispersal of Byzantine art all around the Mediterranean, and arguably harder in the Cold War dominated 1960s and 1970s than nowadays, is one of Robin's specific debts to the empiricism of his training, and it gives a rare weight and depth to his perceptions and attributions.

The influence of his Ph.D. supervisor, Cyril Mango, who in the 1960s held the Koraes Chair of Modern Greek and Byzantine History, Literature and Language at King's College London, can be seen in a commitment to the re-evaluation of objects (both existing and lost) in their archaeological and antiquarian and literary context. This is evident in early pieces such as his 1960s essay on the lost mosaics of St Demetrios at Thessaloniki (which originated in his Ph.D. thesis) and in the fundamental article, written together with the restorer Ernest Hawkins, on the mosaics of the rooms above the South-West vestibule and ramp in St Sophia in Constantinople, which was published in *Dumbarton Oaks Papers* in 1977. The commitment to archaeological reconstruction has continued throughout his career in the various papers on the temple of Aphrodisias, its transformation into a church and the Byzantine paintings in the city. Indeed, in Aphrodisias, Robin was instrumental in saving the fragments of Byzantine painting and piecing them together in the context of a dig whose initial impetus had been a kind of treasure hunt for Roman sculpture, but which has subsequently come to be perhaps the most important excavation of all for examining the transformation of Classical to Late Antique art, urban topography and inscriptions. Likewise, the positivist determination to survey all the sources and to come to a balanced and definitive answer in relation to the arts during and after Iconoclasm (in essays published in the 1970s) reflects the Mango tradition of applying commonsense to the mess of unreliable Byzantine historiography and archaeology. From today's perspective, this may look more like an impossible ideal than a realistic possibility – the *desire* of positivism for a verifiable truth rather than a fully realizable ambition. What Robin brought to this heritage in Byzantine Studies from his specifically Courtauld training with some of the great connoisseurs of the mid century at the end of their careers (including his MA dissertation supervisor Hugo Buchthal from the Warburg), was a fine eye in attribution, which has been at work in his continuing connoisseurship of icons throughout the 1980s, and his discovery of a lost mosaic head from Torcello.

In the early 1980s, Robin took three years out of teaching with a Readership from the British Academy affiliated to the Warburg Institute. This period coincided with the beginning of his relationship with Mary Beard, their marriage and their move to Cambridge in 1983. Institutionally, the Cambridge link for Robin was cemented with a Bye Fellowship at Robinson College – a collegiate connection that has lasted throughout the rest of his career and included his commissioning of a stained glass window from John Piper, just before Piper's death, for the College Chapel. Professionally, this was a period of tremendous change and innovation in the discipline of art history, and Cambridge was arguably the intellectual vortex of that transition producing such seminal figures in the 1980s as John Barrell, Norman Bryson and Michael Camille, none of whom could be described as empiricists or connoisseurs. This is the period when I first met Robin myself, drinking white wine, sitting on the floor of his and Mary's at the time hardly furnished new house in Hertford Street and discussing whether I should leave Cambridge Classics for a Masters degree in art history at the Courtauld (I did). The injection of the approaches of social and economic history in the M.I. Finley and Keith Hopkins tradition of Ancient History at Cambridge, coupled with Robin's new-found interest in panel icons (which had themselves emerged as major objects of study only after Kurt Weitzmann's Sinai campaigns that culminated in publications in the 1970s), fuelled a fundamental reinvigoration in Robin's work. In *Writing in Gold* (published in 1985), commissioned for a series by Michael Crawford (who was then a Cambridge ancient historian), Robin wrote a social history of the Byzantine icon (broadly conceived to include all forms of sacred images). The book remains one of the few art historical attempts in Byzantine studies to locate icons in the society that produced and appreciated them, in something like the post-Marxist ways envisaged by the likes of Barrell, T.J. Clark and Tom Crow in other fields within art history. At the same time, in a review paper for the journal *Byzantine and Modern Greek Studies* (1986), Robin attempted to bring the 'New Art History' into the mainstream of (or perhaps it would be better to say, to the notice of) Byzantine studies as a whole.

While sympathetic with the post-structuralist developments in art history – especially in the 1980s, but less so, I think, when art historians began to lose sight of objects – Robin never himself wrote in that vein. His later work might be characterised as taking on the new consensus around a multifaceted cultural history, theoretically informed and innovative but (in his case) always empirically inflected around objects. His concerns of the 1990s have included the different national constructions of Byzantium (English and French), questions of viewing and gender – very much in the mainstream of the post-New Art History (if I may be allowed the term), and art history as cultural history. The continued interest in icons – and especially the place of

surviving painted panels in helping us trace the transitions from antiquity to Byzantium and of Medieval Byzantium to Renaissance – has been the principal focus of Robin's scholarly attention. _Painting the Soul_ (1998) is an outstanding account of this story, rooted in his Courtauld teaching of the 1990s, in the period when I served as Robin's colleague in the Institute's Classical and Medieval Department. The book presents a wonderful and closely interwoven history of the icon-form, including such reliquary objects as the Turin Shroud, in their theological, functional and aesthetic resonances, that stretches from pre-Christian panel paintings and funerary masks to the early work of El Greco. Robin's survey book _Byzantine Art_ (Oxford, 2000) is a wonderfully mature statement by someone in command of his field. His grasp of the extent of the material, as well as of its literature across all the European languages including Russian, is second to none and his lifetime's experience teaching it has left him with valuable points to make, even when he himself finds them so familiar as to seem commonplace to him. The book remains the first general account of Byzantine art fully to synthesize the icon into the large picture of mosaics, manuscripts, architecture, ivories and enamels.

One particular interest of Robin's career (and I wonder if it is not the thing he has liked best), going back to the 1978 exhibition of Bulgarian icons at Edinburgh and the Courtauld (which I remember seeing as a schoolboy), has been the mounting of exhibitions of Byzantine art. In fact, the turn to exhibitions lies deep in Robin's pre-art historical career, when he was gallery manager at the Institute of Contemporary Arts in the 60s, working for Roland Penrose and Herbert Read. Perhaps his friendship with some of his modern-period Courtauld colleagues, such as Alan Bowness (who went on to be Director of the Tate), was part of the impetus. Over the years he has curated or served as a consultant for several shows including _From Byzantium to El Greco_ (1987) and _Gates of Mystery: The Art of Holy Russia_ (1993-4), both at the Royal Academy in London.

The essays in this volume – all by doctoral students of Robin Cormack (and I should say that I am honoured to have been allowed to write this preface even though I was never Robin's Ph.D. student) – show the range and vibrancy of the field of Byzantine art history in its current incarnation. That so many are focused on icons is both a testament to Robin's personal interests and influence, and a mark of how noticing a new seam of material can give an influx of life to a scholarly tradition. Their span from the conceptual to the historically interesting use of the empirical, and across the range of Byzantine materials from painted panel-icons to inscriptions, murals, mosaics and ivories, evoke well the interests and the range of the teacher who inspired and fostered their authors' work. The fact that so much, highly differentiated, work is now possible in relation to the icon (broadly defined) shows the strength of the cultural history of Byzantine art, in what is now the dominant

paradigm within the subject. In that sense, the essays collected here witness both the current strength of art history within Byzantine Studies and the success of a model of integrating visual with historical questions that Robin has long laboured for. There must have been times when Robin wondered whether he should stay till he retires at a single institution – the very institution where he was trained. But the range and richness of the many excellent students who have come his way at the Courtauld – from Europe and America as well as from Britain – and, as a result, the breadth of his influence in the field of Byzantine art at its time of greatest intellectual crisis in many years, is testimony to the tremendous value of what he has done and where. I might add finally, and on a personal note, that the influence is hardly restricted to doctoral students. In more than thirty years at the Courtauld he has had countless MA students (I was one), many of whom have gone on to other areas of art history or other areas of the field such as curatorship. It has been as a teacher that I personally find Robin most vivid – his sceptical classes on objects, methods and the scholarly literature, his insistence on handling objects or going to see them at every opportunity, his restless dissatisfaction with the work one had done in favour of what it might still become.

# Bibliography of Robin Cormack's Published Works

## 2002

'Crusader art and artistic technique: another look at a painting of St George', in *Technical Aspects of Byzantine art* (in Greek & English), ed. M. Vassilaki (Heraklion, 2002), 163-70

## 2001

'Introduction: Armenian Art from a Byzantine Perspective', in *Treasures from the Ark*, ed. V. Nersessian (British Library, London), 11-13

## 2000

*Byzantine Art* (Oxford)

*Sinai, Byzantium, Russia at the Courtauld* (exhibition guide, London)

*Through the Looking Glass: Byzantium through British Eyes*, ed. with E. Jeffreys (Aldershot)

'Afterword by an art historian', in *Strangers to Themselves. The Byzantine Outsider*, ed. D.C. Smythe (Aldershot), 259-64

'A Gentleman's Book: attitudes of Robert Curzon', in *Through the Looking Glass: Byzantium through British Eyes*, eds R. Cormack and E. Jeffreys (Aldershot), 147-62

'Sinai: the construction of a sacred landscape', in *Sinai, Byzantium, Russia. Orthodox Art from the Sixth to the Twentieth Century*, eds. Y. Piatnitski, M. Mango and S. Baddeley (St Petersburg and London) 40-45

'The Mother of God in Apse Mosaics', 'The Mother of God in the Mosaics of Hagia Sophia at Constantinople', and catalogue entries 1, 2, 31, 32 in *Mother of God. Representations of the Virgin in Byzantine Art*, ed. M. Vassilaki (Athens), 91-106, 106-23

'Veneto-Cretan Renaissance' in *Encyclopaedia of Greece and the Hellenic Tradition*, ed. G. Speake (London), 1442-44

## 1998

*The Art of Holy Russia. Icons from Moscow 1400-1660*, ed. with D. Gaze (exhibition catalogue for the Royal Academy, London)

'Away from the centre: 'provincial' art in the ninth century' in *Byzantium in the Ninth Century: Dead or Alive*, ed. L. Brubaker (Aldershot), 151-63

'Lessons from the Glory of Byzantium', *Dialogos* 5 (1998), 27-39

'Moscow between East and West', in *The Art of Holy Russia. Icons from Moscow 1400-1660*, eds R. Cormack and D. Gaze (London), 21-26

## 1997

*Painting the Soul. Icons, Death Mask, Shrouds* (Reaktion Books, 1997) Winner of the Runciman Award for 1998. Polish translation: *Malowanie duszy. Ikony, maski posmiertne i caluny*

'Ho kallitekhnes sten Konstantinoupole: arithmoi, koinonike these, zetemata apodoses' in *To portraito tou kallitechne sto Byzantio*, ed. M. Vassilaki (University of Rethymnon), 45-76

'Women and Icons, and Women in Icons', in *Women, Men and Eunuchs. Gender in Byzantium*, ed. L. James (London), 24-51

## 1994

'Byzantine Icons', and catalogue entries 73, 140, 191, 206, 220-23 in *Byzantium. Treasures of Byzantine Art and Culture from British Collections*, ed. D. Buckton (exhibition catalogue for the British Museum, London), 21-2, 80-82, 129-30, 176, 192, 203-6

'Reflections on Early Byzantine cloisonné enamels: endangered or extinct?' in *Thumiama in Memory of Laskarina Bouras* (Athens), 67-72

'The Emperor at St Sophia: viewer and viewed', in *Byzance et les images*, ed. J. Durand (Paris), 223-53

'The French Construction of Byzantium: reflections on the Louvre exhibition of Byzantine art', *Dialogos* 1 (1994), 28-41

## 1993

'The Icon. Past, Present and Future', in *Gates of Mystery. The Art of Holy Russia*, ed. R. Grierson (Fort Worth), 321-9

## 1992

'But is it Art?', in *Byzantine Diplomacy*, eds S. Franklin and J. Shepard (Aldershot), 219-36

The Program for Art on Film, *Art on Film, Film on Art* (New York). Various contributions

## 1991

'The wall-painting of St Michael in the theatre', in *Aphrodisias Papers* 2: *The theatre, a sculptor's workshop, philosophers, and coin-types*, eds R.R.R. Smith and K.T. Erim (Ann Arbor), 109-22

'Byzantine Art and the Visual Saint', *Bysantinska Süllskapet Bulletin* 9, 10-14
'Reading Icons', *Valor. Konstvetenskapliga Studier* 4, 1-28

## 1990

'The Temple as the Cathedral', *Aphrodisias Papers* 1: *Recent Work on Architecture and Sculpture*, eds C. Roueché and K.T. Erim, Journal of Roman Archaeology Supplementary Series 1 (Ann Arbor), 75-88

'Byzantine Aphrodisias. Changing the symbolic map of a city', *Proceedings of the Cambridge Philological Society* 216 (NS 36), 26-41

Film: premiere and first panel discussion of *A Window to Heaven* (Getty Foundation and Metropolitan Museum *Program for Art on Film)* at the Louvre on 13 June 1990; and the New York premiere on 21 June. The film won an award at the Paris film festival 1990

## 1989

*The Byzantine Eye. Collected Studies in Art and Patronage,* with additions and commentary, Variorum Collected Studies 296 (Aldershot)

*Information Report on the Cultural Heritage of Cyprus:* presented to the Parliamentary Assembly by the committee on Culture and Education of the Council of Europe. (6 July 1989: *ADOC6079.* Doc 6079). Report by Robin Cormack, consultant expert, 21-35

'The Making of a Patron Saint: The Powers of Art and Ritual in Byzantine Thessaloniki' in *World Art. Themes of Unity in Diversity,* Acts of the XXVIth International Congress of the History of Art III, ed. I. Lavin (Pennsylvania State UP), 547-57

'The Triumph of Orthodoxy', *National Art Collections Fund Review 1989* (London), 93-4

## 1988

'Icons in the life of Byzantium', in *Icon* ed. G. Vikan (Washington, DC, and Baltimore)

'Miraculous Icons in Byzantium and their Powers', *Arte Cristiana* 76, 55-60

## 1987

*An Apostle Mosaic from Medieval Torcello* (Sotheby's)

*From Byzantium to El Greco*, English editor (exhibition catalogue for the Royal Academy, London)

*From Byzantium to El Greco: Greek Frescoes and Icons. Background Material for Teachers,* (Educational Department of the Royal Academy)

Contributions to *East Christian Art*, ed. Y. Petsopoulos (exhibition catalogue, London), 44-5, 46-9

'Patrons and New Programs in the 9th and l0th Centuries', in *17th International*

*Congress of Byzantine Studies, Main Papers* (Washington, DC), 609-38 [reprinted in *The Byzantine Eye. Collected Studies in Art and Patronage,* Variorum CS296 (Aldershot, 1989), Study X]

## 1986

'"New Art History" vs. "Old History": Writing art history', *Byzantine and Modern Greek Studies* 10, 223-31

'Two Icons, More or Less Byzantine', *Apollo* 124, 6-10

## 1985

*Writing in Gold. Byzantine Society and its Icons* (London). French translation: *Icones et société a Byzance* (Paris, 1993)

*The Church of St Demetrios of Thessaloniki. The Watercolours and Drawings of W.S. George,* catalogue of an exhibition in Thessaloniki and Athens (British Council and the Municipality of Thessaloniki) [reprinted in *The Byzantine Eye. Collected Studies in Art and Patronage,* Variorum CS296 (Aldershot, 1989), Study II]

## 1984

*Constantinople in the Early Eighth Century: the* Parastaseis Syntomoi Chronikai, Introduction, translation, and commentary by A. Cameron and J. Herrin with R. Cormack et al. (Leiden)

'A Crusader Painting of St. George: *Maniera Greca* or *Lingua Franca?*', *Burlington Magazine* 126, 132-41

'Aristocratic Patronage of the Arts in 11th- and 12th-Century Byzantium', in *The Byzantine Aristocracy IX to XIII Centuries,* ed. M. Angold (Oxford), 158-72 [reprinted in *The Byzantine Eye. Collected Studies in Art and Patronage,* Variorum CS296 (Aldershot, 1989), Study IX]

## 1983

*The Icon of Saint Peter* (Barbican Art Gallery, London)

'A major new discovery: a Byzantine panel of the 14th century', *Zygos* 2, 130-35

'Byzantine Art' in American Council of Learned Societies, *Dictionary of the Middle Ages* 2, ed. J.R. Strayer (New York), 437-52

## 1982

editor and preface for C. Walter, *Art and Ritual of the Byzantine Church* (London)

'Discussion Report: the image collection discussion group', *Art Libraries Journal* 7:2, 89-91 (Proceedings of the International Seminar on Information Problems in Art History, Oxford, 1982)

## 1981

'Interpreting the Mosaics of S. Sophia at Istanbul', *Art History* 4, 131-49 [reprinted in *The Byzantine Eye. Collected Studies in Art and Patronage*, Variorum CS296 (Aldershot, 1989), Study VIII]

'The Apse Mosaics of S. Sophia at Thessaloniki', *Deltion tis Christianikis Archeologias Etaireias* 11 (1980-1), 111-35 [reprinted in *The Byzantine Eye. Collected Studies in Art and Patronage*, Variorum CS296 (Aldershot, 1989), Study V]

'The Classical Tradition in the Byzantine Provincial City: the evidence of Thessalonike and Aphrodisias', in *Byzantium and the Classical Tradition*, eds M. Mullett and R. Scott (Birmingham), 103-19 [reprinted in *The Byzantine Eye. Collected Studies in Art and Patronage*, Variorum CS296 (Aldershot, 1989), Study VII]

## 1979

'The Conversion of Aphrodisias into a Byzantine City', *Fifth Annual Byzantine Studies Conference* (Dumbarton Oaks), 13-14

## 1978

*Bulgarian Icons from the Ninth to the Nineteenth Century.* Catalogue of an exhibition (selected by Robin Cormack) held at the Edinburgh International Festival and at London (Arts Council)

## 1977

'The Arts during the Age of Iconoclasm', and 'Painting after Iconoclasm', in *Iconoclasm*, eds A.A.M. Bryer and J. Herrin (Birmingham), 35-44, 147-63 [reprinted in *The Byzantine Eye. Collected Studies in Art and Patronage*, Variorum CS296 (Aldershot, 1989), Studies III and IV]

'The Mosaics of S. Sophia at Istanbul: the Rooms above the South-West Vestibule and Ramp', *Dumbarton Oaks Papers* 31, 175-251

## 1974

'Recent Studies in Byzantine and Early Christian Art', *Burlington Magazine* 116, 275-77 and 411-12

## 1969

'The Mosaic Decoration of S. Demetrios, Thessaloniki. A re-examination in the Light of the Drawings of W.S. George', *Annual of the British School of Archaeology at Athens* 64, 17-52 [reprinted in *The Byzantine Eye. Collected Studies in Art and Patronage*, Variorum CS296 (Aldershot, 1989), Study I]

**1968**

*Monumental Painting and Mosaic in Thessaloniki in the Ninth Century,* (London), PhD supervised by Professor H. Buchthal (Warburg Institute) and Professor C. Mango (King's College, London)

**1967**

'Byzantine Cappadocia: the "Archaic Group" of Wall paintings', *Journal of the British Archaeological Association* 30, 19-36 [reprinted in *The Byzantine Eye. Collected Studies in Art and Patronage,* Variorum CS296 (Aldershot, 1989), Study VI]

Introduction

# Icon and Word

Liz James and Antony Eastmond

Robin Cormack's book, *Writing in Gold*, opens with a quotation from Theodore the Stoudite on its title page: 'The gospels were "writing in words", but icons are "writing in gold".' The book itself is a study of visual images in the context of changing Byzantine culture. It is subtitled 'Byzantine society and its icons' and Cormack took 'icon' in its Greek sense, *eikon*, as meaning any image whatsoever. This was one of the first studies that sought to locate Byzantine images within the society that produced and appreciated them. It was a book that brought images and written texts together, seeing both as cultural productions that could influence the other. It was underpinned by a series of questions: 'What was the part played by icons in Christian worship and prayer? How do icons express beliefs and reflect devotional practices? How was art used by the church to confirm doctrines and codes of behaviour? What can be said of the mental habits of the users and spectators of religious art?'[1] This offered a very different way of studying and understanding Byzantine art.

Previously, Byzantine art, above all icons, had been studied in terms of its style and appearance. Icons were regarded as timeless, motionless, and eternal: windows onto Heaven. They appeared to exhibit an unchanging portrayal of divinity. Art historians had been most concerned with ascribing a date and a point of origin to them and this had depended on 'a feeling for style which, in its turn, is the result of long practice'.[2] Such an approach placed the study of Byzantine art squarely within the domain of traditional art history where ascriptions of date, quality, provenance, iconography and artist ruled supreme. Cormack, not alone, but in the forefront, offered an understanding of icons as a part of social and cultural history, whilst still emphasising their visual nature as art. The citation from Theodore the Stoudite served to underline the significance of icons in Byzantium: 'writing in gold', the most precious and

From *Icon and Word: the Power of Images in Byzantium. Studies presented to Robin Cormack*, eds Antony Eastmond and Liz James. © 2003 by contributors. Published by Ashgate Publishing Ltd, Gower House, Croft Road, Aldershot, Hampshire, GU11 3HR, England, pp. xxix-xxxiv.

prestigious of all media, untarnishing and everlasting, against 'writing in words'. This relationship between images and words has proved another field of fruitful debate for students of Byzantine art.[3]

Both of these theoretical positions allowed Byzantine art historians to begin to break away from the tyranny of art historical values that had told them that Byzantine art was flat, two-dimensional and not very good, a low point between the two peaks of the Classical world and the Renaissance. By setting the icon into its own social and cultural context, by asking questions about its use and by seeking to understand its theology, it became possible to see how its appearance was influenced by its own society, rather than by the values that art historians, trapped within a Vasarian world, thought it should be influenced by.[4] The apparently flat and unchanging nature of icons, rather than reflecting 'poor art' or unskilful artists, reflected the icon's role as a vehicle for the divine. For the Byzantines, all icons of Christ had to look the same because they were all images of the same person. They were not simply pictures but served a function as vehicles of the divine, a means of access to the divine, and thus held, and still hold, a central place within Orthodox belief. In this way, scholars began to explore how function influenced form.

In this context, the debate about the nature of Byzantine images, especially icons, surfaced. Were they 'art' or 'image'? Was there a difference?[5] Should Byzantine art be seen as images with a cult function, or do they share a paradigm of art that fits an aesthetic model revolving around the formal properties of the image?[6] This distinction between image and art, as constructed by Belting, perhaps retains the element of the strangeness and difference of medieval art. Icons are images. Yet they are also art. What they looked like mattered. Aesthetics influenced both form and function.[7]

Images have become key players in discussions about Byzantine culture. This book brings together the work of a group of scholars within Byzantine Studies, all of whom studied as doctoral students with Robin Cormack. It contains a series of specially commissioned essays that focus on some of the current issues about images, icons and icon theory in the larger Byzantine world. They explore not just what an icon is, but how it functions in different contexts, periods and cultures. The book examines images in a broad range of media: in addition to the traditional format of painted panels, ivory carvings, manuscript illuminations and monumental wall paintings are also explored. Two interrelated themes are developed in the essays. Some authors take specific images from specific cultural contexts: images of the Virgin Mary in early medieval Rome; images of children in sixth to seventh century Thessaloniki; ivories from Constantinople; icons of St Michael in medieval Coptic Egypt; bleeding icons in twenty-first century Greece and in Byzantium; the re-use of Byzantine ivories in the medieval West; twentieth century forged Byzantine images. Using these as case studies, they discuss the ways in which

Byzantine art forms, particularly icons, were adapted and employed in different and multicultural settings. The second theme is that of the meaning and significance of images within Byzantium. In these essays, the authors examine more specifically how images were perceived and used by the subjects of the Byzantine empire. Issues such as the difference between a portrait and a holy image, the difference between an image of the emperor and an icon, the relation of the icon to the imagination, and of the icon and its inscription are discussed within the context of what such works of art meant in Byzantium.

The book is concerned both with the actual world of Byzantium and with the conceptual world of the Byzantines. Its concern is to discuss 'how far we can explore the self-identity of Byzantium through Byzantine art itself. How do the objects we categorize as art work in the construction of that identity?'[8] It is divided into two sections, 'Icons and Meaning' and 'Icons in Context'. These, however, are not watertight compartments, and context and meaning spill across both, as Maria Vassilaki's paper on bleeding icons demonstrates. In this essay, we see most clearly how the questions that concerned the Byzantines about their icons are not dead-and-buried questions, but are issues still of paramount importance to the faithful today: how can an icon bleed and what does it mean?

'Icons and Meaning' is concerned with the self-identity of Byzantium. The essays here tend to move from written texts to works of art. It opens with a piece by Annabel Wharton that introduces and seeks to define four terms, icon, idol, fetish and totem, that have all been used to describe and categorize different types of holy images. Her emphasis on the differences and similarities between icons and idols is one that recurs throughout the book. The ways in which the Byzantines described their images and contrasted them with idols and the ways in which we interpret and understand these definitions underpin many of the essays. Charles Barber and Karen Boston both, in different ways, deal with the question of labelling an image. Barber investigates how far a label converts an image from an idol or a portrait to a holy icon, or vice versa. Boston's paper is, in some respects, a response to this question, as it examines how intrinsic to meaning a label might be. Antony Eastmond also explores the distinction between icon and image in a consideration of imperial images, suggesting that representations of the emperor fell into a middle ground somewhere between icon and idol, just as the emperor himself occupied a precarious position between God and man. Liz James discusses how theories of sight and the imagination worked in influencing the Byzantines' understanding of the ways in which art functioned. Robert Maniura develops the theme of 'what is an icon?' in a different way, looking at what the concept of images of the Virgin painted by St Luke in the West might say about the West's appropriation and conceptualization of

Byzantine forms. He considers how, in the Renaissance, questions of meaning moved away from a belief in divine inspiration to a belief in the human inspiration in the shape of the artist as creator. Rico Franses' essay in this section takes on more formalist concerns. In looking at the gold backgrounds to Byzantine images, he is interested in Byzantine aesthetics – qualities of art – and how they relate to an object's cult function. He also makes it clear that the nature of modern display means that key aspects of the Byzantine image's visual and iconographic significance have been overlooked. Finally, John Wilkinson looks at the ways in which the interaction between art and the icon and architecture and ritual serve to create a sense of identity. These essays share an interest in defining, in different ways, what an icon was and how it worked in Byzantine society.

The second section, 'Icons in Context', engages with the problem of how the objects we categorize as art work in the construction of self-identity. Here the movement is from work of art to written text. These papers deal in very different materials but share an interest in the use and function of Byzantine and Byzantine-influenced icons beyond Constantinople itself. Taken together, however, they reveal similarities of use and key differences over time and space (Osborne and Hanson with the Virgin; Zeitler and Hunt with the use of icons in western Europe and Coptic Egypt). Many of the themes of the first part recur in the context of very specific bodies of material. John Osborne questions the nature and function of images of the Virgin in early medieval Rome, asking how these images work in this particular setting. Cecily Hennessy asks what the function of images of children in the church of St Demetrios in Thessaloniki might be, and how these images might function as icons. John Hanson's analysis of why three-dimensional sculpted icons never caught on in Byzantium is concerned with the ways in which the function and meaning of images affected – and indeed defined – their forms. He too considers the point at which an icon might be seen as crossing over into an idol in this very specific artistic context. Barbara Zeitler examines the reuse of Byzantine ivories in western medieval Europe and the ways in which their standing as icons in Byzantium was transmuted by their altered functions in the West, where cultural attitudes were very different. Lucy-Anne Hunt discusses a description of an icon of the archangel Michael in an encomium of the archangel. She takes this as a case study in the commissioning, appearance, purpose and subsequent use and reuse of a particular icon in a specific Coptic and gendered context. John Lowden's question reminds us of the place of Byzantium in the modern world. In tracing the forging of a set of Byzantine miniatures onto a tenth-century text of Archimedes, he lays bare modern cultural assumptions influencing both the study, and the faking, of Byzantine art. Finally, the issue of the significance of details of iconography in the Byzantine icon forms the basis of Maria Evangelatou's paper. She explores

reasons why icons of the Virgin depict the Virgin spinning purple thread, setting her readings into the broad cultural context of icons as expressions of beliefs and devotional practices.

All the papers share a belief, articulated in John Hanson's paper, that visuality is a form of intuition that allows access to a world beyond the reach of our senses. Nevertheless, all take some empirical point as their start, be it an image or a text. They recognize that both images and words can be put together to create a sense of meaning and that both serve as part of the same art historical record; all are concerned with both images and words. We learnt all this from Robin Cormack.

*Acknowledgements*

A book of this nature always owes a great deal to the advice and assistance of those far beyond the editors. We would like to thank Mary Beard for her support and encouragement (and for nicking the picture); Jaś Elsner for his many contributions; Rose Walker for insider information; and Nadine Schibille for last-minute checking in the Warburg. John Smedley of Ashgate allowed it all to happen. We owe a great debt to Leslie Brubaker for services (assorted) rendered. We would also like to thank the contributors for their enthusiasm for the project and their willingness to respond to deadlines.

In putting together a collection of essays as a festschrift, decisions have to be taken about appropriate contributors. In Robin's case, a multi-volume set might have been possible. For coherence's sake, we elected to ask only his former Ph.D. students as those who, perhaps, owe him most. We have tried to track down and ask all of these but we apologize to anyone we may have missed.

## Notes

1.  R. Cormack, *Writing in Gold. Byzantine Society and its Icons* (London, 1985), 11.

2.  D. and T. Talbot Rice, *Icons and their dating* (London, 1974), 161, which encapsulates in many ways 'traditional' Byzantine art history.

3.  Other influential books from the 1980s might include Henry Maguire's *Art and eloquence in Byzantium* (Princeton, 1981) and Sabine MacCormack's *Art and ceremony in Late Antiquity* (Berkeley, 1981). Both of these, however, take texts rather than art as their starting point.

4.  On these sorts of themes, see R.S. Nelson, 'The discourse of icons, then and now', *ArtH* 12 (1989), 144-57.

5.  H. Belting, *Bild und Kult – Eine Geschichte des Bildes vor dem Zeitalter der Kunst* (Munich, 1990), trans. by E. Jephcott as *Likeness and Presence. A history of the image before the era of art* (Chicago, 1994).

6.  See R. Cormack, '"New Art History" vs. "Old History": Writing art history,' *BMGS* 10 (1986), 223-31; also the trends displayed by collections such as E. Fernie, *Art History and its methods: a critical anthology* (London, 1995).

7.  G. Mathew, *Byzantine aesthetics* (Oxford, 1963) is still the only outstanding study devoted to Byzantine aesthetics.

8.  R. Cormack, *Painting the Soul: Icons, Death Masks, and Shrouds* (London, 1997), 18.

# Part 1

# Icons and Meaning

# Chapter 1

# Icon, Idol, Totem and Fetish[1]

## Annabel Wharton

Professor Sarah Iles Johnston introduced a session entitled 'The Discourse of Idolatry' at the 2001 meetings of the American Academy of Religion in Denver, Colorado; she then re-presented herself as Professor Froma Zeitlin, the eminent Ewing Professor of Greek Language and Literature at Princeton University. Disruptions of air travel in the aftermath of September 11 had kept Professor Zeitlin from attending the conference. In her absence, her paper, 'Seeing the Gods: Idols, Images, and Representations of the Divine', was read by the session chair. Through a consideration of a set of suggestive Greek texts from the imperial period – Chariton's *Chaireas and Callirhoe*, Dio Chrysostom's *Olympian Oration* (no. 12), and Lucian's *Imagines* and *Pro imaginibus* – Professor Zeitlin's paper mapped the provocative confusion between humans, gods and statues in late classical practice and imagination. Because her paper dealt with metamorphoses in the figuration of the divine and the human, there was something peculiarly appropriate in having Professor Zeitlin represented in the form of another.

Professor Zeitlin expressly framed her contribution as an answer to the question of 'how the gods appear among us'. My paper treats explicitly what Professor Zeitlin considered implicitly: our act of looking at others looking at their gods. Specifically, I pay attention to the *names* we give and do not give to the object of the Other's pious gaze. I might also say that this paper is a speculation on why the term 'idol', so prominent in the AAR session title and in the title of Professor Zeitlin's paper, was absent from her text.

Here I consider four names – icon, idol, totem and fetish – that have been commonly used in a particular modern, Western (predominantly Protestant or secular intellectual) tradition to identify images of the Other's divinity. This sequence of names corresponds to the progressive illegitimacy of its referent. I undertake this basic exercise in the hope that it will not only remind us of how

From *Icon and Word: the Power of Images in Byzantium. Studies presented to Robin Cormack*, eds Antony Eastmond and Liz James. © 2003 by contributors. Published by Ashgate Publishing Ltd, Gower House, Croft Road, Aldershot, Hampshire, GU11 3HR, England, pp. 3-11.

our discourse constructs our vision, but also help us re-see the images of our own gods.

'Eikon' appeared often in Professor Zeitlin's text, with a brief definition: 'portrait, image, statue, likeness, and finally, simile.' Such a definition is completely appropriate for the Greek texts with which she was dealing. As Robin Cormack makes clear in *Writing in Gold*, the Greeks, and after them the Byzantines, used the term to refer to any representation.[2] 'Icon' now has other valences.[3] The term generally refers to a sign that resembles its referent. 'Icon' can be neutral, as when it refers to a picture on a computer screen that represents a file, operation or program.[4] But 'icon' now also bears a spiritual burden, as when it refers to the image of a venerated figure – an icon of the Virgin or an icon of pop culture. Within the interpretative community to which this piece is addressed, this spiritual charge commonly elicits some suspicion. The intense scepticism with which we react to an image of Elvis Presley in a newspaper accompanied by the headline, 'PAINTING OF ELVIS WEEPS REAL TEARS', is only an exaggeration of the mistrust that we harbour of the miraculous work of any image (Fig. 1.1).

If 'icon' bears suspicion, 'idol' engenders disdain. From biblical times, true believers identified an object of misplaced devotion as an idol (eidolon), using the Greek word for 'fantasy image' to describe the (mis)representation of a god.[5] In popular usage 'idol' still means 'false god' – even when it is applied to a movie star. As I mentioned before, although 'idol' appears in the title of Professor Zeitlin's paper, it is absent from her text. And for good reason. From at least the eighteenth century, those who loved the classical world avoided using the term in descriptions of ancient cult practices. In his *Italian Journey*, a record of his visit to Italy in the 1760s, Goethe perfectly described the Western intellectual's understanding of the classical statue:

> In the Palazzo Giustiniani there stands a statue of Minerva that I admire very highly... We had been standing for a long time looking at the statue when the wife of the custodian told us that it had once been a sacred image (*heiliges Bild*). The *inglesi*, she said, who belong to the same religious cult, still come to worship it and kiss one of its hands. (One hand, indeed, is white, while all the rest of the statue is a brownish colour.)... Seeing that I could not tear myself away from the statue either, she asked me if I had a sweetheart whom it resembled. Worship and love were the only things the good woman understood; disinterested admiration for a noble work of art, brotherly reverence for another human spirit were utterly beyond her ken.[6]

Goethe remarks on the discrepancy between his own enlightened view of a goddess as art and the vulgar (ancient or modern) understanding of a goddess

as an object of worship – he scrupulously avoids the term idol.[7]

In those instances in which gods lacked the protection of classical cultural authority, Western intellectuals put 'objective' science to work to monitor the treachery of images. From the eighteenth century through the early twentieth century, the repression of the positive spiritual power of the premodern (a.k.a. primitive) image is nowhere more compellingly recorded than in that image's naming as 'totem' or 'fetish'.[8] By the 1860s the term 'totem' was integrated into anthropological discourse.[9] J.G. Frazer's monumental four-volume work of 1910 is symptomatic of the term's use. Frazer collected and codified the reality of the totem.[10] He explains the significance of his work on totems. It provides 'a broad and solid foundation for the inductive study of primitive man' and 'a glimpse... into the working of the childlike mind of the savage...'.[11] 'Whatever becomes of the savages, the curtain must soon descend on savagery forever.... With their disappearance or transformation an element of quaintness, of picturesqueness, of variety will be gone from the world [though] society will probably be happier on the whole....'[12]

If 'totem' marks an uncivilized representation of spiritual power, the 'fetish' points to the abuse of images by the primitive Other. As William Pietz has recently and brilliantly demonstrated, from the origins of the term with missionaries in Africa to its role in the rationalization of colonial forms of economic exploitation in the nineteenth century, 'fetish' was pseudo-anthropology doing the work of politics.[13] The use made of 'fetish' by both Marx and Freud was symptomatic of the ways in which the term was deployed ethnographically. They put the aberrant connotations of fetish to work respectively describing contemporary economic and sexual deviance.[14]

Totem and fetish appear to be terms that were popularized in the nineteenth and early twentieth centuries by scholars seeking, as Lévi-Strauss recognized some time ago, 'consciously or unconsciously, and under the guise of scientific objectivity, to make ... so-called 'primitives' more *different* than they really are'.[15] It is now generally acknowledged that 'totem' and 'fetish' presented Western fictions of the Other. These terms are finally and fully recognized for what they always were: tools more useful for describing the cultural anxieties of modernity – as in Marx and Freud – than for understanding the tribal practices of the 'primitive'.[16] Having removed 'totem' and 'fetish' from their deceptive ethnographic frames and having revealed the subjectiveness of their constitution, I would argue that they can be effectively redefined and redeployed to identify how images work in the present for an audience of Western Protestant or secular intellectuals.[17] As a first step towards such redefinitions and redeployments, I offer the following Table comparing the attributes of icon, idol, totem and fetish.

| ICON | IDOL | TOTEM | FETISH |
|---|---|---|---|
| representation of the human | representation of the human or animal | representation of the animal | a thing, not a representation |
| work | work | creature or work | product |
| its referent is other worldly | its referent feigns other worldliness | its referent exists in the world | it has no referent |
| god or god-like being | false god | not a god | false god |
| used by those most like us | used by those who should be like us | used by a benign Other | used by a malignant Other |
| source of unearthly power | supposed source of unearthly power | source of earthly power | source of earthly pleasure |
| performs both privately and publicly | performs both privately and publicly | performs publicly | performs privately or performs publicly for private gratification |
| spatial | spatial | territorial | unstable/ placeless |
| subject of theology and semiology as a sign | subject of historians as an artifact | subject of anthropology as an emblem | subject of psychology and critical theory as a symptom |

This Table can be translated into narrative terms:

An icon is a work of art or of craft that represents an accredited form of spiritual power in a dubious manner.[18] It occupies private or public space and alludes to the individual or communal devotion of those with whom an audience of Western intellectuals share their most recent spiritual traditions. The icon is a worthy subject of theological and semiological, as well as art historical, research, as this book suggests.

An idol is a work of art or craft that represents a discredited form of spiritual power in a licit manner. It occupies private or public space and alludes to the practices of those whose cultural, if not spiritual, traditions have been embraced by Western intellectuals. Those who make idols have not realized that their gods are false. The idol is a worthy subject of historical, as

well as art historical, research.

A totem can be either an object in the world, like an animal or a plant, or a work of art or craft figuring that object. It empowers its users by embodying (not simply symbolizing) the terrestrial power that it represents. The totem performs publicly to identify a clan or group. The totem not only defines the membership of a community, but may also mark its domain.[19] The totem is a worthy subject of anthropological and sociological research.

A fetish is a product, not a work of either art or craft.[20] It provides satisfaction to its user as the materialization of (false) power.[21] The fetish performs either privately or, if publicly, for private gratification. The fetish is unstable and unterritorial. The fetish is a credible subject of psychological or critical theoretical research.

A consideration of Minoru Yamasaki's New York World Trade Center of the early 1970s may provide the reader with some sense of the current usefulness of these terms. The World Trade Center was described in the *A.I.A. Guide* to the architecture of New York as a speculative affront to the city: 'From the harbor, Brooklyn or New Jersey, this pair dominates the Lower Manhattan skyline; stolid banal monoliths overshadowing the cluster of filigreed towers that still provide the romantic symbolism that once evoked the very thought of 'skyline'.'[22] The buildings' million square feet of rentable space was seven times that of the Empire State Building and four times that of the MetLife (formerly Pan Am) Building.

The World Trade Center might have been called the 'fetish' of urban developers by those critical of real estate speculators, though that would have sounded shrill. It might less provocatively and more productively have been named a 'totem' of international banking or even the 'idol' of globalization. But since the murder of six people in the 1993 bombing of the World Trade Center and even more powerfully in the wake of the traumatic erasure of its twin towers on 11 September, 2001, the World Trade Center has become, to quote the *New York Times* and the governor of the city, the 'quintessential New York City icon',[23] 'a world-renowned icon'.[24] The term is appropriate. Naming the twin towers as 'icon' alludes to its spiritual burden as memorial and tomb; the term also bears with it our lingering suspicions that its earlier work as 'idol' may have contributed to its destruction.

If 'idol' was absent from a session on idolatry, 'icon' is certainly not missing from the present volume. The icon is the subject of a number of insightful studies by Robin Cormack, whose work has inspired this text. It might well be pointed out that Robin Cormack's understanding of icons has, as one of its many foundations, a profound knowledge of the spatial settings of Byzantine paintings. His control of architecture as well as representation has deeply

informed my own work and consequently this particular contribution written
in his honour.

## Notes

1.  This text was initially written as an invited response to Professor Zeitlin's paper. An
    abbreviated form was given at the meeting of the American Academy of Religion in
    Denver, in November, 2001. I want to thank Professors Richard Powell and Kalman Bland
    for their comments on a fuller draft.

2.  R. Cormack, *Writing in Gold: Byzantine Society and its Icons* (London, 1985), 11.

3.  *Webster's Third New International Dictionary*, http://collections.chadwyck.com/mwd/
    htxview?template=basic.htx&content=frameset.htx (accessed 24/09/2002).

4.  C.S. Peirce, *The Collected Papers of Charles Sanders Peirce*, vols. I-VI, eds C. Hartshorne and P.
    Weiss (Cambridge, MA, 1931-1935), Book 2, Chapter 3, 'The Icon, Index, and Symbol',
    274-309.

5.  On idolatry from a Jewish perspective see M. Halbertal and A. Margalit, *Idolatry*, trans. N.
    Goldblum (Cambridge, MA, 1992). The authors' assumption that Western philosophy
    makes transparent the evils of idolatry exemplifies the uninterrogated use of ideologically
    loaded terms as though they are historically objective. 'Our discussion brings philosophical
    concepts to bear on the study of idolatry, in contrast to historical, theological, and
    anthropological concepts.... We need look no further than the notion of idolatry as error.
    The critical and liberating role of philosophy is the uncovering of deep illusions.
    Philosophy, by its nature, or at its best, is iconoclastic, in the sense of removing ideological
    masks or breaking idols. In this context the idols are the creatures of the human
    imagination that take control over people and their lives, and the breaking of idols means
    the uncovering of the fictional and illusive character of these creatures of the imagination.
    The war against idolatry has the same role of liberation from error and the attempt to break
    the bonds of the imagination.'

6.  J.W. von Goethe, *Italienische Reise*, Teil 1, Project Gutenberg e-text: ftp://ibiblio.org/
    pub/docs/books/gutenberg/etext00/7itr110.txt (accessed 24/09/2002), entry, 13 January,
    1787; *Italian Journey (1786-1788)*, trans. W. H. Auden and E. Mayer (San Francisco, 1982),
    147.

7.  For Goethe, true religion was more likely to deal in false images. He writes: '[The followers
    of Filippo Neri (b. 1515) began] telling him about their delightful visions of the Mother of
    God and various other saints. Knowing only too well that such hallucinations are apt to
    breed spiritual pride... he told them that a diabolic darkness was undoubtedly hiding behind
    this heavenly beauty. To prove this, he ordered them the next time they had a vision of the
    Blessed Virgin to spit in her face; they obeyed, and instead of the vision, a devil's face was
    at once revealed. In giving this command, the great man may have been conscious of what
    he was doing, but more probably he was prompted by deep instinct: in any case, he knew
    that an image evoked by a fanatic love would be transformed into a caricature of itself when
    exposed to the counter-force of hatred or contempt.' 335.

8.  'Totem' appears first in late eighteenth-century travel accounts of North America
    describing the animal emblem with which a clan identified itself. By the mid nineteenth
    century 'totem' was fixed in the early ethnographic travel literature. See, for example,
    George Catlin (1796-1872), *Illustrations of the Manners, Customs, and Condition of the North*

*American Indians, with Letters and Notes Written during Eight Years of Travel and Adventure among the Wildest and Most Remarkable Tribes Now Existing* (London, 1857).

9. Edward Burnett Tylor (1832-1917), *Researches into the Early History of Mankind and the Development of Civilization*, 3rd ed., intro., abridged by P. Bohannan (1st ed. 1865, 3rd ed. 1879, Chicago, 1964).

10. J.G. Frazer, *Totemism and Exogamy: A Treatise on Certain Early Forms of Superstition and Society*, 4 vols (London, 1910), 1.xv.

11. Frazer, *Totemism and Exogamy*, 1.xvi, xiv.

12. Frazer, *Totemism and Exogamy*, 1.xv.

13. W. Pietz, 'The Fetish of Civilization: Sacrificial Blood and Monetary Debt', in *Colonial Subjects*, eds P. Pels and O. Saleminck (Ann Arbor, 1999), 53-81.

14. Karl Marx, *Capital*, ed. Frederick Engels (1867; New York, 1967), vol. 1, part 1, 'Commodities', 35-83; Sigmund Freud, 'Fetishism', in *Works*, ed. J. Strachey, 24 vols (London, 1953-1974), 21: 152-7.

15. C. Lévi-Strauss, *Totemism*, trans. R. Needham (1962; Boston, 1963), 1. Lévi-Strauss' diatribe against totemism seems to have ensured the erasure of totem from anthropological discourse; at the same time, his understanding of the social practices in the West to which totemism might be ascribed prepared the way for the reemergence of totem as a literary-critical tool.

16. Durkheim, as well as Marx and Freud, provided cultural theorists with models of how these terms might be exploited to define their own social realities. É. Durkheim, *The Elementary Forms of Religious Life*, trans. C. Cosman (1912; New York, 2001); S. Freud, *Totem and Taboo: Resemblances between the Psychic Lives of Savages and Neurotics*, trans. A.A. Brill (1913; Amherst, NY, 1999).

17. The recent bibliography of works dealing with the fetish is enormous. In addition to Pietz, 'Fetish of Civilization', see *Fetishism as Cultural Discourse*, eds E. Apter and W. Pietz (Ithaca, 1993), for bibliography. Totem has been less common in contemporary critical discourse, though W.J.T. Mitchell is single-handedly changing that: 'Romanticism and the Life of Things: Fossils, Totems, and Images', *Critical Inquiry* 28/1 (Fall 2001), 167-84, and 'The Surplus Value of Images', *Mosaic: Journal for the Interdisciplinary Study of Literature* 35/3 (2002), 1-23.

18. Be reminded: for the sake of this argument, it is understood that the audience is constituted of Western Protestant or secular intellectuals.

19. Frazer, *Totemism and Exogamy*, 1.89-172; Durkheim, *Elementary Forms*, 89-90.

20. The distinction that I am employing here between work and product depends on Henri Lefebvre, *The Social Production of Space*, trans. D. Nicholson-Smith (1974; Oxford, 1991), particularly 68-84.

21. Or as Bruno Latour 'A Few Steps Toward an Anthropology of the Iconoclastic Gesture', *Science in Context* 10/1 (Spring, 1997), 66, succinctly describes it, 'Something that is nothing in itself but only the screen on which we have projected, by mistake, our fancies, our labor, our hopes and passions'.

22. N. White and E. Willensky, *AIA Guide to New York City* (New York, 1978), 25.

23. T. Bahrampour, 'The Farther Away, The Larger They Loomed', *New York Times*, 23 September 2001, http://www.nytimes.com/2001/09/23/nyregion/thecity/23FORN.html?searchpv=nytToday (accessed 24/09/2001).

24. 'Governor Pataki, Acting Governor Difrancesco Laud Historic Port Authority Agreement
    To Privatize World Trade Center', news release, 24 July, 2001, http://www.panynj.gov/
    pr/101-01.html (accessed 24/09/2001).

**Stunned scientist witnesses incredible phenomenon with his own eyes**

# Painting of Elvis weeps real tears!

Scientists say a painting of Elvis Presley weeps when the owner puts *Heartbreak Hotel* on the stereo and doesn't stop until she plays *Jailhouse Rock!*

By RAGAN DUNN

Analysis of the inexpensive velvet-backed painting remains inconclusive. But Dr. Waring Mayer, the German chemist, says the liquid that flows from the painted King's eyes "is a saline solution that's indistinguishable from the human tear."

"This is a most baffling phenomenon," continued the expert.

"Scientific literature is full of reports of religious icons that cry.

"But this is the first time I've heard of a thoroughly secular object weeping. And weep it does — I've seen it with my own eyes."

Patricia Sieler of Baden-Baden, West Germany, said she bought the painting after Presley's death in 1977.

It began to cry in August, she added. And it's been bawling on cue ever since.

"Sometimes I don't know whether to be grateful or terrified," said an amazed Miss Sieler, 46.

"For so many years the painting just hung there on the wall and didn't do anything but comfort me when I thought about Elvis.

"Then last summer I was gazing at it and saw water glistening on one of Elvis' cheeks.

"When I took a closer look, I could see that it was crying its eyes out.

"I was shocked, but I knew it wasn't a joke. It cried all through *Heartbreak Hotel* and didn't stop until I played *Jailhouse Rock.*"

Miss Sieler reported the incident to newspaper reporters who drove out to her house to inspect the picture themselves.

Alerted by the published reports on the phenomenon, Dr. Mayer and several assistants launched an investigation of their own. They confirmed that the Elvis painting has not been altered in any way.

"The most intriguing aspect of all this is that the painting only cries when Miss Sieler plays her Elvis records," said the expert.

"Needless to say we will continue our study. I won't be able to rest until I determine what makes this painting cry."

Said Miss Sieler: "If the painting continues to cry, I'm going to give it to a museum.

"I can't keep something like this to myself.

"It belongs to Elvis fans everywhere."

## Couple tries to commit suicide with AIDS blood

In an incredibly bizarre suicide attempt, a Denver couple slashed their wrists — and poured AIDS-tainted blood into the wounds, cops said.

Erik and Carmen Henriquez tried to kill themselves with blood from a vial labeled with a warning of AIDS contamination. The vial was one of 49 Henriquez stole from Denver General Hospital.

Believing the blood was infected with the deadly disease, Erik, 24, and Carmen, 36, cut their wrists and emptied the blood into the open wounds, cops said.

The weird suicide attempts came to light when Mrs. Henriquez called police and told them what had happened.

Hospital spokesman John Head said the stolen blood contained AIDS antibodies, not the virus. The dread virus cannot be passed through antibodies alone, he said.

Investigators said Henriquez was obsessed with the idea of committing suicide by AIDS and believed he and his wife were infecting themselves with the virus.

Cops said Henriquez sneaked into the basement of the hospital and swiped the blood from a freezer a few days before the suicide attempt.

The couple were treated at a hospital for the self-inflicted cuts and held for psychiatric examination.

WEEKLY WORLD NEWS
November 1, 1988     **17**

1.1 *Weekly World News*, 1 November 1988: 'Painting of Elvis weeps real tears'.

# When all that is Gold does not Glitter: On the strange history of looking at Byzantine art[1]

Rico Franses

Not long ago, as I was holding forth to students in an introductory college art history class about the Justinian and Theodora panels in the church of S. Vitale at Ravenna, a pair of good quality slides of which were projected onto the screen behind me, a shadow of doubt suddenly crossed my mind. I paused and asked, 'What colour is the background in these pictures?' Without the slightest hesitation, they answered, 'Yellow'. 'Are you sure?' I replied, giving them every opportunity to change their opinions, 'Nothing else comes to mind?' But they were insistent. Yellow it was. 'And what medium is it?' I continued. 'Paint', they affirmed confidently. 'Are you sure?' I repeated, somewhat desperately. 'Well, it may be a little cracked, but yes, paint, definitely', was the reply.

To be sure, this is hardly the fault of the students. It is rather the result of the fact that a particular paradigm of looking is in place in relation to images having gold as a major component, one which is specially active in museum displays and photography. Today, when we see the many such works of art either in photographic reproductions or in museums, we look at them under very carefully controlled light conditions which radically affect the nature of what we see. Unlike the regular pigments used in art, gold possesses not only hue (or colour), but, being a metal, it has a much higher degree of reflectivity than they do, sending much more of the incoming light back out into the world. This reflectivity is at its most intense when the light catches in the gold, that is, when the light source is directly reflected within it. This phenomenon causes contemporary curators and photographers no end of trouble because it

From *Icon and Word: the Power of Images in Byzantium. Studies presented to Robin Cormack*, eds Antony Eastmond and Liz James. © 2003 by contributors. Published by Ashgate Publishing Ltd, Gower House, Croft Road, Aldershot, Hampshire, GU11 3HR, England, pp. 13-24.

creates a sharp point of light concentration (called a hotspot) that has a blinding effect on the viewer, reducing the image to near-indecipherability.

Yet gold is not only the surface element of a painting most responsive to external lighting in this way, but also the most variable. When the gold does not catch the light (that is, when one cannot see a reflection of the light source in its surface), then it behaves much like other pigments. It ceases to appear metallic, and one is only really aware of its colour. This property, in turn, is put to use by the aforementioned curators and photographers who carefully position the lights around the works so that they do not catch in the gold; in museums, lights are placed high overhead and relatively close to the wall surfaces on which the paintings hang, and in photography studios they are placed at an oblique angle to the images. Under these conditions (which I will call conventional lighting), the glare of hotspots does not appear, and the gold returns to quiescence, becoming nothing more than another colour.

It is the argument of this paper, however, that this uniform method of lighting, which consistently reduces the gold to just another regular pigment, is entirely alien to the spirit of these images. Rather, they were specifically designed to be seen with the gold in its fully reflective state, although, to be sure, without the attendant hotspots. As will become evident, much of the detail, subtlety and sophistication (both optical and conceptual) of the images is lost when the reflecting gold is neutralized.

Whilst an appreciation of the special reflective qualities of gold is often voiced by writers on Byzantine art,[2] there has not been any attempt made to either reproduce or study specific images with it in its 'live' state. Our first step, then, will be to re-examine some of these scenes in both a 'before' and 'after' state. Yet, the issue is not simply one of returning to the gold its inherent properties. In their reflective condition, the pictures undergo an extraordinary transformation that has radical implications for almost every aspect of their interpretation, as well as for broader issues concerning regimes of visuality and the demands that we place upon vision itself.

Plates I and II demonstrate the changes that take place when the gold appears in its different guises. Both show the same scene, a Deposition and Lamentation from the Morgan Lectionary of 1050-1100 (New York, Pierpont Morgan Library, MS M639, fol. 280r).[3] Plate I is taken under the conventional lighting conditions designed to minimize gold reflection. Plate II shows the scene with the lights positioned so as to allow the reflection of the gold to be visible. In order to appreciate these changes fully, however, it is necessary first to examine Plate I alone in greater detail.

Excluding momentarily the Lamentation in the foreground and focusing primarily on the Deposition, we find (as with almost all figural compositions) a clear hierarchy of elements within the scene. Least important is the background, which stretches from the upper frame down to the floorline, and

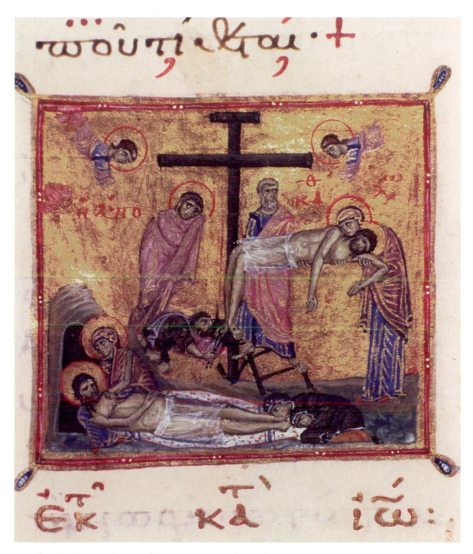

Plate I. Deposition and Lamentation, from the Morgan Lectionary, 1050-1100. New York, Pierpont Morgan Library MS M639, fol. 280r (courtesy of the trusteees of the Pierpont Morgan Library, New York).

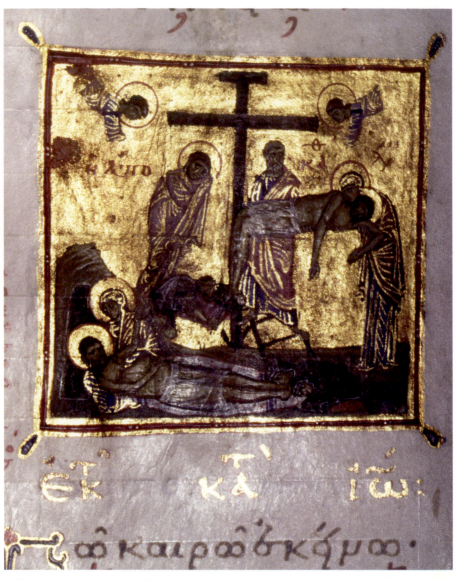

Plate II. Deposition and Lamentation, from the Morgan Lectionary, 1050-1100. New York, Pierpont Morgan Library MS M639, fol. 280r (courtesy of the trustees of the Pierpont Morgan Library, New York).

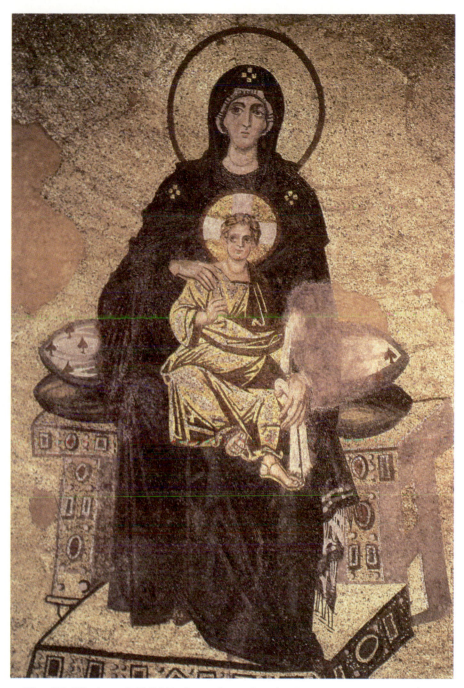

Plate III. Virgin and Child Enthroned, c. 843-867. Apse Mosaic. Hagia Sophia,
Istanbul (E.J.W. Hawkins).

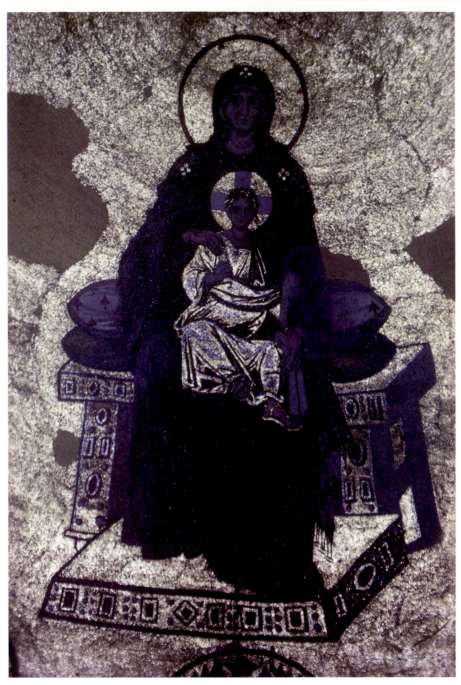

Plate IV. Virgin and Child Enthroned, c. 843-867. Apse Mosaic. Hagia Sophia, Istanbul (E.J.W. Hawkins).

which contains nothing of significance in narrative terms. Next up the scale are the onlookers and corpse-bearers, who demonstrate their secondary nature by the fact that they direct their ministrations and attentions to Christ, with whom we finally reach the apogee, the narrative heart of the image: this is his story, his drama that is unfolding. This narrative hierarchy is matched by the formal structure of the scene. The neutral yellow background functions largely as a backdrop, a setting for the figures; whereas at the other end of the scale, Christ's body is accentuated in several different ways. It is naked when all others are clothed, and is strongly horizontal, as opposed to the standing figures (and cross) that surround him. Furthermore, the skin tones of Christ's body differentiate it from the pinks, blues, and reds of the other figures, and a significant proportion of its surface area is covered in white or near-white tones, making it the lightest object in the scene.

In Plate II, however, this hierarchical organization is dramatically unsettled. With the gold ground now very much alive, it is no longer merely a yellow backdrop, a passive foil against which the action takes place. Now a brilliantly glowing field, it becomes a commanding visual presence in itself, which, in turn, has a profound effect on the visual balance and accenting of the scene. Rather than automatically centring on Christ, or indeed even on the surrounding figures as subsidiary characters, as tends to happen in Plate I, one's gaze is now drawn as well by a glittering field of great beauty that stretches out over much of the surface of the image.

Yet, to say that the gold ground has become a new centre of attention is not to say that Christ's body disappears from view. On the contrary, it remains a corporeal presence of extreme importance, although its manifestation and significance are both highly complex and entirely different from the standard presentation of the scene. For as much as one's gaze is drawn by the shining field, it is simultaneously pulled back to the figure of Christ for two overlapping reasons. In the first place, it now stands out as an interruption, a gap, within that brilliant surface; it is felt as an absence, a caesura within a field of extraordinary beauty and intensity, and one is inexorably led back to it as the site of a cut, a rupture. Simultaneously, gap though it may now constitute, it remains the narrative centre of the image: Christ is still the character upon whom the whole story hinges.

Yet, in looking back at that narrative centre, now located as a pause within a field of light, we find that what is revealed there has itself been transformed. For, one of the effects of the brilliance of the gold, only partly reproducible in photographs, is a shimmer that dazzles the eye, and that tends to swamp the non-gold areas, partially blotting out or obscuring many of their details. The gap thus appears as a dark hole, a precipitous cavity that in contrast to its radiant surroundings appears to be sucking light in and swallowing it, allowing very little to escape. And what one discovers within it, instead of a clear, easy-

to-read body, is a dark world where rough outlines emerge only dimly from the gloom.

It is this constellation of effects that I take to cover something of the full range of functioning of many of these golden images when seen in their optimal state. The visual experience as one scans them in the process of reading them is entirely different from that on offer under conventional lighting; one is entranced simultaneously both by a kind of visual seduction emanating from the gleaming gold ground and by the gap within it, and further, one is confronted within that gap by obscurity, unclarity and mystery. The encounter with the image in this state is thus marked by a particular complexity and intensity. No longer drawn only to a few figures posed towards the centre of the scene, the gaze is lured by both an unpopulated, unlined, formless, but irresistible zone of pure optical repleteness, less colour than light itself, and narrative, figural forms that are difficult to see and require effort to decipher. There is no longer anywhere in the entire image that is not laden with significance of one sort or another, that is unstressed.

It needs to be emphasized at the outset, however, that the essence of this experience is founded on the armature of a fundamental dichotomy, or binary, between one part of the image that is light reflecting and another that is light absorbing. I call this the reflection-absorption binary, and it appears in Plate II not only at Christ's body in the Deposition, but in many other places as well, particularly in the left half of the Lamentation, and in all the faces in the scene as a whole. It forms a dominant and deliberate compositional principle, as surely as does the characteristic central triangle constituted by figures in carefully aligned postures within High Renaissance paintings (see, for example, Fig. 2.1.). Obviously, this binary only comes into play when the gold is live. Without it, the image has lost a fundamental aspect of its compositional structure.

This device can be clearly and spectacularly seen in Plate IV, a picture taken by Ernest Hawkins of the Hagia Sophia apse mosaic of the Virgin and Child. It is to be compared with Plate III, which shows the image as it is usually reproduced in publications. In Plate IV, it becomes clear that the entire scene has been structured as a sequence of alternating layers of reflection and absorption, with its gold ground, dark figure of the Virgin, and gold-robed Christ.[4] The deliberateness with which the principle has been adhered to is evident in the rigour with which each layer has been closed off by its opposite. Christ is carefully centred so that he is entirely surrounded by the looming, dark form of the Virgin. She has no chrysography in her robe at all, so that at no point does the gold in the Christ layer meet up with gold in any other layer. Christ is sealed within darkness, just as the Virgin is sealed within light, from her halo to the suppedion to the gold bench. Nowhere does gold bleed into gold or dark into dark. This truly is a binary, the borders between

them strictly controlled.

As with the Morgan Lectionary Deposition, a transformation in terms of overall appearance and pictorial balance occurs in this scene, although here that transformation also radically affects the subject matter of the image. As it appears in its conventional guise (Plate III), the scene is heavily visually weighted towards the Virgin, who emerges as the dominant figure. She has size, mass and bulk on her side, and her face attracts attention both as a light coloured surface and as the bearer of personal identity. The Christ Child, by contrast appears much as a secondary figure. In Plate IV, however, with the reflection-absorption binary in effect, the entire balance is altered. Attention is now drawn towards two new gleaming optical zones, the gold ground and the figure of Christ. Leaving aside momentarily the gold ground, to which we will return shortly, it becomes evident, in a way that it certainly was not before, that the image lays a vast amount of stress on Christ, as one's eyes are pulled towards his resplendently glowing figure.

Yet, despite the fact that a visual re-weighting occurs in this image, just as it does in the Deposition, a closer comparison between the two reveals that the reflection-absorption binary is anything but a device uniformly applied. In both, Christ is the most important character, yet in the Deposition he is the darkest figure in the scene, and in Hagia Sophia he is the lightest. That there are iconographic consequences in relation to both will be obvious, but before turning to them, let us pause a little longer on the implications that this fact has for the processes of scanning and reading these images mentioned earlier. As we have seen, in the Deposition the reflection-absorption binary causes a distinctive, almost paradoxical, mode of reading. A blaze of light encompasses much of the image, yet the point to which one is led by the narrative drive (that is, the compulsion to look at Christ as the chief protagonist, the centre of meaning in the scene) is obscured and is not easy to decipher. Despite the brilliance, what one needs to see in terms of figural content cannot be made out clearly, and what one is given to see, entrancing and profoundly significant though it is, does not help in revealing the crucial part that resists one's visual grasp. In the Hagia Sophia Virgin and Child, however, this tension between the various parts of the image is not in play to quite the same extent. There is luminosity in the field, there is darkness covering one of the figures who carries the content, but the personality on whom the scene centres is clearly displayed. To be sure, some of that tension still exists. One still looks to the Virgin as a break within the gold ground, still searches within the gloom for signs of her body and face, as one does, indeed, even for Christ's face, but one is not forced by the structure of the image to grope around in the dark in an attempt to make out its figural core.

Clearly, the changes produced in both images by the new lighting mode have profound iconographic significance. The Hagia Sophia scene in its new

guise, for example, must be seen as the very visual embodiment of Christ's proclamation, 'I am the light of the world' (John 1.9). He is a light-emitting, divine figure, in contrast to the Virgin, who, without her characteristic chrysography, appears distinctly lacking in divine radiance. In the Deposition, by contrast, Christ is the only one amidst the company of John, Mary and Joseph of Arimathea who is not shot-through with light. The iconographic point here (entirely lost in the conventional reproduction of the scene) is evident as well. What better way to show the theological truth that it is as both fully man and fully god that he is murdered than to deprive him of divine light?

In this context of the significance of light, we may add the obvious point here that with the reflection-absorption binary active, the gold ground, long interpreted as being symbolic of divinity, is not so much symbolic of it as demonstrative of it, an actualization of it. It is a field of divine immanence, the very substance of divinity itself. It is the place where optics and theology coincide. And if a field of divine immanence it is, then we may say that the Hagia Sophia Virgin and Child visually makes the theological point that Christ is formed of the same stuff. He is composed of immanence, is immanence incarnate. Clearly, much work remains to be done in the investigation of other, similar pictures in this regard, but in a culture that has such a well developed verbal theology of light, stretching from Pseudo-Dionysios to Gregory Palamas, is it not time to consider images in gold as a parallel track in the development of a visual theology of light?[5]

Let us now turn to a more detailed examination of some of the physical conditions required for the optimal viewing of these scenes. One of the most striking aspects of these pictures is the smooth, even glow that the gold ground is capable of providing as it contrasts with the more textured and lined light-absorbing surfaces of the figures. The key difficulty here, as mentioned earlier, is how to get the gold to catch the light and yet avoid hotspots. This problem, it turns out, is easy to solve. Hotspots, as we have seen, are caused by point sources of light, usually light bulbs, being reflected in the metallic surface, and the extremely bright lights commonly used in contemporary photography make matters considerably worse. However, if these images are illuminated not by a direct point source of light, but an indirect, broadly spread light, for example an open window or door that allows some light, but not direct sunlight, to enter a room, the gold can pick up that ambient light without the attendant hotspots.

Indirect light of this sort, however, is generally not particularly strong, and not coincidentally, these images are at their arresting best in very low light, when counterintuitive though it may seem, the contrast between the light-reflecting and light-absorbing areas is at its peak. This occurs at the point just

before the dark zones fall off into indecipherability, where there is barely sufficient light available for their interior details and markings to be dimly glimpsed, yet they immediately abut the smoothly glowing fields of gold, the optical dazzle of which, as mentioned, compounds the effect of a creeping invisibility.

These conditions of low, indirect light, of course, recur in Byzantine churches every day at dawn or dusk. The most effective moment for viewing these pictures arrives at the moment when the church itself is almost completely black, yet a tiny amount of light still filters in. Suddenly, in a particularly dark corner, the gold of an icon or mosaic comes alive. Glowing impossibly brightly given the amount of dim light entering from a distant window or door, the image appears to be a source of light in itself, and the binary, in effect, seems to be not so much reflection and absorption as emission and absorption. And within the dark pauses that inhabit that incandescent field, one struggles to make out the forms of the godly. These images truly are magical, mystical meditations on theology and divinity.

Although the argument for the reflection-absorption model has so far been made primarily in visual terms, there is considerable evidence available that this was the way in which Byzantine viewers themselves regarded their images. Liz James, in *Light and Colour in Byzantine Art*, concludes that amongst Byzantine authors writing about art, images are particularly admired for their brightness and brilliance. Thus Paul the Silentiary, in his sixth-century description of the church of Hagia Sophia makes frequent use of the term 'glitter', and refers to 'the gilded tesserae from which a glittering stream of golden rays pours abundantly'.[6] Much emphasis too, is placed on the contrast between areas of light and dark. Individual colours, by comparison, are considerably less appreciated, and terms for them are vague and imprecise. Sparkle and glitter are thus more highly valued than hue.[7] These findings, of course, are entirely congruent with the contentions of this paper. With the reflection-absorption principle in operation, the pictures do indeed sparkle and glitter and there is great contrast between lights and darks, yet they are not particularly colourful because the optical dazzle and low-light conditions considerably diminish the eye's ability to perceive the local hues in the clothing and skin tones of the figures.

As James makes clear, this Byzantine concentration on brilliance and sparkle is diametrically opposed to our own modes of perception, in which colour plays a much more important role. This and other perceptual differences, I will argue, are ultimately responsible for the current, conventional displays of Byzantine images with the gold in its flat, unreflective state. In respect of those differences, however, it is not simply that we are out of step with the whole of history; rather, we are direct heirs to visual regimes that begin in the Renaissance, supplanting the earlier regimes under which

Byzantine images were made. In this last section, then, we will look briefly at the significance of some of the changes that take place in two-dimensional imagery as the use of gold falls out of favour during the Renaissance, and the reflection-absorption binary as a principle of composition is eclipsed.

Let us take as an example of the new Renaissance mode of painting Raphael's *Madonna of the Meadows*, of 1505 (Fig. 2.1; Vienna, Kunsthistorisches Museum). Most importantly, without the extreme of the dazzling gold, there are no longer any dark intervals in the image that are difficult to discern. Rather, all details are clearly visible; everything, including the most subtle shades of colour, is revealed to the eye. It is this, I believe, that marks a watershed in relation to both vision itself and painting, towards the visual paradigms that we ourselves now inhabit. The shift that takes place, evident in scene after scene in the Renaissance, is one away from anything in the visual field that is not absolutely clear and easy to see. Whatever does not reveal itself fully and distinctly to vision, the vague, obscure, and indiscernible, is refused. It is almost as though vision takes on a new arrogance, a heightened sense of its own importance, a sense of what it can do, and decides that it will not tolerate anything over which it does not have total dominion. What the new painting offers the eye, so evident in the clear, easy vistas of Raphael's Madonna, is proof that there is nothing that can resist the penetrations and grasp of vision. Byzantine vision, by contrast, as the golden images demonstrate when the reflection-absorption binary is active, is indeed tolerant of uncertainty, obscurity, and things that escape it, is not as demanding that everything be revealed to it.[8]

What this concerns, then, is the ideology of vision, the series of beliefs, expectations, and demands that coalesce around the act of looking itself. It will be evident that the current methods of displaying and photographing Byzantine images (which in fact amount to the mode in which this art is represented) are entirely dictated by that paradigm of vision that begins in the Renaissance, and is with us still. It demands that no bothersome reflections dazzle the eye and make areas difficult to see. Everything must be delivered up so that our gaze can march unimpeded across the surface of the scene, easily grasping all details, all colours that cross its path. No dark corners where objects withdraw from visibility. We now live the imperious reign of vision.[9]

Yet the case to be made for Byzantine vision is infinitely stronger in that it can more easily tolerate uncertainty and obscurity. The obscurity in the pictures is hardly deployed there simply because the period vision can tolerate it. Byzantine theology is full of the idea that there is much in the workings of Christianity that escapes human understanding.[10] Not for nothing is reference constantly made to the 'sacred mysteries' of the Trinity, Incarnation, and Salvation, and it is difficult not to cite St Paul's 'Now we see through a glass, darkly' (1 Cor. 13.12) in reference to our images. But then, similarly, it is also

difficult not to cite Gregory Palamas's 'When it [our supernatural ability to see God] looks at itself, it sees light, when it looks at the object of its vision, it too is light, and if it looks at the means that it uses to see, there again, there is light.'[11] In these images, we both sense divine immanence and glimpse things that we cannot comprehend completely; we know that they are there, but cannot grasp them fully. These pictures are, again, visual theology in process. The shimmering light side by side with dematerialized, shadowy bodies and strange markings that do not reveal themselves fully are the workings of theology in vision. To represent these scenes with the gold unrecognizable as a lively metallic surface, to insist on the perfect scrutability of the figures in particular is to impoverish them indeed. It is to succumb to an ideology that believes that figures carry the only meaning in the scene and is blind to the light that surrounds them.

These points, incidentally, provide a response to a question that arises in relation to the reflection-absorption model for which I have been arguing. If these golden scenes were intended to be looked at with so many of the bodily and facial features, fabric folds, and colours all obscured by the dazzle of the gold and made almost indecipherable by the low light, why are all those details and colours still painted in? Why not use a much rougher, cruder outlining of the main parts, rather than wasting time and effort on refinements of colour and shading which would hardly be seen? The answer will be evident in the light of what has been said above. The details are not wasted, but are rather intrinsic to the mode of operation of these images, which is to provide a sense of things that withdraw from vision. To sense them eluding one's grasp, to know that one is not seeing them, is their point.

Yet this is only half of the story. I have been arguing so far in terms of opposite extremes, contrasting the low light reflection-absorption model with the bright but no-reflection model of contemporary displays. And although I stand by the argument that these pictures are at their best when the reflection-absorption binary is in force, the actual situation is far more fluid and variable. Byzantine churches are often dark, specially in the early mornings and late evenings when services are held, but they are also very often very light, as full daylight floods the building. What this means, then, is that at certain times of day, the reflection-absorption binary is in full force, whereas at others the images appear in circumstances that are not unlike the ones we now generally see them in, with the gold not reflecting and the central figures themselves easy to see. If they were designed to operate only in the reflection-absorption mode, and did not carry the full range of pictorial signs and colours, they would be unserviceable for large portions of the day. As they stand now, they are fully formed as images: the figures can be appreciated for their beauty, for the delicate pinks and blues of the robes in the Morgan Deposition, for the modelling in the face of the Virgin in Hagia Sophia. In low light, the gold field

takes over, the figures are darkened, and the visual theology in all its profundity, mystery, suggestiveness and allusiveness begins.

In comparison with Renaissance paintings, then, which constantly require high levels of light to be fully appreciated, and simply fade into the darkness without any further ado when those levels drop, these are the most flexible of images. They are not simply polysemic, as we students of Robin Cormack so often say, but polymorphously polysemic, entirely changing their appearance and meaning in response to ambient light conditions. They are, to this observer, the most subtle art and the most theologically complex pictures because they do not simply represent theology, but enact it.

To paint in gold is to paint in light rather than to represent it, as Renaissance painting does. Yet the images are for nought if observers are not allowed to see it. The key argument of this paper may be summed up with one rhetorical question: Why would metallic, reflective gold be inserted into the image if it were not intended to be seen in the full dynamic range of its optical possibilities? Within Byzantine art alone, as the two examples illustrated here begin to demonstrate, the gold is used in a startling variety of ways, the visual, iconographic, and theological implications of which have barely been indicated. And this is not even to mention Italian art of the thirteenth to fifteenth centuries, which my own preliminary investigations show to be surprisingly different in ways both large and small to the Byzantine material. None of it has been studied in relation to the changes produced when that gold comes alive, because painting in light has dropped below our horizon of visibility. Contemporary modes of presentation and representation simply do not allow us to determine if, how much, or where there is gold in an image. Much work remains to be done. Might we not, perhaps, open some new sub-headings within the History of Art: the History of Vision, and the History of Painting in Light?

## Notes

1.  Special thanks are due to Liz James and Antony Eastmond for their assistance beyond the call of duty in the preparation of this essay, and to Dr Roger S. Wieck for his help with photography. Thanks also to Abbey Braden for help in digitizing images.

2.  Two examples chosen at random are D. Janes, *God and Gold* (Cambridge, 1998), esp. chap. 4, and J. Gage, *Colour and Culture* (London, 1993), esp. chap. 3.

3.  See *In August Company: The Collections of the Pierpont Morgan Library* (New York, 1993), 76-8, for more on this manuscript.

4.  This is one of several pictures taken by Hawkins that demonstrate that he was clearly fascinated by the reflective capacity of gold in mosaics. I only came across these images after his death, and I greatly regret that I did not get a chance to discuss the topic with him personally.

5. See for example Pseudo-Dionysios, *The Divine Names*, in *Pseudo-Dionysius. The Complete Works*, trans. C. Luibheid (Mahwah, NY, 1987), 593B-C and 697B-700C; and Gregory Palamas, *Triad* II, 3, 6, in *Défense des Saints hésychastes*, ed. and French trans. J. Meyendorff (Louvain, 1959). In general, see V. Lossky, *The Mystical Theology of the Eastern Church* (London, 1957), esp. chapter 11, 'The Divine Light'.

6. Paul the Silentiary, *Descr. S. Sophiae*, in *Johannes von Gaza und Paulus Silentarius: Kunstbeschreibungen justinianischer Zeit*, ed. P. Friedländer (Leipzig, Berlin, 1912), 668; trans. C. Mango, *Art of the Byzantine Empire, 312-1453; Sources and Documents* (Englewood Cliffs, NJ, 1972), 86.

7. L. James, *Light and Colour in Byzantine Art* (Oxford, 1996).

8. R.S. Nelson, 'To say and to see: ekphrasis and vision in Byzantium', in *Visuality Before and Beyond the Renaissance*, ed. R.S. Nelson (Cambridge, 2000), 143-68.

9. Almost alone in the Renaissance it is left to Leonardo da Vinci to grapple with the issue of the obscurities of vision and those things that resist it.

10. In this regard see Lossky, *The Mystical Theology of the Eastern Church*, and M.-J. Mondzain, *Image, Icon, Economy*, trans. R. Franses (Stanford, forthcoming).

11. Gregory Palamas, *Triad* II, 3, 6, in *Défense des Saints hésychastes*.

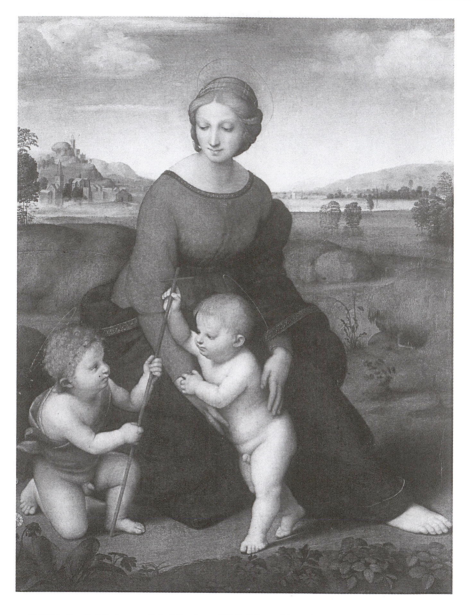

2.1 Raphael, *Madonna of the Meadows*, 1505 (Kunsthistorisches Museum, Vienna).

Chapter 3

# Icon and Portrait in the Trial of Symeon the New Theologian

Charles Barber

In this essay, I will use the instance of a trial held in 1009 to consider some of the conditions that can shape the use of two of the more common terms in the art historian's vocabulary, namely: *icon* and *portrait*. My point of departure for this enquiry is a lengthy section from the *Vita* of Symeon the New Theologian, a leading and contentious figure in monastic reform at the end of the tenth century and the beginning of the eleventh century.[1] Symeon's extensive writings present a mystical and personal vision of monasticism that was often at odds with the more hierarchical structures of the Stoudite monasticism that nurtured him and the scholastically-minded ecclesiastical hierarchy with whom he was often in conflict. His *Vita* and one edition of his works were written and edited by Niketas Stethatos, a Stoudite monk and disciple of Symeon.[2] It is Niketas who, writing in the mid-eleventh century, has provided us with an account of the trial that condemned Symeon.

The story begins with the death of the spiritual father of Symeon the New Theologian, one Symeon Eulabes.[3] He was a monk of the Stoudios monastery and died in 986 or 987. Soon after this date, and prompted by divine inspiration, Symeon initiated a cult of this father. The performance of the cult included a feast day marking Symeon Eulabes' death, *encomia* written in praise of the man, hymns to be sung in his honour, a biography, and an icon of Symeon. All of these were the normal trappings for the cult of a saint (although it is notable that there is no specific mention of Symeon's bodily remains).[4]

In a world in which the more rigid and legalistic practices of the Catholic Church's approach to canonization defines the expectations of such a process, this seems like an extraordinary and presumptive act on the part of the

From *Icon and Word: the Power of Images in Byzantium. Studies presented to Robin Cormack*, eds Antony Eastmond and Liz James. © 2003 by contributors. Published by Ashgate Publishing Ltd, Gower House, Croft Road, Aldershot, Hampshire, GU11 3HR, England, pp. 25-33.

disciple. Yet, the Orthodox Church had no systematic process for canonization until the late thirteenth century.[5] Indeed, it appears that the basic mechanism operated by the church is that noted in this *Vita*. This is to say that the church only reacted to the developments of such local, even personal cults when they began to flourish and enter the public realm. It was then that these cults might be policed by the Holy Synod of Constantinople and the Patriarch, who would either sanction or condemn them.

In this instance, once the popularity of the cult had brought it to the attention of Patriarch Sergios II, he invited Symeon the New Theologian to explain the basis for his devotion. In response, Symeon presented him with his writings on Symeon Eulabes. These were read and approved. Thereafter, the Patriarch undertook to send candles and incense on the feast day of the holy man. The cult and all its trappings were thereby sanctioned at the start of the eleventh century, perhaps in 1001 or 1002.[6]

The next stage of Niketas' narrative introduces the primary terms whereby the icon and its cult were to be contested. In 1003 a certain Stephen of Nikomedia, a *synkellos* in the Patriarchate of Constantinople whose particular province was to advise the Patriarch on theology and teaching within the church, challenged the new cult before the Holy Synod. Two related issues were discussed. Neither was necessarily directed at the icon itself, although both carry implications for the perception of the holy man's icon. The first part of the charge was introduced by the Patriarch of Constantinople, Sergios II, who now criticized Symeon for allowing the cult to become excessive. Significantly, he noted that while the celebration of Symeon Eulabes attracted large numbers from the city, the status of the holy man, even granted the existing Patriarchal sanction, remained open to question. In consequence, the Patriarch asked Symeon to limit and thereby localize the celebration of Symeon Eulabes to the precinct of his own monastic community. The doubt regarding the status of Symeon Eulabes was elaborated by Stephen of Nikomedia, who stated that Symeon the New Theologian had wrongfully proclaimed 'a sinner, his spiritual father, a saint among saints'.[7] The discussion thus added the consequences of cult practice to the examination of Symeon's writings that had shaped the first trial.

In response to this double charge, Symeon said little regarding the specific nature of the holiness of Symeon Eulabes. Instead, he focused upon the question of an excessive cult. Using a series of Biblical and patristic quotations, he argued that the practice of veneration was an important Christian act, as the honour directed towards his spiritual father was passed on through him to Christ. Although he was silent on the nature of Symeon Eulabes' holiness, Symeon contended that the cult was beneficial, as it provided in the person of the saint a model of holiness for those that participated in it.[8]

This second trial is presented as a victory for Symeon, even though it appears to result in a re-privatization of the cult of this particular saint. Furthermore, while the discussion did not specifically address the role of the icon in this cult, the issue of the saint's holiness was to return as a crucial turning point in the distinction between the icon of a holy man and the portrait of a beloved forebear.

At the end of 1008, Stephen of Nikomedia persuaded the Holy Synod to return to this matter. This time, the icon itself was made the central issue in the dispute. Immediately preceding the trial, renegade monks from Symeon's own community had taken the icon of Symeon Eulabes from the church of the monastery of St Mamas, Symeon the New Theologian's monastery. They brought it to the patriarchal palace and there subjected it to a remarkable visual test. The icon was compared to images of other saints and of Christ himself. This action implies that, in a very specific manner, they were trying to provide a visual test to define whether Symeon Eulabes could literally be seen to be 'a saint among saints'. Unfortunately, the participants in this examination could come to no firm conclusion. One party felt that Symeon could indeed be imagined among these saints, while a second party argued that the icon did not in fact show a saint. As the matter remained unresolved after this act of comparison, the icon was then brought before the permanent patriarchal synod.[9]

The *Vita* then jumps to Symeon's defence of the icon and its cult. This is largely a recapitulation of his earlier case, but with the icon inserted as a point of reference. Hence he argues that it is not only important to honour the saints, but also to honour them through their icons. The notion of the 'saints-as-models' introduced in the first trial is similarly given a more precise visual framing when, for example, Symeon notes that he also painted the saint on the walls of his monastery as a 'model and archetype of virtuous conduct'.[10] Once he has made this more visually oriented case, Symeon then turns to the icon itself and prays before it in these terms:

> Saint Symeon, thanks to the participation of the Holy Spirit you have come to resemble the icon of my Lord Jesus Christ. Following a long struggle, you are dressed in the brilliant garb of the passionless. You are bathed in your own tears, that in their abundance are like the waters of baptism. You bear Christ within yourself, whom you have loved, and who loved you so very much. You, whose holiness, which equals that of the apostles, was revealed to me by a voice from on high, come now to my defence. O wretched me, who is on trial for your sake. Bring me the strength that I need to struggle on behalf of you and your image. Or rather on behalf of Christ, as he has taken upon himself all that is ours except sin, and takes upon himself, being God, all the affronts and

mockery that men do to us. Until I also will share in the glory that you
have already had in this life; as I witnessed when I was shown you
standing at God's right hand. A glory that you among all the saints
deserve even more now.[11]

Following this prayer, Symeon falls silent. Without any reported argument
and without any resistance, Stephen of Nikomedia then simply walked up to
the icon and erased half of the inscription that named the saint. As one would
expect in a post-iconoclastic icon, the saint was named on his icon. This
would have read: Ὁ ἅγιος Συμεον, literally 'The Holy Symeon'. Stephen
removed the first part of this, leaving only the personal name, 'Symeon'. The
portrait was then returned to Symeon the New Theologian. The following
day, he was sent into exile, his homilies and hymns on the holy man were
banned from public performance, and all other icons of Symeon Eulabes were
destroyed.[12]

In commenting upon these events, Niketas Stethatos presents Stephen's
act of erasure and the consequent destruction of the cult and icons of Symeon
Eulabes as being akin to the iconoclastic activities of Constantine V.[13] By the
mid-eleventh century this is a somewhat disengenuous mask for the specific
goal of Stephen's act of erasure. Stephen's act, as I will argue below, was in
fact a very precise, indeed acute gesture, that not only turns upon but also
assists us in defining some grounds for the distinction that might be drawn
between an icon and a portrait.

Central to this discussion is the idea of the cult image or icon. In this regard, it
is apparent that the cult status of the portrait is, perhaps unsurprisingly,
negotiable. This is revealed when Stephen, having erased the inscription that
denominated Symeon Eulabes as a holy person, was content to return the
portrait of the no-longer-holy Symeon to Symeon the New Theologian. This
change of status, from icon to portrait, is effected by verbal rather than by
visual means. The other words that framed this portrait and that had defined it
as a cult image were also destroyed. Symeon had written hymns, homilies, and
a biography. These were public accounts that had constructed the cult of
Symeon Eulabes. Without these testimonies and without the inscription, the
visual image can continue to exist, but is now, without this web of words, to
be understood as a portrait of a man rather than the icon of a saint.

This first point emphasizes the value of words in developing a context that
is both inscribed and performed and that frames this panel. Such an emphasis
appears sanctioned by the *Vita* text. Here, Niketas says little concerning the
visual content of this icon. For example, there is no mention of the presence
or the removal of a nimbus. This would be a normal attribute of the holy man
in the post-iconoclastic era. Such a silence opens the way to a variety of

speculations. For example, if there was a nimbus, why was it not destroyed along with the inscription? Does this imply that its presence was not deemed an essential attribute of holiness, such that its presence or absence could be treated as a visual trait that was without autonomous authority? Or was the nimbus simply absent from the depiction, thus closing the gap between the appearance of secular portrayal and holy icon? While such a silence might raise these and other questions, an emphasis upon the silence surrounding such an obvious iconography would lead to our losing sight of those points in the text that do define some value for this visual text.

Let me turn to these. The theme that linked the three trials of Symeon the New Theologian was the question of the holiness of Symeon Eulabes. The first two trials focused on the texts and public cult of this figure. The third trial changed the point of attention, making the icon itself *the* subject of discussion. That significance was granted to the visual was made clear by the first act of this third drama. Prior to the meeting of the synod itself, the icon was compared to icons of Christ and other saints held in the patriarchal collection. The precise nature of this comparison is not made explicit. Indeed, it forces us to ask what they were looking for.

It would appear that the participants in this process were making the representation of the body of the saint a means of testing his sanctity. In effect, they were asking whether Symeon Eulabes looked like a saint, or to put it another way, could be imagined among the saints. The value of such categorizations has recently been tellingly examined by Henry Maguire.[14] Yet the *Vita*'s text does not name examples of other saints with whom Symeon is to be compared. Rather, it defines his holiness by describing him as having become 'Christ-like'. Hence, Symeon the New Theologian defends the icon in these words:

> I have painted this icon of a servant of Christ who both bears his deeds and has come to conform to his image or icon. In venerating this, I honour and worship Christ in the saint and the saint in Christ-God.[15]

This theme is also developed in the prayer that Symeon addressed to the icon:

> Saint Symeon, thanks to the participation of the Holy Spirit you have come to resemble the image or icon of my Lord Jesus Christ. Following a long struggle, you are dressed in the brilliant garb of the passionless. You are bathed in your own tears, that in their abundance are like the waters of baptism. You bear Christ within yourself, whom you have loved and who loved you so very much.[16]

These two passages, uttered in the context of this trial, give value to the icon.

It has become an exact eyewitness to the visual and corporeal economy of holiness, maintaining the claim that this particular body has become holy by conforming to the image or icon of Christ. In the case of Symeon Eulabes, this sense of value is underlined by the reason given for the dissemination of his icon. Symeon the New Theologian reports that he has had the icon painted on the walls of his own monastery in Constantinople. This icon, placed alongside images of Christ, has been set up as 'a monument of virtue set before others as a model and archetype of good conduct'.[17]

In order to overcome this icon and the cult to which it belongs, Stephen of Nikomedia has therefore to return to the question of Symeon Eulabes' holiness.[18] In so doing, he uses icon theory to distinguish between a sacred icon and a secular portrait. It is a distinction that depends upon a reciprocal relationship in which the icon acts as both a witness to the status of the one represented therein and is validated in its own right by the status of the one shown. Although Stephen's rebuttal of the icon's claim admits a tacit acceptance of this visual economy, he nonetheless undermines the autonomous authority of visual testimony by focusing exclusively upon the verbal claims to Symeon's holiness. Disappointingly, all that Stephen had to do was to erase the word 'holy' for the iconic truth-claim to collapse.

In order to unpack this act a little further, I would like to consider briefly the implications of the fate of the inscription. In the first instance, the gesture depends upon an acceptance of its effect. By which I mean that this act of re-labelling would indeed have been understood as sufficient to change the status of this work of art from that of an icon embedded in a public cult to that of a private portrait of a deceased individual. In this regard, it is notable that Stephen has not erased the name as a whole. He has retained the personal identification that nominates the work of art as a portrait. The name remains to confirm that *this is* Symeon that we see. As such, this partial erasure complies in part with a broad understanding of representation that was current in post-iconoclastic Byzantium, that the name and form of the person portrayed are both necessary to their complete depiction.[19] Together, homonymy (the common name) and likeness (the common form) bind subject and object in a representation understood to be governed by relation. Stephen, in maintaining Symeon's personal name, is thus operating within the parameters of acceptable iconic theory.[20]

Nonetheless, what he has done in this instance has been to threaten that aspect of this iconic economy that interweaves holiness and the body in the face of the portrayed. He has removed, according to this account, the one trace of this holiness, here bound to the inscription, that has transformed this portrait into an icon. In effect, he has deconsecrated (perhaps deconstructed) the work of the icon itself.

A starting point for an examination of the work of the name in the icon is

offered by an issue raised by the iconoclasts of the eighth century. They argued that it was wrong for an artist to call an icon 'Christ'. This led them to an interrogation of the seemingly simple phrase: 'This is an icon of Christ' (εἰκὼν τοῦ Χριστοῦ ἐστι).[21] In naming this icon 'Christ', the iconoclasts claim that the painter has proposed an impossibility, that Christ can be represented in a material icon. This iconoclastic reading of the act of naming is predicated upon an assumption that a true image was essentially the same (ὁμοούσιον) as the one shown in that image.[22] As such, an icon could not be a true image because its material nature prevented it from representing Christ's divine nature. It is, therefore, impossible to paint Christ in an icon, as Christ, by definition, escapes the limits of the medium.

This reading of the icon as a non-image is clarified by the iconoclast's assertion of a model for the true image of Christ: the bread and wine of the eucharist. The designation of the eucharist as a true image is proposed in Constantine's *Enquiries* and is adopted by the iconoclastic council of 754. In both cases the definition of the eucharist as a true image follows immediately after an examination of the 'false' claim that the icon can truly represent Christ. The key to the truthfulness of the eucharist-as-icon lies in Christ's declaration at the Last Supper that 'This is my body' (τοῦτό μού ἐστι τὸ σῶμα), and 'This is my blood' (τοῦτό μού ἐστι τὸ αἷμα). These words of consecration are to be contrasted with the painter's claim concerning the painted icon that: 'This is an icon of Christ.'[23]

Unlike the painter, Christ was able to consecrate the material object, the bread, making it into something holy. It is the act of consecration, marked by Christ's words, that transforms the bread into divine flesh (θεῖον σῶμα), turning it from a thing made by human hands to a thing not made by human hands. For the iconoclasts, it is impossible for the painter to take the place of Christ. The painter cannot, when uttering the phrase: 'This is an icon of Christ', transform that which is 'common and worthless' into a true image. For the iconoclasts, an icon of a holy person must be a holy thing. The existence of a common name is not only insufficient to confer holiness but also misleading in its claims to underline an identity between subjects and objects that are essentially different.

The writings of iconophile theologians of the eighth century demonstrate the currency of the iconoclastic argument.[24] For example, John of Damascus suggests that when a viewer utters the name of the person represented in an icon, they signal that the icon has become filled with the grace of the one depicted, transforming it from a mere material thing.[25] Such a proposition licenses the iconoclastic critique introduced above. Furthermore, it is an understanding of the function of the name that appears to be vindicated by the seventh ecumenical council when it states in regard to icons that:

> Many of the sacred things that we have at our disposal do not need a
> prayer of consecration, since their name itself says that they are holy and
> filled with grace.[26]

Yet in the very next line of the conciliar text an important qualification is
introduced: 'when we call an icon by its name, we transfer the honour to the
prototype'.[27] Building upon Basil the Great's famous definition of the imperial
icon, this quote interjects a relational aspect into the operation of the name.
Holiness is conferred upon the icon by its direct relation to the one shown
and named therein. The power of the image and the name do not depend
upon the intervention of or invocation by the artist. Rather their power
derives from the person that they depict and denominate. If that person is not
holy, then the icon cannot be holy.

In spite of his lack of interest in the visual aspect of this cult, Stephen's
gesture should be read as being in line with this iconophile tradition. With one
or two strokes of his stylus he has erased both the holy status of Symeon
Eulabes and the holy status of the icon representing Symeon. What remain are
the personal name and features of this man. Separated from the words that
situate this depiction within cult practices, the visual testimony leaves us with
a memory of a body that cannot now be recognized as holy. The icon has
become a simple portrait. This has the potential to become an icon, but it
cannot do this by itself.

# Notes

1.  I. Hausherr, *Un grand mystique byzantin: Vie de Syméon le Nouveau Théologien (949-1022) par Nicétas Stethatos*, Orientalia Christiana Analecta 45 (Rome, 1928), 98-128. A good recent introduction to Symeon's life and works is A. Golitzin, *St Symeon the New Theologian, On the Mystical Life: The Ethical Discourses, Vol. 3: Life, Times and Theology* (Crestwood, NY, 1997).

2.  A useful introduction to Niketas is to be found in J. Darrouzès, *Nicétas Stéthatos, Opuscules et lettres*, SC 81 (Paris, 1961), 7-39.

3.  For an introduction to the life and writings of this figure see H. Alfeyev, *Syméon le Studite, Discours Ascétique*, SC 460 (Paris, 2001).

4.  *Vie de Syméon*, 98.

5.  R. Macrides, 'Saints and Sainthood in the Early Palaiologan Period', in *The Byzantine Saint*, ed. S. Hackel (London, 1981), 83-86.

6.  *Vie de Syméon*, 100.

7.  *Vie de Syméon*, 110.

8.  *Vie de Syméon*, 112-118.

9.  *Vie de Syméon*, 120.

10. *Vie de Syméon*, 124.

11. *Vie de Syméon*, 124.

12. *Vie de Syméon*, 126-128.

13. *Vie de Syméon*, 128.

14. H. Maguire, *The Icons of their Bodies: Saints and their images in Byzantium* (Princeton, 1996).

15. *Vie de Syméon*, 122.

16. *Vie de Syméon*, 124.

17. *Vie de Syméon*, 124.

18. The theoretical basis for this point is set forth at length in my *Figure and Likeness: On the Limits of Representation in Byzantine Iconoclasm* (Princeton, 2002), 128-30.

19. A question mark hangs over the precise nature of the visual aspect of the icon throughout this work. One might expect an alteration to the visual component of the icon in addition to an alteration of the name. As mentioned above, why is the nimbus not an issue?

20. Likeness and homonymy are standard terms used by iconophile authors of the ninth century to define the relation between an image and the one shown in an image. For a fuller discussion of this see Barber, *Figure and Likeness*, 112-15, 123-8.

21. Nikephoros, *Antirrhetici*, I.43; *PG* 100, 309A.

22. Nikephoros, *Antirrhetici*, I.14; *PG* 100, 225A.

23. For the iconoclast's use of the eucharist see S. Gero, 'The Eucharistic Doctrine of the Byzantine Iconoclasts and Its Sources', *BZ* 68 (1975), 4-22. The discussion in this section of the paper can be found in an expanded version at Barber, *Figure and Likeness*, 73-6.

24. This theme of consecration is explored in G. Lange, *Bild und Wort: Die katechetischen Funktionen des Bildes in der griechischen Theologie des sechsten bis neunten Jahrhunderts* (Paderborn, 1999), 233-245.

25. B. Kotter, *Die Schriften des Johannes von Damaskos III. Contra imaginum calumniatores orationes tres* (Berlin, 1975), 90 and 148.

26. Mansi 13, 269D.

27. Mansi 13, 269D.

Chapter 4

# The Power of Inscriptions and the Trouble with Texts

Karen Boston

In *The Icons of Their Bodies*, Henry Maguire sought to define and explain a number of iconographic and stylistic innovations or modifications found in images of saints produced after iconoclasm.[1] In his view, these changes reflected the difference between pre-iconoclastic expectations of how an icon worked, and the post-iconoclastic operation of icons which necessarily had to function within the theology of the image that had developed out of the iconoclastic debate. Maguire maintained that ambiguity was one of the characteristics of pre-iconoclastic images of saints. He argued that before iconoclasm, icons were 'signs in their own right' that effected cures and offered protection directly without the mediation of a particular saint, and that operated outside the official sanction of the church.[2] In effect, they were expected to act in ways reminiscent of pre-Christian amulets and other images intended to deflect demonic envy. Therefore, it was not necessary for the portrayed saint to be identifiable and, for this reason, pre-iconoclastic icons of saints 'frequently omitted' inscriptions.[3] Maguire proposed that it did not matter to the viewer who was depicted, as long as the icon worked.

In contrast, he argued that after iconoclasm, images of saints were under the control of the church and were understood, not as 'signs in their own right', but as representations of a particular saint who could act as intercessor on behalf of the viewer. It was not the icon itself that was believed to effect miracles and direct prayers to God, but the saint who was portrayed. Thus, saints had to be readily identifiable and therefore were defined more clearly by costume, attributes, portrait type (hair, beard, etc.), formal characteristics and 'almost invariably by an inscription giving the name' of the saint.[4] For Maguire, the inscribed name was an important part of the definition of a saint

From *Icon and Word: the power of images in Byzantium. Studies presented to Robin Cormack*, eds Antony Eastmond and Liz James. © 2003 by contributors. Published by Ashgate Publishing Ltd, Gower House, Croft Road, Aldershot, Hampshire, GU11 3HR, England, pp. 35-57.

that made identification possible.

In choosing his images, Maguire focused on images of saints, and he emphasized the 'domestic' arts such as textiles, amulets and ceramics, although he also made use of monumental art, liturgical vessels and manuscripts. He relied heavily upon hagiographies for his textual support. His underlying assumption appears to be that pre-iconoclastic and post-iconoclastic icons were produced with formal differences because they were expected to be used and understood in different ways.

Maguire's book raises many issues that encourage further discussion, only one of which will be considered in this paper. I will examine Maguire's thesis that an inscribed name was an important part of the post-iconoclastic necessity for an accurate, unambiguous identification of the portrayed person. In contrast to Maguire, I will limit my visual evidence to monumental mosaics and wall-paintings, large panel icons and liturgical implements and furnishings. In doing so, I am attempting to narrow the viewing frame to images that would have been sanctioned by the Orthodox church.

More importantly, I will limit my examination to images of Christ, as opposed to the broader category of images of saints with which Maguire dealt, for two reasons. First, any attempt to identify and understand changes in images before and after iconoclasm must consider images of Christ, as the representation of Christ was at the heart of the iconoclastic controversy. Second, although post-iconoclastic images of Christ increasingly were inscribed IC XC (Iesous Christos), as will be demonstrated below, it seems likely that these images, distinguished by the cross in the halo, would have been recognizable in post-iconoclastic Byzantium without the aid of an inscription. Thus, while inscriptions may have served the purpose of aiding in the identification of images of saints, the same argument cannot be made for images of Christ. While there certainly must have been a disruption in the public viewing of the image during iconoclasm, the exact extent and severity of iconoclasm remains a subject of debate and it is far from clear that all public images were actually destroyed. The case for the destruction of private icons is even less clear.[5] Further, it is accepted that religious figural art was produced between 726 and 843, even if only during the gap in iconoclasm from 787 to 813.[6] Although many images of Christ were removed during iconoclasm, their eventual reappearance would have been the subject of comment and discussion. Surely no one would have wondered who was being depicted, if for no other reason than immediately after the Triumph of Orthodoxy, the image of Christ appeared on the coins of Michael III along with the inscription 'Iesous Christos'. All things considered, it is highly improbable that images of Christ erected in churches after iconoclasm required inscriptions for identification.

Nevertheless, the inscription IC XC which, as will be demonstrated below,

is non-existent in images of Christ produced within the Byzantine church before iconoclasm, is found extensively in post-iconoclastic images, eventually becoming an almost invariable part of the image of Christ. If it reasonably cannot be held that this inscription was for identification, why did it become a standard part of the iconography for the majority of post-iconoclastic representations of Christ?

In order to answer this question, this paper will: 1) establish the differences between inscriptions on pre-iconoclastic and post-iconoclastic images of Christ; 2) trace the emergence of the inscription IC XC to icons produced around the time of iconoclasm; and 3) interpret the significance and frequency of this inscription according to iconophile thought, with particular emphasis placed upon the writings of Theodore the Stoudite.

This approach is not without its problems. Cormack has cautioned that one should be wary of assuming a direct cause and effect relationship between a text and the production of an image.[7] However, this paper will not attempt to associate a particular image with a particular text. Rather, various texts that were written around the time that the inscription IC XC appeared in Byzantine art will be examined in order to reveal current 'structures of theological thought' that might explain this iconographic development.[8] The number and importance of these texts suggests that the concepts that were developed in them would have been familiar to most patrons and many, if not all, viewers. While this will make it possible to offer an explanation for the significance of the inscription IC XC and its proliferation after iconoclasm, nevertheless it will be found that not all post-iconoclastic images incorporated the inscription. This inconsistency raises questions about the practical application of the theory of images developed during the iconoclastic controversy to the actual production of icons. Images of Christ that omitted this inscription will be addressed in the final part of this paper, where it will be proposed that these deviations from the standard post-iconoclastic practice of inscribing Christ IC XC, although few in number, may enrich our understanding of the relationship between Byzantine art and texts, patrons and viewers, and iconoclasm in general.

*Pre-iconoclastic images of Christ*

Pre-iconoclastic images of Christ may be divided into three groups for our purposes. In the first group are images of Christ, alone or with others, which have no inscriptions. The second group consists of images of Christ which incorporate one of a small repertoire of inscriptions. In the third group, Christ is depicted with others, and in these images everyone *except* Christ has a naming inscription.

The first group, which is most common, is exemplified by the famous icon of Christ at St Catherine's at Mt Sinai (Weitzmann's B.1), attributed to the

sixth century (Fig. 4.1).[9] Here, Christ is depicted bust-length against an architectural background, holding a jewelled codex and gesturing with his other hand. This image of Christ was not inscribed originally; the inscriptions that we see today are later additions to the original sixth-century icon.[10] Liturgical implements also reflect this practice, as illustrated by a silver and gold medallion from a processional cross dated to the sixth or seventh century.[11] Christ is also depicted in pre-iconoclastic images with other individuals, none of whom are labelled, as in the sixth-century icon of St Peter at Sinai (Weitzmann's B.5), the sixth-century silver cross of Justin II and the fifth-century narrative on the triumphal arch at S. Maria Maggiore in Rome.[12]

In the much rarer second group of images, Christ is accompanied by an inscription, the most frequent being AⲰ. This inscription often occurs in funerary contexts, appearing in early Christian catacombs such as Petrus and Marcellinus (Fig. 4.2) and Commodilla.[13] In these images, Christ's inscription functions not as an identifying name but as one of his titles that, according to Gregory of Nyssa, told one how to think about God.[14] The reference to Christ as the alpha and omega (AⲰ), the beginning and the end, alluded to the entire soteriological economy through which the dead were saved and would rise through Christ: 'I am the alpha and the omega, says the Lord God, who is, and who was, and who is to come...I am the first and the last. I am the living one: I was dead and behold I am alive forever and ever. And I hold the keys of death and Hades'.[15] As St Basil had made clear, only he who had created the world in the beginning had the power to raise the dead.[16] Thus the inscription AⲰ would have affirmed the ability of Christ to raise the deceased. It was not an identifying name, but a guarantee of salvation.

This same inscription appears in other contexts, such as the ninth-century apse mosaic in the church of San Marco in Rome.[17] Significantly, while the individuals flanking Christ are identified by their inscribed names, Christ is not inscribed with a name, but with the title AⲰ. A functionally similar inscription is found on another icon dated to the sixth or seventh century, which depicts Christ, labelled as ⲮⲰTHP (Saviour), alongside Menas who is labelled with his name.[18] While Menas' inscription serves the purpose of identifying him, Christ is identified by the cross in his halo and does not need an inscription for identification. Rather, the inscription characterizes him as Menas' Saviour; it is another one of Christ's titles.

A different inscription appears on Weitzmann's B.16, a sixth-century icon at Sinai that depicts Christ with long white hair and beard, holding an open book in one hand and gesturing with his other hand.[19] The inscription flanking him reads E[....]NOYHⲀ (Emmanuel). While Weitzmann interpreted this inscription as referring to the young Christ, and Manafis interpreted it as the 'Incarnate Word of God ... eternally young', the Bible itself gives us the meaning of the term.[20] The Gospel of Matthew relates that 'The virgin will be

with child and will give birth to a son and they shall call his name Emmanuel which means God is with us'.[21] This emphasis on the divine in the Incarnation was incorporated into the Orthodox interpretation of the term.[22] Thus, 'Emmanuel' functions less as an identifying name than as a title that has a message to transmit about the two natures of Christ.

In the third group of images, Christ is depicted with other individuals, and while they have naming inscriptions, Christ does not. These images are intriguing because the lack of an inscription for Christ, in the presence of inscriptions for all other depicted figures, proves that an inscription was not needed to identify Christ in pre-iconoclastic art. This trend can be seen in the sixth-century triumphal arches in Parenzo's Basilica Eufrasiana and Rome's S. Lorenzo fuori le Mura.[23] It also occurs in mosaics where Christ and the saints are depicted in a series of medallions, as in the sixth-century presbytery arch at San Vitale in Ravenna.[24] Images of the Virgin and Child in this period exhibit the same practice: in the sixth-century Cleveland textile as well as in the sixth- or seventh-century mosaic of the Virgin and Child in the apse of the church of the Panagia Angeloktistos at Kiti, Cyprus, everyone is labelled except Christ.[25] A particularly interesting case is the sixth-century mosaic of the Transfiguration in the apse of St Catherine's on Mt Sinai (Fig. 4.3). Obviously, no one would have doubted who any of the people were in this mosaic, especially in this location, yet all were inscribed except Christ.

*Post-iconoclastic images of Christ*
Immediately after the Triumph of Orthodoxy in 843, images of the Virgin and Child began to appear in apses. As at Hagia Sophia in Istanbul, the early examples lack identifying inscriptions, indicating that there was no problem in identifying these figures after iconoclasm. Nevertheless, these images excepted, post-iconoclastic images of Christ in the media under consideration increasingly came to be inscribed IC XC. As early as the second half of the ninth century, Christ was represented in Cappadocia at Yılanlı Kilisi, İhlara, flanked by the inscription HC XC, a variant of IC XC.[26] This inscription became ever more common in the monumental arts of Cappadocia, and can be seen in Göreme, Chapel 21 and Göreme, Chapel 20 (St Barbara), dated to the tenth and eleventh centuries respectively.[27] This trend culminated in the middle Byzantine tradition of placing Christ in the dome flanked by the inscription IC XC.

This inscription also appears on panel icons and liturgical objects produced after iconoclasm. In the icon of St Nicholas on Mt Sinai, dated to the late tenth or early eleventh century, everyone is labelled with their name, including Christ who appears in a medallion at the top of the icon accompanied by the inscription IC XC.[28] A number of late ninth- to tenth-century liturgical objects, including the Chalice of Romanos (Fig. 4.4) and a processional cross in the

Benaki Museum, similarly are made up of a number of 'mini-icons' of Christ, Mary and the apostles, all of whom are inscribed with their names.[29]

Narrative programs are less rigorous in their use of the inscription. While all of the figures in many narrative scenes are accompanied by inscribed names, including IC XC for Christ, as in the tenth-century paintings at Tokalı Kilise, at other churches the names are omitted and only the title of the scene is inscribed, as at Daphne (Fig. 4.5).[30] Still, the use of the inscription IC XC, as well as naming inscriptions for other major figures in images, became the norm. Early non-narrative examples of this practice include the late ninth-century Christ in Majesty in the apse at Yılanlı Kilisi, İhlara and the tenth-century Deesis on the sanctuary screen of a church at Selçikler.[31]

The most interesting post-iconoclastic images are those in which Christ is depicted with others but *only* Christ is labelled. Although examples of this are rare, they are significant, not only because the inclusion of the inscription IC XC stands out formally in the absence of inscriptions for the other depicted figures, but also because it stands in contrast to the third group of pre-iconoclastic images described above. In the eleventh-century Transfiguration at Saklı Kilise at Göreme and the c.1200 Transfiguration icon in the Louvre (Fig. 4.6), only Christ is labelled, in opposition to the pre-iconoclastic Transfiguration in the apse at St Catherine's where everyone except Christ is labelled (Fig. 4.3).[32] Some post-iconoclastic images of the Crucifixion also omit inscriptions for everyone except Christ. The Cosenza Staurotheke of c.1100 depicts Christ with the evangelists on one side, and the Crucifixion with John and Mary on the other, and no one is labelled on either side except Christ.[33] This curious phenomenon is also found in the mosaics in Hosios Loukas, where no one is named in any of the narrative scenes with the exception of the Crucifixion, and there only Christ is labelled.[34] Obviously, these inscriptions were not for identification. Rather, like those inscriptions associated with Christ on pre-iconoclastic images (Group II above), it would seem that IC XC was intended to convey a message.

Significantly, the inscription IC XC first appears within the media being examined here on icons of the Crucifixion attributed by Weitzmann to the eighth and ninth centuries.[35] These are preserved at Mt Sinai. The earliest, Weitzmann's B.36 (Fig. 4.7), was dated by Weitzmann to the first half of the eighth century. Weitzmann's B.50, another Crucifixion, dated by him to the first half of the ninth century, may have incorporated the inscription as well: here, XC may be discerned on the gold ground under the angels.[36] Both of these icons can be interpreted as artefacts from a time when iconoclastic and iconophile issues would have been current. While the surviving evidence is admittedly meagre, and thus may not reflect accurately the actual pattern of production of icons at the time, it seems worthwhile to examine the apparent emergence of the inscription 'IC XC' on icons of the Crucifixion, especially in

light of its solitary appearance on post-iconoclastic images such as the Hosios Loukas Crucifixion and the Cosenza Staurotheke.

Weitzmann's dating of B.36 depended in great part upon the icon's similarities to the Crucifixion in the Theodotus Chapel at S. Maria Antiqua, securely dated to 741-52.[37] However, the two are fundamentally different. At S. Maria Antiqua, Christ is depicted alive and is not inscribed with a name, although Mary, John and Longinus are labelled, recalling Group III of pre-iconoclastic images defined above. In contrast, in B.36 Christ is depicted dead with twin jets streaming from his side, and unlike the image at S. Maria Antiqua, he is labelled IC XC. For all the formal similarities between the two images, the messages were quite different and it is possible that B.36, with its dead Christ, should be dated after the Theodotus chapel and closer to the onset of iconoclasm than Weitzmann's date might suggest.

The significance of the reality of the dead Christ on the cross had been addressed by Anastasios of Sinai in the 680s. Kartsonis has drawn attention to copies of Anastasios' *Hodegos* that show the dead body of Christ on the cross flanked by the inscription, 'The Word of God on the cross and the reasonable soul and body'.[38] The combination of text and image was intended to define who – in terms of nature – had died on the cross. According to Kartsonis, the human nature was indicated by the representation of Christ's body and by the words ΣѠMA and ΨYXH, and the divine nature was represented by the twin jets of blood and water issuing from Christ's side.

While the twin jets of blood appear on icon B.36, the inscription IC XC is far more important in defining who died on the cross. The meanings of the names 'Jesus' and 'Christ' had been the subject of many early Christian writers. Justin Martyr was only one of the church fathers to address their significance. He wrote that Jesus was 'his name as man...[it has significance] for he was made man...'. But he 'is called Christ, in reference to his being anointed and God's ordering of all things through him. This name itself also containing an unknown significance'. It was Christ, not Jesus, who was 'begotten before the works [the created world]'. Together, Justin wrote, the 'name Jesus Christ has the power' to heal and to exorcise.[39]

However, texts from the time of iconoclasm, when the inscription IC XC first appears in Byzantine art, reveal a shift in the meaning of the name 'Christ'. Iconophiles and iconoclasts were united in believing that it signified the presence of both the divine and human natures in Jesus, but they used this understanding to different ends.

The Horos of the Iconoclastic Council of 754 argued:

> How senseless is the notion of the painter who ... makes an image and calls it 'Christ': now the name 'Christ' means both God and man. Hence he has either included according to his vain fancy the uncircumscribable

Godhead in the circumscription of created flesh, or he has confused that unconfusable union.[40]

For the iconoclast, since the divine nature of Christ was uncircumscribable and at the same time could not be separated from the human nature, Christ could not be depicted.

But for the iconophile, as recorded in the Acts of the Seventh Ecumenical Council of 787:

> The name 'Christ' is indicative of both divinity and humanity, the two perfect natures of the saviour. Christians have been taught to portray this image in accordance with his visible nature, not according to the one in which he was invisible; for the latter is uncircumscribable.[41]

For the iconophile, the icon portrayed the likeness of the visible ὑπόστασις, and the use of a particular name indicated the particular ὑπόστασις.[42] Thus the inscription IC indicated the visible ὑπόστασις, the Incarnated Word which Gabriel directed Mary to call 'Jesus'.[43] Since the human could not be separated from the divine in the prototype, the inscription XC was used to indicate the presence of the divinity in the prototype, but specifically as 'God-man,' the divine united without division or confusion to the human in the visible ὑπόστασις. God could not be portrayed, but Jesus, the visible ὑπόστασις of the God-man, could. Together, the inscription IC XC signified the inseparable, unconfused union of the two natures in the Incarnation. According to the words of Gregory the Theologian recorded in the Acts of the Council of 787: 'Whenever the two natures are distinguished from one another in our thoughts, the names are also distinguished'.[44] It may be that the innovative inscription IC XC on icons produced in the eighth and ninth centuries reflected this understanding. Besides the images of the Crucifixion in B.36 and B.50, the inscription appears on an image of the Nativity, Weitzmann's B.41, also preserved at St Catherine's, and attributed by him to the eighth or ninth century.[45] Again, the inscription may have served to indicate the presence of the two inseparable natures in Jesus at the time of his birth. This affirmed the ability to depict him without severing his natures.

The appearance of IC XC on images of a dead Christ on the cross may be interpreted as a response to another iconoclastic argument regarding the temporal nature of the Incarnation. While it was held by some that after Christ died on the cross, the Incarnation ceased, and therefore images could not be made of Jesus, iconophiles stressed that the Incarnation was an eternally present reality, and not an event confined to the time of Jesus' life on earth. In his *Second Refutation*, Theodore the Stoudite wrote, 'Christ is

circumscribed even after his Resurrection' in response to his hypothetical iconoclast who had argued, 'Admittedly, it is agreed that our Lord Jesus Christ is circumscribed, but only up to his Passion, and by no means after his Resurrection'.[46] It was essential to the iconophile understanding of salvation that both natures remained intact after the Passion. John of Damascus had written that in the Incarnation, the Logos assumed flesh 'made divine and endures after its assumption. ... Therefore I boldly draw an image of the invisible God'.[47] For John, the Incarnation took place so that we could be 'partakers of his divine nature'.[48] If the reality of the Incarnation, which changed the nature of matter thus making our deification possible, was denied after the Passion, the entire economy of salvation foundered, as did the ability to depict Christ. The appearance of the inscription IC XC on icons B.32 and B.50 may reflect these concerns. If so, B.52 must be later than Weitzmann's early eighth-century date, or else these concepts were being discussed before they were recorded in the texts that have come down to us.

It is worth noting that at this time another innovative inscription appears which can be interpreted as fulfilling the desire to demonstrate the presence of both natures at the time of Christ's death. The icon of the Crucifixion, B.50, is the earliest extant panel icon that refers to Mary as MHTHP ΘEOΥ, rather than HAΓIA MAPIA.[49] Since Mary had been proclaimed Theotokos in 431, yet continued to be labelled HAΓIA MAPIA on icons, it is reasonable to question why she came to be labelled MHTHP ΘEOΥ (as well as ΘEOTOKOC) at this point in time. I would argue that this title proclaims the union of the two natures in the incarnate ὑπόστασις, and in this icon it may be interpreted as signifying that they remained intact after his death.[50]

The significance of the emergence of the inscription IC XC and its connection to images of the dead Christ on the cross that has been proposed above is only hypothetical. The extant art historical evidence is extremely limited, and the problem of associating the icons with the iconophile texts is complicated not only by Weitzmann's dating, but also by the assumption – by no means provable – that the makers of these icons were responding to any text at all.

However, some of the iconophile texts specifically address the significance of names and inscriptions, and here we are on firmer ground. Iconophile authors agreed that a representation of Christ or a saint was related to the prototype by formal likeness and by the shared name, but that it differed in essence.[51] The importance of the formal likeness between the prototype and icon is familiar to art historians. However, the significance of the shared name should be reviewed. The Acts of the Seventh Ecumenical Council recorded that when 'Christ is portrayed according to his human nature, it is obvious that the Christians ... acknowledge the visible image to communicate with the archetype in name only, and not in nature'.[52] The Acts further asserted, 'When

we signify an icon with a name, we transfer the honour to the prototype'.[53] Thus, the name was identified in the Acts as a means of establishing contact with the prototype and transferring honour to the prototype. John of Damascus extended this concept to inscriptions on icons of Christ when he wrote, 'I honour and venerate ... everything where God's name is found, not for their own sake, but because they are vessels of divine power'.[54]

Patriarch Nikephoros and Theodore the Stoudite expanded upon this. While Nikephoros wrote that inscriptions served the function of 'authentication', he also identified the name as an important means of binding the image to the prototype.[55] However, his method was different from that of John of Damascus or that expressed in the Acts of 787, and was founded upon the Aristotelian concept of homonymy. The history of homonymy has been traced from Aristotle into Christian times by John Anton, and Kenneth Parry has examined the use of the term in iconophile texts.[56] Parry demonstrated that, in spite of a misunderstanding of Aristotle's concept by many early Christian authors, both Nikephoros and Theodore adopted his definition of the term: 'When things have a name in common, and the definition of being (λόγος τῆς οὐσίας) which corresponds to the name is different, they are called homonymous (ὁμωνύμους)'.[57] Thus, for Nikephoros, the icon of Christ was more holy than a representation of the cross (one of the iconoclasts' preferred images) because the icon was homonymous with Christ.[58]

Throughout most of his writings, Theodore's understanding of homonymy was in line with Aristotle and Nikephoros. In his *First Refutation*, Theodore wrote that it was not possible to distinguish the image from its prototype according to its name, which both shared, being homonymous, but only according to their natures: 'Christ is one thing and his image is another thing by nature (φύσιν), although they have an identity in the use of the same name.'[59] He reaffirmed this throughout his writings. In a letter to John the Grammarian he explained, 'We are taught according to the definition of philosophy that things are said to be named homonymously if, though they have a common name, the definition of being (λόγος τῆς οὐσίας) corresponding to the name differs for each, as in Christ himself and his portrait.'[60] In his *Second Refutation*, he wrote that the icon of Christ was called 'Christ' because of the signification of the name, not because it shared Christ's nature.[61] What was said of the prototype could be said of the icon, but it was said homonymously, and 'applies to the name only, and the identity of veneration'.[62]

Like John of Damascus, Theodore extended his understanding of the significance of names to inscriptions on icons. In his *First Refutation*, his imaginary iconoclast asked whether the inscription (γράμμα) was to be venerated, or the icon on which the name (κλῆσιν) was inscribed, or both.[63]

Theodore answered that asking such a question was as foolish as asking whether we venerate the Gospelbook or the title on it, a representation of the cross or an inscription on it, or a man or his name. For the thing which was named, explained Theodore, could not be separated in honour from its own appellation.

These passages all reflected the Aristotelian concept of homonymy. But then Theodore went on to say, 'These are relationships, for a name is by nature (φύσιν) the name of something which is named, and a sort of *natural image (φύσικη εἰκών)* of that to which it is applied.'[64] This was a unique contribution to iconophile thought, and careful analysis is required in order to comprehend what Theodore was stating. The first step is to define a 'natural image'. In his *Third Refutation*, Theodore had stated that a natural image shared the essence of the prototype, for example, Christ and the Father. This was in contrast to an artificial image which did not share the essence of the prototype, for example, Christ and an icon of Christ.[65] If this definition is applied to names, rather than images, it would seem that Theodore was saying that the name of Christ 'sort of' shared the essence of Christ when it was applied to Christ himself, but that the name of Christ when inscribed on an icon 'sort of' shared the essence of 'that to which it is applied', i.e., the icon which was of 'perhaps wood, or paint, or gold, or silver, or some one of the various materials which are mentioned'.[66] Interpreted in this way, the inscribed name and the image on the icon both were related to the prototype, the first by homonymy and the second by formal likeness, but each differed from the prototype in essence. Theodore seems to have been using the concept of essence to equate word and image on an icon. Yet, it is also worth contemplating that he may have blurred the boundaries of the definition of 'homonymous', privileging the name that was a 'sort of' natural image, over the icon which was an artificial image. If the inscribed name was experienced by the viewer as an invocation of the prototype, as opposed to a means of identifying the icon, the name would then be a 'sort of' natural image of the prototype, sharing in some way in its essence. Referring back to the passage from Theodore's *First Refutation* quoted above, in which the heretic asks whether the inscription was to be venerated, or the icon on which the name (κλῆσιν) is inscribed, it is interesting to note that the word κλῆσιν carried connotations of a magical invocation.[67]

While the meaning of this last passage is somewhat ambiguous, Theodore offered more unequivocal explanations for the inscription of names on icons. In response to his heretic who argued that many icons of Christ signified many Christs, therefore falling into polytheism, Theodore wrote:

> Every image [is] a kind of seal and impression bearing in itself the proper appearance of that after which it is named. … We call the image Christ

'Christ' because it is also Christ, but there are not two Christs. ... The use of an identical name brings together the many representations into one form.'[68]

Theodore also emphasized the value of the inscription when he interpreted it as confirmation of the visual image: 'However far you go back, you would find the written word originating in observation.'[69] This understanding would have been especially important with reference to icons of Christ: the inscription confirmed the Incarnation.

Although Theodore had more to say about names and inscriptions than other iconophiles, the importance of the shared name in binding the icon to the prototype was evident in all major iconophile texts, and perhaps offers the best explanation for the dramatic increase in inscriptions on icons that were produced after iconoclasm. This is particularly true of images of Christ, since the inscription IC XC was not needed in order to identify Christ. Although icons of saints may have needed inscriptions to identify the saint, the importance of the shared name could have operated in these images as well. In post-iconoclastic Byzantium, text and image were equally potent means of establishing a relationship through which honour could be transferred to the prototype.

*The trouble with texts*

The examination of post-iconoclastic mosaics and wallpaintings, panel icons and liturgical implements has shown the proliferation of the inscription IC XC, and the analysis of major iconophile texts has provided a reason for this. It would be easy to end this article at this point. However, the inscription did not appear on all images made in the years following the Triumph of Orthodoxy.[70] Perhaps the most intriguing post-iconoclastic image that was created without the inscription is the mosaic over the Imperial Doors in the narthex of Hagia Sophia, Istanbul, dated to c.900 (Fig. 4.8). This icon, highly significant for its location and relatively early date after the Triumph of Orthodoxy, has generated abundant debate over the identity of the emperor and the interpretation of the scene as a whole, but the inscription IC XC that flanks Christ has been less noticed.[71] According to Ernest Hawkins, who uncovered the inscription in 1959-1960 during the second cleaning of the mosaic, this inscription was not part of the original mosaic.[72] He reported that 'The forms of the letters and abbreviation signs were cut out from the setting-bed plaster of the [original] gold background and filled with beeswax into which glass tesserae were embedded. Only small pieces of wax bearing impressions of the fragmented glass were found.' He detected 'scant evidence' for dating the insertion, but suggested the eleventh century, when the inscription became common on coins.

Why was the iconophile theory of homonymic inscriptions not put into practice in this prominent mosaic in the patriarchal church? Although any attempt to retrieve a patron's intentions or the texts with which he was familiar is laden with difficulties, the evidence seems to suggest that this patron – probably the emperor or patriarch – either was unfamiliar with the convoluted arguments of the iconophiles regarding the value of shared names, or saw no reason to express them in an icon. For the patron of the narthex mosaic, acting some fifty years after the Triumph of Orthodoxy, the Acts of the Seventh Ecumenical Council and the writings of John of Damascus, Nikephoros and Theodore the Stoudite, so assiduously studied by art historians, were remembered only for their end result: the validation of images.

On the other hand, the art historical evidence, while limited, suggests that the theory of shared names first found expression on images of Christ manufactured outside of Constantinople, the artistic and theological 'centre'. The practice of inscribing images of Christ IC XC, first seen in Cappadocia (Yılanlı Kilise) and Syria or Palestine (Weitzmann's B.36 and B.50), seems to have travelled from the 'perimeters' to the 'centre', perhaps through the dispersion of portable objects bearing the inscription or the movement of artists. It was not until the second quarter of the tenth century that the inscription became common in Constantinople, as exemplified by the Chalice of Romanos, and it is probable that IC XC was added to the narthex mosaic at Hagia Sophia at that time.[73] Further research may indicate whether the emergence of the inscription in Constantinople was accompanied by a renewed study of iconophile texts, perhaps prompted by the arrival in the capital of images with the inscription, or whether it was simply a response to changing ideas of how an image of Christ should look, engendered by a proliferation of inscribed images from outside the capital or the movement of artists. It is hoped that this paper will encourage further consideration of the ways in which patrons and artists received and reacted to iconophile texts.

## Notes

1. H. Maguire, *The Icons of Their Bodies: Saints and Their Images in Byzantium* (Princeton, 1996).

2. Maguire, *The Icons of Their Bodies*, 144.

3. Maguire, *The Icons of Their Bodies*, 38.

4. Maguire, *The Icons of Their Bodies*, 100.

5. For a summary of 'secret' icons in the imperial palace, see L. Brubaker and J. Haldon, *Byzantium in the Iconoclast Era (ca 680-850): The Sources* (Aldershot, 2001), 71.

6. For the most recent survey of iconoclasm, including a review of arts that have been attributed to the period, see Brubaker and Haldon, *Byzantium in the iconoclast Era*. Also see R.

Cormack, 'The Arts during the Age of iconoclasm', in *Iconoclasm*, eds J. Herrin and A. Bryer (Birmingham, 1977), 35-44.

7.  Cormack has summarized his own evolving approach to art and texts in *The Byzantine Eye: Studies in Art and Patronage* (London, 1989). He has continued to explore the kinds of questions that may be asked of images in *Writing in Gold* (London, 1985), *Painting the Soul: Icons, Death Masks and Shrouds* (London, 1997), and in *Byzantine Art* (Oxford, 2000).

8.  Quote in R. Cormack, 'Patronage and New Programs of Byzantine Iconography', in *The 17th International Byzantine Congress, Major Papers* (New Rochelle, NY, 1986), 609-638; repr. in Cormack, *The Byzantine Eye*, Study X, quote on p. 618.

9.  See K. Weitzmann, *The Monastery of St Catherine at Mount Sinai: The Icons from the Sixth to the Tenth Centuries* (Princeton, 1976), Vol. I, Pl. I, II.

10. M. Chatzidakis, 'An Encaustic Icon of Christ at Sinai', *ArtB* 49/3 (1967): 197-208. He believes the face is original, but I am convinced by Cormack's observation that it appears to be overpainted.

11. For the medallion from the processional cross, see *Byzance: L'art byzantin dans les collections publiques françaises*, ed. J. Durand (Paris, 1992), 119. The arms of the cross are preserved in the Metropolitan Museum in New York, and have inscriptions on both sides.

12. For the icon of St Peter, see Weitzmann, *The Monastery of Saint Catherine...The Icons*, 1: 23-6. For the Cross of Justin II, see G. Cavallo, *I Bizantini in Italia* (Milan, 1982), Figs 275-276. For S. Maria Maggiore, see W. Oakeshott, *The Mosaics of Rome* (Greenwich, CT, 1967), Figs 55-60.

13. For Commodilla, see J. Deckers, G. Mietke and A. Weiland, *Der Katakombe 'Commodilla': Repertorium der Malereien*, IV (Vatican, 1994).

14. Gregory of Nyssa, *Refutatio confessionis Eunomi*, 126, *PG* 45, 524; *Gregorii Nysseni Opera*, ed. H. Langerbeck (Leiden, 1960), 2: 366; English translation in J. Pelikan, *Christianity and Classical Culture* (New Haven and London, 1993), 254.

15. Rev. 1.8 and 1.17-18.

16. St Basil, *De Spiritu sancto* xvi, *PG* 32, 133-144, in *Sur le Saint-esprit*, SC 17, ed. and trans. B. Pruche (Paris, 1968), 376-391. Also see Basil's *Epistle VIII, To the Caesareans*, *PG* 32, 264-5, in *Nicene and Post-Nicene Fathers*, trans. P. Schaff and H. Wace (Grand Rapids, 1955), VIII, 121.

17. See Oakeshott, *The Mosaics of Rome*, Pl. XXIII.

18. *The Age of Spirituality: Late Antique and Early Christian Art, Third to Seventh Century*, ed. K. Weitzmann (New York, 1979), Cat. no. 497.

19. Weitzmann, *The Monastery of St Catherine... The Icons*, 1: Pl XVIII.

20. Weitzmann, *The Monastery of St Catherine... The Icons*, 1: 41-2. K. Manafis, *Sinai: Treasure of the Monastery of St Catherine* (Athens, 1990), 93.

21. Matt. 1:23.

22. J.H. Thayer, *A Greek-English Lexicon of the New Testament* (Grand Rapids, 1977), 207.

23. For Parenzo, see *Mother of God: Representations of the Virgin in Byzantine Art*, ed. M. Vassilaki (Milan, 2000), 90. For S. Lorenzo, see Oakeshott, *The Mosaics of Rome*, Fig. 77.

24. *La Basilica di San Vitale a Ravenna*, ed. C. Franzoni (Modena, 1997), Figs 518, 591, 606.

25. See *The Mother of God*, ed. Vassilaki, 6, 224.

26. See *Arts de Cappadocia*, ed. L. Giovammini (Geneva, 1971), 141, Photo 81.

27. For Chapel 21, see T. Velmans, *Byzanz: Fresken und Mosaike* (Zurich, 1999), 61, Fig. 53. For Chapel 20, see C. Jolivet-Lévy, *Les églises byzantines de Cappadoce: le programme iconographique de l'abside et de ses abords* (Paris, 1991), Pl. 77.

28. *The Glory of Byzantium. Art and culture of the Middle Byzantine Era AD 843-1261*, eds H.C. Evans and W.D. Wixon (New York, 1997), 118.

29. For the processional cross, see *The Glory of Byzantium*, eds Evans and Wixom, 59.

30. A. Wharton Epstein, *Tokalı Kilise: Tenth-Century Metropolitan Art in Byzantine Cappadocia* (Washington, DC, 1986). For other examples with inscribed names, see Jolivet-Lévy, *Les églises byzantines de Cappadoce*, and M. Restle, *Byzantine Wallpainting in Asia Minor* (Greenwich, CT, 1967).

31. See Jolivet-Lévy, *Les églises byzantines de Cappadoce*, Pl. 16, Fig.1. For Selçikler, see L. Rodley, *Byzantine Art and Architecture* (Cambridge, 1994), 147.

32. For Saklı Kilisi see Restle, *Byzantine Wallpainting*, Vol. II, Fig. 30.

33. See M. Rotili, *Arte Bizantina in Calabria e in Basilicata* (Milan, 1980), Pl. LXL, LXLI.

34. *Hosios Loukas: Mosaics and Wallpaintings*, ed. M. Chatzidakis (Athens, 1997), Fig. 19.

35. There are earlier instances of the inscription in wallpaintings at Bawit, but given the Christological differences between the Coptic and Orthodox churches, and the difficulties in ascertaining whether Monophysites or Melkites were in control of a monastery at the time the paintings were made, these images, while perhaps seminally important, are beyond the scope of this paper.

36. Weitzmann, *The Monastery of St Catherine...The Icons*, 1: Pl. XXXII.

37. W. de Grüneisen, *Sainte Marie Antique* (Rome, 1911), Pl. IC.XXXVI, IC.XL, IC.LX.

38. Anna Kartsonis, 'The Emancipation of the Crucifixion', in *Byzance et les images*, ed. A. Guillou (Paris, 1994), 151-188; quote p. 164; Figs 11-12.

39. Justin Martyr, *II Apology*, vi, PG 6, 453, trans. A. Roberts and J. Donaldson, *The Apostolic Fathers with Justin Martyr and Irenaeus* (New York, 1926), 1: 190.

40. *Acts of the Seventh Ecumenical Council*, Mansi 13: 252, trans. C. Mango, *Art of the Byzantine Empire, 312-1453: Sources and Documents* (Englewood Cliffs, NJ, 1972), 166.

41. Mansi 13, 252.

42. Theodore the Stoudite, *Antirrhetici tres adversus iconomachus*, III.A.34, III.A.17-20, PG 99, 405; 99, 397-400, trans. C. Roth, *On the Holy Icons* (Crestwood, NY, 1981), 90.

43. Matt. 1:21; Luke 1:31.

44. *Acts of the Seventh Ecumenical Council*, Mansi 13, 341B, trans. D. Sahas, *Icon and Logos: Sources in Eighth Century iconoclasm* (Toronto and London, 1986), 158.

45. Weitzmann, *The Monastery of St Catherine's...The Icons*, 1: Pl. XXVII.

46. Theodore the Stoudite, *Antirrhetici*, II.41, PG 99, 381, trans. Roth, *On the Holy Icons*, 69.

47. John of Damascus, *Contra imaginum calumniatores orationes tres*, I.4, PG 94, 1236, trans. D. Anderson, *On the Divine Images* (Crestwood, NY, 1980), 16.

48. John of Damascus, *Contra imaginum*, I.4, PG 94, 1236, trans. Anderson, *On the Divine Images*, 16.

49. Brubaker and Haldon, *Byzantium in the iconoclast Era*, 69.

50. For a contrasting interpretation, see I. Kalavrezou, 'Images of the Mother: When the Virgin Mary Became Meter Theou', *DOP* 44 (1990): 165-172. Kalavrezou emphasizes the humanity of Mary implied in the inscription, 'Meter Theou', which contrasts with the

inscriptions 'Hagia Maria' and 'Theotokos' (Bearer of God). For Kalavrezou, the telling word is 'Meter'. Conversely, my interpretation emphasizes the divinity implied in the terms 'Theotokos' and 'Meter Theou'.

51. The best study on this is K. Parry, *Depicting the Word: Byzantine Iconophile Thought of the Eighth and Ninth Centuries* (Leiden, 1996).

52. *Acts of the Seventh Ecumenical Council*, Mansi 13, 252.

53. *Acts of the Seventh Ecumenical Council*, Mansi 13, 269, trans. Sahas, *Icon and Logos*, 99.

54. John of Damascus, *Contra imaginum*, III.34, *PG* 94, 1354, trans. Anderson, *On the Divine Images*, 86.

55. Nikephoros, *Antirrhetici tres adversus constantinum*, I.38, *PG* 100, 293B, trans. Mango, *The Art of the Byzantine Empire*, 150.

56. J. Anton, 'The Aristotelian Doctrine of Homonyma in the *Categories* and its Platonic Antecedents', *Journal of the History of Philosophy* 6 (1968), 315-326; J. Anton, 'Ancient Interpretations of Aristotle's Doctrine of Homonyma', *Journal of the History of Philosophy* 7 (1969), 1-18. Also see Parry, *Depicting the Word,* 52ff.

57. Parry, *Depicting the Word*, 55.

58. Nikephoros, *Antirrhetici*, III.35, *PG* 100, 431, summarized in Parry, *Depicting the Word*, 187-8.

59. Theodore the Stoudite, *Antirrhetici*, I.11, *PG* 99, 341, trans. Roth, *On the Holy Icons*, 31-32. See also I.8.

60. Theodore the Stoudite, *Ep.528, Fat. 2, 790*, in Parry, *Depicting the Word*, 56.

61. Theodore the Stoudite, *Antirrhetici*, II.17, *PG* 99, 362, trans. Roth, *On the Holy Icons*, 51-52.

62. Theodore the Stoudite, *Antirrhetici*, II.16, 18, *PG* 99, 360-364, trans. Roth, *On the Holy Icons*, 51-53.

63. Theodore the Stoudite, *Antirrhetici*, I.14, *PG* 99, 345, trans. Roth, *On the Holy Icons*, 34-35. While the term γράμμα can be used to indicate a drawing as well as a written inscription, the context makes it clear that Theodore was using it to denote a written inscription; otherwise the passage is nonsensical. Although Roth translated the word κλῆσιν as 'title', it also means 'name, appellation'. Theodore's example of 'a man or his name' indicates the latter translation is justified, without excluding Roth's translation which is applicable to Theodore's example of 'the Gospelbook or the title on it'. See G.H.W. Lampe, *A Patristic Greek Lexicon* (Oxford, 1961) 757-81.

64. Theodore the Stoudite, *Antirrhetici*, I.14, *PG* 99, 345, trans. Roth, *On the Holy Icons*, 34-35.

65. Theodore the Stoudite, *Antirrhetici*, III.B.2, *PG* 99, 418, trans. Roth, *On the Holy Icons*, 100.

66. Theodore the Stoudite, *Antirrhetici*, I.11, *PG* 99, 342, trans. Roth, *On the Holy Icons*, 31-32.

67. Lampe, *A Patristic Greek Lexicon*, 757-81.

68. Theodore the Stoudite, *Antirrhetici*, I.8-9, *PG* 99, 338, trans. Roth, *On the Holy Icons*, 27-29.

69. Theodore the Stoudite, *Antirrhetici*, III.A.2, *PG* 99, 392, trans. Roth, *On the Holy Icons*, 78.

70. Due to space constraints, the emergence of this inscription on other kinds of objects such as pectoral crosses, ivories and manuscripts must be deferred to another article.

71. The bibliography on the interpretation of this mosaic is enormous; only a few of the more important sources will be given here. A. Grabar, *L'empereur dans l'art byzantine* (Paris, 1936), 100-6; A. Grabar, *L'iconoclasme byzantine* (Paris, 1957), 239-241; N. Oikonomides, 'Leo VI and the Narthex Mosaic of Hagia Sophia', *DOP* 30 (1976), 151-172; Z.A. Gavrilović, 'The Humiliation of Leo VI the Wise', *CahArch* 28 (1979), 87-94; R. Cormack, 'Interpreting the Mosaics of S. Sophia at Istanbul', *ArtH* 4/2 (1981), 131-150; C. Barber, 'From

Transformation to Desire: Art and Worship after Byzantine iconoclasm', *ArtB* 75/1 (1993), 7-16; S. Horner, *The Emperor's New Pose? Re-Reading the Narthex Mosaic at Hagia Sophia as a Liminal Image in Liminal Space* (unpublished MA thesis, Courtauld Institute of Art, University of London 1994); R. Cormack, 'The Emperor at Hagia Sophia: Viewer and Viewed', in *Byzance et les images,* ed. Guillou, 223-254.

72. E.J.W. Hawkins, 'Further Observations on the Narthex Mosaic in St Sophia at Istanbul', *DOP* 22 (1968), 151-168.

73. Assuming the chalice is from the reign of Romanos I (920-44), as suggested in *The Glory of Byzantium*, eds Evans and Wixom, 71.

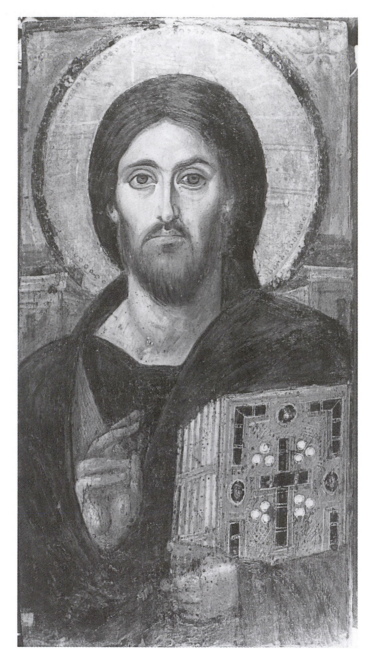

4.1 Icon of Christ, 6th century. St Catherine's Monastery, Mt Sinai (reproduced by courtesy of the Michigan-Princeton-Alexandria Expedition to Mt Sinai).

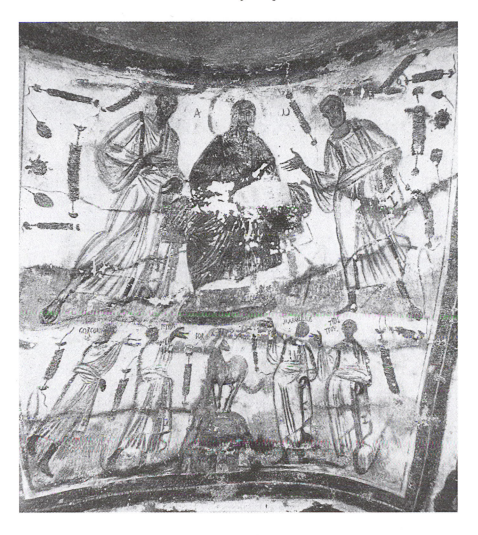

4.2 Christ between Sts Peter and Paul, 4th century. Catacomb of Petrus and Marcellinus, Rome (after O. Marucchi, *Le Catacombe Romane* (Rome, 1933), Fig. 114).

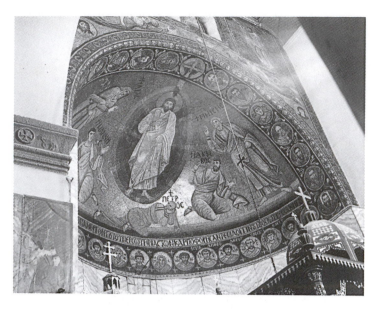

4.3 Transfiguration, 6<sup>th</sup> century. Aspe of St Catherine's Monastery, Mt Sinai
(courtesy of A.F. Kersting).

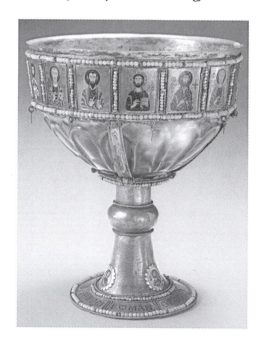

4.4 Chalice of Romanos, 10<sup>th</sup> century. Treasury of San Marco, Venice
(courtesy of Procuratoria di San Marco, Venice).

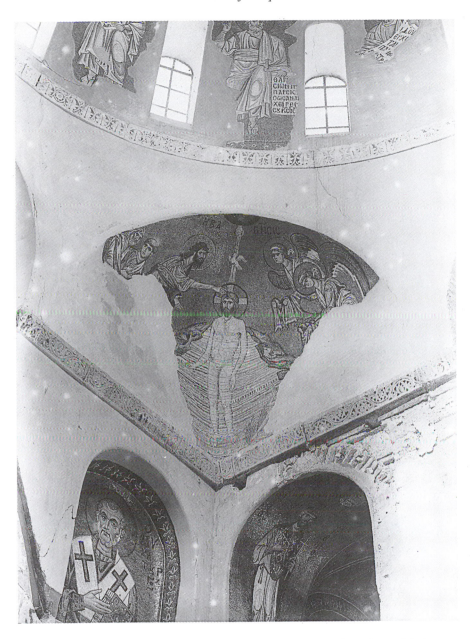

4.5 Baptism, c.1100. Daphne (Conway Library, Courtauld Institute of Art).

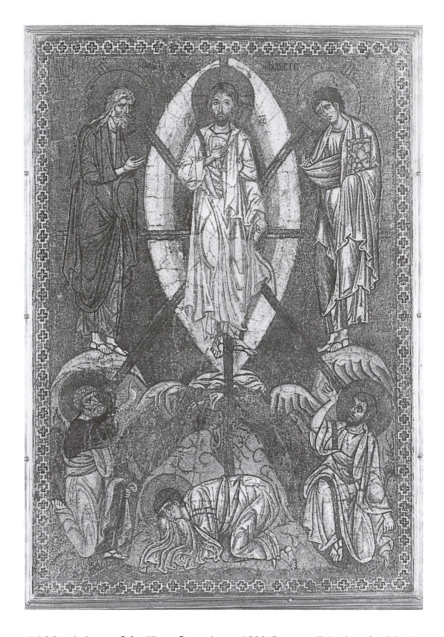

4.6 Mosaic icon of the Transfiguration, c.1200. Louvre (Réunion des Musées Nationaux/Art Resource, NY).

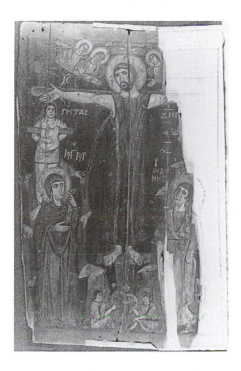

4.7 Icon of the Crucifixion, 8th century. St Catherine's Monastery, Mt Sinai (reproduced by courtesy of the Michigan-Princeton-Alexandria Expedition to Mt Sinai).

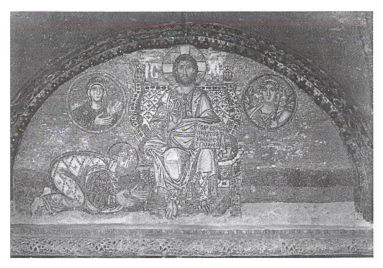

4.8 Narthex Mosaic, c.900. Hagia Sophia, Istanbul (Dumbarton Oaks, Byzantine Photograph and Fieldwork Archives, Washington DC).

Chapter 5

# Art and Lies: Text, image and imagination in the medieval world

Liz James

...[T]hey (artists) lie by representing the appearance of saints in different forms according to their whim, sometimes delineating the same persons as old men, sometimes as youths, [and so] intruding into things which they have not seen...[1]

And she said to him 'How can I worship Him (Christ), when He is not visible and I do not know Him?'[2]

These two texts, the first apparently a letter of Epiphanios of Salamis, writing in the late fourth century, the other a Syriac text dated to the mid-sixth century, share a common concern with identification. Epiphanios claims that painters lie by creating images on a whim, inventing things, and thus making a nonsense of Biblical events. The passage goes on to argue that painters show Christ with long hair, conjecturing this on the basis of Christ being called a Nazarene and Nazarenes having long hair. These same painters illustrate the other disciples with short hair. This, in Epiphanios' argument, removes the need for Judas to identify Christ since he is already distinguished from the other disciples by his hairstyle. In this way, Epiphanios highlights a gap between image and reality, or truth, in art, a gap created by the imagination of artists interfering in things they have not seen. The 'she' in the other passage, a woman on the verge of conversion, confronts the problems of sight and representation from the other side: how can she worship if she cannot see and thus does not know whom she is worshipping? Her imagination is not enough to bridge the gap; indeed, she is not able to imagine because she might get it wrong.

From *Icon and Word: the Power of Images in Byzantium. Studies presented to Robin Cormack*, eds Antony Eastmond and Liz James. © 2003 by contributors. Published by Ashgate Publishing Ltd, Gower House, Croft Road, Aldershot, Hampshire, GU11 3HR, England, pp. 59-71.

Of the many questions that these two passages introduce, it is the nature of art and lies and art's connection with the role of the visual imagination that interests me here.[3] Art and the imagination, I shall suggest, were closely associated by the Byzantines, with both the imagination and memory being constructed in visual terms. Sight was believed to be the most reliable of the senses, but how did sight link to the imagination and was there such a thing as a Byzantine visual imagination? What part did imagination play in the use and perception of images? I will argue that beliefs in the nature of sight, imagination and memory underpinned both Byzantine writings about art and Byzantine theorizing about art and the nature of images.

Both of the passages reveal a concern with seeing: seeing correctly and seeing to believe. They imply a negative or indeed a non-existent role for what we might understand by the term imagination. We tend to define imagination as the forming of images by the mind, or as the conception of external objects that are not present to the senses. We associate it with the creative faculty of the mind and indeed with fancy or even fantasy; there is an implicit stress on the 'unreality' of these images formed by the mind.[4] This is, perhaps, what Epiphanios is opposed to, the imagining 'by whim' of the appearance of the saints and even of Christ. Yet the woman is unable to create an image of Christ for herself; she appears to have no creative faculty of the mind.

*Phantasia* is the word most frequently translated as 'imagination'. It has a primary translation of 'appearance' or 'presentation' and a secondary meaning of 'imagination' or 're-presentation'. In a Christian context, it seems to have subtly altered its sense to mean 'illusion' or 'delusion', and was ascribed a relationship with 'apparition'.[5] This appears to hint at *phantasia* as something not to be trusted in terms of sight and is perhaps closer to our definition with its stress on the creative nature of the imagination. In philosophical terms, Aristotle defined imagination as a faculty possessed by the soul, relating it to sensory activity and to perception and mental imagery.[6] Plotinus also took *phantasia* as the basis of memory, but the Neoplatonists were concerned in particular with the question of whether the imagination received material from the higher soul, or conveyed material to the higher soul, or both.[7] What is important for this discussion is that both of these philosophical strands, both significant in Byzantine thinking, associated *phantasia* with visual perception and memory. In Byzantium, the tenth century *Souda* lexicon echoed both sets of views on the nature of *phantasia*. It defined it as an impression on the soul, imprinted from an already existing object, and stated positively that this impression could not come from anything non-existent. It also suggested that *phantasia* worked through the sense organs: '*phantasia* receives the form of the five senses and each of the senses knows only what it perceives'.[8] What remains constant in the varying definitions of *phantasia* is the emphasis on its visual nature and the associations that this therefore created between

perception, thought and sight, which were all conceived of as being, in some way, interactive. Sight, in the Classical world and in Byzantium, was defined as the most important and reliable of the senses.[9]

Vision worked through touch for the gaze was believed to be tactile, either, as Plato believed, a ray flowing out from the eye that grasped the object and brought it back to the mind or, in Aristotelian thought, the object entering the eye to leave an impression. In this context, Aristotle defined memory as both an imprint on the soul and as a picture.[10] Byzantine theories of vision borrowed from both Plato and Aristotle and so the concept of the visual imprint of vision on the memory and imagination is found in Byzantine writings, as is apparent in the *Souda's* definition of *phantasia* as an imprint on the soul.[11] Memory and *phantasia* assumed a visual form, as happened when people recalled likeness from images.[12] To recollect someone, it was necessary for the mind's eye to scan and retrieve visual memories. Thus many miracle stories explain that the recipient of the saint's favour recognizes the saint when seen through the saint's icon. In the *Miracles* of St Artemios, a child is asked 'In what form did you see St Artemios?' to which she replies 'He resembled the icon standing on the left side of the same church on the templon of the sanctuary where in the middle is the lambda-shaped area in which the Lord is depicted and on the right an icon of St John the Forerunner', a very precise identification.[13] It is a construction of the nature of the imagination that we see time and again in Byzantine stories about images: identification through visual recall. This is what formed the root of the dilemma for the anonymous woman. She could not envisage Christ for she had no visual reference for him. She needed an image to create his image. Similarly, Epiphanios appears to be thinking within the same paradigm. He suggested the problem if painters created images of things that they had not seen: they would create false images and also false memories.

Another element of Classical and Byzantine thought that appears crucial in the understanding of memory and *phantasia* is that of rhetoric. Memory and rhetoric intersect, for, as Yates indicated in the context of the medieval west and the Renaissance, the orator's memory was envisaged as working – and was trained to work – through visualization.[14] Further, rhetoric relied on memory and *phantasia* to create some of its more striking effects. According to rhetorical handbooks, the orator needed to employ both *enargeia*, 'vivid illustration', and *phantasia*, 'imagination' or even 'visualization', to make the audience see situations in their minds and respond to them – which was how the orator achieved his effect.[15] Quintillian saw *phantasia* and *enargeia* as cause and effect. He described *phantasia* as the mental images that the orator had to conjure up in order to create *enargeia*.[16] This would ensure that his speech was vivid enough to produce a comparable image in the minds of its listeners. The speech would thus achieve one of the key goals of rhetoric, that of making the

listener present at the scene, placing the scene described before their eyes, and thus influencing them appropriately. The audiences of such speeches were asked to draw on their own experiences through phrases such as 'you have seen', 'you see' that appealed to their own memories of a sight.[17] Such phrases recur time and again in Byzantine rhetorical descriptions. Paul the Silentiary in his account of Hagia Sophia, reiterates seeing on the part of the audience; Photios in his *Tenth Homily* stresses the spectator's gaze; and Nikolaos Mesarites claims that his account of the church of the Holy Apostles will allow author and audience to perceive the beauty of the church more clearly.[18]

In this way, the speaker did not necessarily use words to conjure an impression. Rather, words were used to evoke and stimulate memories and to bring to life the images already stored in the listener's mind/memory. By summoning up such mental images, the orator called up the emotions and thoughts associated with the sights and memories. In this way, *phantasia* was constructed as a mimetic imagination. To be able to imagine, the audience had to already have knowledge of the pre-existing reality that it could re-visualize.[19] Thus imagination was also bounded by accepted truths and value. For evocations to be effective, they had to correspond to specific experiences, shared values, cultural norms which could be recognized by the audience and shared by the speaker. The anonymous woman could not visualize Christ for she had no pre-existing reality in which to locate him, whilst Epiphanios' complaint is, perhaps, that painters could destroy the mimetic (and thus truthful) aspects of the images they created. The audience's presuppositions about what was plausible set limits for what was acceptable in rhetorical visualization: what the speaker could get away with. Not only do they also explain the common stereotypes of rhetoric (the mental image of a bad woman as a sexual lax woman, for example), they also offer some understanding of some of the cultural assumptions underlying images.

The intersection of *phantasia*, memory, rhetoric and sight is apparent in Byzantine writings, including descriptions of works of art. Based on the rhetorical handbooks, Byzantine orators were well aware of the need to create visual images for their audiences. *Ekphrasis* in particular was employed as a rhetorical device that aimed to bring the subject matter described vividly before the eyes of the audience.[20] Its aim was to convey the effect that the perception of a particular object had on the viewer, appealing to the listener's imagination. To us, *ekphrasis* appears to stress the imaginative impact of the thing described on the audience, but it is an imagination that envisages rather than creates. It is 'as if' you are present at a scene or before an object, not what you think that scene or object looks like.

How then are these aspects apparent in descriptions of images? In Photios' *Homily* on the inauguration of a church in the Palace, *Homily 10*, he begins with an introduction to the celebration and an invocation to the emperor to

explain why all have been called together. References to those present at the inauguration serve to recreate that audience for later audiences of the homily; they also offer Photios an opportunity to lay out themes to which he returns later in the piece. He then opens his description of the church, explaining it is a temple to the Virgin. His description begins in the atrium, where he suggests that the viewer is rooted to the spot by what he sees.[21] On entering the church, the viewer is as if in heaven, his senses bedazzled as he swings round in all directions to take in the variegated spectacle. Photios then offers some details of this spectacle: the gold mosaics, the capitals and cornices adorned with gold, the altar table, the marble, the mosaic pavements, all of which pull the spectator from one thing to another, as Photios' own account also does.[22] Here Photios breaks down the sight he is describing into selected details rather than simply narrating facts, as a way of bringing it vividly before his audience.[23] In this way, the spectator is moved inside the church and then bedazzled. It is not possible to reconstruct the church from this description; rather, Photios offers a sense of the effect of the church on the spectator through reference to a body of material and images with which the spectator would be familiar. There are no obscure terms, but references to bright white marble slabs, to gold tesserae and silver ornamentation, to decorated pavements. All would have been familiar to the viewer, easy to reconstruct in the mind's eye and to put together to create an overall impression of splendour and brilliance.

The culminating point in Photios' description deliberately comes at the end – and to highlight this, Photios says that it should have come first. It is the mosaic of Christ, flanked by angels. Again, Photios offers little in the way of 'description'. The image is a 'man-like figure bearing the traits of Christ. You might say he is overseeing the earth and devising its orderly arrangement and government, so accurately has the painter been inspired to represent, though only in forms and in colours, the Creator's care for us'.[24] From that, the spectator is assumed to have the necessary visual referents to see an image of Christ. Photios stresses that this is an image put up by an artist, but, as if in answer to Epiphanios, that it represents Christ accurately.

Photios notes a host of other mosaics: the Virgin, the apostles, martyrs, prophets and patriarchs. He does not need to describe the images to bring them to the minds of his auditors; a few brief delineations create the image: the Virgin stretching out her arms recalls a generic image of 'Virgin'. Rather, he is concerned to tell his audience how to perceive these images. Christ appears to oversee the earth, devising its orderly arrangement and government, so accurately is his care – not his appearance – represented. Similarly, the Virgin is protector of the emperor, and the prophets, though silent, cry out in praise of the temple of the Lord, praise transferred here to the church.[25]

The purpose of Photios' ekphrasis was to reveal the hidden realities of the church and its decoration, to tell the audience what it was really about. Implicit in this is the concept that sight could transcend normal human experience to allow the soul to see deeper and imagine further with the eyes of the spirit.[26] He invoked *phantasia* and memory to call to mind the absent and to express the intelligible meanings implicit in material sights. At two points indeed, he appealed directly to the spectator's imagination. The façade of the atrium 'suggests to the beholder's imagination (*phantasia*)' that it is made of a single piece of stone; within the church, the spectator, constantly in motion, 'imagines (the verb is *phantazo*) that his personal own is transferred to the object'.[27] The mind constructed and interpreted what the orator described to it through its store of visual recollections. In this *Homily*, delivered at the inauguration of a church built by an emperor, Photios is clearly concerned that his audience see how the church and its images fit with the emperor and his great and good works. Thus he emphasizes Christ overseeing and ordering the earth, devising its proper government, implicitly through the emperor. He summons an image of the Virgin as imperial protector and intercessor. He turns the prophets into heralds and exalters of the new church. Whether the prophets' scrolls actually carried the inscriptions he claims they did is irrelevant; indeed, he includes a figure whom he says is not there but who forms a part of the overall message. In this homily, vision and rhetoric combine to create the same image for the audience, for within *ekphrasis*, the distinction between the perceptible and the imperceptible becomes unimportant. Because of the nature of memory and of *phantasia*, both became visual, both could be seen.

Here, rhetoric, the nature of vision, and theories about the nature of icons entwine. Gregory of Nyssa said:

> if we contemplate a painting and try to understand it, at first it is simply a material surface which by way of different patches of colour helps to fulfil the portrayal of a living reality. Yet what the beholder of the painting observes is what the colour technique itself helps to fulfil: he does not confine himself to admiring coloured masses on a surface, his perception moves only towards the form which the artist reveals by way of the colours. In precisely this way in the *Song of Songs*, we must not confine our gaze to the expressiveness of the colours in their material aspect, but perceive in the colours a kingly form, forming itself by means of pure thoughts. White, ochre, black, red, deep blue, or any colour – these are the expressions in their everyday usage; these are the mouth, the kiss, the unguents and wine, the names of the limbs, the couch and the maidens and all the rest. But the perception that is fulfilled through all these is blessedness, serenity, cleaving to God...[28]

This is exactly what Photios' description sets out to do as it moves its listeners through the church and its mosaics, coloured masses on a surface, to a vision of their meanings and the perceptions fulfilled through these. Gregory is explicit about the theological dimensions. He indicates that divine meaning is the full integration of the cognitive process that begins with sensory perception – sight. The viewer is meant to move from the visual form of the image to its deeper meaning revealed by way of the art. Sight is fulfilled by a perception of God.

Many of the beliefs about sight, *phantasia* and memory that I have outlined above are also apparent in religious thinking. To the Church Fathers, as to Classical philosophers, sight was the sense that mattered most: 'we sanctify the noblest of the senses which is sight'.[29] Byzantine theologians repeat Classical views about the tactile nature of vision. John of Damascus spoke of embracing and kissing icons with the eyes: vision grasping and taking the object back in to the mind.[30] In this context, because of the belief that what the eye saw, it appropriated, it was crucial for the eye to see the right things, lest both the memory and the imagination become contaminated.[31] Nikephoros echoed both Plato and Aristotle on memory when he used the metaphor of a seal-ring to define the icon: 'the icon of a person will never be identical to that of another, like the seal in wax it could not coincide with another imprint'.[32] The concept of visual memory is apparent in authors such as Leontios of Neapolis in the seventh century, who claimed that images were represented everywhere to keep the memory of Christ and his suffering continually in view in order to remember them. Since memory was visual, mementoes needed to be visual.[33] Otherwise, as the anonymous woman, and indeed, any rhetorician, realized, there was nothing to remember with. Patriarch Nikephoros, in his *Third Antirhettikos,* in distinguishing between the Cross and an icon of Christ stressed the greater visual understanding offered by the icon. 'Christ's icon first and immediately, directly and at first glance, manifests his form to us and sets forth the memory of him, for he is rendered in this as in a glass darkly'.[34] As well as the theological debate about the nature of images that it forms a part of, this is also a passage that deals with sight, memory and recollection which together offer the believer the best vision of Christ.

It was on the intersection of beliefs about vision, *phantasia* and memory that definitions of the icon gained part of their meaning. The material world mattered to the iconophiles because it was visible. When Leontios listed ways of venerating the Creator, the element that bound them together was that they could all be seen. The sight of the holy Places recalls Christ, brings him to the mind's eye; the sight of the sea recalls the Creator.[35] It is a remembrance not through touch or any of the other senses, but through sight. In similar fashion, Canon 82 of the Council in Trullo, when it decreed that the symbol

of a lamb be replaced with the image of Christ as a man dealt, among other things, with the recollection, visualization, and memory of Christ's life through the sight of Christ. In this way, 'what is perfect may be depicted, even in painting, in the eyes of all'.[36] Iconophile theologians were concerned to define the icon as a manufactured depiction of the holy person or event as a legitimate medium for Christian knowledge. Here beliefs about memory appear crucial. John of Damascus saw the image as participating to some degree in that of which it was an image; what the image represented was that participation. Thus images served as a way of promoting imitation: 'shall we not make forms and images of things which are visible and perceptible to us that we may remember them and be moved to imitate them?'[37] This, indeed, is what the anonymous woman appears to have been asking for: 'How can I worship Him (Christ), when He is not visible and I do not know Him?' However, and this was where iconophiles and iconoclasts parted company, this imitation needed also to be the real thing, else it was only the lying whim of the painter. Recognition is the key here: without *phantasia*, memory and sight, there could be no recognition.

For the iconophiles, words were not enough. The anonymous woman could not recognize or worship Christ simply through what she had heard. Here again, rhetorical theory and theology appear to share a fundamental belief based on the nature of vision, *phantasia* and memory. The Seventh Ecumenical Council declared that 'that which the narrative declares in writing, is the same as that which the icon (or image) does', reiterated by Theodore the Stoudite: 'whatever is marked there [on the page] with paper and ink is marked on the icon with varied pigments'.[38] Whatever else may be going on here, this is also a case of *ut pictura poesis*, painting as silent poetry and poetry painting that speaks. This should not surprise us, for the equivalence of poetry and painting rests on a belief in the primacy of vision.[39] Nikephoros shared this view: '[words] enter hearing, for first the sounds of the things spoken encounter those listening, then, second, the listener achieves understanding of the given facts through analogy' but then, in contrast, '[painting] directly and immediately leads the minds of the viewers to the facts themselves, as if they were present already, and from the first sight and encounter, a clear and perfect knowledge of these is gained'.[40] Both are valuable but the visual is clearly prioritized to lead the spectator to hidden truths. It is 'as in painting, so in poetry': image first. But both writer and painter are conceived of as thinking in the same way – through visual images – which they express through either words or pictures.

Theodore the Stoudite said of *phantasia* that 'imagination is considered a receptacle of an image [*eikon*] because the two have in common [the transmission] of resemblances'.[41] The icon did not make present what would otherwise only exist in the mind because without the image in the first place,

those images in the mind could not exist. Because the Byzantine imagination appears to be one of vivid, mimetic perception within an existing reality, bounded by accepted truths and values, these are elements that theories of the icon had to take on and use. For both iconoclasts and iconophiles, the truth of the icon mattered, but some, if not all of the impetus for this came from theories of vision and memory. For the believer in icons, the true icon could not show an imaginary (fictional) invention.

Hans Belting has suggested a distinction between images and art as being that images confuse the portrait and the portrayed.[42] The anonymous woman did not appear to fall into this trap, nor the child who saw St Artemios and knew he resembled his icon, nor Photios, who knew that the mosaic of Christ was an accurate representation made by the painter. Time and again, Byzantine stories about images make the distinction between portrait and portrayed apparent. It was a distinction that owed much to beliefs about the nature of vision. A portrait was a memory; it was not the portrayed but it was a recollection and a means of recollection of them. Images, rather than words, were crucial to the act of remembering because they presented the object of memory in a visual form and this was how memory worked. By this logic, icons were not simply a means of recognition, they were the only form of recognition, for recognition worked through memory which worked through sight. The Eighth Ecumenical Council declared that 'if anyone does not venerate the icon of Christ, they will not see his form in the Second Coming.'[43] Vision contained the power to conjure, constitute and respond to presence of divine. Only through sight would it be possible to know Christ; art and the visual imagination were intimately interwoven. In the end the anonymous woman's question won out over Epiphanios' fears. In answer to her plea, she received an *acheiropoietas* image of Christ, an image not made with hands and thus unquestionably accurate. In Christian Byzantium, with its privileging of the sense of sight, both before and after the eighth century, religious images had to exist. The nature of vision, *phantasia* and memory made them inevitable. The rest, as we see during Iconoclasm, was negotiation.

## Notes

1. Epiphanios of Salamis, *Letter to the emperor Theodosios*, fr. 23-27, in *Studien zur Geschichte des byzantinisches Bilderstreites*, ed. G. Ostrogorsky (Breslau, 1929), 71-2; trans. C. Mango, *Art of the Byzantine Empire* (Englewood Cliffs, NJ, 1972), 41-2. There is much debate about whether the anti-images passages of Epiphanios are genuine. See the discussion in L. Brubaker and J. Haldon, *Byzantium in the Iconoclast Era (ca 680-850): The Sources* (Aldershot, 2001), 253 and n.38.

2. From the account of the Kamuliana image of Christ in *The Syriac Chronicle known as that of Zachariah of Mitylene*, trans. F.J. Hamilton and E.W. Brooks (London, 1899), 320, and see also Mango, *Art of the Byzantine Empire*, 114-5.

3. These are questions that come out of an interest in the Byzantines' ways of seeing the world which owes much to the thinking and teaching of Robin Cormack.

4. In part, our definition arises from an awareness of consciousness, of the sub-conscious and the unconscious, concepts that do not really feature in Aristotelian philosophy, but are apparent in Neoplatonic thought.

5. H.G. Liddell, R. Scott, H.S. Jones, *A Greek-English Lexicon* (Ninth edition, Oxford, 1968), *phantasia*; G.W.H. Lampe, *A Patristic Greek Lexicon* (Oxford, 1961), *phantasia*. It was Robin Cormack who assured me that Lampe was the essential tool for a *real* art historian!

6. Aristotle's primary definition of *phantasia* is in *De Anima* 3, 3. His discussion of *phantasia* here and elsewhere appears complicated and contradictory and I offer only a crude simplification at this point. For detail, see J.I. Beare, *Greek theories of elementary cognition* (Oxford, 1906), esp. 290 on, M. Schofield, 'Aristotle on the imagination', in *Aristotle on mind and the senses*, eds G.E.R. Lloyd and G.E.L. Owen (Cambridge, 1978), 99-140. Also, in a Byzantine context, see and R. Webb, 'Mémoire et imagination: les limites de l'enargeia dans la théorie rhétorique grecque' in *Dire l'évidence*, eds. C. Levy and L. Pernot (Paris, 1997), 234.

7. H.J. Blumenthal, *Aristotle and neoplatonism in Late Antiquity* (New York, 1996), esp. ch.10. Both Aristotle and the Neoplatonists believed that *phantasia* was not always correct and, indeed, could often be wrong.

8. *Suida Lexicon*, ed. A. Adler (Leipzig, 1928-29), 4, *phantasia*, 697 and 698 (Adler entries nos 84 and 85). The quotation is from no. 84. A translation and commentary of no. 85 can be found at *Suda On Line*: http://www.stoa.org/. The headword is *phantasia*, which the translator, Marcelo Boeri, translates as 'presentation'. Boeri sees this entry as Stoic in character. In entry no. 84, *phantasia*, the definition is associated with Aristotle. My thanks to Vassiliki Dimitropoulou for help with no. 84. The history of Byzantine philosophy has not been written, though see *Byzantine philosophy and its ancient sources*, ed. K. Ierodiakonou (Oxford, 2002).

9. Aristotle, *Metaphysics*, 1.1.2, *De Anima* 2, 7.

10. Aristotle, *De Anima*, 2, 12, 424a17-24, 435a9.

11. In entry no. 84, the *Souda* says ' sense perception knows only what is present and what it perceives from outside...*phantasia*, after receiving the forms of sensible beings from sense perception, forms these [forms] anew in itself'. For Byzantine vision see the discussion in R.S. Nelson, 'To say and to see: ekphrasis and vision in Byzantium', in *Visuality before and beyond the Renaissance*, ed. R.S. Nelson (Cambridge, 2000), 150-1.

12. On memory and vision, particularly in Late Antiquity, see the important book by G. Frank, *The Memory of the Eyes* (Berkeley, 2000), here, esp. p. 126.

13. *The Miracles of St Artemios*, ed. and trans. V.S. Crisafulli and J.W. Nesbitt (Leiden, 1997), Miracle 34, 176-181. The quotation is from 181. In this context, the number of times Artemios appears in disguise (about half) is also interesting. See Crisafulli's Preface, xiv-v. Leslie Brubaker has raised important questions over miracle stories such as these in the context of Iconoclasm and Iconophile fictions. See L. Brubaker, 'Icons before Iconoclasm?', *Morfologie sociali e culturali in europa fra tarda antichità e alto medioevo*, Settimane di Studio del Centro Italiano di Studi sull'Alto Medioevo 45 (1998), 1215-54. If these stories are 'invented', how far are they works of the imagination? In this context, G. Dagron, *Constantinople imaginaire* (Paris, 1984) offers many insights.

14. Byzantine knowledge and techniques of artificial memory have been little explored. However, F. Yates, *The Art of Memory* (London, 1966), 107 and n. 4, points out that the memory section of the key Latin 'memory' text, *Ad Herennium*, was known certainly in fourteenth-/fifteenth-century Byzantium, when the text was translated into Greek.

15. See R. Webb, 'Imagination and the arousal of the emotions in Greco-Roman rhetoric' in *The passions in Roman thought and literature*, eds S.M. Braund and C. Gill (Cambridge, 1997), 112-127, esp. 116-117 and Webb, 'Mémoire et imagination', 229-248. My debt to Ruth Webb and her work on Byzantine rhetoric, especially *ekphrasis*, will be apparent throughout this paper.

16. Quintillian, *Institutio oratoria*, 6, 2, 29-30, Webb, 'Imagination', 118.

17. See Webb, 'Imagination', 120-1 and the discussion in R. Webb, 'The aesthetics of sacred space: narrative, metaphor and motion in *ekphraseis* of church buildings', *DOP* 53 (1999), 63.

18. Paul the Silentiary, *Description of Hagia Sophia*, e.g. lines 398 ('as you direct your gaze'), 417 ('one may see'), 532 ('you will see'), text in *Johannes von Gaza und Paulus Silentiarius*, ed. P. Friedländer (Leipzig-Berlin, 1912), partial trans. in Mango, *Art of the Byzantine Empire*, 80-96. Photios, *Homiliai*, 10, 4, in *Photiou Homiliai* ed. B. Laourdas (Thessaloniki, 1959). For a translation of the homily, see C. Mango, *The Homilies of Photius Patriarch of Constantinople* (Harvard, 1958), 184-90. Nikolaos Mesarites, *The description of the Church of the Holy Apostles at Constantinople*, 12.4; the whole text ed. and trans. G. Downey, *Transactions of the American Philosophical Society* N.S. 47,6 (1957), 859-918.

19. As Webb says, 'Imagination', 123-4.

20. For a definition of *ekphrasis*, see R. Webb, 'Ekphrasis ancient and modern: the invention of a genre', *Word & Image* 15 (1999), 11-15, R. Webb, 'Ekphrasis, amplification and persuasion in Procopius' *Buildings*', *Antiquité Tardive* 8 (2000), 67-71, esp. 68-9. Also L. James and R. Webb, '"To understand ultimate things and enter secret places": ekphrasis and art in Byzantium', *ArtH* 14 (1991), 1-15.

21. For an identification of the church, see the discussion in Mango, *Homilies of Photius*, 177-183. Mango dates it to 864-66. It thus predates Homily 17, the dedication of the Virgin in the Apse of Hagia Sophia. The mosaics are perhaps some of the earliest mosaics put up after Iconoclasm.

22. See Webb, 'Aesthetics of sacred space' on these themes in other narratives. On movement through a church, see R. Macrides and P. Magdalino, 'The architecture of ekphrasis: construction and context of Paul the Silentiary's ekphrasis of Hagia Sophia', *BMGS* 12 (1988), 47-82.

23. In similar fashion, Georgia Frank has noted that pilgrim descriptions emphasize seeing but give little description of what pilgrims actually saw. Frank, *Memory of the Eyes*, 105. Recollection as envisioning appears to close the gap between past and present and to enable the actual event to be relived.

24. Photios, *Homily* 10, 6; trans. Mango, *Homilies*, 187-8.

25. These prophets include Barlaam, who would not have been depicted but who offered praise of the houses and tabernacles of Israel, here transferred to the church. Photios, *Homily* 10, 6, and Mango, *Homilies of Photius*, 188 and n.18.

26. For this concept, see James and Webb, 'Ekphrasis and art', 11-13, Webb, 'Aesthetics of sacred space', 69.

27. Photios, *Homily* 10, 4; trans. Mango, *Homilies*, 186.

28. *Commentary on the Song of Songs*, I, 1, *PG* 44, col. 776A-B. The translation is taken from P. Dronke, 'Tradition and innovation in medieval western colour imagery', *Eranos Yearbook* 41 (1972), 72.

29. John of Damascus, *First Oration on the Holy Images*, 17, *PG* 94, 1248C-D; *De fide Orthodoxa* 2,18, *PG* 94, 933D-936A; Nikephoros, *Refutatio et Eversio*, fol. 273v, quoted in P.J. Alexander, *Patriarch Nicephoros of Constantinople* (Oxford, 1958), 211 and n.3. 'Often what the mind has not grasped while listening to speech, sight seizes without risk of error, has interpreted more clearly', *Antirheticus* 3, 3, *PG* 100, 380D-381A.

30. John of Damascus, *First Oration on the Holy Images*, 1, Commentary on St Basil, *PG* 94, 1268B-C and again, *Second Oration on the Holy Images*, 10, *PG* 94, 1293B. Also Nelson, 'To say and to see', 153.

31. See Frank, *Memory of the eyes*, 131 on the importance of this in the early Christian period for monks shunning the sight of women.

32. Nikephoros, *Antirhetici* 1.38, *PG* 100, 293B-C; Plato, *Thaetetus*, 191a-195b; Aristotle, *De Anima* 2,12, 424a17-24. This metaphor is used by the *Souda* lexicon in one of its definitions of *phantasia: Suida Lexicon*, Adler no. 85 and *Suda On Line*, Boeri's n.2 and 3.

33. Leontios of Neapolis, *Apology*, Mansi, 13, 45B, lines 5-10. C. Barber, 'The truth in painting: Iconoclasm and identity in early medieval art', *Speculum* 72 (1997), 1028, suggests that in Christianity the image became central to the act of remembering. Rather, I would argue, the image was always central to the act of remembering. It was, in fact, the very act itself.

34. Nikephoros, *Antirhetici* 3.35(2), *PG* 100, 428D.

35. Leontios of Neapolis, *Apology*, Mansi 13, 48D, lines 5-48E. Although it has been suggested that in this passage Leontios was concerned with a validation of non-corporeal relics sanctified by contact, what I think matters more is a validation and, more importantly, a recollection through sight. See C. Barber, *Figure and Likeness. On the limits of representation in Byzantine Iconoclasm* (Princeton, 2002), 19-20.

36. Text of Canon 82 available in *The Council in Trullo revisited*, eds G. Nedungatt and M. Featherstone (Rome, 1995), 162-4.

37. John of Damascus, *First Oration on the Holy Images*, Commentary on Pseudo-Dionysios, *PG* 94, 1260C. English trans. taken from *St John of Damascus on the Divine Images* trans. D. Anderson (New York: St Vladimir's Seminary Press, 1980), 34. For John's theology of the icon, see A. Louth, *St John Damascene. Tradition and originality in Byzantine theology* (Oxford, 2002), ch.7, 193-222. Also the argument of L. Brubaker, 'Conclusion: Image, audience and place: interaction and reproduction', in *The sacred image east and west*, eds R. Ousterhout and L. Brubaker (Urbana and Chicago, 1995), 209-11.

38. Sixth session of the Seventh Ecumenical Council, Mansi 13, 232C; trans. D.J. Sahas, *Icon and Logos: Sources in Eighth Century Iconoclasm* (Toronto and London, 1986), 69; Theodore the Stoudite, *First Refutation on the Holy Icons* 10, *PG* 99, 340D-341A. Nikephoros says the same thing also, see for example, *Apologeticus pro sacris imaginibus*, 61, *PG* 100, 748D. See also the remarks in L. James, *Light and colour in Byzantine art* (Oxford, 1996), 130-1.

39. As, indeed, Frances Yates pointed out, *Art of Memory*, 28.

40. Nikephoros, *Antirhetici* 3.3, *PG* 100 381C-384B and *Apologeticus* 61, *PG* 100, 749-52. The Iconoclast patriarch, John the Grammarian, appears to have engaged with these ideas, privileging texts rather than images, and using encomium rather than ekphrasis as his point of reference. See J. Gouillard, 'Fragments inédits d'un antirhéttique de Jean le Grammairien', *REB* 24 (1966) and the discussion in Barber, *Figure and Likeness*, 126.

41. Theodore the Stoudite, *Letter to Naukratios, Epistle* 2, 36, *PG* 99, 1220B. See also John of Damascus, *De Fide Orthodoxa*, II, 17, *PG* 94, 933.

42. *Bild und Kult – Eine Geschichte des Bildes vor dem Zeitalter der Kunst* (Munich, 1990), trans. by E. Jephcott as *Likeness and Presence. A history of the image before the era of art* (Chicago, 1994.

43. *Conciliorum Oecumenicorum Decreta*, ed. P. Joannou (Basle, 1962), 114.

Chapter 6

# Between Icon and Idol:
# The uncertainty of imperial images

Antony Eastmond

Iconophile theologians sought to examine one crucial question: was the veneration paid to an image of God idolatrous? To answer this, they elaborated a theory of images that allowed them to divide icons (good) from idols (bad). Such a division should have been absolute, but it was not. A third class of images slipped through; one that overlapped the divide between icons and idols. These were imperial images: images to which veneration should be paid, yet images that were not icons. At the same time, the ways in which imperial images functioned in practice sometimes shared more with idols than icons, yet they were not idolatrous. This paper explores the uncertain status of imperial images in the context of icon theory.

It has long been accepted that the status and function of imperial images are self-evident: they display the majesty of the Byzantine emperor and thereby magnify his power and that of the empire everywhere an image was placed. As André Grabar declared at the outset of his study of imperial art in 1936: 'L'art impérial byzantin n'a eu qu'un but: magnifier le pouvoir suprême du *basileus*'.[1] In this paper, the ostensible purpose and theory of imperial images, as described by Grabar, will remain unchallenged; what will come under scrutiny is one aspect of the way in which such images functioned in practice. I concentrate on the reception, rather than creation of imperial art. In the discussion that follows, the functioning of imperial images will be compared to the ways in which icons and idols were perceived to work. Behind the official doctrine of imperial image veneration, the status of images of emperors was ambiguous and contested, and this can best be seen by looking at cases in which images are attacked. For the ways in which icons, idols and imperial images all responded to attack reveals much about the way

From *Icon and Word: the Power of Images in Byzantium. Studies presented to Robin Cormack*, eds Antony Eastmond and Liz James. © 2003 by contributors. Published by Ashgate Publishing Ltd, Gower House, Croft Road, Aldershot, Hampshire, GU11 3HR, England, pp. 73-85.

in which they were perceived to function. In particular, such attacks tell us much about the relationship between the image and its prototype, between the picture and what is depicted in it; a fundamental aspect of icon theory.

The imperial image should be above suspicion. Its importance was stressed by the church fathers of the fourth century, such as Athanasios of Alexandria and Basil of Caesarea, who were happy to accept the cult of the emperor in return for official recognition and state support for the church. Both used the example of imperial images to help explain aspects of Christianity.[2] Athanasios, in his third *Oration against the Arians*, wrote that:

> For the likeness of the emperor in the image is exact... to one who after [viewing] the image wished to view the emperor, the image might say: 'I and the emperor are one; for what you see in me, that you behold in him, and what you have seen in him, that you behold in me'. Accordingly, he who worships the image also worships the emperor in it; for the image is his form and appearance.[3]

Similar thoughts were expressed at the Second Council of Nicaea in 787: 'When the population rushes with candles and incense to meet the garlanded images and icons of the emperor, it does not do so to honour panels painted with wax colours, but to honour the emperor himself'.[4] These quotations outline the relationship between the image and that which it depicted, the prototype. More important is their context, for both employ imperial images to provide the paradigm for icon veneration. The key concepts that imperial images brought to icon theory were that the honour paid to the image passed to the prototype, and that there was seen to be an identity between the image and its model. Indeed, Byzantine theologians employed the idea of the imperial image as an exemplar to validate icons. The concepts that were established were central to iconophile argument in the eighth and ninth centuries.[5] At the same time, however, theologians were concerned to maintain a separation between icon and prototype. The icon remained a purely material object which facilitated access to the saint. Its power derived only from its resemblance to its prototype.[6]

Saints can act through their icons, but the icons themselves remain no more than windows or doors.[7] This separation is crucial to the ways in which icons were perceived and functioned. At a theoretical level, it enabled Byzantine theologians to argue that venerating icons was not idolatrous as it was the prototype, not the base materials of the image that were being venerated. At a practical level, it protected the saint from attack. Whilst icons could be, and indeed often were, attacked, this was perceived by Christians as no more than an attack on wood and paint; the prototype – the saint – remained inviolate. The attack merely reflected the barbarity and heretical

nature of those who perpetrated it. It would be impossible for Christianity to admit that saints and Christ could be hurt through their images, as this would deny the point of the Resurrection, which ensured saints their posthumous existence and power. There is a clear distinction and absolute separation between signifier (icon) and signified (prototype). For our purpose here, the main point to establish from this is that the relationship between icon and prototype was, essentially, one-way. This is shown frequently in chronicles and saints' *vitae*, which are full of tales of those who attacked images, themselves suffering. Either the saint reacts to defend his image, as in a life of St George, which tells of a Saracen killed when the missile he threw at an icon of the saint painted on a wall returned and pierced his heart. In this story the saint stretches his hand out through the icon to return the missile.[8] Alternatively, the saint stands by unharmed during the act of destruction and, more in sorrow than in anger, promises retribution. Theophanes Confessor records the Virgin watching a man destroying an icon on which she was depicted, and predicting that he will, as a result, suffer exactly the same fate. The next day he died during a Saracen attack.[9] In either case, whatever happened to the icon, the prototype was left unharmed; it existed outside and beyond the image. Moreover, one saint could be depicted in multiple icons, through all of which he could act.

The perception of damaged icons demonstrates the separation clearly. Views differed as to how damaged icons should be treated, and this reveals a certain level of inconsistency about attitudes towards the icon, though all agreed about the inviolability of the prototype. One interpretation, promoted by John of Damascus among others, argued that damaged icons should be destroyed.[10] In this view, the presence of damage meant that the image was no longer a true representation of the prototype, and so it could no longer function as an icon: the link between image and prototype was severed. In general, however, there seems to have been a belief that, even when they had been damaged, icons remained effective objects. This is most evident with bleeding icons.[11] It is unclear in these cases whether the material or the saint bleeds. However, the fact that such objects were treated as miraculous indicates that the status of the prototype did not come under any real threat of harm. This was the case with an icon of Christ that bled after being stabbed by a Jew.[12] By imperial decree, this was subsequently put on display in the church of St Nicholas behind Hagia Sophia in Constantinople. At no point does the story suggest that Christ himself was affected by the attack; the very idea is implausible in a Christian context.

On a more prosaic level, the survival of so many ancient icons on which hands and faces, and in particular eyes, have been defaced, and which Orthodox viewers over centuries have continued to revere, indicates their continued perceived sanctity.[13] These retain all their original powers as

vehicles of communication with God and the saints. The same is true of images which have simply worn away through centuries of touching and kissing, such as a sixth- or seventh-century encaustic icon of an archangel in the collection of St Catherine's Monastery on Mount Sinai,[14] or, in a western context, the Acheropita in the Sancta Sanctorum in Rome, which barely exists beneath its later revetments.[15] In whichever view is held, the distance between image and prototype is maintained: either damage has no effect on the link with the saint, or it cuts the link absolutely. The divide between signifier and signified is absolute. The image remains base materials – wood, paint, gesso – and its destruction does not, *per se*, matter.

In practice, of course, the relationship between icon and prototype was more complex. As Gilbert Dagron has pointed out, the initial relationship between icon and prototype was often reversed. The likeness of the saint, as witnessed in visions and dreams, was often determined by his or her appearance on an icon, rather than the other way round.[16] However, this is a practical rather than a theological point. It affected the mechanics of icon construction and the way in which the prototype was conceived by viewers, rather than the theory by which they operated. The relationship is also complicated by *acheiropoietai*, since the material status and creation of these images tend to blur the distinction between image and prototype, especially in the case of the Mandylion (but also in that of bleeding icons); but it is only a blurring, not a fudge.[17] Finally, as Henry Maguire and Alexander Kazhdan have pointed out, not all icons were equal in their relationship to their prototype: the *Life* of St Nikon Metanoeite tells of a monk, Luke, who prayed before an icon of the saint at his home monastery of St Nicholas, and through this he was transported in a vision to St Nikon's own monastery, where he was cured by the tomb and icon of the saint (as well as an icon of Christ Antiphonetes).[18] Once again, this event does not have a theological rationale, but reflects common perceptions about the efficaciousness of individual images.

In theory, the relationship between an idol and its prototype was thought to be different from that between an icon and its prototype, but in practice, they had much in common.[19] As with icon theory, there was a certain level of (necessary?) inconsistency in the way in which idol theory was elaborated. In essence, theologians argued that idols are worthless because they do not truly have a prototype to refer to. Ignatios the Deacon wrote in his *Life* of the patriarch Tarasios in c.843 that idols are 'inventions of Greek superstition, formed anew from something that in no wise exists and invoking honour to themselves by qualities liable to corruption, whereas the latter [icons], achievements as they are of Christian holiness bringing forth into existence something from what already exists, are accompanied by the sanctity of the archetypes'.[20] If the prototype does not

exist, then the image can only be an idol.

However, when they came to discuss idols, particularly those that had demonstrated some form of power, theologians had to resort to prototypes. The malevolent deed enacted by an idol was caused by a devil – the idol's perverted prototype. Elsewhere in his *Life* of the patriarch Tarasios, Ignatios describes a statue as an 'utterly outrageous abomination' of its prototype;[21] and the Seventh Ecumenical Council of 787, Nicaea II, called idols 'the images of devils'.[22] Although theory and practice differed in their view about the nature of an idol's prototype, an uneasy and implicit compromise emerged. In that an idol did have a prototype, it only existed within the image; it could have no external validity. This respected the theoretical point that an idol was just an invention of man's imagination, and also tied any devil into the image. In semiotic terms, in an idol the signifier and the signified are identical. This is crucial when it comes to attacks on idols, as the attack has a direct impact on the devil it represented. Unlike an icon, to attack an idol is to attack its prototype, its devil. This means that the relationship in an idol between the image and prototype is more ambiguous as it has a two-way element.

Like an icon, an idol could work through its image, as many stories in the eighth-century *Parastaseis Syntomoi Chronikai* demonstrate.[23] However, the stories also show that destroying the idol has an impact on the demon that it represents. Chapter 28 of the *Parastaseis* tells of a statue that killed the author's colleague, Himerios. The statue was subsequently buried to prevent it from harming anyone else. Although the text says that it was impossible to destroy the statue, it is clear that the act of burial was considered sufficient to neutralize its power: once the image was removed its putative prototype could no longer act.[24] As we have seen, this is very different from the ability of saints to act after the destruction of their icons. Later writers, including Niketas Choniates and Robert de Clari, also recounted stories in which statues were attacked as a way of affecting what they were perceived to represent. Both, for example, tell of statues thought to represent forces attempting to invade Constantinople that were destroyed as a way of depriving these enemies of victory.[25] This is strikingly different from the way in which icons were perceived to function, and lies at the root of the difference between them as objects. It also provides a way of explaining the ambiguous nature of imperial images.

Imperial images provide another way of viewing the relationship between image and prototype, which shares features with both icons and idols. As will be shown, in imperial images, the relationship fluctuates according to need and circumstances, and this is most evident when the images were attacked.

Imperial images, as has been stated above, provided the basis for the mechanism of image veneration. In theory, they operated in the same way as

icons: 'whoever venerates the image, also honours the emperor in it'.[26] At an official level, the image reflected the emperor's position as god's vice-regent on earth and so the source of all earthly power; this gave him a quasi-saintly and also quasi-priestly status, reflected in his appearance in images with haloes and his ability to enter the sanctuary of churches.[27] However, imperial images differ from icons in one fundamental respect: the nature of their prototype. Saints, the prototypes for the images in icons, were guaranteed through their blameless life or martyrdom to be in heaven, beyond human harm. Emperors on the other hand were still alive, their acts could be judged, and they could themselves be deposed from power and personally harmed, through exile, mutilation or death. The official status of the emperor and his image was often at odds with the personal nature of imperial rule, the capriciousness of imperial policy, and the ability to sin and commit foul deeds. Emperors were all too human. This is what gives Byzantine chronicles their force and interest.

Whilst the dual nature of the emperor could be reconciled within the political theology of the King's Two Bodies, it was hard to do so in actuality.[28] The official recognition of a distinction between political and personal is visible in images of the Last Judgement. Frequently these number emperors among the damned in Hell, which can only be a reference to bad individuals rather than the quasi-saintly institution. Emperors and empresses roast in the fires of Hell in the Last Judgement in an eleventh-century Gospel book in Paris (BN gr. 74, fol. 93v),[29] and throughout the Byzantine commonwealth: Torcello near Venice, c.1095;[30] Timotesubani in Georgia (c.1220);[31] in the Armenian Four Gospels by Toros Roslin of 1262.[32] Last Judgements, however, are narrative images, and so do not directly affect the veneration of official imperial representations. However, they do show that the difficulty of reconciling the dual natures of the emperor was an issue in Byzantine art, and this had a significant impact on the issue of the veneration of official imperial images.

The veneration of the imperial image could only work if it was accepted that it was only the official body of the emperor that was being represented. The idealized nature of surviving imperial imagery indicates that this was the primary function of such depictions. The preference for model moral and physical attributes over facial or bodily verisimilitude is pervasive. Basil II, a man of 'less than normal stature' according to Michael Psellos, is enhanced so that he grows into the figure of the victorious emperor in his Psalter (Venice Marciana gr.Z.17, fol. 3r);[33] and empress Zoe retains her youthful beauty in her mosaic in the south gallery of Hagia Sophia despite being in her sixties.[34]

Using the argument for the identity of emperor and image, it was possible for images to improve the emperor: to turn the man into the institution.[35] As a soldier is reported to have said on seeing Leo VI: 'I felt I was looking at a marvel, not a man'.[36] The magnificence of imperial images disguised the

flawed characters portrayed in the chronicles of Michael Psellos or Niketas Choniates (let alone the imperial pair of Justinian and Theodora in Prokopios' *Secret History*). It is clear in these cases that to venerate the image is to venerate the ideal of the emperor, not the men that enacted this role. Indeed, to venerate such sinful men and women would be theologically dubious to say the least.

In the same way that it was important for chroniclers to be able to discuss the two different aspects of imperial power, so it was important for the distinction between the political and the personal to be recognized when it came to official images. Indeed, it was necessary to the success of the empire that the two natures of the emperor could be distinguished. The fact that reigning emperors could be deposed through usurpation or murder could only be legitimated if it distinguished between an attack on the institution and an assault on the individual.[37] It was the co-existence of the personal nature of the emperor along with the political that enabled such changes of regime to be justified. This is significant for the perception of images, since it was during the change of regime that images were often attacked, mutilated or destroyed. In these instances, it is necessary that the image represent the personal body – the individual emperor – rather than the institution. Thus, the destruction of images of Andronikos I Komnenos that accompanied his death at the hands of the mob in 1185 represented only the obliteration of the individual; it had no impact on the status of his successor, Isaak II Angelos, who subsequently set up images which ascribed his elevation to miraculous intervention.[38] The immediate change in the status of the portraits of Andronikos at the time of his death is clearly noted by Niketas Choniates: 'his image had become an abomination, whether it be the features of his face as one would visualize them or his portrait found on walls and panels; large numbers of the populace abused these and ground them down and scattered them over the city, even outdoing what Moses' chosen followers did to the idol of the bull they cast in drunkenness.'[39]

There was thus an ambiguous relationship between the image and the two natures of the emperor. As the cases outlined above demonstrate, images could relate to the different facets of the imperial prototype depending on context and circumstances. Emperors and viewers of imperial imagery were able to exploit the ambiguity of the distinction between personal and political in a number of different ways, and this is most clearly visible in cases where images are attacked. In every case, the attitude towards the image depends on the success or failure of the attack. Images of emperors were not stable, but fluctuated according to political and other need.[40]

When in a position of strength, emperors were able to insist on the most elevated status of the imperial image as the direct representations of the majesty of the state. The most famous example of this is the Riot of the

Statues in Antioch in 387, when the destruction of statues of Theodosios I was treated initially as a direct attack on the empire. This was clearly seen as an attack on the political body of the emperor: the ultimate crime of treason against the state, lèse-majesté. The dire punishment that the citizens of Antioch expected in return reflects their own perception of the seriousness of their crime.[41]

At the other extreme are the cases when the attacks on emperors and their imperial images succeeded. In these cases the new power demonstrated its authority by the annihilation of every reference to the previous regime: *damnatio memoriae*.[42] Indeed, the new emperor's legitimacy was demonstrated by this retrospective act of writing the previous ruler out of history. The example of Andronikos I Komnenos has been mentioned already, and a poem of John Geometres records the destruction of images of Nikephoros II Phokas by his usurper, John Tzimiskes (969-76).[43] The possible example of the destruction of the image of the empress Zoe (1028-50), her husband Romanos III Argyros, and Christ, by Michael V serves to demonstrate the way in which the destruction of an imperial image at the heart of the empire was perceived as contributing to the collapse of a regime.[44] In these cases it was the person of the emperor (or empress) that was destroyed. This is analogous to the destruction of idols: the end of the image was equated with that of the prototype.

These represent the two extremes, in which the image stands for either the political or the personal body. In between these, the status of the imperial image continually shifted, and could be exploited by both its defenders and attackers in order to affect the rule of the empire. The ability either to distinguish or to overlap the political and personal nature of the emperor was seen and recognized by the Byzantines, not least by emperors themselves. The replacement in 1078 of the head of Michael VII Doukas with that of the man who usurped his throne, Nikephoros III Botaneiates, in three miniatures in an imperial copy of the homilies of John Chrysostom (Paris BN, Coislin 79, fols. 2r, 2v, 2 bis v) demonstrates this.[45] In all three miniatures the imperial body survives as evidence of institutional continuity, but the individual is altered. Recognition of the difference between the two natures of imperial rule is required for the act of alteration to be effective (although they were, of course, designed to disguise all evidence of alteration). The two aspects of the imperial person are fused to guarantee the change in regime. The survival of the image of the empress, Maria of Alania, along side both old and new emperor further demonstrates the way in which power lay in the image and could be co-opted. The power implicit in the imperial image by virtue of its analogy to icons could be physically harnessed during a coup d'état. That which affects the image affects the emperor depicted, in this case by changing his identity and transferring legitimacy. The replacement of the image paralleled the

replacement of the emperor.

The eventual relaxation of the punishment of Antioch after the Riot of the Statues in 387 was credited by Theodoret to the monk Macedonios, who was able to persuade Theodosios to acknowledge the dual status both of himself and his image: 'you are not only an emperor, you are also a man… Think how you are acting thus in your wrath for the sake of a brazen image. Now all who are endued with reason know how far a lifeless image is inferior to one alive and gifted with soul and sense'.[46] The ability to threaten punishment and to display magnanimity required that Theodosios manipulate his own perception of his statue and shift its status from the political to the personal.

The opposite side to this example can be seen in the mutilation and then destruction of images of the empress Xene by emperor Andronikos I Komnenos (1183-85). Here the portraits of the former empress were 'done over so that she appeared as a shrivelled-up old woman because he [Andronikos] was suspicious of the piety elicited by these radiant and very beautiful portrayals'.[47] The new emperor sought to downgrade the image from the political to the personal. Niketas Choniates indicates that Andronikos clearly believed that making the empress's image worse would have a similar impact on perceptions of the empress herself.

The one other area of imperial portraiture that required the blurring of the political and the personal was in depictions of dynastic continuity. The clear attempts by the Macedonian and Komnenian dynasties to use art to promote a blood inheritance of power could only work by suggesting an identity between the emperor as family and the institution. The display of generational continuity provided by Basil I, surrounded by his family, in the Kainourgion of the Great Palace, echoed on a smaller scale in the homilies of Gregory Nazianzos in Paris (BN gr.510, fols. Cv-Br) placed this association of family and throne in its most official setting.[48] It has been argued that the Kainourgion image, with its depiction of Basil and all his children, should be distinguished from that in gr.510, which just shows Basil, his empress and immediate heirs, as the difference between an extended family portrait and an official imperial representation. However, this misses the point that political legitimacy required that the distinction between the two be blurred in all dynastic imagery.[49] Both sets of imagery helped to build up the impression that the family and the institution were inseparable. A similar argument applies to the imposing (but ultimately failed) linking of Alexios Komnenos to his parents in the south gallery of Hagia Sophia, the most sanctified of all locations for an imperial image.[50] In order to overcome the traditional disregard of the hereditary principle, which would allow the best man to become emperor, these images required viewers to conflate family with institution.

The shifting nature of the imperial prototype and its relationship to the

image is one of the areas that separates it from religious icons. Another is the fact that there is a perceived ability to harm the emperor through his image. This has already been noted in the manipulation of art in the reign of Andronikos I, whether to alter others' images or have his own destroyed. It is implicit in the idea of *damnatio memoriae*, as well as in the alteration of images to change identity; an attack on an imperial image can contribute to damage inflicted on an emperor. I have argued above that each of these acts relates to different aspects of the dual nature of the emperor, but in every case the ability to use an imperial image to affect perceptions of its prototype indicates that there is a two-way relationship between them. This separates the imperial image from icons, which can never harm the saint depicted on it, and links it in more closely with idols, the destruction of which ended their capacity to act. Imperial images, which provided the theoretical foundation for icon veneration, actually seem to have functioned in a way more analogous to idols.

The fact that imperial images had such ambivalent status, even late in the middle Byzantine period, reflects the fact that Christianity could never quite come to terms with what was, after all, a pre-Christian form of image cult.[51] Theologians seem to have preferred to gloss over this problem, preferring the theoretical absolute of the status of the emperor as God's ruler on earth, to the practical problem of his actual nature with the consequences that that entailed. The political exigencies of imperial rule in Byzantium and the impossibility of balancing the two natures of the emperor, forced imperial images into an uneasy and uncertain role.

## Notes

1. A. Grabar, *L'empereur dans l'art byzantin* (Paris, 1936), 1.

2. Basil of Caesarea, *De Spiritu Sancto*, xviii, 45; *PG* 32: 145; Mansi 13, 69D; trans. C. Mango, *The Art of the Byzantine Empire 312-1453* (Englewood Cliffs NJ, 1972; reprinted Toronto, 1986), 47.

3. Athanasios, *Oratorio contra Arianos* iii.5; *PG* 26, 332; Mansi 13, 69B-D; trans. A. Robertson, *Select Library of Nicene and Post-Nicene Fathers.* 2nd series, IV (London, 1896), 396.

4. Mansi 12, 1014D; trans. H. Belting, *Likeness and Presence. A history of the image before the era of art* (Chicago, 1994), 102-3.

5. K. Parry, 'Theodore Studites and the Patriarch Nicephoros on Image-Making as a Christian Imperative', *Byz* 59 (1988), 164-83.

6. As noted by Nikephoros, *Antirrhetici* I.28, *PG* 100, 277A-C; trans. M-J. Mondazin-Baudinet, *Nicéphore: Discours contre les iconoclasts* (Paris, 1989), 109-110.

7. *La vie d'Étienne le Jeune par Étienne le diacre*, ed. and trans. M.-F. Auzépy, Birmingham Byzantine and Ottoman Monographs 3 (Aldershot, 1997), 122.

8. *BHG* 690.i; ed J.B. Aufhauser, *Miracula S. Georgii* (Leipzig, 1913), 10-11; A. Kazhdan and H. Maguire, 'Byzantine Hagiographical Texts as Sources on Art', *DOP* 45 (1991), 3.

9. Theophanes Confessor, *Chronographia*, ed. C. de Boor (Leipzig, 1883), 406; *The Chronicle of Theophanes Confessor. Byzantine and Near Eastern History AD 284-813*, trans. C. Mango and R. Scott (Oxford, 1997), 560 (AM 6218).

10. John of Damascus, *Oration* 2.19, 3.12, *Die Schriften des Johannes von Damaskos*, ed. B. Kotter (Berlin, New York, 1988), 3:118, 123; Leontius of Neapolis, *Contra Judaeos*, PG 93, 1597C; Parry, 'Image-Making', 181-82.

11. See Maria Vassilaki's article in this volume.

12. G.P. Majeska, *Russian Travelers to Constantinople in the Fourteenth and Fifteenth Centuries*, Dumbarton Oaks Studies: 19 (Washington, DC, 1984), 136-8.

13. The issue of damage to icons is raised in passing by R. Cormack, *Painting the Soul. Icons, Death Masks and Shrouds* (London, 1997), 38-43. Normally, however, it is an issue that is ignored, the matter of damage not being considered relevant to the functioning of the image as an icon. See for example the discussion by A. Tourta of an icon of the Virgin Dexiokratousa in Thessaloniki which has suffered heavy scoring around the face and hands in *Mother of God. Representations of the Virgin in Byzantine Art*, ed. M. Vassilaki (Athens, 2000), 474-5.

14. K. Weitzmann, *The Monastery of Saint Catherine at Mount Sinai: The Icons* 1: *From the Sixth to the Tenth Century* (Princeton, 1976), icon B.21 (pl. 69).

15. For images of the Acheropita and its cover in their present condition see H.L. Kessler and J. Zacharias, *Rome 1300. On the path of the pilgrim* (New Haven, London, 2000), 62-3.

16. G. Dagron, 'Holy Images and Likeness', *DOP* 45 (1991), 23-33, esp. 30-31.

17. *Chudotvornaia ikona v Vizantii i drevnei Rusi*, ed. A.M. Lidov (Moscow, 1996). On the Mandylion see *The Holy Face and the Paradox of Representation*, eds H.L. Kessler and G. Wolf, Villa Spelman Colloquia 6 (Bologna, 1998).

18. *The Life of St Nikon*, ed. and trans. D.F. Sullivan (Brookline, MA, 1987), 212-18; Kazhdan and Maguire, 'Byzantine Hagiographical Texts', 14-15.

19. I.M. Resnick, 'Idols and Images: early definitions and controversies', *Sobornost* 7/2 (1985), 25-51, esp. 35-41.

20. Ignatios the Deacon, *The Life of the Patriarch Tarasios (BHG 1698)*, ed. and trans. S. Efthymiadis, Birmingham Byzantine and Ottoman Monographs 4 (Aldershot, 1998), §32.16-21. Compare Nikephoros, *Antirrhetics*, 1.29, PG 100, 277B; trans. Mondazin-Baudinet, *Discours*, 109-110; Origen, *Homilies on Exodus*, PG 12, 353D-354A.

21. Ignatios, *The Life of the Patriarch Tarasios*, §55.1-4. The *Vita* of Theodore of Stoudios says that an idol has a similarity – ἐμφέρεια – with a demon: the abomination of its prototype.

22. *Decrees of the Ecumenical Councils* vol 1, *Nicaea I to Lateran V*, ed. N.P. Tanner (London and Washington, DC, 1990), 134.

23. *Constantinople in the Early Eighth Century: The* Parastaseis Syntomoi Chronikai, eds A. Cameron and J. Herrin (Leiden, 1984), §14, 28. For a useful discussion of this text, with an alternative comparison of icons and idols, see L. James, '"Pray Not to Fall into Temptation and Be on Your Guard": Pagan Statues in Christian Constantinople', *Gesta* 35/1 (1996), 12-20.

24. *Parastaseis*, §28, and note on 202, with different conclusion.

25. Niketas Choniates, *Historia*, ed. J.L. van Dieten, (Berlin, 1975), 151, 558; trans. H. Magoulias, *O City of Byzantium, the Annals of Niketas Choniates* (Detroit, 1984); Robert de Clari, *The Conquest of Constantinople*, trans. E.H. McNeal (Columbia, 1936), 110.

26. Athanasios, *Oratorio contra Arianos* iii.5; PG 26, 332.

27. G. Dagron, *Empereur et prêtre: étude sur la 'césaropapisme' byzantin* (Paris, 1996).

28. The classic study remains E. Kantorowicz, *The King's Two Bodies: a study in medieval political theology* (Princeton, 1957). For a discussion of public versus private body in the case of early Byzantine empresses, see L. James, *Empresses and Power in Early Byzantium* (London, 2001).

29. H. Omont, *Évangiles avec peintures byzantines du XIe siècle (Reproduction des 361 miniatures du manuscrit Grèc 73 de la Bibliothèque Nationale* (Paris, 1908), pl. 41, 81.

30. *The Glory of Byzantium. Art and Culture of the Middle Byzantine Era, A.D. 843-1261*, eds H.C. Evans and W.D. Wixom (New York, 1997), 437.

31. E. Privalova, *Rospis' Timotesubani* [The paintings of Timotesubani] (Tbilisi, 1980), pl. 37.

32. Baltimore, Walters Art Gallery, MS 539, fol. 109v: S. Der Nersessian, *L'Art Arménien* (Paris, 1977), 126.

33. Michael Psellos, *Chronographia*, ed. and trans. E. Renaud (Paris, 1926), 1.36; A. Cutler, 'The Psalter of Basil II', *Arte Veneta* 30 (1976), 9-19 and 31 (1977), 9-15.

34. R. Cormack, 'Interpreting the Mosaics of S. Sophia at Istanbul', *ArtH* 4 (1981), 143-4.

35. Athanasios, *Oratorio contra Arianos* iii.5; *PG* 26, 332; Mansi 13, 69B-D.

36. Liutprand of Cremona, *Antapodosis*, ed. P. Chiesa, *Liutprandi Cremonensis Opera Omnia*, Corpus Christianorum Continuatio Mediaevalis 161 (Turnhout, 1998), 11, trans. F.A. Wright, *The Works of Liutprand of Cremona* (London, 1930), 39.

37. On the vagaries of views about the legitimacy of usurpation and the subsequent legitimation of emperors, see Dagron, *Empereur et prêtre*, section I.

38. Robert de Clari, *The Conquest of Constantinople*, 56.

39. Choniates, *Historia*, 352. Similarly, Psellos records Zoe calling Michael IV her idol, and comparing him to a golden statue: Psellos, *Chronographia*, 3.20.

40. This fluctuation has also been exploited by modern scholars, notably N. Oikonomides, 'Leo VI and the narthex mosaic of Saint Sophia', *DOP* 30 (1976), 151-72, whose argument depends on conflating the personal history of Leo VI and the political (but unnamed and hence presumably universal) imperial image.

41. The fear of punishment is recorded by, among others, Theodoret, *Historia Ecclesiastica*, ed. L. Parmentier (Berlin, 1954), V.19; trans. B. Jackson in *The Writings of the Nicene and Post-Nicene Fathers*, 2nd series III (Oxford, 1892), 146.

42. For a useful survey of *damnatio memoriae* see P. Stewart, 'The destruction of statues in late antiquity', in *Constructing identities in late antiquity*, ed. R. Miles (London, New York, 1999), 159-89.

43. John Geometres, poem 56 (vς'), *PG* 106: 932, although this is written in defence of Nikephoros; C.A. Bourdara, 'Quelques cas de *damnatio memoriae* à l'époque de la dynastie macédonienne', *JÖB* 32/2 (1982), 337-42.

44. For the latest argument in favour of these alterations being seen as an example of *damnatio memoriae*, see B. Hill, L. James, D.C. Smythe, 'Zoe: the rhythm method of imperial renewal', in *New Constantines. The Rhythm of Imperial Renewal in Byzantium*, ed. P. Magdalino, SPBS 2 (Aldershot, 1994), 223-25, esp. 223-25.

45. I. Spatharakis, *The Portrait in Byzantine Illuminated Manuscripts* (Leiden, 1976), 107-118, pl. 69-76.

46. Theodoret, *Historia Ecclesiastica*, V.19; trans. Jackson, 146.

47. Choniates, *Historia*, 332-3.

48. On this see L. Brubaker, *Vision and Meaning. Image as Exegesis in the Homilies of Gregory of Nazianzos* (Cambridge, 1999), 5, 158-63.

49. The description of the Kainourgion images appears in chap. 89 of the *Vita Basilii*, in *Theophanes Continuatus*, ed. I. Bekker (Bonn, 1838), 333; trans. Mango, *Art*, 196-99. For this interpretation see I. Kalavrezou-Maxeiner, 'The Portraits of Basil I in Paris gr.510', *JÖB* 27 (1978), 19-24.

50. The Komnenos panel reinforced the hereditary principle, but ultimately in favour of John II's younger son Manuel, as Alexios predeceased his father: T. Whittemore, *The Mosaics of Haghia Sophia at Istanbul. Third Preliminary Report. Work Done in 1935-8. The Imperial Portraits of the South Gallery* (Boston, Oxford, 1942), 21-28.

51. P. Zanker, *The Power of Images in the Age of Augustus* (Michigan, 1988); S.R.F. Price, 'From noble funerals to divine cult: the consecration of Roman emperors', in *Rituals of Royalty. Power and ceremonial in traditional societies*, eds D. Cannadine and S.R.F. Price (Cambridge, 1987), 56-105.

Chapter 7

# The Icon is Dead, Long Live the Icon: The holy image in the Renaissance

Robert Maniura

A concept closely related to the modern art historical notion of the icon – a panel painting of a sacred subject from the Orthodox East – was widespread by the late Middle Ages in the Latin West. It is embedded in the legendary tradition of St Luke the Evangelist as a painter. In medieval tradition, Luke was a close associate of the Virgin Mary and the Apostles and thus 'active' in the Holy Land in the first century. Any work of this 'first Christian artist' is, implicitly, said to be what an art historian would call an icon.

The legend of St Luke's authorship became associated with a large number of highly venerated images in the West.[1] Some of these images, such as the panel of the Virgin now in the cathedral museum in Freising, do seem to be eastern in origin and hence 'icons' in the art historical sense.[2] The majority, however, seem to be of western manufacture. As Belting remarks, 'the imported icon was more important as an *idea* than as a *fact*.[3] This tension between actual and legendary origin can easily make the St Luke legend seem a fanciful irrelevance but the appeal to the East involves another issue which is often overlooked: the very status of the 'cult' images linked to the legend of St Luke relates them very closely to the icons of the Orthodox world. It is upon this issue of status that I will concentrate in this paper.

This is something which the traditional concerns of the history of the art of the Latin West tend to disguise. In the literature on Byzantine art the role of images as focal holy objects – as the *palladia* of communities and institutions, as processional objects and as the conceptual and visual foci of churches – is a well-established proposal. In the literature on the art of the Latin West from the thirteenth century onwards, when surviving panel paintings become common, however, these roles are scarcely accommodated.

From *Icon and Word: the Power of Images in Byzantium. Studies presented to Robin Cormack*, eds Antony Eastmond and Liz James. © 2003 by contributors. Published by Ashgate Publishing Ltd, Gower House, Croft Road, Aldershot, Hampshire, GU11 3HR, England, pp. 87-103.

Panels are classified as 'altarpieces', 'private devotional panels' or, less frequently, 'votive panels'. A narrowly conceived and often liturgical or quasi-liturgical 'function' provides the analytical framework. Yet the role of the image as focal holy object is also of crucial importance in the West. Perhaps the clearest examples of such images are those which were associated with miracles and to which pilgrimages were made. It is precisely such images which were often articulated by the St Luke legend. Art history has given these images scant attention. In as far as the holy image is admitted as an issue in the West it is as a 'medieval' issue. Belting, for example, has recently proposed that in the Renaissance the holy image was effectively displaced by the rising notion of 'art'.[4] In appealing to the 'icon', I wish to draw attention to the focal holy image in the West. I will suggest that the holy image was not only much more tenacious than Belting suggests but also that changes in the articulation of the West's holy images can tell us important things about the visual culture of the 'Renaissance'.

I will begin by considering a canonical western image which visualizes the St Luke legend: the panel of *St Luke drawing the Virgin*, now in Boston, attributed to Rogier van der Weyden and usually dated in the 1430s (Fig. 7.1).[5] On the left side of the panel, the Virgin Mary, seated on the step of a throne, nurses the Christ Child. On the right, facing her, kneels St Luke identified by his attribute of the bull nestling beneath the writing desk in the chamber to the far right. The book on the desk is presumably his Gospel. Close examination reveals that St Luke is making a drawing of the Virgin's face with a metalpoint stylus. This celebrated panel crystallizes a number of key issues and, as I will argue later in the paper, evidences a subtle change in attitudes to the holy image.

In the existing literature on this object, the holy image is not an issue. The sole focus for interpretations of the picture has been the well-known fact that from at least the fourteenth century onwards St Luke was adopted all over Christendom as the patron saint of trade guilds and religious confraternities of painters. Painters, it is argued, would have had a clear interest in making and using an image of their patron engaged in the very act that rationalized his patronage. On this argument the picture was thus likely to have been made as an altarpiece for a chapel or hall used by a painters' guild, perhaps that of Brussels where Rogier was official town painter by 1436.[6] Conventionally this is thus primarily a painting about painting. As Erwin Panofsky put it, 'in representing St Luke portraying the Virgin, the art of painting renders an account of its own aims and methods'.[7]

We must be clear, however, that we have no independent evidence of the picture's patron or its intended location. It is a wholly undocumented work whose provenance can be traced back no further than the early nineteenth century when it was in Spain.[8] Moreover, if a date in the 1430s is correct, then

this is the earliest surviving monumental version of this iconography, that is, with the Virgin facing St Luke, so we cannot claim a precedent for the use of such a compositional scheme by painters' guilds. There are textual records of lost paintings of 'St Luke painting the Virgin' made for St Luke guilds,[9] but this description can also be used for an image of St Luke alone with his panel. We do have sixteenth-century pictures with the same basic compositional structure as the Boston panel which have unambiguous provenances from the chapels of painters' guilds and it is certainly possible that Rogier's panel fulfilled the same function.[10] But we should acknowledge the reverse chronology in the argument. There is also a complicating factor.

Rogier's picture was a hugely successful and much imitated work. Even today it survives in no less than four almost identical versions, the other three hanging in the Alte Pinakothek in Munich, the Hermitage in St Petersburg and the Groeningemuseum in Bruges. Scientific examination has confirmed the Boston panel as the original of the series.[11] The three 'copies' appear to date from the late fifteenth and early sixteenth centuries.[12] As luck would have it none of the other versions have fully traceable provenances either.[13] But the other versions raise a question which has so far been avoided. Even if Rogier's picture was for a painters' guild, were all of the copies also guild pictures? Must we not rather acknowledge a wider appeal and hence wider audience and market for the original?

The 'guild hypothesis' overlooks the very feature with which we began. The legend of St Luke as a painter, far from being a minority interest, was deeply embedded in a mass devotional practice with a heavy emotional investment: pilgrimage. The phenomenon of pilgrimage to images has yet to be studied systematically and extensively but my research has convinced me that image shrines, particularly those of the Virgin Mary, constituted a central focus of Christian devotional practice throughout Europe over a long period. The St Luke legend was one of the most common ways of articulating such 'special' images of the Virgin: large numbers of people made vows to go to see pictures of the Virgin said to have been painted by St Luke and hoped for all kinds of spiritual and physical benefits in return.[14] By concentrating on the narrower 'professional' relevance of the St Luke story, art historians have effectively discounted this mass-market basis of the legend and with it the issue at the centre of this study: the focal holy image. We must consider the force of the legend of St Luke as painter.

Pilgrimage provides the basic reference point. In the cults of many saints the body was the principal focus of pilgrimage but in the case of the Virgin, the body was held to be inaccessible because of widespread belief in her Assumption – her physical raising to heaven at the end of her earthly life. But there were images, and images have always played an important role in her cult. The St Luke legend is a way of articulating how the images step into this void.

It has been argued that the legend of St Luke as a painter was developed in the heat of the Iconoclastic controversy in Byzantium forming one of a battery of arguments to support the making and use of religious images in the face of an imperial policy of prohibition.[15] Certainly the earliest surviving and securely dateable textual versions of the legend date from this period. In this context, the legend asserts the validity of images: they are acceptable because St Luke, associate of the Virgin and the Apostles, made an image or images of her. Images of the Virgin have an apostolic pedigree. Scholars of the art of the later Middle Ages have been reluctant to admit the relevance of this polemical role for St Luke in this period. The making of religious art was not widely contested at this time so why do we need to refer to a centuries-old controversy? To be specific, surely Rogier did not need to worry about the validity of making religious images?[16]

But there is a further twist to the legend. In making the 'first Christian painter' one of the Evangelists, the images he is said to have produced are implicitly placed on a level with the Gospels themselves. St Luke's paintings have Gospel parity: they are, quite simply, true. To the assertion of validity, the legend adds the reassurance of authority and reliability. This is of interest to more than just painters; it is also of profound interest to viewers. It is the issue of paramount interest to pilgrims at a Marian image shrine: St Luke's icon gives the pilgrim a 'true' view of the Virgin Mary. The St Luke legend, and with it Rogier's picture, is about looking at, as well as making, images. It is about trustworthiness as well as validity. A St Luke icon effectively comes with a guarantee and Rogier's picture articulates that guarantee. The composition pans out, as it were, from one of St Luke's works to reveal the profoundly reassuring process of its creation. We can begin to see the breadth of the appeal of such a composition.

We do not need to assume familiarity with Byzantine image theology to validate this reading but reconsideration of the Byzantine textual tradition is helpful in clarifying a detail. In the early texts the authority of Luke's images is established in a very specific way. St Luke is said to have painted the Virgin Mary's portrait from life: the 'truth' of the image lies in a verisimilitude derived from direct observation.[17] It is important to realize that this remained the basis of the legend throughout the Middle Ages in East and West. We will come to a late fourteenth-century western acknowledgement of this in a moment. Commentators on Rogier's picture, though, have been resistant to the idea that it represents a portrait 'sitting' and have tended to rationalize it in a much more roundabout way. For some authors, the Virgin is St Luke's 'vision', visualized for the viewer on the surface of the panel.[18] Perhaps most elaborate of all is Panofsky, who admits the Virgin's 'apparent reality' but sees Rogier's compositional solution as an outcome of the development of painterly technique with the 'vision' as an intermediate stage:

> In High Medieval art, when portraiture from life was the exception
> rather than the rule, St Luke produced the image of Our Lady by sheer
> inspiration; but with the rise of naturalism he needed a model. This
> model was often furnished him by a vision ....[19]

Contrasting Rogier's approach with a reconstruction of a presumed 'lost
original' by the more down-to-earth Master of Flémalle, he remarks of the
Virgin that 'instead of visiting St Luke in his studio she receives him in an
ideal throne room'.[20] The Virgin is, in other words, 'really there' in the logic of
the picture but she has either herself materialized or somehow transported St
Luke especially for the purpose.

Such a convoluted process is a world away from the direct eye-witness
logic of the most widely diffused versions of the St Luke story. I know of no
text linked to a picture attributed to St Luke which claims that St Luke painted
the Virgin from a vision or some miraculously arranged sitting. It is indeed
important that in the context of Marian devotion the St Luke story renders
any kind of ecstatic visionary experience or even 'imaginative visualization'
redundant.[21] Because St Luke painted the Virgin she is visible anyway. The
'vision' explanation is also, arguably, a very forced reading of Rogier's picture.
Given an awareness of the core form of the legend, is not the most
straightforward reading of the picture that it shows the making of a portrait
from life? One of the most idiosyncratic features of the painting can be taken
to support this reading. Rather than producing a finished painting of the
Virgin, St Luke is shown recording the features of her face in a metalpoint
drawing. As far as we know, this is how artists in this region in this period,
who used a time-consuming oil glaze technique, captured a likeness in
portraiture.[22] Much has been made of this detail in terms of artistic self-
awareness and professional identity.[23] But the detail most immediately stresses
the 'actuality' of the sitting: a 'realistic' device to stress the verisimilitude of the
depicted portrait.

Rogier's picture is profoundly engaged with the underlying currents of the
St Luke legend found in the articulation of pictures said to have been painted
by the Evangelist. The panel could well have been painted for a painters' guild
but its force derives from this profound and pervasive ideology of pictorial
authority. St Luke was more than just an apt saintly patron for painters
because of his legendary painterly 'spare-time' activity. He was a purveyor of
pictorial truth. I have been stressing the significance of this for viewers but it
should be clear that it also amounts to a very powerful statement of
professional pride for painters. We should read the treatment of this theme
not as a defensive retreat to an old polemic but as a celebration of the very
underpinning of a notably image-rich culture. When we later come to consider
the more subtle inflections of the image we will need to keep this broad frame

of reference firmly in mind.

There is, of course, a notorious problem with the idea of St Luke as a maker of life portraits of the Virgin *and Child*. It incorporates a startling anachronism. Christ only began his ministry and had disciples as an adult. Even if St Luke was an associate of the Apostles he could not have been around to make a portrait involving Christ as a child. The naturalistic devices exploited in Rogier's picture perhaps make the anachronism too evident and too uncomfortable for the modern viewer. This may be the unstated motivation for the evasion of the life portrait motif in much of the literature on the picture. How could an artist as sophisticated as Rogier peddle such credulous nonsense? Is he not knowingly manipulating the tradition, toying with ideas of vision, seeing and inspiration in making a statement about contemporary artistry? I will return to the idea of Rogier's manipulation of the legend later on and I will argue that it is indeed being modified in a very important way, but I do not think that he is evading the idea of the life portrait like his modern commentators. Rogier is merely pursuing the logic of the images attributed to St Luke, most of which show the Virgin with the Christ Child. Indeed the retention of this formula argues strongly for a direct reference to the cult images in Rogier's composition and related pictures.

It appears that in the late Middle Ages the anachronism implicit in St Luke's authorship of images of the Virgin and Child did not cause any great concern. Even critics of the cult of images did not attempt to challenge the St Luke story directly. For example the Prague reformer Matthew of Janov, the forerunner of the theologians whose work gave rise to what has been labelled Hussitism, writing in about 1390 admitted that the image of the Virgin Mary 'drawn directly from the living model' by St Luke was worthy of honour: confirmation, as I promised above, of the tenacity of the life portrait motif in the West.[24] But that is not to say that the story of St Luke's authorship of individual images always went unchallenged. There is at least one example of a dispute over the origin of a highly venerated 'St Luke' picture. It occurs in late fourteenth-century Florence.

The image in question is the panel painting housed in the *pieve* or baptismal church at Impruneta to the south of the city. The Impruneta painting, championed as a key element for an understanding of Florentine Renaissance culture by Richard Trexler, was Florence's rain image.[25] When threatened by drought or flood from at least the fourteenth century onwards the Florentines would process to Impruneta and bring the revered panel painting back to the city. Its powers were held to be truly prodigious and it was asserted that she had never been called on in vain.[26]

As so often, it is not clear exactly when the cult of the image arose. The earliest surviving written account of the picture's origin survives in a prologue to the statutes of the *Compagnia della Madonna dell'Impruneta*, the confraternity

which grew up around the image, written by a certain Ser Stefano, the *pievano* or parish priest of Impruneta, in about 1375.[27] The image is said to have been discovered when excavations began for the building of the church. Bullocks being used for moving the building stone for the new church wandered off and halted at a place where ruins of a previous church were discovered. As those assembled to help in the building began to investigate these ruins, a languishing voice was heard and, proceeding more cautiously, those digging discovered the image painted by St Luke. At once miracles began to occur and the site became a pilgrimage destination. The legend was later elaborated to account for the image's presence in the ruined church. These later additions have the panel brought by St Romulus, sent to Fiesole by St Peter, and later hidden by the new Christian community fearing persecution.[28] That the image was promoted as a St Luke icon by the late fourteenth century is confirmed by a letter of 3 March 1385 from the *Signoria* in Florence to Pope Urban VI recommending the candidature of a certain Francesco Zabarella for *pievano*. The letter refers to the church of the Virgin 'in pruneta' where 'resides the miraculous panel with the effigy of that same Mother of God painted by St Luke as is attested by tradition'.[29]

As its quotation in official correspondence and its history of later elaborations make clear, this story became the authorized account of the origin of the picture. However, the contest over the story of the picture's origin seems to appear at the very moment of its articulation. Another manuscript of the late fourteenth century preserved in the Biblioteca Riccardiana in Florence contains three closely related versions of a very different story.[30] According to these texts, the image and its cult arose in the period of the Crusades. After the capture of Jerusalem, a group of crusaders from the area of Impruneta belonging to the Brandi, Casini, da Doglia, da Montecchio, da Fabbiole and Salini families met in the church of S. Stefano a Pozzolatico for a mass of thanksgiving. The leader of the group, one Stefano Mazzuolo, told of a vision he had received in the church of the Virgin at Bethlehem, according to which he and his fellows should retire to an eremitical life on their return home. All received the proposal with joy and they sought approval of their decision from the bishop of Florence. He gave permission for the erection of a hermitage and chapel but he also instructed Stefano Mazzuolo to have a picture of the Virgin painted. The picture was to be commissioned from a Florentine painter of notably holy life called 'Luca Santo'. Picture and hermits were duly installed on the site of what was later to become the *pieve*. In 1140, however, plague ravaged the community and the hermitage fell into ruins and was forgotten. Later the site and the picture were rediscovered by another member of the Mazzuoli family, kin to the original founder Stefano, called to the place by a mysterious voice. The same family played a large part in the building of the new *pieve*.

As Carlo Nardi comments, the Riccardiana version of the story clearly sets

itself up in antithesis to the *pievano*'s version.[31] They are alternative ways of articulating a growing cult.[32] Nardi examines the ideological implications of the 'alternative' story concluding that it attempts to reaffirm the prominence of a number of local families in the face of ascendancy of the Buondelmonti under whose patronage, or perhaps one of whose number, was the *pievano* who wrote the text attributing the picture to St Luke.[33]

Whatever the roots of the contest, however, we must bear in mind the rhetorical field in which it is played out. The Riccardiana texts, which have long been known to Florentine scholars but which have been neglected in the recent Impruneta literature, were seized upon eagerly by eighteenth-century antiquarians keen to debunk any lingering suspicions of the historicity of St Luke as a painter. The legend of the Evangelist painter was sustained in the West, claimed such writers as Frova, Manni and Lami, through a confusion with the name of the 'historical' Florentine painter Luca Santo.[34] Even Nardi is led to ask whether the *pievano* Stefano may have been exploiting a local tradition of an artist of this name when penning his version of the legend in the 1370s, a circumstance he sees as more likely than the only apparent alternative: that the *pievano* simply 'made it up'.[35]

It is important, though, that even if the idea of St Luke's authorship was a novelty with respect to the Impruneta picture in the 1370s, by the late fourteenth century no-one had to 'make up' the story of St Luke's authorship. It was, as already noted, by far the most common way of articulating the 'specialness' of a highly venerated image of the Virgin Mary – an off-the-peg solution. It is the competing 'Riccardiana' story that is the more imaginative. But the very neatness of the inversion in its denial of evangelical authorship – not St Luke but 'Luke Saint' – should make us wary of seeking any 'historical' ground for the story. We no more have to believe in the Tuscan painter Luca Santo than we have to believe in St Luke the Evangelist as a painter.

What is crucial in this episode is that the rival story of origin is not intended to devalue the worth of the picture or the holiness of the shrine. The Impruneta picture is not derided as a fake or an impostor. Nor can we read the rival origin story as a sceptical response to a discredited legend. It is a very adept, and perhaps characteristically Florentine, piece of rhetorical one-upmanship apparently motivated by family rivalry. What is interesting is that this could be seen as a reasonable strategy. There is a suggestion here that the St Luke legend is dispensable. St Luke's authorship is no longer needed as the guarantee of the authority of a holy picture.

The example of Impruneta is unusually explicit in its open contestation of the St Luke legend but, when we come to consider the articulation of other new cults of miraculous Marian images in the fourteenth and fifteenth centuries in Italy, we can begin to see a distinct trend. The recent work of Paul Davies on the centrally planned church in Italy in the fifteenth century has

drawn attention to the remarkable flourishing of new pilgrimage cults of the Virgin Mary centred on miracle-working images in the period.[36] Architectural historians have long been aware of this development, for some of the most celebrated monuments of Italian Renaissance church architecture were built to house such newly-miraculous Marian images. Important examples include Giuliano da Sangallo's church of Santa Maria delle Carceri in Prato, the church of the Madonna della Consolazione at Todi and Antonio da Sangallo the Elder's church of the Madonna di San Biagio outside Montepulciano. These famous examples of the Renaissance centrally-planned church enshrine paintings of the Virgin and Child which began to be associated with miracles in 1484, 1508 and 1518 respectively. This 'canonical' trio was picked out by Wolfgang Lotz in 1964 in a study which highlighted the churches' roles as containers of miraculous images.[37] Historians of pictorial art, though, have been slow to pick up on the implications of these cults. Here I want to concentrate on one feature of them which has largely escaped notice. As far as I am aware, few of these new holy images were claimed to have a miraculous, saintly or otherwise special origin.

It must immediately be noted that a significant number of the new cults grew up around wall paintings. The shrine images at Prato, Montelpulciano and Todi are all, for example, wall paintings. It might be objected that, having raised the issue of the holy image with respect to the legend of St Luke as a painter, we could not reasonably expect claims of Lucan authorship for Italian wall paintings without claiming an Italian phase of the Evangelist's career: something which might offend even late medieval notions of decorum. Perhaps surprisingly, such claims seem to have been made. A 1464 memorandum of an unnamed *vicarius* of S. Maria Maggiore in Rome lists the image of the Virgin in the major Florentine shrine of the Santissima Annunziata – a wall painting of the Annunciation – among the works of St Luke.[38] Nor can this have been purely the error of a misinformed Roman since the sixteenth-century Florentine historian Benedetto Varchi took the trouble to pour scorn on the idea of St Luke's authorship of the image.[39] The idea of St Luke as the guarantor of images was clearly very deeply ingrained.

More significant, though, is that there was a traditional way of articulating the authority of miraculous wall paintings. The model is revealed in the local legend of the Annunziata image in Florence. It is said to have been begun by one of the Servite friars but finished by an angel: the image is not, or not wholly, made by human hands.[40]

The earliest surviving text of the Annunziata legend dates from the 1460s but the visual diffusion of the image towards the end of the fourteenth century implies that its cult was well established by then and the legend was probably already in place at that stage.[41] Other miraculous images in the region claiming a fourteenth century or earlier origin also claim a related authority. The image of the Madonna delle Grazie in Pistoia, also called the Madonna del Letto or

'Madonna of the bed', is said to have appeared miraculously on the wall of what was then a hospital after the Virgin had appeared to one of the patients, a young woman whose hospital bed is also preserved as a relic of the incident.[42] The story of an image 'not made by human hands' was as much the standard way of articulating a highly venerated wall painting as the legend of St Luke was the way of articulating a highly venerated panel.

This stock of legendary motifs was, of course, available to those who wrote the stories of the wall paintings whose cults grew up in the fifteenth century and later, but in most cases the option was avoided. We cannot explain the variance in terms of regional taste because new shrines arising in towns already claiming an image 'not made by human hands' failed to avail themselves of this rationale. In Pistoia, for example, home to the Madonna del Letto, we have the case of the Madonna dell'Umiltà which was seen to exude holy oil in 1490 and was placed at the focus of a new church built from 1495 onwards.[43] The holy picture was an image in the former church of S. Maria Forisportam which was subsequently demolished to make way for the new shrine.[44] No further claims were made for the status of the picture. Similarly in Florence itself we have the story of the Madonna della Pura, venerated since the late fifteenth century in the church of S. Maria Novella. The legend has it that boys playing in the church's graveyard heard a voice calling 'clean me, clean me!' which emanated from one of the *avelli* or grave niches, which still surround the church. On following the voice, they found a wall painting of the Virgin covered by cobwebs which was subsequently enshrined in a new chapel.[45] The voice drew attention to the holy image but once again no claims were made about its origin.

I propose that in these shifts of legendary presentation we can see confirmation of the tendency which I suspected was present in the contest over origin at Impruneta: a growing feeling that an image did not need a 'special' origin to be considered holy. These wall paintings could admit to be being man-made just as the Impruneta picture no longer needed to pretend to be a St Luke icon.

Given that these examples are all Italian it might be tempting to conclude that these modifications were part of the new 'historical perspective' of the Renaissance. But the shifts in evidence here were not just confined to some precocious Italian sensibility. Traces of a new attitude to the authority of holy images can also be found in the North and they hint at something very important about the visual culture of Europe as a whole in this period. We must return to the apparently traditional formulation in Rogier's *St Luke*.

The anachronism of the life portrait of the Virgin and Child is not the only anachronism in Rogier's picture. As is often noted the picture also mixes the apostolic past with the fifteenth-century present.[46] We have already considered the Evangelist's up-to-date fifteenth-century use of metalpoint but his clothing, in contrast to the timeless robes of the Virgin, is also contemporary

with Rogier and has been said to be suitable for a physician, thus acknowledging St Luke's other legendary specialization, or a cleric.[47] A further feature also reinforces this temporal shift in a very subtle but powerful way. St Luke's features are clearly delineated and highly individualized. This has led to the suggestion that the figure of St Luke is intended as a self-portrait of Rogier.[48] The suggestion is intriguing but, as so often in this period, impossible to judge. However, the issue of portraiture *per se* remains.

Portraiture was one of the new staples of the artist's output in the early fifteenth century in the North. There are spectacular examples by Jan van Eyck, the so-called Master of Flémalle and, indeed, by Rogier himself. Many of these portraits appear in a devotional context either with a portrait figure as part of a sacred scene or on the wing of a diptych or polyptych with a sacred scene or figure on the main panel. A celebrated example of the former type of portrait can be seen in a picture that is always discussed alongside the Rogier and is often taken to be its compositional model: the so-called *Virgin of Chancellor Rolin* by Jan van Eyck in the Louvre.[49] I do not intend to go into the vexed issue of the precise relationship between these pictures. Rather I want to use the van Eyck as a control for the issue of contemporary portraiture in a sacred scene.

In the case of the van Eyck there is little doubt about the identity of the male figure. The man closely resembles the male figure on the outside of the wings of the great polyptych of the Last Judgement in the Hôtel-Dieu in Beaune, an institution founded by Nicholas Rolin, where he is identified by his coat of arms.[50] Van Eyck's picture has a provenance from the church in Autun adjoining Rolin's palace and in which he was buried.[51] Moreover an eighteenth-century description of the picture notes an inscription on the frame, now lost, and names Rolin.[52] In this case, even we as modern viewers are in a position to identify the portrait figure; but even if we did not have the comparison of the Beaune picture or any information as to provenance we would still probably identify the male figure as a contemporary portrait, not just because of his contemporary dress but also because of the unflinchingly 'veristic' rendering of his face. It seems likely that the response of a fifteenth-century viewer would have been the same. Whatever the relationship between van Eyck's *Rolin Madonna* and Rogier's *St Luke drawing the Virgin,* I think we must assume that, given the visual conventions exemplified in the van Eyck, contemporary viewers of Rogier's picture would also have thought that St Luke looked like a portrait.

For the purposes of my argument it does not matter that we cannot be sure who this is a portrait of or even that it is, strictly, a portrait at all. The important point is that it looks like one.[53] Whether or not it is Rogier himself, this portrait-like face of St Luke adds significantly to the 'presentness' of the depicted scene. There is an anachronistic tension in this picture, but the

tension is not primarily in the motif of the life portrait of the Virgin and Child. The tension lies in the fact that, for the fifteenth-century viewer, it looks as though they are being painted *now*.

This is no accidental or ill-considered by-product of Rogier's new 'realist' technique.[54] It is at the very heart of what this painting is trying to do. In the highly charged context of the wider legendary tradition of Luke as a painter, this image makes a quite extraordinary claim. The fifteenth-century artist takes St Luke's place. Rogier's picture apparently shows a fifteenth-century painter producing a life portrait of the Virgin Mary. Like Luke, he too can make authoritative images. Implicitly Rogier's picture claims that a contemporary painter can give the viewer a 'true' view of the Virgin. As we have seen, the St Luke legend from its days as a weapon in the Byzantine iconoclastic controversy always upheld an apostolic tradition of image-making. Rogier's picture claims nothing less than an apostolic succession of image makers.

We have seen that this composition as a whole was extensively reproduced. The figures of the Virgin and Child from the Boston picture were also reproduced in half-length images, presumably as part of devotional diptychs in conjunction with a portrait on the other wing.[55] Given a knowledge of the full image of St Luke drawing the Virgin these images have a very clear logic. They are, in a very straightforward sense, what St Luke painted. The Boston picture prompts us to see them as St Luke icons. But in the light of the analysis I have just advanced it is interesting to consider how far Rogier's fame may have caused them to be acknowledged as Rogier's work. Most of the panels have not been accepted as 'originals' by van der Weyden, though some, like the panel in the Musée des Beaux-Arts in Tournai are held to be close to his activity, perhaps produced by his workshop.[56] They all, however, represent part of his 'enterprise' in the terms proposed by Svetlana Alpers in respect of Rembrandt: whether or not he painted them, his very reputation ensured their production.[57] Even if the development of these half-length 'details' of his St Luke panel was wholly outside of Rogier's individual control it may be seen as another step in his usurpation of the Evangelist. These are 'St Luke icons' painted by Rogier van der Weyden.

Rogier's painting was not alone in the Netherlandish tradition in this manipulation of iconic authority. Koerner has pointed out the far-reaching implications of the reworkings of the traditional Holy Face imagery apparently initiated by Jan van Eyck.[58] There exist a number of closely related versions of a full-face image of Christ in an Eyckian style.[59] Connoisseurs are unwilling to attribute any of the surviving versions to van Eyck himself but there is a consensus that these pictures reproduce an Eyckian invention. The version in Berlin 'copies' a plausible van Eyck signature and also includes his famous motto – *als ikh kan*, 'as I can' – on the frame. The full face image refers directly to the great western image of Christ 'not made by human hands': the 'Veronica' of Rome. But van Eyck does not show us the disembodied face of the Veronica.

He gives us a head and shoulders view. As Koerner puts it: 'By depicting Christ in body, and by integrating that body as part of a world fully homologous to our own he claims to show us Christ himself as a living prototype'.[60] The Holy Face is assimilated to the contemporary portrait. The icon 'not made by human hands' is displaced by van Eyck's prominently signed work. Van Eyck gives the viewer a 'true' view of Christ.

Both Rogier's St Luke and van Eyck's Holy Face embrace the traditional legends of pictorial authority but also claim to supersede them. St Luke, I have suggested, rendered visions or even imaginative visualization redundant for a 'sight' of the Virgin. The same could be said of the Veronica for Christ. Rogier and Jan claim to make St Luke and the Veronica redundant. What the viewer wants and needs is not the hallowed 'original' images but the new authoritative 'portraits' – the new 'icons' – which deliver the very prototype with a new immediacy. The multiple surviving versions of these compositions imply that people did indeed want these pictures in large numbers.

On the very face of Rogier's painting of St Luke drawing the Virgin we see a shift paralleling that which I proposed was discernible in the changes in the articulation of cult images in the same period in Italy: a readiness to drop a reliance on the inherited legends of authority and to rely on the sheer visuality of the pictures themselves. The viewer no longer needs the icons imported from the East or 'not made by human hands': the images made in the viewer's own culture are a more than adequate focus for devotion. Rogier's picture, in its sheer audacity, reveals something of the mentality underlying the shift. It is evidence of a profound self-confidence in the visual arts in this period.

I have been keen to stress the Northern European example. The art of the 'Early Renaissance' in Italy has long been regarded as a new beginning, the dawn of a new age in culture. With respect to the art of the North, however, nothing has emerged to replace Johan Huizinga's forceful characterization of the fifteenth century as a period of magnificent decline with images implicated in a failure of the religious imagination.[61] A more coherent view of the visual arts of the period in both North and South, avoiding the interpretative extremes of an incipient modernity or a teleological slide into 'Reformation', can be built on Huizinga's insight into the 'predominantly visual' nature of the culture.[62] This was indeed an age saturated with images but with great faith in those images.

The 'Renaissance' I invoke in my title is characterized not so much by a rebirth of the antique as by a rejuvenation of established 'medieval' tradition. I want to go beyond Trexler's famous declaration that 'the pagan Renaissance is no more' to argue that the defining feature of the art of the period was its constructive transformation of the Christian pictorial tradition.[63] Not only did the focal holy image 'survive' into the Renaissance, the visual arts of the period were exploited to invest in it anew. In the Renaissance the western holy

image came of age. Belting's announcement of the death of the holy image in the Renaissance is premature. The icon is dead. Long live the icon!

## Notes

1. The most thorough recent study of the St Luke legend and its application is M. Bacci, *Il pennello dell'Evangelista. Storia delle immagini sacre attribuite a san Luca* (Pisa, 1998).

2. H. Belting, *Likeness and Presence. A history of the image before the era of art* (Chicago, 1994), 333.

3. Belting, *Likeness and Presence*, 332.

4. Belting, *Likeness and Presence*, 458-90.

5. For this image see most recently *The Museum of Fine Arts in Boston. Rogier van der Weyden. St Luke Drawing the Virgin. Selected Essays in Context*, ed. C.J. Purtle (Turnhout, 1997).

6. E. Dhanens, *Rogier van der Weyden. Revisie van de documenten* (Brussels, 1995), 54-7 and 98.

7. E. Panofsky, *Early Netherlandish Painting. Its Origins and Character* (Cambridge, MA, 1953), 253.

8. C. Eisler, *Les Primitifs Flamands. I. Corpus de la Peinture des Anciens Pays-Bas Méridionaux au Quinzième Siècle* 4: *New England Museums* (Brussels, 1961), 80.

9. Ibid. 85-6.

10. For example Jan Gossaert's panel for the guild chapel in St Rombout in Mechelen now in the Národní Galerie in Prague. See Eric Marshall White, 'Rogier van der Weyden, Hugo van der Goes, and the Making of the Netherlandish St Luke Tradition' in *St Luke Drawing the Virgin*, ed. Purtle, 39 and 46 n. 5.

11. The most recent statement of the technical evidence is R. MacBeth and R. Spronck, 'A Material History of Rogier's *Saint Luke Drawing the Virgin,* Conservation Treatment and Findings from Technical Examinations' in *St Luke Drawing the Virgin*, ed. Purtle, 103-34.

12. D. de Vos, *Rogier van der Weyden. The Complete Works* (Antwerp, 1999), 204.

13. See W. Loewinson-Lessing and N. Nicouline, *Les Primitifs flamands. Le museé de l'Ermitage Leningrad* (Brussels, 1965), 48-9, and D. De Vos, *Bruges Musees Communaux. Catalogue des Tableaux du 15e et du 16e siècle* (Bruges, 1982), 218.

14. The most celebrated paintings attributed to St Luke and associated with pilgrimage in the West were the ancient panels of Christ and the Virgin in Rome but they represented, of course, only one element in a rich array of holy objects and bodies. See G. Wolf, *Salus Populi Romani: Die Geschichte römischer Kultbilder im Mittelalter* (Weinheim, 1990). My own research in this area has concentrated on the Polish shrine of Our Lady of Częstochowa, another panel of the Virgin and Child attributed to St Luke, which had become the focus of pilgrimage by the middle of the fifteenth century. See my forthcoming book *Pilgrimage to Images in the Late Middle Ages: the Origins of the Cult of Our Lady of Częstochowa.*

15. R. Cormack, *Writing in Gold. Byzantine Society and its Icons* (London, 1985), 126.

16. A. Kann, 'Rogier's *St Luke*: Portrait of the Artist or Portrait of the Historian?', in *St Luke Drawing the Virgin*, ed. Purtle, 16-7

17. E. von Dobschütz, *Christusbilder. Untersuchungen zur christlichen Legende* (Leipzig, 1899), 278**.

18. Kann, 'Rogier's *St Luke*', 16.

19. Panofsky, *Early Netherlandish Painting*, 254.

20. Panofsky, *Early Netherlandish Painting*, 254.

21. For the importance of imaginative visualization for the interpretation of Early Netherlandish paintings see C. Harbison, 'Visions and meditations in early Flemish painting', *Simiolus* 15 (1985), 99.

22. L. Campbell, 'The Making of Early Netherlandish Portraits' in *The Image of the Individual: Portraits in the Renaissance*, eds N. Mann and L. Syson (London, 1998), 105-112.

23. J. H. Marrow, 'Artistic Identity in Early Netherlandish Painting: The Place of Rogier van der Weyden's *St Luke Drawing the Virgin*', in *St Luke Drawing the Virgin*, ed. Purtle, 53-9.

24. Quoted in Belting, *Likeness and Presence*, 540, App. no. 36.

25. R. Trexler, 'Florentine Religious Experience: the Sacred Image', *Studies in the Renaissance* 19 (1972), 7-41.

26. A claim made by the sixteenth-century historian Bernardo Segni. Quoted in Trexler, 'Florentine Religious Experience', 15 n. 26.

27. Archivio di Stato di Firenze, *Compagnie soppresse*, 78. Published as *Capitoli della compagnia della Madonna dell'Impruneta scritti nel buon secolo della lingua e citati dagli Accademici della Crusca*, a cura di C. G[uasti] (Florence, 1866).

28. Giovanni Battista Casotti, *Memorie istoriche della miraculosa Imagine di Maria Vergine dell'Impruneta* (Florence, 1714), 42.

29. '... quam residet miraculosa tabula in effigiem eiusdem Matris Domini per beatum Lucam ut testatur fama depicta'. Casotti, *Memorie istoriche*, 155.

30. Biblioteca Riccardiana, Florence, Cod. 1063. Published in C. Nardi, 'La "Leggenda riccardiana" di Santa Maria all'Impruneta: un anonimo oppositore del pievano Stefano alla fine del Trecento?', *Archivio Storico Italiano* 149 (1991), 503-51. I am grateful to Megan Holmes for drawing my attention to this text.

31. Nardi, 'Leggenda Riccardiana', 528.

32. Nardi, 'Leggenda Riccardiana', 537.

33. Nardi, 'Leggenda Riccardiana', 535.

34. Nardi, 'Leggenda Riccardiana', 527.

35. Nardi, 'Leggenda Riccardiana', 529.

36. P. Davies, 'Studies in the Quattrocento centrally planned church' (unpublished Ph.D. thesis, University of London, 1992).

37. Translated as W. Lotz, 'Notes on the Centralized Churches of the Renaissance', in *Studies in Italian Renaissance Architecture* (Cambridge, MA, 1977), 66-73.

38. Biblioteca apostolica Vaticana, Cod. Vat. lat. 3921, fol. 77r. Excerpts of this document are published in Wolf, *Salus Populi Romani*, 330-8. This reference is on p. 331.

39. Benedetto Varchi, *Storia Fiorentina*, ed. L. Arbib, I, (Florence, 1843), 239.

40. A fully elaborated version of the story can be found in *Scelta d'alcuni miracoli e Grazie della Santissima Nunziata di Firenze Descritti Dal P. F. Gio. Angiolo Lottini dell'Ord. de Servi* (Florence, 1619), 11-16.

41. P. Attavanti, *Dialogus de origine Ordinis Servorum ad Petrum Cosmae* published in *Monumenta Ordinis Servorum sanctae Mariae* 11 (1910), 88-113. I am once again indebted to Megan Holmes for this reference.

42. G. Beani, *S. Maria delle Grazie volgarmente del Letto. Notizie storiche* (Prato, 1892), 8-9.

43. A. Belluzzi, *Giuliano da Sangallo e la chiesa della Madonna dell'Umiltà a Pistoia* (Florence, 1993), 5-11.

44. N. Rauty, 'Tracce archivistiche per l'antica chiesa di Santa Maria Forisportam', *Centenario del miracolo della Madonna dell'Umiltà a Pistoia* (Pistoia, 1992), 21-40.

45. G. Richa, *Notizie istoriche delle chiese Fiorentine divise ne' suoi Quartiere* 3 (Florence, 1755), 56-8.

46. For example H. Belting and C. Kruse, *Die Erfindung des Gemäldes: Das erste Jahrhundert der niederländischen Malerei* (Munich, 1994), 32, and Marrow, 'Artistic Identity', 53-4.

47. D. Klein, *St Lukas als Maler der Maria. Ikonographie der Lukas-Madonna* (Berlin, 1933), 39, and Belting and Kruse, *Die Erfindung des Gemäldes*, 32.

48. Panofksy, *Early Netherlandish Painting*, 253-4; Marrow, 'Artistic Identity', 54.

49. M. Comblen-Sonkes and P. Lorentz, *Corpus de la Peinture des Anciens Pays-Bas Méridionaux et de la Principauté de Liège au Quinzième Siècle*, 17, *Musée du Louvre, Paris* II (Brussels, 1995), plates 2, IX and XX.

50. N. Veronée-Verhaegen, *Les Primitifs Flamands. I. Corpus de la Peinture des Anciens Pays-Bas Méridionaux au Quinzième Siècle* 13: *L'Hôtel-Dieu de Beaune* (Brussels, 1973), 46-8, 61, and plates II and CXLV-CXLVIII.

51. Comblen-Sonkes and Lorentz, *Louvre Corpus* I, 50-1.

52. Comblen-Sonkes and Lorentz, *Louvre Corpus* I, 21.

53. On the 'passion for identifying' and the tension between the individuality of the subject and the particularity of the portrait image see G. Didi-Huberman, 'The Portrait, the Individual and the Singular: Remarks on the Legacy of Aby Warburg', in *The Image of the Individual*, eds Mann and Syson, 165-88.

54. For other examples of Rogier's constructive anachronism see A. Acres, 'The Columba Altarpiece and the Time of the World', *Art Bulletin* 80 (1998), 422-51.

55. M. J. Friedländer, *Early Netherlandish Painting* 2 (Leiden, 1967), 23-7 and pls. 120-1.

56. De Vos, *Rogier van der Weyden*, 298-301.

57. S. Alpers, *Rembrandt's Enterprise* (London, 1988).

58. J. L. Koerner, *The Moment of Self-Portraiture in German Renaissance Art* (Chicago, 1993), 104.

59. Friedländer, *Early Netherlandish Painting*, 2, 68-9, plate 63.

60. Koerner, *The Moment of Self-Portraiture*, 104.

61. J. Huizinga, *The Autumn of the Middle Ages*, trans. R. J. Payton and U. Mammitzsch (Chicago, 1996).

62. Huizinga, *The Autumn of the Middle Ages*, 353.

63. Trexler, 'Florentine Religious Experience', 7.

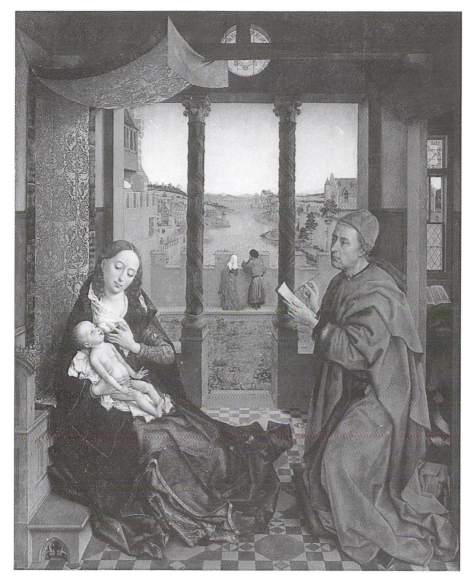

7.1 *Saint Luke drawing the Virgin*, attributed to Rogier van der Weyden, 1430s. Gift of Mr. and Mrs. Henry Lee Higginson, 93.153 (© 2003 Museum of Fine Arts, Boston).

Chapter 8

# Picturing New Jerusalem

## John Wilkinson

Often there are great heaps of carpets in Jerusalem shops. The top carpet in the heap does not say anything about the design of the next one down. And this is very like the Christian liturgy in the Churches on Golgotha. You have worked out the meaning of a particular section of it. But you have only worked on the carpet on top, and the chances are that you may find a second one lying below, with an entirely different meaning. This article will define the iconic value of Christ's tomb study in a service Egeria described in her *Travels*.[1] When this carpet has been lifted off, a different service lies below, also described by Egeria, with another iconic value.

Usually 'iconic value' is a quality of a holy picture. But almost the same value attaches to the Holy Places of Jerusalem. John of Damascus became familiar with these during his twenty-five years at Mar Saba, eleven kilometres away. He believed that these Holy Places deserved the same veneration (*proskynesis*) which was given to icons. He says, 'I venerate Mount Sinai, Nazareth, ... [another eighteen holy objects and places,] ... the Pool of Bethesda and the sacred garden of Gethsemane, and all similar spots. I cherish them ... not only on their own account, but because they show forth the divine power, and through them and in them it pleased God to bring about our salvation.'[2]

It is true that some fourth-century ecclesiastics refused to give the Holy Places this value. Gregory of Nyssa, for example, was shocked by his visit to Jerusalem and reacted by saying that good Christians can very well exist without going to the Holy Land.[3] But St Gregory seems to have been in a minority.

Egeria came as a pilgrim to Jerusalem in 381, when the Bishop, Cyril of Jerusalem, must have been about seventy years old. When he had been a boy, the 'major church' in Jerusalem, the cathedral, was on Mount Sion on the

From *Icon and Word: the Power of Images in Byzantium. Studies presented to Robin Cormack*, eds Antony Eastmond and Liz James. © 2003 by contributors. Published by Ashgate Publishing Ltd, Gower House, Croft Road, Aldershot, Hampshire, GU11 3HR, England, pp. 105-118.

south-western hill. But then Emperor Constantine built his churches, which included a new 'major church' at the Golgotha site. The new buildings changed the liturgy. Cyril was in fact exiled from the Holy City three times, but he had been bishop of Jerusalem for a total of thirty-two years before Egeria's visit, and the revision of the liturgy was probably largely due to his leadership. Cyril is most probably responsible for the two services in this article.

In the 380s the regular services of Jerusalem, as Egeria describes them, were often combined with pilgrimage to biblical Holy Places. But even before Cyril became bishop, prayers and pilgrimage had gone together. In 333, the Pilgrim of Bordeaux speaks of 'the rock where Judas Iscariot betrayed Christ', and 'the palm tree, from which children took branches and strewed them in Christ's path' at his triumphal entry into Jerusalem.[4] Some biblical sites had long been forgotten. The rock and tree were no doubt near the sites where Christ had been, but they were no longer sites which could be historically verified. More probably they were convenient points where the later church – maybe on a pilgrimage, or a procession – could stop for prayer.

Egeria describes in some detail the services in 'the Great Week'.[5] In the eight days before Easter the clergy and people of the church visited every one of the places connected with Christ's passion. For instance Christians began the week by remembering Christ's announcement of his death. So the pilgrimage was to Bethany, a village outside Jerusalem. They read there about the feast where the hostess, Mary, anointed Christ's feet, and he declared that the perfume was for the day of his burial.[6]

Egeria's home was on the coast of the Atlantic, and there she had prepared for her visit to the Holy Land by studying the Bible. But when the Bible was read to her at Bethany she comments that 'all the readings are suitable to the day *and the place*' (italics mine).[7] Often elsewhere she remarks on the readings and the psalms, and how appropriate they are.[8]

At the Holy Places praying and emotion went together. Paula, in her epitaph by Jerome, 'prostrated herself before the Cross, and worshipped as though she could see the Lord hanging there'.[9] Egeria too used emotions as well as intellect to study the Bible. She went up Mount Sinai, but the walk did not tire her 'Because by God's will I was seeing my hopes coming true.'[10] She 'prayed very earnestly' in Elijah's cave on Horeb,[11] and continually 'gave thanks to God'.[12] And in Egeria's day when a congregation was moved by bible-readings or sermons they still applauded or groaned.[13]

Some of those who had been touched by their visit to Jerusalem returned home determined to revise their own Church's services. They wished to introduce some of the features of the Jerusalem liturgy. For instance Armenia, Eastern Albania and Georgia took over the Jerusalem series of liturgical readings for the whole year.[14]

The liturgy of the Great Week had the widest influence. The Jerusalem service at cockcrow on Easter Day was an example, commemorating the visit of the Holy Women to Christ's Tomb. Egeria does not describe it. No doubt she was exhausted by the efforts of Holy Week. But she speaks of the first service on Sunday, and implies that this was like Easter.[15]

The service at cockcrow was timed to correspond with the exact moment of the Holy Women's arrival at Christ's Tomb, 'as it began to dawn toward the first day of the week'.[16] The Bishop enters the Tomb, and the people come in. Psalms and prayers are said.

Then deacons come to the Tomb carrying incense, and a reference to this stage in the liturgy is referred to by several pewter phials. These were made in Jerusalem in the seventh century for the Oil of the Holy Places. On these phials is a scene of the Holy Women approaching the Tomb, and the front figure is carrying a censer. The Women's spices, called in the Gospels *arômata kai mura,* were thus symbolized by the incense, *thumiama,* carried by the deacons.[17]

Now the deacons go into the Tomb[18] and cense it. Then the Bishop comes out and reads the Resurrection Gospel.[19]

Seven centuries later the Jerusalem Typicon gives another account of this service. The account is fuller, since it describes the service at Easter, and by then the service has no doubt developed.[20] The Jerusalem Patriarch goes into the Tomb and the 'Incense-bearers' stand outside. The Patriarch, representing the angel, comes out of the Tomb and says to them, 'Be of good cheer, Christ is risen!'. Hymns are sung and then the Gospel.

This version of the service must have existed for some time. Its actions are dramatic, but the drama is restrained. But when this service was imitated outside the Holy Land it was provided with words. Here is a tenth-century Italian example from Aquileia.[21] It was sung:

WOMEN: Who is going to roll away the stone for us from the entrance which, as we saw, closed the holy Tomb?

ANGEL: Whom do you seek [*quem quaeritis*], O fearful women, as you mourn at this tomb?

WOMEN: We seek Jesus of Nazareth who was crucified.

ANGEL: The one you seek is not here. But go quickly and tell his disciples and Peter that Jesus is risen.

WOMEN: We came weeping to the tomb. We have seen the angel of the Lord who said that Jesus is risen.

BISHOP: Look, my friends!

CHOIR: The Lord is risen!

This is a drama which would be incomplete without scenery, and no doubt a

temporary sepulchre was provided, like the *epitapheion*, the cloth remembering Christ's burial in Jerusalem in the Byzantine rite.[22] But by 1077, about a century later than the manuscript of the drama, a permanent imitation of Christ's Tomb was built in the basilica at Aquileia. It is not, in a modern sense, architecturally realistic. But, as Professor Richard Krautheimer once remarked, the context in which the similarities ought to be seen is the liturgy.[23]

Both the words and the model at Aquileia interpret the Tomb of Christ in Jerusalem. It is a literal reminder, an icon, of Christ's burial and resurrection on Easter morning, and this was the iconic value which was exported to many other countries in their own versions of the Aquileia drama. This simple, biblical icon of the burial and resurrection is the top carpet in the heap.

Remove this level, and another independent icon awaits discovery. Its value is in some senses valid for every church, but it has one meaning which is confined to Jerusalem. Its meaning becomes clearer if you try and envisage the buildings as Egeria saw them. Constantine, according to Eusebios of Caesarea, wanted 'a place of worship to be constructed at the most blessed site in Jerusalem ... of the Saviour's resurrection'.[24] This was a site somewhere near the site of the crucifixion, marked by the cracked rock of Golgotha.[25] The area had mostly been occupied by a Temple of Aphrodite, but as the workers cleared away this building, 'against all expectation' they discovered an artificial tomb-chamber cut in the living rock, which they identified as Christ's.[26] Another discovery is mentioned by Cyril of Jerusalem, the Wood of the Cross.[27] And the emperor was duly informed.

When the new plan had been made the two churches were laid out. The outside of the Tomb was cut to shape and ornamented, and a porch was added in front. On either side of the Tomb ran a straight sanctuary rail.[28] And again pictures of the Tomb appear on the phials for the Oil of the Holy Places. This is the Tomb as it appeared in the Church and its shape is indicated.[29] The phials are not all consistent, and different features appealed to the different artists, but even so one can gain a rough idea of what it was like (Fig. 8.1).

Two churches had been planned. The first was a rectangular church called the Martyrium, taking the place of Aphrodite's Temple, where the remains of the Wood of the Cross were discovered.[30] This church had its sanctuary at the west end. The site of the rock marking Golgotha was just outside the sanctuary, and was housed in the corner of an open colonnade. This ran around three sides of a court, and on the fourth side was the façade of the Anastasis, or church of the Resurrection.

The Anastasis was in fact the second church to be built on the site, but it was planned from the start. Its interior contained the sanctuary and the Tomb, and was circular in plan. The outer wall was once believed to have had a circular plan.[31] But in the last forty years archaeologists have worked at either

end of the original façade. They located eight doors, which agrees with the documents,[32] and discovered that, as far as they were allowed to go, the façade was simply a straight wall. The archaeologists did not work thoroughly in the centre. But the documents tell us that in the centre was an altar of St Zacharias.[33] Probably this was in a chapel matching the other three small apses, so the plan may thus be architecturally reconstructed as in Fig. 8.2. Only the dimensions of small apse and the Tomb are in doubt.

The second carpet down – the second iconic value of Christ's Tomb – is expressed in the daily evening service of the churches on Golgotha called '*Lucernare*' or 'Lamplighting'. The clergy prepared for it by lighting a candle from the perpetual light inside Christ's Tomb and then lighting the church's lamps and candles. During this time they sang the 'lamplighting' psalms.[34] In the Jewish afternoon Temple service a priest had prepared the *menorah* (or candelabrum) before the afternoon Whole Offering,[35] while other Jewish priests sang the same 'lamplighting' psalms.[36] The Christian service clearly has its origin in this service of the Jewish Temple. And it was held more or less at the same time. The Christian daily service was held at four o'clock, half an hour after the timing of the Whole Offering in the Jewish Temple.[37]

The origin of a Christian evening service in other parts of the world was ancient. In about 200, Tertullian had commented that the main morning and evening services were 'services in the Law, which without any further reminder should be held at the coming of daylight and night'.[38] So at least some of these Christian services were based on those of the Jewish Temple, and depended on the Jewish Law, that is, on the five books of Moses. Indeed Egeria once tells us of the Lamplighting service not in its normal place, but at the church on the Mount of Olives, the Eleona.[39] This shows that the service is regarded as obligatory, and that it does not depend on the place where Egeria usually speaks of it, the Anastasis and the Martyrium. But it is in this, the normal site, that a new iconic value emerges for Christ's Tomb.

Eusebios points out that the churches on Golgotha, or as he calls it 'New Jerusalem', faced:

> the famous Jerusalem of old, which after the bloody murder of the Lord had been overthrown in utter devastation, and paid the penalty of its wicked inhabitants. Opposite this then the Emperor erected … perhaps that fresh New Jerusalem proclaimed in prophetic oracles … [40]

The churches on Golgotha were located on a slope facing the site on which the Jewish Temple had formerly been. But it had long ago been destroyed, and Eusebios believed that the new churches, or 'New Jerusalem', replaced it. When Eusebios speaks of Christ's Tomb as 'the holy of holies',[41] or the sanctuary of the Jewish Temple, he is not simply commenting on its likeness

but thinking of it as a successor.

During the Christian Lamplighting service the Bishop of Jerusalem made three movements:

A.    The Bishop entered the Anastasis with his clergy (Fig. 8.3).[42] They went into the sanctuary and sat down (the Bishop at point B1). Hymns were sung.

B.    The Bishop came out through the chancel rail and went to stand at the top of the steps of the tomb (at B2) for a litany. He blessed the people.

C.    The Bishop now left the Anastasis and went across the courtyard to the place of the crucifixion, the Golgotha rock (B3). He prayed and blessed the people. Then he went into the Martyrium to the Wood of the Cross (B4), and again prayed and blessed the people

These are very simple movements. But none the less they are very like those of the Jewish High Priest in the Temple, described in the Mishnah tractate Tamid. The service started off with an hour's preparation. One junior priest looked after the candelabrum and others slaughtered the lamb for the Whole-Offering.[43] Then the High Priest arrived and the main service took place:

A.    The High Priest and the junior priests went into the Temple (Fig. 8.4) and prostrated themselves (at HP1).

B.    The High Priest, and the other priests, came out of the Temple to the top of the Temple steps (HP2) and blessed the people.[44]

C.    The High Priest went to the altar (HP3), and threw the meat of the lamb as a Whole-Offering onto the fire.[45]

The Bishop imitated the High Priest. But there are two slight divergences. The Bishop and clergy began by taking their seats in the sanctuary, where the High Priest entered the Temple, and the Bishop then had to come round to the steps of the Tomb. This may simply have been a practical step. The Tomb would not hold the Bishop and all the clergy, and they had to listen to psalms. So the status of the Tomb as the 'holy of holies' is not affected.

What caused the Bishop to imitate the High Priest? The Jews as a nation, at least for Eusebios, had been responsible for Jesus' death, and many Christians agreed with him. Eusebios was thus unlikely to believe that Christians should take as an example the Temple whose fall he had prophesied.[46] More probably the movements were the same because both Jews and Christians accepted the authority of one of the Books of the Law, in this case Exodus. In fact, in their liturgy the Jews tried to follow the Scriptures. They said prayers which were in the Law, like the Shema',[47] or the Priestly Blessing.[48] And during the services priests, of whatever rank, had an

officer over them whose duty was to remind them of the Law.[49]

The Christian and the Jewish service were alike because they were based on the Law of Moses. Part of the Law is the consecration of Aaron in the 'Tent of Meeting' or the Tabernacle in the Book of Leviticus. Moses started off by telling the people that this was 'what the Lord had ordered to be done'.[50] Since this is Aaron's first evening Whole-Offering, Aaron's sacrifice at the altar is followed by a miracle, but before it Aaron must have arranged the sacrifice on the altar. These are the words of Leviticus:

A.   'And Moses and Aaron entered the Tent of Meeting' (at A1 in Fig. 8.5).
B.   'When they came out (to A2), they blessed the people, and the glory of the Lord appeared to all the people'.
C.   [Aaron arranges the sacrifice on the altar.] 'Fire came out from before the LORD and consumed the whole-offering' (at A3).[51]

Sacrifices of this kind were to continue twice a day, 'at dawn and … between dusk and dark', 'a regular whole-offering generation after generation for all time. You are to make the offering at the entrance to the Tent of Meeting.'[52] This law did not only apply to the Tabernacle but also to the Jewish Temple in Jerusalem.

The Jewish Tabernacle and the Temple were God's or designed by God,[53] and Eusebios therefore believed that church buildings were imitations of the heavenly Temple,[54] despite the fact that they were not in a modern sense architectural copies. Additionally the Churches on Golgotha were perhaps seen to inherit some of the responsibilities of the Jerusalem Temple. In particular the Jerusalem Church remembered that human worship in the Holy City happened at the same time as the angelic praises of God in heaven.[55] On the one hand the Jerusalem versions of Morning Hymns and Lamplighting were held at roughly the same time as the morning and evening Whole Offerings in the Temple. On the other hand when the Lamplighting was late, according to Egeria it was not cancelled. The rule was that they insisted on having a late service, no doubt because of its association with the heavenly worship.[56]

Christians of course differed from Jews, particularly over belief in sacrifice. The Jews had sacrificed animals, but the *Epistle to the Hebrews* claims that Jesus is 'the high priest of the faith we profess'.[57] The *Epistle* makes this contrast:

> Day after day every priest stands performing his service and time after time offering the same sacrifices, which can never remove sins. Christ, having offered for all time a single sacrifice for sins, took his seat at God's right hand.[58]

Consequently the first two movements of the Christian Lamplighting service, namely going into the sanctuary, and coming out to bless the people, are the same as the Jewish service. But when it reaches the moment of the sacrifice, the Jews sacrificed lambs at the altar, but the Christians went to Golgotha and the Cross, to remember Christ's single sacrifice.

This article has shown that Christ's Tomb has at least two iconic values. First Christians valued it as the literal place of the resurrection. This is the value which the foreign designers aimed to reproduce when they built models of the Jerusalem tomb, either by itself of in conjunction with other holy places in Jerusalem. It is a biblical value which includes both burial and resurrection. The second value was as 'the holy of holies', the sanctuary of a Christian 'New Jerusalem'. The same, admittedly, could be said of the sanctuary of any church. For the time before the fourth century most of the evidence for Christian services is lacking, but we can guess from Tertullian's reference to 'services in the Law' that Africans in Carthage observed morning and evening prayer. St Basil regarded the hymn for Lamplighting, *Phôs hilaron*, as ancient,[59] and it is present in a wide number of churches, including the Armenian, the Byzantine and the Ethiopian.[60] Thus we can state that for a long time and over a wide area the model of the Christian evening service was some version of the Mosaic Law's Lamplighting and Whole Offering. But the Church in Jerusalem had special responsibilities. Its own special version was described by Egeria and we suppose was largely due to Cyril. It was like the God-given liturgy of the Tabernacle. But it also made clear the belief that Jesus had his own kind of sacrifice: of himself.

## Notes

1. *Itinerarium Egeriae*, eds A. Franceschini, R. Weber, Corpus Christianorum Series Latina 175 (Turnhout, 1958), 37-90.

2. John of Damascus, *De Imaginibus* III, 34; *PG* 94, 1353.

3. Gregory of Nyssa, *Letter* 2; *PG* 46, 1009B-1016A.

4. *Itinerarium Burdigalense*, 594f, in *Itineraria Romana* 1, ed. O. Cuntz (Stuttgart, 1929, reprint 1990).

5. *It. Eg.* 30.1. This phrase is also used by John Chrysostom, *Expositio in Ps. 145.2*, §1; *PG* 55, 472-74.

6. *It. Eg.* 29.3. Reading John 11.55-12.11.

7. *It. Eg.* 29.5.

8. For instance *It. Eg.* 31.2, 32.1, 35.3, 4, 36.1, etc.

9. Jerome, *Letter* 108. 9; *Hieronymus* 4: *Epistolae*, ed. I. Hilberg, Corpus Scriptorum Ecclesiasticorum Latinorum 55 (Vienna, 1996), 193-4.

10. *It. Eg.* 3.2.

11. *It. Eg.* 4.2.

12. *It. Eg.* 16.7.

13. Applause: *It. Eg.* 47.2 etc.; groaning: *It. Eg.* 24.10 etc.

14. For the Armenian see C. Renoux in *Patrologia Orientalis* 48, Fasc. 2, No.214, (Turnhout, 1999); for the Georgian see M. Tarschnishvili in Corpus Scriptorum Christianorum Orientalium 189, *Scr.Iber.* 10 (Louvain, 1959). Professor Zaza Alexidze has identified the lectionary from Eastern Albania in a manuscript from Sinai. He has also used this text to work out the hitherto unknown language, and is about to publish the result.

15. *Ac si per pascha*: *It. Eg.* 24.8.

16. Matthew 28.1.

17. For example Monza flask 15 in A. Grabar, *Les Ampoules de Terre Sainte (Monza-Bobbio)* (Paris, 1958), Pl. 18.

18. As the women 'went' in, Mark 16.5.

19. John 19.38-20.18.

20. A. Papadopoulos-Kerameus, *Analekta Ierosolumitikês Stachuologias* (St Petersburg, 1894), 191, 199.

21. G. Vale, 'Il Dramma liturgico Pasquale' in *Rassegna Gregoriana* Anno [3] 4 (1905), N. 5-6 coll. 193-202. I should like to thank Dr L. Holford-Strevens for his advice.

22. See N.C. Brooks, *The Sepulchre of Christ in Art and Liturgy*, 65, in *University of Illinois Studies in Language and Literature* VII, 2 (May 1921), 203.

23. R. Krautheimer, 'Introduction to an "Iconography of Medieval Architecture"', *JWCI* 5 (1942), 1-33, the first article Robin Cormack gave me to read. Krautheimer's argument was weakened by veering away from the liturgical context.

24. Eusebios, *Life of Constantine*, trans. A. Cameron and S.G. Hall (Oxford, 1999), III. 25.

25. See John 19.41f.

26. Eusebios, *Life of Constantine* III. 28.

27. Cyril of Jerusalem, *Catechesis* 10.19; *PG* 33, 673.

28. The same arrangement was there in the ninth century: Photios, *Quaestion 316 ad Amphilochium*, 1.2; *PG* 101, 116D-1169A.

29. See J. Wilkinson, *Egeria's Travels* (Warminster, 1999), 173-175.

30. *It. Eg.* 48. 2.

31. See for instance Père Hugues Vincent, in L.H. Vincent, F.M. Abel, *Jérusalem Nouvelle* (Paris, 1926), Pl. XIII, and J. Conant, 'The Original Buildings at the Holy Sepulchre in Jerusalem', *Speculum* 31 (1956) 19.

32. Adomnan, *De locis sanctis*, ed. D. Meehan, Scriptores Latini Hiberniae 3 (Dublin, 1958), I. 2.5.

33. *Breviarius de Hierosolyma*, eds T. Tobler and A. Molinier (Geneva, 1879-85), A. 3, CC 175, 110.5.

34. For this service see *It. Eg.* 24.4-7.

35. Tamid 6.3.

36. Tamid 7.1.

37. Ex. 29.39 does not give an exact time, Mishnah Pesahim 5.1, *It. Eg.* 24.4. I would like thank my friend Professor Robert Ousterhout for his article 'The Temple, the Sepulchre, and the *Martyrion* of the Savior', *Gesta* 29/1 (1990), 44-53.

38. Tertullian, *de Oratione*, 25; *PL* 1, 1300-1301.

39. *It. Eg.* 43.6.

40. Eusebios, *Life of Constantine* III. 33. 1f.

41. Eusebios, *Life of Constantine* III. 28.

42. *It. Eg.* 24.3. Figure 8.3 has several added features, which are all supported by documents. But their exact size and position are not known.

43. Mishnah Pesahim 5.1.

44. Tamid 7.2.

45. Tamid 7.3, Pes, 5.1.

46. Mark 13.2.

47. Tamid 4.3 (Deut. 6.4-9).

48. Tamid 5.1 (Num. 6.24-26).

49. In Tamid 5.1 the Officer in charge of the Lots told them to read Deut. 11.13-21 and Num. 15.37. See also Tamid 1.4 ( Exod. 30.20-21); Tamid 2.5 (Lev. 24.7); Tamid 7.3 (Lev. 9.22).

50. Lev. 8.4.

51. Lev. 9.23.

52. Exod. 29.39, 42.

53. Exod. 25.9 and 1 Chron. 28.19.

54. Eusebios, *Historia Ecclesiastica*, eds E. Schwartz and T. Mommsen (Leipzig, 1909), 10.4.69-70, on the new church at Tyre. Further discussion of this topic may be found in my own book *From Synagogue to Church* (London, 2002), 110.

55. Babylonian Talmud, Hullin 91b, and Rev. 4.8.

56. *It. Eg.* 27.7, 31.4, 32.2.

57. Heb. 3.1.

58. Heb. 10.11-12.

59. Basil, *De Spiritu Sancto* 29.73; *PG* 32, 204B-205A.

60. See *The Study of Liturgy*, eds C. Jones et al. (London, 1997), 419 n.60.

8.1 Reconstruction of the Tomb of Christ in the Holy Sepulchre, Jerusalem in the fourth century (John Wilkinson).

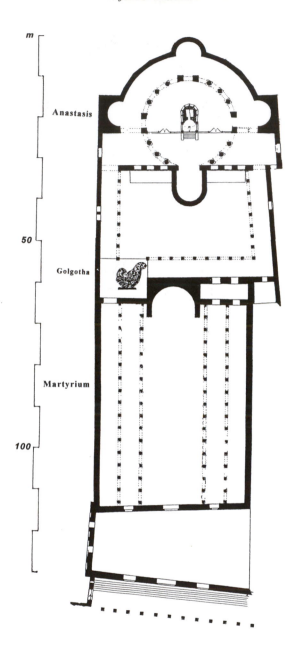

8.2 Reconstruction of the Holy Sepulchre, Jerusalem in the fourth century
(John Wilkinson).

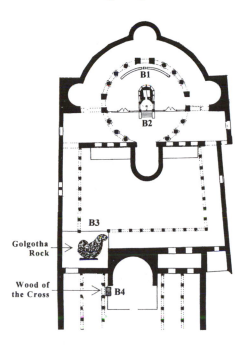

8.3 Movements of the Bishop of Jerusalem during the Lamplighting service in the Holy Sepulchre, Jerusalem (John Wilkinson).

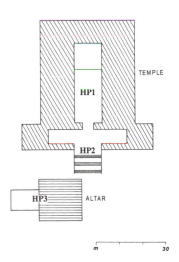

8.4 Movements of the Jewish High Priest in the Temple, as described in the Mishnah tractate Tamid (John Wilkinson).

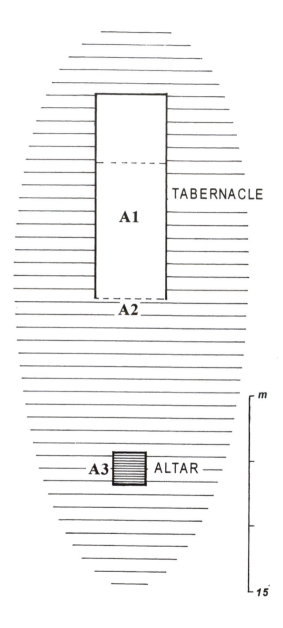

8.5 Reconstruction of the consecration of Aaron in the 'Tent of Meeting' or the
Tabernacle according to the Book of Leviticus (John Wilkinson).

# Part 2

# Icons in Context

Chapter 9

# Bleeding Icons

Maria Vassilaki

A contemporary icon of the Virgin and Child located in the church of Agios Nektarios at Kipoupolis of Peristeri, a suburb to the North-West of Athens, was reported in March 2001 to have started bleeding from the neck (Fig. 9.1). As the faithful gathered in their thousands to venerate the icon,[1] the incident came with the help of the Media to assume incredible proportions. Interviews with the painter of the icon, with the priests of the church in which it is located, and with the people queuing for long hours to witness the miracle, showed them all trying to account in their own way for the event. For most of them, there were no doubts as to the authenticity of the miracle, but as to the reasons for it a variety of views were expressed. The most extreme among them were found to believe that the icon's bleeding was a clear sign of the Virgin's opposition to the proposed visit of the Pope to Athens in May 2001.[2] The most sceptical though suggested that a scientific examination of the blood issuing from the icon was required, so as to establish the DNA of the Virgin. However, the priests of the church immediately turned this down and refused to allow anybody to remove the glass protecting the icon. Even politicians and members of the parliament were asked to offer their own interpretations of the bleeding.[3]

On a recent visit to the church I was able to talk to two of the people who had witnessed the miracle, namely the sacristan of the church and the painter of the icon. Unfortunately, as he had recently retired, I was not able to meet the Archimandrite, who had also witnessed the miracle and had played the most significant part in events succeeding it. His successor was unable or unwilling to give me any information. The Archimandrite, however, has left a written testimony of the event and the miracles associated with it in the form of a booklet (Fig. 9.2) printed on the occasion and distributed to the faithful visiting the church. The booklet is entitled *Παναγία η Καρδιώτισσα*

From *Icon and Word: the Power of Images in Byzantium. Studies presented to Robin Cormack*, eds Antony Eastmond and Liz James. © 2003 by contributors. Published by Ashgate Publishing Ltd, Gower House, Croft Road, Aldershot, Hampshire, GU11 3HR, England, pp. 121-133.

*(Η Αιματώσασα)* which translates as *The Virgin Kardiotissa (the one that has bled)*. I quote and translate from this book:

> The parish church of St Nektarios at Kipoupolis belongs to the diocese of the metropolitan bishop of Peristeri and is located at 145, Makriyannis Street. It is a church under construction and for the past ten years church services have been performed in the chapel, which is on the lower ground floor of the main church.
>
> This humble church was chosen by the grace of the all holy Theotokos to perform her miracle. On 16th March 2001, which is the Friday during which the Third Salutations (Γ΄ Χαιρετισμοί) to the Virgin are read, the icon of the Virgin Kardiotissa was, in just the way that it has always been during the weeks of the Salutations since it was painted and donated to the church in 1997, placed on a lectern to the left of the nave. That Friday at 17.30 when the faithful started gathering for the church service and while they were venerating and kissing this very icon, they all realized that blood had started coming out of a hole in her neck. Dumbfounded by the incident, some started crying quietly and they all remained mute, unable to talk about what they had just witnessed.

The Archimandrite continues his narrative as follows:

> At 18.30 I arrived at the church in order to prepare myself in time for the church service that would start at 19.00. As I was crossing the nave heading towards the sanctuary, I stood for a second in front of the icon of the Virgin wanting to kiss it. I soon realized that the glass protecting the icon was stained and immediately asked the sacristan to clean it. She admitted nervously that she had already tried to remove the stain, unsuccessfully though, as the stain was not on the glass but on the painted surface of the icon underneath the glass. Then I moved closer to the icon, I put my glasses on and could not believe what I saw: drops of blood were issuing from the Virgin's neck. 'This is blood', I cried out and everybody in the church also cried out in one voice: 'Yes, Father, it is blood, we saw it as soon as we entered the church this evening, but we were too afraid to say anything about it'. We started ringing the church bells in joy and I performed a holy unction. The church was soon full of people who were gathering to witness the miracle and pray to the Virgin. To date thousands of people have visited the church in order to venerate the bleeding icon and to ask for the Virgin's intervention in solving the problems of their lives and in curing them of various diseases.

Further on the Archimandrite describes in his booklet some of the miracles the bleeding icon of the Virgin and Child performed in the days that

followed. I have singled out three of them:

1. A lady by the name of Mrs Pelagia (no surname is given), a resident of New York, phoned to say that she was suffering from cancer. A relative of hers sent her a copy of the bleeding icon together with oil from the candle that is burning in front of it. She put the oil over the part of her body that was affected by cancer. When she next visited her doctor, who was going to operate on her, he found there was no trace of cancer and that she had been completely cured. Mrs Pelagia is now healthy and well.

2. Mrs Magdalene from Pangrati (an area in central Athens) has two sons both of whom ride motorbikes. That of the first son was stolen and he managed to get it back after praying to the Virgin Kardiotissa, whose icon he had seen on the television. The second son was miraculously saved from a serious accident, which happened soon after he had left his house. Before leaving home his mother had prayed to the Virgin Kardiotissa to keep him safe and well.

3. Ms Katerina Antonopoulou, the daughter of a Greek family in Australia, was watching a Greek television programme on the bleeding icon of the Virgin. People were casting doubt on the miracles and were even swearing at the icon. Feeling shocked and deeply upset she called out to her mother, who had been disabled and in a wheelchair for many years. The mother who was in the next room stood up and walked to her daughter unaided. The two women embraced each other and prayed to the Virgin. This miracle happened on 20th August 2001.

According to the Archimandrite the icon stopped bleeding on 2 July 2001. Some of the above miracles, however, happened after that date.

As mentioned above, I visited the church and was able to talk to the sacristan of the church, Mrs Anastasia, as well as to the painter of the icon, Ms Euphrosyne Kostopoulou, who lives nearby. The church was very quiet and none of the faithful was there at the time. They were both very pleased to see that somebody was still interested in the bleeding icon, a miracle that they had both witnessed. The painter gave me her own version of the story, saying that this icon of the Virgin Kardiotissa was her beloved one and that it had produced all sorts of signs of its specialness from the very day that she had started painting it. She would feel from the start that this icon had special powers, so for her the blood that came out of the Virgin's neck was simply one among a series of signs. She could not explain the incident but she was absolutely convinced of its authenticity. She told me, however, that she had asked the carpenter who had provided the wooden board for the icon whether he had any explanation for the bleeding. His answer was that the blood of the icon could have been glue, which had been sealed in the wood. She made no comment on that.

With tears in her eyes and in the minutest detail, the sacristan described to

me what happened on the day that the icon started to bleed in front of her. She told me how she had tried initially to clean what she thought to be a stain on the glass and how shocked she was when she realized that the stain was on the Virgin's neck. She also described the reactions of the faithful who were in the church at the time and what happened afterwards when the news spread and thousands of the faithful began coming from every corner of Greece to witness the miracle and pray to the Virgin. Having found the church to be so quiet and empty, I was very curious to know how this ferment had come to an end and when. She simply stated that in June 2001 another bleeding icon of the Virgin was reported in the church of St Phanourios at Argyroupolis, a suburb to the South-East of Athens. A sample of the blood taken from that icon to the State Laboratories proved to be morello cherry juice.[4] This unfortunate incident obviously had an adverse effect on the celebrity of the bleeding icon of the Virgin Kardiotissa, as the number of faithful visiting the church gradually diminished.

I tried to contact the Archbishopric of Athens and find out what attitude they had towards this and other incidents involving bleeding icons which had occurred in churches in their jurisdiction. It has to be said that they were rather diplomatic in their response. They did not make any negative comment but at the same time it sounded as if they viewed such events with complete indifference. When I asked them whether they had kept records of similar incidents from other churches in Greece, they said they had not and simply advised me not to take such incidents too seriously.

The incident of the bleeding icon of the Virgin Kardiotissa at Kipoupolis offers us a starting-point for investigating the occurrence of such phenomena in Byzantium. Are Byzantine icons recorded to have bled and when they did why did they do so? Recent incidents of bleeding icons may echo patterns already occurring in Byzantium and may prove instructive by providing the kind of information that Byzantine texts are unlikely to provide. Do Byzantine sources help us to understand how such incidents were experienced in a religious society like Byzantium and what role they played in its religious and social life?

Three bleeding icons are listed in the *Letter of the Three Patriarchs to the Emperor Theophilos*, a text usually associated with the period immediately after Iconoclasm and dated between 861 and 866.[5] As this text explicitly states, these icons bled when wounded. In the first, a mosaic icon of the Virgin and Child on Cyprus, the Virgin was struck on the knee by the arrow of an Arab.[6] In the second, an icon of Christ at Berytus (Beirut), Christ was stabbed in his side by the spear of a Jew.[7] In the third, an icon of Christ in the church of Hagia Sophia in Constantinople, Christ was stabbed in the heart with the knife of a Jew.[8] In all three cases, the icons that bled when wounded simply behaved like human bodies, like the living bodies of their prototypes.

Do other Byzantines texts offer accounts of bleeding icons and in what contexts do these accounts occur? Information on bleeding images in Byzantium is very sparse and scattered in the sources and so far no comprehensive study has been undertaken of the subject. As far as the iconographic evidence is concerned the only such representations are displayed on a limited number of lead seals bearing the Virgin and Child in the Nikopoios type and carrying the epithet H MAXAIPΩΘEICA (stabbed with a knife).[9] All these lead seals seem to have belonged to members of the clergy of Hagia Sophia and are believed, therefore, to make reference to the bleeding icon of this church. The *Letter*, however, describes this icon as depicting Christ and not the Virgin. On the other hand, pilgrims' records speak of an icon of the Virgin.[10]

Gregory of Tours, writing in the sixth century, gives the earliest account, which concerns an image of Christ that bled when pierced by a Jew.[11] John of Damascus, in the ninth century, quotes a story in the writings of Anastasios Sinaites (640-700) about an image of St Theodore that bled when wounded by Saracens.[12] Bishop Peter of Nicomedia is documented to have read out, in a session of the anti-iconoclastic council of Nicaea in 787 a sermon attributed to St Athanasios in which the story of the Beirut icon that bled is recorded.[13] This icon was transferred to Constantinople in 975 by the emperor John Tzimiskes and was housed in the chapel at the Chalke Gate of the Imperial Palace.[14] The blood that was collected from this icon had already been transferred to Constantinople in 968 by Nikephoros Phokas[15] and was deposited in the Pharos' church of the Imperial Palace. The blood relic was taken in 1204 by Enrico Dandolo to the church of San Marco in Venice.[16]

Pilgrims to Constantinople offer testimony on the presence of a number of bleeding icons in the churches and monasteries of the capital. The Anonymous English pilgrim of the late eleventh-century mentions the stabbed icon displayed in the church of Hagia Sophia,[17] as also do the Anonymous Tarragonensis and the Anonymous Mercati in the twelfth century.[18] In the fourteenth century, both Stephen of Novgorod and the Anonymous Armenian mention an icon of Christ in the church of the Holy Apostles which was stabbed by an infidel and bled.[19] In the last years of the fourteenth century, Alexander the Clerk mentions that in the Peribleptos he saw an icon of the Holy Mother of God 'which a Jew stabbed during a chess game', and which thereupon bled. It is assumed that this was the icon in Hagia Sophia, which had been transferred to the Peribleptos sometime after 1200.[20] The chapel of St Demetrios in the Vatopedi monastery of Mount Athos possesses an icon of the Virgin known as H Εσφαγμένη, which means the slaughtered Virgin.[21] This icon was struck in anger, not by an infidel, but by a deacon or sacristan, whose appointed task of cleaning the candlesticks in front of it every morning made him late for meals.[22]

The information mentioned so far makes it clear that the majority of bleeding or stabbed icons that have been recorded existed in Constantinople. One such icon was transferred from Berytus (Beirut) to the capital but the original place of provenance of the others is not specified. Most of the information concerning these icons is very laconic and repeats the same pattern: an icon, usually of the Virgin or Christ, was stabbed by an infidel, most commonly a Jew, and bled. We are unable to reach any conclusion as to whether any or all of these icons also performed miracles, a thing that would have definitely added to their importance. Only the icon transferred to Constantinople from Beirut is reported in the *Letter* as having performed many healings of the blind, the lame and the sick. The fact that pilgrims to Constantinople make special reference to the bleeding icons displayed in the churches and monasteries of the capital does, however, in itself bespeak their importance.

The only visual material relating to the stabbed icons of Byzantium is offered by the four lead seals in the Dumbarton Oaks Collection, dated to the late eleventh and the thirteenth century.[23] The Virgin is full-length in the type of the Nikopoios. The nature of the material, the small size of the seals and their poor state of preservation, however, do not allow us to see the details clearly in the stabbed image of the Virgin. It has been assumed that these seals presumably depict the stabbed icon of the Virgin kept in Hagia Sophia. This suggestion is supported by the fact that three of the seals belonged to a certain Petros, deacon and chartophylax (Fig. 9.3), while the fourth belonged to a Constantine, deacon and chartophylax of the Great Church, which is Hagia Sophia. Peter has been identified with the deacon and chartophylax of Hagia Sophia, whose name appears in two ecclesiastical documents of 1086 and 1092, respectively. Constantine has been identified with Constantine Aulenos, deacon and chartophylax of Hagia Sophia, whose name appears in a patriarchal document issued by Germanos II, in July 1235. A fifth lead seal also from the Dumbarton Oaks Collection may be added to this group (Fig. 9.4).[24] It belongs to Michael, Bishop of Traianoupolis and president of the protosynkelloi, and shows the Virgin Hodegetria with a knife next to it. Michael's honorary title, president of the protosynkelloi, associates him with the clerical establishment of Constantinople and particularly of Hagia Sophia.[25] The slaughtered icon of the Virgin at Vatopedi (Fig. 9.5) still exists to this day and is displayed in the narthex of the chapel of St Demetrios. It shows the Virgin holding the Christ Child and belongs to the Hodegetria iconographic type. The wound on the Virgin's cheek is still visible to this day.

Returning to my point of departure, the recent incident of the icon of the Virgin Kardiotissa at Kipoupolis, I would like to draw attention to some of the similarities and differences between the bleeding images in Byzantium and those of today. The basic difference between them appears to be that the

bleeding icons in Byzantium were 'wounded'. Blood did not come out of the icon spontaneously but as the result of an act of aggression, of an attack with a knife or a spear. It also seems that blood came out only once, when they were attacked, and not repeatedly over a certain period, as has happened with the icon at Kipoupolis. The bleeding of the latter lasted for almost four months (from 16/03/2001 till 02/07/2001).

We have seen that accounts of bleeding images existed as early as the sixth century, as Gregory of Tours made a reference to one,[26] while later sources connect the name of St Athanasios the Great in the fourth century with the narrative of such an incident.[27] It is not difficult to imagine what a significant role the reaction against Iconoclasm must have played in the emergence of such stories. The *Letter of the Three Patriarchs to the Emperor Theophilos* included the three bleeding icons in the list of twelve miraculous icons of Byzantium. St John of Damascus also made reference to a bleeding icon of St Theodore and St Theodore the Stoudite made reference to the Beirut icon and attributed the account of it to St Athanasios the Great.[28]

The surviving sources on bleeding images in Byzantium do not allow us to investigate the subject any further. They tell us something about the place traditions relating to such incidents came to have in the theological confrontations of the time, but do not in themselves enable us to see how they were experienced in Byzantine society or to speculate on the dimensions they may or may not have acquired in the everyday life of the Orthodox Church. Modern instances like that of the Virgin Kardiotissa, however, do give us some inkling of how such traditions may have arisen and of the depth of feeling that generated them and that they in turn generated.

## Notes

1.  Seven thousand people are reported to have visited the church and its icon during the first week of the miracle.

2.  This view was expressed by the abbot of the holy monastery of Sts Augustine and Serapheim at Trikorphon, Nektarios Moulatsiotis, and was published in the newspapers.

3.  Mr Stelios Papathemelis, a member of the Parliament and ex-minister of the PASOK government, when asked about the miracle and its association to the planned visit of the Pope said: 'There have always been signs of the time as the Gospels say, but I cannot be absolutely certain if this is such a sign.'

4.  According to the 18 June 2001 issue of the newspaper 'Eleftherotypia', an investigation of the priests of the church was called for soon after the 'miracle' was shown to be a fraud.

5.  *The Letter of the Three Patriarchs to the Emperor Theophilos and Related Texts*, eds J.A. Munitiz, J. Chrysostomides, E. Harvalia-Crook and Ch. Dendrinos (Camberley, Surrey, 1997). The *Letter* and the icons listed in it, are also discussed by R. Cormack, *Writing in Gold. Byzantine Society and its Icons* (London, 1985), 121-31.

6.  *Letter of the Three Patriarchs*, 40-4, 7.7: 'In the land of the Cypriots, in one of the towns there, such things are enacted to this day. For in the same Cyprus, in the southern part, a house was erected to the Holy Mother of God, in which there was an icon in mosaic. A certain Arab shot (at the icon) with his arrow at the knee where the Saviour sits on her lap. Immediately blood gushed forth in abundance down to her feet, and so it is to this day.' Though neither of the two mosaic representations surviving on Cyprus from the Pre-iconoclastic period, namely the church of the Virgin Kanakaria at Lythrankomi and the Virgin Angeloktisti at Kiti, can, in iconographic terms, be identified with the mosaic icon of the text, it is believed that the *Letter of the Three Patriarchs* makes a reference to one of those. A.H.S. Megaw and E.J.W. Hawkins, *The Church of the Panagia Kanakaria at Lythrankomi in Cyprus. Its Mosaics and Frescoes* (Washington, DC, 1977), 161-70.

7.  *Letter of the Three Patriarchs*, 46-7, 7.12. 'Again there was once a Jew in the city of Berytus, who pierced the side of the icon of Christ with his lance, as did the Jews in the past. Suddenly a fountain of blood brimming with life gushed out, miraculously performing many healings on the blind and lame and sick.'

8.  *Letter of the Three Patriarchs*, 46-7, 7.13a-b: 'And another Jew once in the imperial city of Constantine plunged a dagger into the heart of the icon of the Saviour, which was set up in the Holly Well of the church of the Holy Great Sophia. Suddenly streams of blood gushed out spattering his face and clothes. Out of fear he threw the icon into that well, and immediately the water became blood. And in fact when the Jew was arrested as a murderer, on account of the garment he wore being red, he showed what he had done, and they brought the icon out of the well carrying the dagger still plunged in its breast. When they saw the icon spurting blood, they were all gripped with amazement and terror. Because of this miracle the Jew was baptized, having believed in the Lord together with his entire household.'

9.  G.P. Galavaris, 'The Mother of God "Stabbed with a knife"', *DOP* 13 (1959), 229-33, figs 1-4. All these lead seals belong to the Dumbarton Oaks Collection.

10. C. Walter, 'Iconographical Considerations', in *Letter of the Three Patriarchs*, eds Munitiz et al., lx-lxi.

11. Gregory of Tours, *De Gloria martyrum*, PL 71, 724. E. Kitzinger, 'The Cult of Images in the Age before Iconoclasm', *DOP* 8 (1954), 100, repr. in *The Art of Byzantium and the Medieval West: Selected Studies by Ernst Kitzinger*, ed. W.E. Kleinbauer (Bloomington and London, 1976), no. V, 106. J.-M. Sansterre, 'L'image blessée, l'image souffrante: quelques récits de miracles entre Orient et Occident (VIe-XIIe siècle)', in *Les images dans les sociétés médiévales: Pour une histoire comparée*, Actes du colloque international organisé par l'Institut Historique Belge de Rome en collaboration avec l'École Française de Rome et l'Université Libre de Bruxelles (Rome, Academia Belgica, 19-20 juin 1998), *Bulletin de l'Institut Historique Belge de Rome* 69 (1999), 115.

12. John of Damascus, *De imaginibus oratio* III, PG 94, 1393.

13. Mansi 13, 24-32. *De imagine Domini nostri Jesu Christi, et de miraculo edito in urbe Beryto*, PG 28, 805-812. M. Bacci, 'The Berardegna Antependium and the *Passio Ymaginis* Office', *JWCI* 61 (1998), 4-8.

14. C. Mango, *The Brazen House. A Study of the Vestibule of the Imperial Palace of Constantinople* (Copenhagen, 1959), 150.

15. E. von Dobschütz, *Christusbilder. Untersuchungen zur christlichen Legende* (Leipzig, 1899), 218, no. 71.

16. Mango, *The Brazen House*, 151.

17. K.N. Ciggaar, 'Une description de Constantinople traduite par un pèlerin anglais', *REB* 34 (1976), 221, 248.

18. K.N. Ciggaar, 'Une description de Constantinople dans le *Tarragonensis* 55', *REB* 53 (1995), 137.

19. In G. Majeska, *Russian Travelers to Constantinople in the Fourteenth and Fifteenth Centuries* (Washington, DC, 1984), 304.

20. Majeska, *Russian Travelers*, 282.

21. G. Smyrnakis, *Το Ἅγιον Ὄρος* (Karyes, 1903, 1988(2)), 434.

22. A detailed account of the incident is given in the anonymous collection of narratives on the miraculous icons of the Virgin on Mt Athos. *Ανώτερα επισκίασις επί του Ἄθω ήτοι διηγήσεις περί των θαυματουργών εικόνων της Θεοτόκου* (Constantinople, 1861; Mt Athos, 2000 (7)), 43-46, pl. on p. 42.

23. See footnote 9.

24. *Catalogue of the Byzantine Seals at Dumbarton Oaks and in the Fogg Museum of Art* II, eds J. Nesbitt and N. Oikonomides (Washington, DC, 1994), no. 61.2.

25. V. Penna, 'The Mother of God on Coins and Lead Seals', in *The Mother of God. Representations of the Virgin in Byzantine Art*, ed. M. Vassilaki (Milan and Athens, 2000), 214, pl. 156.

26. See above, footnote 11.

27. *PG* 28, 805-12.

28. Theodore the Stoudite, *Epistolarum Lib. II*, no. 199 (to Emperors Michael and Theophilos), *PG* 99, 1608B and *Antirrhetici II, PG* 99, 365B-D.

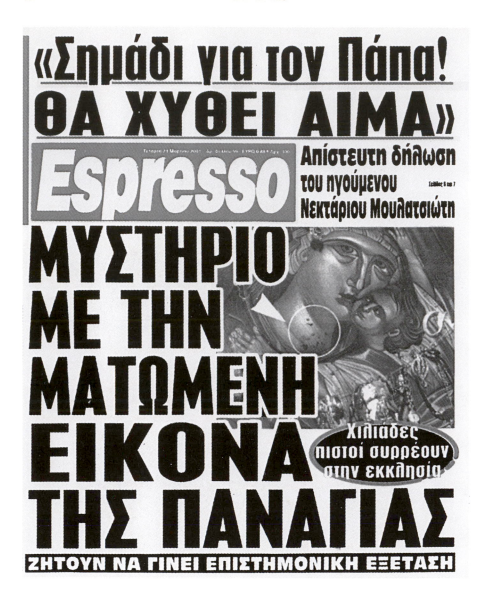

9.1 The front page of the newspaper *Espresso* of 21 March, 2001.

IЄPA MHTPOПOΛIC ПЄPICTЄPIOY

IЄPOC NAOC AГIOY NЄKTAPIOY
KHПOYПOΛЄѠC

ПANAГIA H KAPΔIѠTICCA
(H AIMATѠCACA)

9.2 Frontispiece of the booklet, *Παναγία η Καρδιώτισσα* (Athens, 2001).

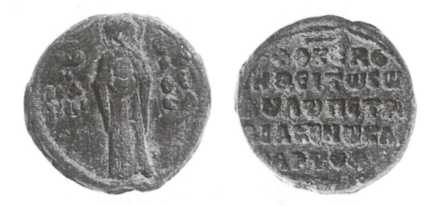

9.3 Lead seal of Petros, deacon and chartophylax, 1086-92 (Dumbarton Oaks Collection, no. 47.2.291).

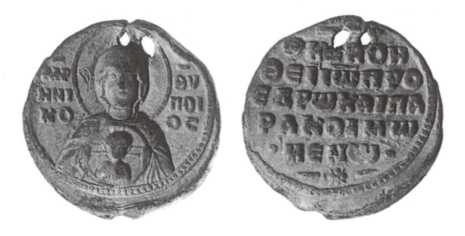

9.4 Lead seal of Michael, Bishop of Traianoupolis, 11th century (Dumbarton Oaks Collection, no. 58.106.5678).

9.5 The slaughtered icon of the Virgin from the Vatopedi Monastery, Mt Athos.

Chapter 10

# Images of the Mother of God in Early Medieval Rome

John Osborne

Although not quite as old as Christianity itself, the cult of Mary was promoted from at least the second century CE by theologians such as Irenaeus of Lyons and Justin Martyr. At about the same time apocryphal texts, most notably the *Protoevangelium of James*, began to expand on the meagre details of her life supplied by the authors of the New Testament. In subsequent centuries, Mary's role both as a model for ascetic virginity and as the instrument which made possible the incarnation of divinity in human form, led writers such as Ambrose, Jerome and Augustine in the West, and Gregory of Nyssa and Ephraim the Syrian in the East, to champion her cause; and in the early fifth century, her status as Mother of God, or *Theotokos*, became a formal component of orthodox belief with the defeat of the Nestorians at the Council of Ephesos in 431. Images of Mary, with or without her child, would subsequently play a major role in the artistic production of medieval Byzantium, as attested for example by the vast range of objects included in the recent exhibition devoted to the *Mother of God* at the Benaki Museum in Athens.[1] Contributing to this prominence was Mary's special role, acquired by the mid seventh century, as the spiritual patron and defender of the city of Constantinople, where the relics of her robe and girdle, and in later centuries venerable icons depicting her image, were regarded as special talismans bearing thaumaturgic powers to defend the imperial capital in moments of crisis.[2] These aspects of the cult of Mary are well known to all historians of Byzantine art, and need not be rehearsed in any detail here. But what may be somewhat less well known is that the cult of Mary also enjoyed a prominent position, and arguably one of even greater importance, in the life and art of another great city of the medieval Mediterranean, even if she was never

From *Icon and Word: the Power of Images in Byzantium. Studies presented to Robin Cormack*, eds Antony Eastmond and Liz James. © 2003 by contributors. Published by Ashgate Publishing Ltd, Gower House, Croft Road, Aldershot, Hampshire, GU11 3HR, England, pp. 135-156.

proclaimed formally as its spiritual defender. That city was Rome, and it is the intention of this paper to explore various aspects of Marian imagery in the context of Rome's early medieval history.[3]

There is no place in the Christian world which can rival Rome for the longevity of its interest in Mary, nor too for the longevity of her very tangible presence in the city's material culture. This is not simply a question of survival, in comparison to Constantinople, for example, where our knowledge of late classical and Early Christian artistic production has been irreparably diminished by the subsequent ravages of iconoclasm. Long before the fate of the city of Byzantium was changed forever by the emperor Constantine, images of Mary would have been familiar to the Christian community in Rome. Indeed, what is arguably the earliest surviving image of Mary anywhere in Christian art may be found in a mural in the Catacomb of Priscilla, now dated to the second quarter of the third century.[4] Whereas no churches dedicated to Mary can be documented before the second half of the fifth century in Constantinople, in Rome her name was given a generation earlier to the imposing basilica which graced the summit of the Esquiline hill, S. Maria Maggiore, constructed by Pope Sixtus III (432-440); and images of the newly-proclaimed *Theotokos*, lavishly dressed in the court costume of a *femina clarissima*,[5] figure prominently in the contemporary mosaic decorations of its triumphal arch, and presumably once did so as well in those of the apse, now lost. It was similarly in Rome that Mary would achieve the pinnacle of her artistic glorification, clothed in the crown and purple robes of the empress of Byzantium in an iconography which has come to be called *Maria Regina*.[6] The earliest surviving example of this type may be found in another important Roman church dedicated to Mary: S. Maria Antiqua, situated in the Roman Forum, under the slope of the Palatine hill (Fig. 10.1). Here Mary is no longer the humble *ancilla Domini* of the catacombs; rather, she has been elevated even beyond her status in S. Maria Maggiore, now queen of heaven and co-equal with her son in sharing the attributes of imperial dignity. What is perhaps remarkable is the rapidity with which this progression took place over the course of the fifth and sixth centuries. It can also be documented with reasonable precision, thanks to the very large number of Marian images which have survived from early medieval Rome. Once again, no other city in Christendom can boast of such a wealth of extant documentation.

Mary would continue to enjoy a pre-eminent position in Rome throughout the long course of the Middle Ages. The early seventh century witnessed the re-dedication in her honour of the city's best-preserved pagan temple, the Pantheon;[7] and in the late decades of that same century a series of Greek-speaking popes began to regularize Marian devotion, placing it at the very core of the Roman church's official cult practice. For example, Sergius I (687-701), born in Sicily to a family of *émigrés* from the region of Antioch, formalized the

introduction of a series of Marian feasts (including her Nativity and her Dormition) into the Roman liturgy, to be accompanied by processions from the Forum to her principal shrine at S. Maria Maggiore.[8] His successor next-but-one, John VII (705-707), *'natione Grecus'*, the son of Plato, the administrator in charge of the imperial palace on the Palatine hill, similarly made no secret of his own special devotion to the *Theotokos*. In addition to his complete redecoration of her shrine church in the Forum, S. Maria Antiqua, John also constructed a chapel in her honour against the inner façade wall of Old St Peter's, intended as his own place of burial. Its lavish mosaic decorations are known from a series of drawings by Jacopo Grimaldi, made in the early seventeenth century, immediately prior to the chapel's demolition, and a few fragments of these still survive, principally in Rome, but also in Orte, Florence, and even Moscow.[9] The main wall of the chapel was adorned with a large image of Mary, shown standing and crowned as empress, her hands spread in prayer for the soul of her devoted servant, the pope, who would later be buried beneath. John himself is portrayed at her side, offering a model of the chapel.[10] An accompanying inscription, now known only through copies, also recorded his patronage, referring to the pope as 'BEATAE DEI GENETRICIS SERVUS'.[11] Another inscription, on the edge of the covering barrel vault, identified the place as the 'DOMUS SANCTAE DEI GENETRICIS MARIAE'. [12] Thus both make use of the direct Latin equivalent of the Greek word *Theotokos*, and this same language appears in John's other projects. At S. Maria Antiqua, for example, it may be found in the fragmentary dedication inscription flanking the apse,[13] as well as on the surviving octagonal slab from the stone *ambo*. The latter is a rare example of an object mentioned directly in the *Liber pontificalis* (I, 385) which has come to light through modern archaeology. Its bilingual inscription again records the patronage, identifying the pope in Latin as the 'servus sanctae Mariae', and in Greek as the *'doulos tou Theotokou'*.[14]

Other pontiffs would continue this tradition of devotional service to Mary. Notable among them is Paschal I (817-824), who appears with the enthroned Madonna and Child in the apse mosaic of the Roman church of S. Maria in Domnica. The kneeling pontiff holds the Virgin's slipper, presumably intended as a demonstration of his obeisance, and paralleling the gesture of the donor figure (probably Pope John VII) on the icon from S. Maria in Trastevere, which may have served as the model. She in turn gestures towards him, conveying her acceptance of his devotion and her consequent blessing. Marian devotion is a theme which had considerable currency in the early medieval West. It was explored by theologians such as Ildefonus of Toledo in the seventh century, Ambrosius Autpertus in the eighth, and Paschasius Radbertus in the ninth, many of whom saw it as mirroring Mary's humble acceptance of her own role, in response to the divine command conveyed by

the archangel Gabriel.[15] But it found a particular potency at the papal court, perhaps filling a void caused by the absence of a strong female presence, and here too it was transformed into visual terms with a frequency and domination that find few parallels, even in Byzantium. Just as Constantinople would develop its own particular forms of Marian imagery, for example the *Hodegetria*, so too would Rome; and in the early Middle Ages the iconographic type most closely associated with the city, and perhaps more specifically with the papacy, was undoubtedly the *Maria Regina*.

This appellation for images of Mary with the crown and robe of the empress is derived from the painted inscription which accompanies a prominent example of this type, formerly on the atrium wall of S. Maria Antiqua (Fig. 10.2). It can be dated with precision to the pontificate of Pope Hadrian I (772-795), whose portrait with square 'halo' is included at the far left of the composition.[16] However, it is not improbable that there were earlier examples of this usage which simply have not survived. The actual designation of Mary as queen can be documented in Rome at least a decade or two earlier, in an inscription recording donations by *dux* Eustathius to S. Maria in Cosmedin, today preserved in the narthex of that church. This builds on the language of the era of Pope John VII, addressing Mary as 'praeclara virgo caelestis regina sancta superexaltata et gloriosa domina mea Dei genetrix Maria'.[17] In the early ninth century, Mary is also referred to as queen in an inscription on the enamel cross of Pope Paschal I.[18]

While the atrium painting in S. Maria Antiqua is the first surviving instance of an image in which Mary is named as *regina*, it was by no means the first Roman example of this iconographic type. That honour must go to another mural in the same church, located on the earliest level of the aptly named 'palimpsest' wall to the right of the apse (Fig. 10.1). The term 'palimpsest' wall derives from the fact that remnants of no fewer than four superimposed levels of figural decoration can be identified on this surface, of which the fourth, and hence most recent, belongs to the general campaign of redecoration of the church associated with Pope John VII (705-707). Although the earlier layers cannot be dated with equal precision, the third level has been convincingly linked to the deliberations of the Lateran Synod of the year 649;[19] it features the standing figures of theologians holding unfurled scrolls bearing texts which were used at the Synod to condemn the monothelite heresy. For the dating of the first two levels, however, we are on considerably less firm ground. What can be said with certainty is that level one, bearing what remains of the enthroned '*Maria Regina*' and Child, flanked by angels, must predate the physical renovations which transformed this Domitianic structure at the foot of the Palatine ramp into an actual church, since the left side of the painting was clearly lost when the apse was cut into the thickness of the adjacent wall. Level two, containing an Annunciation with the famous

'Pompeian angel', is presumably contemporary with this campaign of restructuring, which also witnessed the replacement of some of the piers in the central quadriporticus with columns, creating the effect of a 'nave' and 'aisles'. While there is no absolute evidence which can be used to date the moment of this transformation, the reported discovery of a coin of the Emperor Justin II (565-578), under one of the replacement columns in the 'nave', may point to the second half of the sixth century, a date that is certainly not implausible.[20] In turn, this would push the first level, and thus the earliest recorded instance of a '*Maria Regina*', back into the era of Justinian (527-565).

Once again, such a suggestion appears quite reasonable. Although in the aftermath of the Council of Ephesos, the images of Mary on the triumphal arch of S. Maria Maggiore depict her in the court costume of a *femina clarissima*, a century later Mary's star had risen substantially, as reflected in the sixth-century *kontakia* of Romanos the Melodos, including the most famous of all Byzantine hymns to the Virgin, the *Akathistos*.[21] Among the earliest texts to specifically link Mary with the term 'regina' is the panegyric poem, *In laudem Iustini*, written for Justin II by the court poet Corippus, in which the Empress Sophia invokes Mary in prayer with these words:

> Virgo creatoris genetrix sanctissima mundi,
> Excelsi regina poli …

This reflects a general attitude which had gained currency by the mid sixth century, and, as Averil Cameron has commented, 'The idea of the Virgin as queen could be found in Greek sources available to Corippus, and he gives it no special emphasis.'[22]

The appearance of this iconographic type in the visual arts is thus highly appropriate for a century which witnessed a dramatic growth of interest in the cult of Mary, a cult which was, moreover, promoted actively by the imperial court. Perhaps significantly, it is also in the sixth century that Marian feasts began to be added to the Greek liturgy, and that the veneration of the relics of her robe and girdle at the Constantinopolitan shrines of Blachernai and Chalkoprateia developed into full-blown cults.[23] This suggests that there must surely have been images of Mary on view in the Byzantine capital, of which the famous icon preserved in the monastery of St Catherine at Mount Sinai is now perhaps the only reflection.[24] But did any of these early images depict Mary as empress? There is no reason to think not. Although the literature on the '*Maria Regina*' iconography prefers to view it as an essentially western phenomenon, there is no compelling evidence to place its origins in Rome. The first surviving example in S. Maria Antiqua – and, perhaps significantly, the earliest extant example of this type by at least a century, if not more –

dates from a moment prior to the structural conversion of the building into a church, and its unknown patron is thus much more likely to have been an imperial administrator situated close at hand, in the imperial palace at the summit of the adjacent Palatine ramp, than a member of the city's clergy or papal administration, whose sphere of influence was then centred elsewhere, at the Lateran. In the mid sixth century, such an administrator would have been appointed from, and probably also sent out from, Constantinople, and thus fully cognizant of the latest developments in Mariology at the imperial court.[25] Belisarios and Narses are two prominent examples of such officials who come quickly to mind. One could even go further and argue that the exaltation of Mary as Queen of Heaven may have been intended in part as a political statement against the Arian beliefs of the Ostrogoths, but that might be stretching the point.

Further fuel for the fire which this debate has engendered has been provided by the discovery of an early '*Maria Regina*' outside Rome: a mosaic, probably of the late sixth century, in the amphitheatre chapel at Durrës (ancient Dyrrachium) in Albania. Here the standing figure of Mary, robed as empress, wearing the crown, and holding an orb and sceptre, is shown flanked by two attendant archangels, with a pair of diminutive donors at her feet.[26] Was this an isolated example, or is it testimony to a much wider diffusion of the type than hitherto known? Without more substantial evidence, it is difficult to say. But, given the poem of Corippus, and the presumed patronage of the earliest Roman example in S. Maria Antiqua, the cult of Mary as empress may well have found its origins at the Byzantine court. Although its popularity in the East may have been comparatively short-lived, in the West it would be re-born c.700 under the auspices of a line of popes of eastern origin, who did much to introduce Byzantine liturgical and artistic practices. Thereafter, the Roman church would make the type particularly its own.

There can be little doubt that its subsequent history is closely linked to the institution of the papacy. There are no known examples of this iconographic type which can plausibly be assigned to the seventh century,[27] and it should be remembered that the mural in S. Maria Antiqua would *not* have been visible after c.575. By contrast, however, the eighth century witnesses what can only be described as an explosion of interest in this theme, including the mosaic of John VII formerly in Old St Peter's, two new murals in S. Maria Antiqua (the first in the Theodotus chapel, and the second in the atrium), other wall-paintings in S. Clemente (Fig. 10.3),[28] S. Lorenzo fuori le mura,[29] and S. Susanna,[30] and the imposing icon of the 'Madonna della Clemenza' in S. Maria in Trastevere.[31] A number of these also feature papal portraits, thus leaving little doubt as to the source of the patronage. As the papal state developed its fledgling wings in the eighth century, the imperial image of the enthroned Mother of God found new life – and the link to contemporary politics should

not be underestimated.[32] This would be true again with the revival of the type in the early twelfth century.

In addition to the *Maria Regina*, there are two other groups of Marian images which became prominent in the visual culture of early medieval Rome. The first is a series of painted icons, a number of which were rediscovered beneath later medieval overpaintings in the years following World War II. Included in this group are icons from S. Maria Nova, the Pantheon, the *Monasterium Tempuli*, and the previously mentioned *Maria Regina* from S. Maria in Trastevere.[33] All are difficult to date with precision, although the Pantheon icon is widely assumed to have been installed as part of the process of transforming the pagan temple into a church in the year 609. Little or nothing is known about their original settings and function, nor even whether they were painted in Rome. However, it is widely assumed that they were used for devotional purposes in the same way as icons in contemporary Byzantium, of which Rome was at least nominally still an important part.[34]

The second and much less studied group consists of images of the Madonna and Child located in small niches, of which the example in the right aisle of S. Clemente, perhaps dating to the middle or second half of the eighth century, has already been mentioned. The *Maria Regina* recently discovered at S. Susanna might also originally have decorated a wall niche, although its original context will likely never be known. Other examples in niches, however, depict Mary in a much more traditional, and less regal, manner. Of these, perhaps the best known may be found in the niche cut into the north-west pillar in S. Maria Antiqua, part of the campaign of redecoration undertaken in the early eighth century by Pope John VII (Fig. 10.4).[35] Very close to this mural in terms of style, and possibly of exactly contemporary date, is the niche in the entrance chamber to the Catacomb of S. Valentino, located just to the north of the city on the Via Flaminia, in the stretch between the Porta Flaminia and the Ponte Milvio.[36] Of much less certain date are niches in the crypts below the vestibule of SS. Cosma e Damiano in the Roman Forum,[37] and the extra-mural church of S. Urbano alla Caffarella.[38] Once again, these depict Mary in more traditional dress, and in both instances flanked by saints.

Although the precise function of these niche images has yet to be determined, it may perhaps be inferred that they constitute more personal expressions of religious devotion, associated more directly with actual cult practice, as opposed to more 'political' statements of dogma. Archaeology may also assist us in this regard. In the lower church of S. Clemente, for example, the niche cut into the outer wall of the right aisle received at least two campaigns of decoration, both apparently depicting the same subject. At the time of its discovery, the uppermost of these layers crumbled away, revealing the earlier image beneath: the enthroned *Maria Regina* with infant

Christ which survives today (Fig. 10.3). Mary's imperial vestments, and crown with hanging *prependoulia*, bear such a close resemblance to contemporary Byzantine imagery, for example the mosaic portrait of the empress Theodora in the church of S. Vitale at Ravenna, that one scholar even suggested that the mural had initially depicted that empress, and was only later changed into a depiction of Mary by the addition of the Child.[39] However, an examination of the plaster surface reveals that both elements of the composition belong to the same pictorial campaign, and thus its religious nature was present from the start. But the more interesting question is perhaps: what are the Madonna and Child doing here?

Despite almost four centuries of scholarly interest in Rome's early churches, rather little is known today about how the different spaces, and above all the peripheral spaces, actually functioned in the early Middle Ages. Was the right aisle reserved for the laity? Or more specifically for women?[40] In the absence of explicit contemporary texts which treat this issue, answers to such questions are not easy to find. To date, the most useful source has been a series of protocols for papal services and ceremonies, known as the *Ordines Romani*. It is generally accepted that the Early Christian church provided separate spaces, not only to divide the laity from the clergy, but also to divide men from women, and that this division persisted in Rome through the early Middle Ages. The *Ordo Romanus* I, compiled probably at the end of the seventh century, describes in some detail the movements of the celebrant during the offertory and communion, first to the 'senatorium' on his right (the place of greater honour), and secondly to the 'pars mulierum' to his left.[41] The *Liber Pontificalis* also uses the term 'matroneum' to indicate one part of the latter space, at the head of the right, or north, aisle.[42] It should be remembered here that Rome's major churches were all occidented, not oriented, and that in this period the celebrant stood behind the altar, with his back to the apse, facing the congregation.[43] Thus his 'right side' is what we would normally think of as the 'left' aisle, and the 'pars mulierum' corresponded to the 'right' aisle. This may help to explain, among other things, the location of the funerary chapel of Theodora, mother of Pope Paschal I, adjoining the right aisle of S. Prassede. As late as the first half of the ninth century, Pope Gregory IV (827-844) apparently found the mingling of the congregation at S. Maria in Trastevere to be objectionable, and thus took steps to put things right. We are told specifically that he 'joined on the northern aisle a "matroneum" fenced round with stone'.[44] In the light of this separation of the sexes, it is interesting to observe that the Marian niches at both S. Maria Antiqua and the lower church of S. Clemente are to be found on the right side of the church as one enters, and hence were located in the 'pars mulierum'. This is also true for a second niche in S. Maria Antiqua, in the outer wall of the right aisle, which depicts the three 'holy mothers' with their children: Mary with the infant

Jesus, flanked by Anne with the infant Mary, and Elizabeth with the infant John the Baptist.[45] Did this happen by chance, or can more significant reasons be adduced? Is it possible, for example, that the veneration of images of the Madonna and Child was primarily an activity undertaken by women? In addition to popes, of course!

Further insights may perhaps be provided by evidence found at the sites themselves, evidence which has hitherto been all too frequently overlooked. At S. Clemente, for example, recent archaeology has brought to light a series of rooms, including a baptistery, located beyond the right aisle wall of the basilica. Their decoration includes another image of the Madonna and Child, this time without the imperial vestments, although still richly dressed and perhaps dating from the eleventh or twelfth centuries.[46] But while this is important for our general understanding of the larger site, and for its chronology, it is not particularly helpful for understanding the specific function of the right-aisle niche. For that we are still very much in the dark, although there is one tangible bit of evidence which may assist us: the presence of graffiti. These are located on the back wall, to the right of Mary's throne, and consist of four names, two of which are additionally identified as priests: Johannes *presbyter*, Rosa, Vitalis, and Salvio *presbyter*.[47] Graffito signatures of this type are not uncommon in early medieval Rome, particularly in the period of the seventh through the ninth centuries.[48] A much larger number may be found, for example, elsewhere in S. Clemente itself, on the mural in the nave depicting the Ascension of Christ.[49] This latter mural was associated with the prominent display of some object or relic, beneath which was set a small altar, and presumably it formed some sort of focus for cult activity, although once again its precise function has not been determined.[50] As is still the case today, such graffiti constitute a tangible attestation of physical presence. They create a permanent record of an ephemeral moment. Thus the act of being present was presumably imbued with some sort of significance, worthy of being recorded, and this in turn would have been linked to the site. Carola Jäggi, noting that early medieval graffiti are usually found on iconic as opposed to narrative images, has suggested that this significance is related to the intercessory function of whichever saint was depicted in the mural: in other words, by creating a permanent record of the request for intercession, the request itself was carried forward in perpetuity.[51] The Ascension mural might at first glance appear to be the exception which proves her rule, since it is a narrative event, but here it may be the relic set in the wall above the altar which provided the focus, and not the event of the Ascension itself. Otherwise, Jäggi's observation does appear to ring true. While perhaps of lesser importance than the Ascension mural in the nave, the niche in the right aisle was evidently also a site of some significance, at which priests and others did something of sufficient meaning that they wished to

have their participation recorded for posterity. It is also interesting to note that one of the signatories is presumably a woman, Rosa, unlike the Ascension mural where all the names are male. Indeed, I am not aware of any other female names in the *corpus* of graffiti which have survived from Rome's early medieval churches. Such names are not only male, but usually also clearly identified as members of the clergy rather than the laity, although this restriction does not apply to graffiti found in the catacombs. Perhaps it also says something about the exercise of power in terms of controlling access. Presumably then, as now, not everyone was allowed to carve their names in the painted plaster, or at least not with official sanction. In this regard, church walls must have been easier to monitor than catacomb shrines.

The niche in the north-west pillar at S. Maria Antiqua, displaying only the half-figures of the Madonna and Child, may also contain evidence useful for this discussion. As has been documented by Eva Tea and Per Jonas Nordhagen, when this niche was repainted in the campaign sponsored by Pope John VII, the artists responsible were asked to preserve some sort of object in the upper right corner, possibly an *ex-voto* offering or a lamp. This necessitated cutting off the new mural before it reached the corner. Nail holes on the surrounding face of the pillar, also recorded by Tea and Nordhagen and still clearly visible, may provide further evidence of *ex-votos*, implying that this image, and presumably its seventh-century predecessor, was again the focus of some devotional practice.[52] Given the location of the niche outside the presbytery, and the probability of *ex-voto* offerings, it is plausible to suggest that this cult practice was associated with the laity, and not the clergy, even if Nordhagen is correct in identifying the fragmentary donor figure to the left of the niche as Pope John VII himself. Perhaps surprisingly, there are no discernible traces here of graffito signatures.

It is also worth noting that the niches at S. Clemente and S. Maria Antiqua were both repainted at a fairly early date. While we cannot be certain what prompted this, there is no suggestion that the earlier painting was dilapidated and in need of repair, nor that the subject matter was changed in the process. Indeed, at S. Clemente, where it is the earlier of the two levels that survives, we know from eyewitness accounts of the discovery that the second layer also depicted a Madonna and Child.[53] This practice of 'refurbishing' images of the Madonna and Child is well known from icons, including most of the early examples in Rome which were rediscovered beneath later re-paintings during the course of a modern restoration. In Italy, it would continue until the very late Middle Ages, and has been linked to expressions of popular piety and devotion, rather than to any physical deterioration.[54]

That these images are set in niches, as opposed to being painted on the flat surface of a wall, must also be of some significance. In the ancient world, niches served a wide variety of purposes, housing everything from statues to

cinerary urns. In the early Middle Ages, however, the range of their use was considerably more restricted. In the context of painted images, niches provided a physical space for the placement of objects adjacent to the image which they both contained and framed: for example, lamps or candles at places of burial, in a tradition which may be traced back through funerary practice in the Roman catacombs.[55] At S. Clemente, the niche is quite large: some 200 cm in height, 94 cm wide, and 69 cm deep, with its base set some 86 cm above the floor (Fig. 10.5). The base is itself decorated with small tesserae of coloured stone, arranged in a geometric pattern, perhaps suggesting that it was of some importance, although there is no evidence to indicate what object or objects may have been placed here. It is also worth noting that the evidence of the surviving plaster suggests that the mural was confined to the upper part of the back wall of the niche. By contrast, the niche in the pillar at S. Maria Antiqua, fully occupied by its mural decoration, is very small and much squarer, measuring only 45 cm in height, 53 cm wide, and 24 cm deep, although beginning 115 cm above the floor. However, it may once have had an elegant marble frame, given the one piece of green serpentine which still survives on its left side. Unlike its counterpart in S. Clemente, this base had no fancy design, although Nordhagen does draw attention to the presence of a sizeable circular cavity, some 15 cm in diameter. He suggests that this may have been used for relics,[56] but its very simple nature perhaps indicates a more prosaic function, possibly as a receptacle for a lamp or a candle.

The offering of candles to important images of Mary and other saints has a long history in Christian religious practice, stemming from earlier pagan usage, and of course continues in the Roman Catholic and Orthodox churches to this day.[57] The candle is in the first instance a tangible gift, requiring some expense by the donor, and it serves a practical purpose in terms of providing illumination for the image which it honours. But its wax is also a material which is consumed as it burns, transformed into smoke which rises to the heavens, thus transferring the gift to a higher physical plane. It is probably significant that a number of early medieval images in Roman churches actually portray lay donors offering candles to Mary and other religious figures: the widow Turtura in the Catacomb of Commodilla; the *primicerius* Theodotus in the chapel to the left of the apse in S. Maria Antiqua; an unidentified and very fragmentary woman in a large niche in the atrium of the same church;[58] and the family of Beno de Rapiza in the nave and narthex of the lower church of S. Clemente.[59] A good early medieval parallel outside of Rome may be found at Torba, north of Milan, in which a female donor presents a candle to a Madonna and Child of the Hodegetria type.[60] This must reflect actual devotional practice, and would in turn necessitate the provision of some sort of space in or on which the candles would be placed. Setting the devotional image in a niche certainly solved this problem. And thus it is tempting to think

of the group of niche images as representing a special class of devotional pictures, not unlike the more traditional icons on wooden panels in terms of how they functioned, but unlike the icons obviously not portable. As we obtain better knowledge of how the interior space of churches was put to use in this period, we may eventually gain a better understanding of this phenomenon.

Writing to Charlemagne c.791 following his receipt of the so-called *Libri Carolini*, Pope Hadrian I commented on the importance of images for Roman religious practice, making specific reference to images of Mary: '... sanctamque semper virginem eius genetricem Mariam ... sacras effigies atque imagines...'.[61] Later in the same letter he borrows from the rhetoric of those opposed to Byzantine iconoclasm in explaining how these images worked to bridge the gulf between the visible face and the invisible majesty of holy persons, just as the Son of God himself has been incarnated in the flesh as a human being: 'Quia in universo mundo, ubi christianitas est, ipse sacre imagines permanentes ab omnibus fidelibus honorantur, ut per visibilem vultum ad invisibilem divinitatis maiestatem mens nostra rapiatur spiritali affectu per contemplationem figurate imaginis secundum carnem, quam filius Dei pro nostra salute suscipere dignatus est'.[62] For the Roman church, images provided the tangible link between this world and the next, enabling the devotee to transcend the gulf between the 'visible face' and the 'invisible majesty' of God and his saints; and given this intense Roman focus on the cult of Mary, it perhaps comes as no surprise to find that it is her image, above all others, which dominates so much of the surviving pictorial art of this era.[63]

## Notes

1. See the exhibition catalogue, *Mother of God. Representations of the Virgin in Byzantine Art*, ed. M. Vassilaki (Milan, 2000), with a succinct summary of the growth of the importance of Mary in Early Christian theology in the essay by A. Cameron, 'The Early Cult of the Virgin', 3-15.

2. This topic has been recently surveyed by C. Mango, 'Constantinople as Theotokoupolis', in *Mother of God*, ed. Vassilaki, 16-25.

3. There is considerable literature on this topic, including T. Klauser, 'Rom und der Kult des Gottesmutter Maria', *Jahrbuch für Antike und Christentum* 15 (1972), 120-135, and E. Russo, 'L'affresco di Turtura nel cimitero di Commodilla, l'icona di S. Maria in Trastevere e le più antiche feste della Madonna a Roma', *Bullettino dell'Istituto Storico Italiano per il Medioevo e Archivio Muratoriano* 88 (1979), 35-85; 89 (1980-81), 71-150.

4. For the most recent discussion, see F. Bisconti, 'La Madonna di Priscilla: interventi di restauro ed ipotesi sulla dinamica decorativa', *Rivista di Archeologia Cristiana* 72 (1996), 7-34.

5. For the costume, see B. Brenk, *Die frühchristlichen Mosaiken in S. Maria Maggiore zu Rom* (Wiesbaden, 1975), 50.

6.  For the first study devoted specifically to this iconographic type, see M. Lawrence, 'Maria Regina', *ArtB* 7 (1924-25), 150-161, whose conclusions have not been substantially altered by subsequent research. For the political connotations of this imagery in the context of the twelfth-century papacy, see U. Nilgen, 'Maria Regina – Ein politischer Kultbildtypus?', *Römisches Jahrbuch für Kunstgeschichte* 19 (1981), 1-33; and M. Stroll, 'Maria *Regina*: Papal Symbol', in *Queens and Queenship in Medieval Europe*, ed. A. Duggan (Woodbridge, 1997), 173-203.

7.  *Liber pontificalis*, ed. L. Duchesne, 2 vols (Paris, 1886-92) I, 317.

8.  *Liber pontificalis* I, 376. That Pope Sergius based these innovations on contemporary Byzantine models, at least in part, is suggested, for example, by the choice of the Gospel reading assigned to the Feast of the Assumption: see the discussion by M. Fassler, 'Mary's Nativity, Fulbert of Chartres, and the *Stirps Jesse*: liturgical innovation circa 1000 and its afterlife', *Speculum* 75 (2000), 389-434, at 392-395. My thanks to Jim Bugslag for drawing my attention to this article.

9.  See Per J. Nordhagen, 'The Mosaics of John VII (A.D. 705-707)', *Acta ad archaeologiam et artium historiam pertinentia* 2 (1965), 121-166; O. Etinhof, 'I mosaici di Roma nella raccolta di P. Sevastjanov', *Bollettino d'Arte* 66 (March-April 1991), 29-38; A. van Dijk, *The Oratory of Pope John VII (705-707) in Old St Peter's* (Ph.D. dissertation, The Johns Hopkins University, Baltimore, 1995).

10. The figure of Mary is preserved today in the church of S. Marco in Florence; that of Pope John is in the Vatican grottoes. See Nordhagen, 'The Mosaics of John VII', cat. nos 1 and 2.

11. Ibid., pl. XVIII.

12. The evidence is summarized by van Dijk, *Oratory of Pope John VII*, 106-108.

13. '+ S(anct)AE D(e)I [geni]T[ri]CI SEMP[erque Virgini Mar]IAE': see Per J. Nordhagen, 'The Frescoes of John VII (A.D. 705-707) in S. Maria Antiqua in Rome', *Acta ad archaeologiam et artium historiam pertinentia* 3 (1968), 39.

14. G. Rushforth, 'The Church of S. Maria Antiqua', *Papers of the British School at Rome* 1 (1902), 1-123, at 89-91.

15. See R. Deshman, 'Servants of the Mother of God in Byzantine and medieval art', *Word & Image* 5 (1989), 33-70.

16. Rushforth, 'S. Maria Antiqua', 102-104; J. Osborne, 'The atrium of S. Maria Antiqua, Rome: a history in art', *Papers of the British School at Rome* 55 (1987), 186-223, at 194-196.

17. N. Gray, 'The paleography of Latin inscriptions in the eighth, ninth and tenth centuries in Italy', *Papers of the British School at Rome* 16 (1948), 38-162, at 55. The inscription has recently been reproduced in *Roma dall'Antichità al Medioevo: Archeologia e Storia*, ed. M. Arena et al. (Milan, 2001), 112. Eustathius is recorded as an envoy of Pope Stephen II in c.756.

18. See C.R. Morey, 'The inscription on the enameled cross of Paschal I', *ArtB* 19 (1937), 595-596.

19. See Rushforth, 'The Church of S. Maria Antiqua', 67-73; and Per J. Nordhagen, 'The earliest decorations in Santa Maria Antiqua and their date', *Acta ad archaeologiam et artium historiam pertinentia* 1 (1962), 53-72, at 58-61.

20. Despite some claims to the contrary, the coin may indeed exist: see Osborne, 'The atrium of S. Maria Antiqua', 188-189, n. 11.

21. For the date and attribution of the *Akathistos* hymn, see E. Wellesz, 'The "Akathistos": a study in Byzantine hymnography', *DOP* 9-10 (1956), 141-174.

22. A. Cameron, 'The Theotokos in sixth-century Constantinople', *Journal of Theological Studies* N.S. 29 (1978), 79-108, at 85. For the text: Flavius Cresconius Corippus, *In laudem Justini Augusti minoris*, ed. and trans. A. Cameron (London, 1976), II, 52-53.

23. Cameron, 'The Early Cult of the Virgin', 12-13. It is interesting to note that Justin II added a large new basilica at Blachernai, and also made gifts to the Chalkoprateia.

24. K. Weitzmann, *The Monastery of Saint Catherine at Mount Sinai. The Icons. Volume One: From the Sixth to the Tenth Century* (Princeton, 1976), 18-21 (B3). The most recent discussion of this icon is the entry by R. Cormack in *Mother of God*, 262-263, where it is described as '6th century (?). Constantinople (?)'.

25. For the 'imperial' nature of the installation of the Marian cult see the cogent remarks of A. Augenti, 'Continuity and Discontinuity of a Seat of Power: the Palatine Hill from the Fifth to the Tenth Century', in *Early Medieval Rome and the Christian West: Essays in Honour of Donald A. Bullough*, ed. J. Smith (Leiden, 2000), 43-53, at 50-51.

26. N. Thierry, 'Une mosaïque à Dyrrachium', *CahArch* 18 (1968), 227-229; and M. Andaloro, 'I mosaici parietali di Durazzo o dell'origine costantinopolitana del tema iconografica di Maria Regina', *Studien zur spätantiken und byzantinischen Kunst*, eds O. Feld and U. Peschlow (Bonn, 1986), III, 103-112. The suggestion that the central figure represents the *Maria Regina* was first made by Robin Cormack, in a seminar at the Courtauld Institute in December 1976. I am honoured to have had the opportunity to examine the mosaic in his company, earlier that same year on 18 April. It should be noted, however, that the identification of the figure as Mary is not universally accepted; for example, see V. Pace, 'Between East and West', in *Mother of God*, ed. Vassilaki, 424-433, at 425. The visual evidence is ambiguous at best, although most observers in April 1976 were convinced that the face was intended to be that of a woman, not a man. To complicate matters, the figure holds an orb and sceptre, and not the usual infant Jesus.

27. This is not entirely an argument 'ex silentio'. While seventh-century images of Mary are not plentiful in Rome, a good example may be found in the apse mosaic of the S. Venanzio chapel at the Lateran Baptistery.

28. See J. Osborne, 'Early medieval painting in S. Clemente, Rome: the Madonna and Child in the niche', *Gesta* 20 (1981), 299-310.

29. The S. Lorenzo mural was found in the mid nineteenth century and subsequently destroyed when this part of the church was remodelled to serve as the tomb of Pope Pius IX. It is known principally from a watercolour copy, preserved in the Raccolta Lanciani at the Palazzo Venezia (XI, 45, ii, no. 31726), published in A. Muñoz, *La basilica di S. Lorenzo fuori le mura, Roma* (Rome, 1944), pl. 89.

30. Excavations beneath the floor of S. Susanna in September 1991 brought to light a most curious discovery: a sarcophagus containing thousands of fragments of mural painting, including a *Maria Regina*: see M. Cecchelli, 'Dati da scavi recenti di monumenti cristiani. Sintesi relativa a diverse indagini in corso', *Mélanges de l'École Française de Rome: Moyen Âge* 111 (1999), 227-251, at 239-240; and M. Andaloro, 'S. Susanna. Gli affreschi frammentati', in *Roma dall'Antichità al Medioevo*, 643-645.

31. C. Bertelli, *La Madonna di S. Maria in Trastevere* (Rome, 1961); and M. Andaloro, 'La datazione della tavola di S. Maria in Trastevere', *Rivista dell'Istituto Nazionale d'Archeologia e Storia dell'Arte* 19-20 (1972-73), 139-215. Although Bertelli's attribution of the icon to the

time of Pope John VII has been widely accepted, Andaloro makes a compelling case for dating it much earlier. The figure of the kneeling pontiff may still have been intended as a portrait of John VII, however. At least parts of it are additions in tempera to an icon painted in encaustic, and this is certainly plausible for a pope well known for including his own image in his projects.

32. The idea is developed by H. Belting, 'Papal artistic commissions as definitions of the medieval church in Rome', *Light on the Eternal City: Observations and Discoveries in the Art and Architecture of Rome*, eds H. Hager and S.S. Munshower, Papers in Art History from the Pennsylvania State University II (University Park, PA, 1987), 13-29, at 14-15; Stroll, 'Maria *Regina*: Papal Symbol', 177; and most recently by T. Noble, 'Topography, celebration and power: the making of a papal Rome in the eighth and ninth centuries', in *Topographies of Power in the Early Middle Ages*, eds M. de Jong and F. Theuws (Leiden, 2001), 45-91, at 66, who observes: 'As the popes were separating themselves from Byzantium, it is striking that they very quickly fashioned an explicit message saying that their allegiance was not owed to anyone on earth'.

33. In 1988 all four were brought together for a special exhibition. For colour photographs and a complete bibliography, see the catalogue P. Amato, *De Vera Effigie Mariae: Antiche Icone Romane* (Rome, 1988). For the most recent discussion of this group, see M. Andaloro, 'Le icone a Roma in età preiconoclasta', *Roma fra Oriente e Occidente*, Settimane di Studio del Centro Italiano di Studi sull'Alto Medioevo XLIX (Spoleto, 2002), 719-753.

34. For the similarity of Roman and Byzantine usage of icons, see J.-M. Sansterre, 'Entre "Koinè méditerranéenne", influences byzantines et particularités locales: le culte des images et ses limites à Rome dans le haut Moyen Âge', *Europa medievale e mondo bizantino: contatti effettivi e possibilità di studi comparati*, eds G. Arnaldi and G. Cavallo, Istituto Storico Italiano per il Medio Evo: Nuovi Studi Storici 40 (Rome, 1997), 109-124. For a discussion of the very plausible suggestion that they may also have functioned as a replacement for relics, required for the dedication of a church, see C. Barber, 'Early representations of the Mother of God', in *Mother of God*, ed. Vassilaki, 252-261, at 255-256.

35. Nordhagen, 'The Frescoes of John VII', 75-76, pls. XCII, XCIII.

36. For a dating to the pontificate of John VII, see J. Osborne, 'Early medieval wall-paintings in the Catacomb of S. Valentino, Rome', *Papers of the British School at Rome* 49 (1981), 82-90.

37. See P. Mangia Renda, 'Il culto della Vergine nella basilica romana dei SS Cosma e Damiano dal X al XII sec.', *Rivista dell'Istituto Nazionale d'Archeologia e Storia dell'Arte* 8-9 (1985-86), 323-364, esp. 331-344 and fig.10. The proposed tenth-century date is by no means certain.

38. See K. Noreen, *Sant'Urbano alla Caffarella: Eleventh-Century Roman Wall Painting and the Sanctity of Martyrdom* (Ph.D. dissertation, The Johns Hopkins University, Baltimore, 1998), 61-79, where a date in the late ninth century is tentatively proposed.

39. See Osborne, 'Madonna and Child in the niche', 303. This error is still repeated in some guidebooks and in notices at the site.

40. As has been suggested for the right aisle of S. Maria Antiqua: see W. de Grüneisen, *Sainte Marie Antique* (Rome, 1911), 85.

41. M. Andrieu, *Les 'Ordines Romani' du Haut Moyen Ages. II: Les Textes (Ordines I-XIII)* (Louvain, 1971): OR I, 69, 74, 75, 13, 117, 118. For analysis, see T.F. Mathews, 'An early Roman chancel arrangement and its liturgical functions', *Rivista di Archeologia Cristiana* 38 (1962), 73-95; and S. de Blaauw, *Cultus et Decor. Liturgia e architettura nella Roma tardoantica e medievale*

(Vatican City, 1994), 83, 100-102. De Blaauw argues for a further distinction of men and women by rank, with the nobility being placed in closer proximity to the altar.

42. *Liber pontificalis* I, 202; II, 80. See also R. Davis, *The Lives of the Ninth-Century Popes (Liber pontificalis)* (Liverpool, 1995), 314. The *vita* of Paschal I (LP II, 60) also refers to the presence of women close to the altar, too close indeed for the pope's comfort!

43. See de Blaauw, *Cultus et Decor*, 82-83.

44. *Liber pontificalis* II, 80; translation from Davis, *Lives of the Ninth-Century Popes*, 65.

45. W. de Grüneisen, *Sainte Marie Antique*, 104 and fig. 84. J. David, 'L'église Sainte-Marie-Antique dans son état originaire. Étude liturgique et hagiographique suivie d'un catalogue raisonné des saints de cette église', in W. de Grüneisen, *Sainte Marie Antique*, 449-559, at 456, was among the first to observe that the proliferation of female saints on the right side of S. Maria Antiqua might reflect this liturgical division.

46. F. Guidobaldi, 'Gli scavi del 1993-95 nella basilica di S. Clemente a Roma e la scoperta del battistero paleocristiano. Nota preliminare', *Rivista di Archeologia Cristiana* 73 (1997), 459-491, esp. figs 10, 14.

47. The names are arranged in four lines, and read as follows (from top to bottom): IOH(annes) PR(es)B(yter)/ROSA/BITALIS/SALBIO PR(es)B(yter). The 'betacism', in which the sound of the modern letter 'v' is expressed through the letter 'b', is very common in texts and inscriptions from eighth-century Rome, including the inscription in the mid eighth-century Theodotus Chapel in S. Maria Antiqua, which refers to the '*birgo* Maria'.

48. For a general discussion of graffiti in early medieval Rome, see C. Tedeschi, 'L'onciale usuale a Roma e nell'area Romana in alcune iscrizioni graffite', *Scrittura e Civiltà* 16 (1992), 313-329; idem, '"Scrivere i santi": epigrafia del pellegrinaggio a Roma nei secoli VII-IX', *Roma fra Oriente e Occidente*, 323-360; and C. Jäggi, 'Graffiti as a Medium for Memoria in the Early and High Middle Ages', *Memory & Oblivion: Proceedings of the XXIXth International Congress of the History of Art*, eds W. Reinink and J. Stumpel (Dordrecht, 1999), 745-751.

49. See Tedeschi, 'L'onciale usuale', 319-320.

50. A good start on deciphering this has been made by W. Tronzo, 'Setting and structure in two Roman wall decorations of the early Middle Ages', *DOP* 41 (1987), 477-492, although no convincing identification has yet been offered for the relic which formed the focus of this small chapel.

51. Jäggi, 'Graffiti as a Medium for Memoria'.

52. E. Tea, *La basilica di S. Maria Antiqua* (Milan, 1937), 292; Nordhagen, 'The Frescoes of John VII', 75-76; Per J. Nordhagen, 'Icons designed for the display of sumptuous votive gifts', *DOP* 41 (1987), 453-460, at 454.

53. See, for example, the report by Felice Profili, secretary of the Pontifical Commission for Sacred Archeology, in *Il Giornale di Roma* for 8 January 1859. He reports the subject of the second level as 'una immagine della Beatissima Vergine, che teneva nel suo seno il Fanciullo Divino'. The plaster of this level crumbled and fell away within a few days of the excavation. The fragments seem not to have been kept.

54. For the general context of this practice, almost always in connection with images of Mary, see C. Hoeniger, *The Renovation of Paintings in Tuscany, 1250-1500* (Cambridge, 1995), 21-42.

55. For the importance of lamps burning before thaumaturgic images of saints, and the importance of their oil for effecting miraculous cures, see J.-M. Sansterre, 'Entre deux

mondes? La vénération des images à Rome et en Italie d'après les textes des VIe-XIe siècles', *Roma fra Oriente e Occidente*, 993-1050, at 995-6.

56. Nordhagen, 'The Frescoes of John VII', 75. The same suggestion had earlier been proposed by J. David, 'L'église de Sainte-Marie-Antique', 474, who noted that there were no liturgical texts which could be used to confirm this practice. The *Ordines Romani* refer only to the placement of relics in altars.

57. Cf. 'Cierge' in *Dictionnaire d'Archéologie chrétienne et de Liturgie*, eds F. Cabrol and H. Leclercq, 15 vols (Paris, 1907-57), III, 1613-1622.

58. See Osborne, 'The atrium of S. Maria Antiqua', 197-198, pl. XVIa. The candles are being offered to a large figure whose identity has not been established, although it is likely to have been Mary: see Nordhagen, 'The Frescoes of John VII', 83. If that identification could be confirmed, it would be another example to add to the list of Marian niche images.

59. See C. Filippini, *The eleventh-century frescoes of Clement and other saints in the Basilica of San Clemente in Rome* (Ph.D. dissertation, The Johns Hopkins University, Baltimore, 1999), 71-82, 155-158.

60. See C. Bertelli, *Gli affreschi nella torre di Torba* (Milan, 1988), 28 and fig. 44.

61. Hadrian, *Epistola* 5 in MGH 5 (Berlin 1899), 6-57, at 19.

62. Hadrian, *Epistola* 5, 56.

63. An earlier version of this paper was given at the 22nd Canadian Conference of Medieval Art Historians in April 2002. I am particularly grateful to Laura Marchiori for her insightful comments and useful bibliographic suggestions.

10.1 Detail of *Maria Regina*, 705-707 CE. S. Maria Antiqua, Rome (Istituto Centrale per il Catalogo e la Documentazione, Rome).

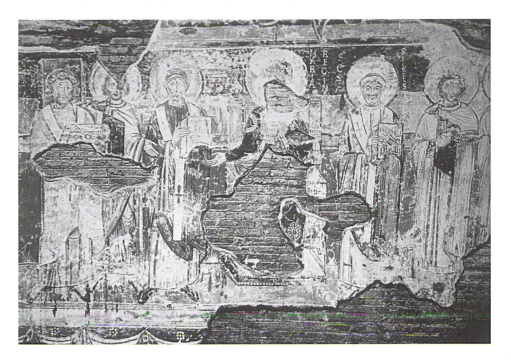

10.2 *Maria Regina* with saints and Pope Hadrian I, 772-795 CE. S. Maria Antiqua, Rome (after J. Wilpert, *Die römischen Mosaiken und Malereien* (Freiburg im Breisgau, 1917)).

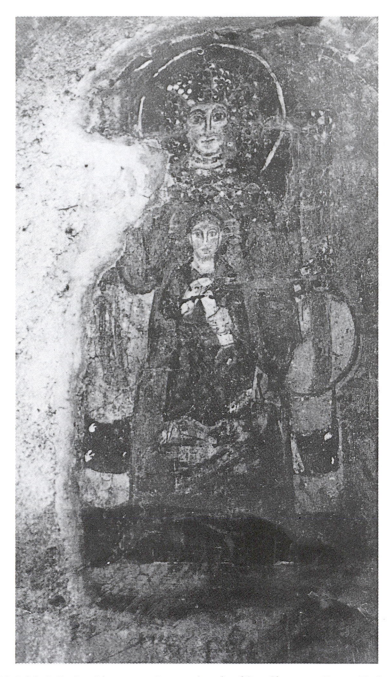

10.3 *Maria Regina*, 8th century. Lower church of San Clemente, Rome (Parker Collection no. 1267, The British School at Rome).

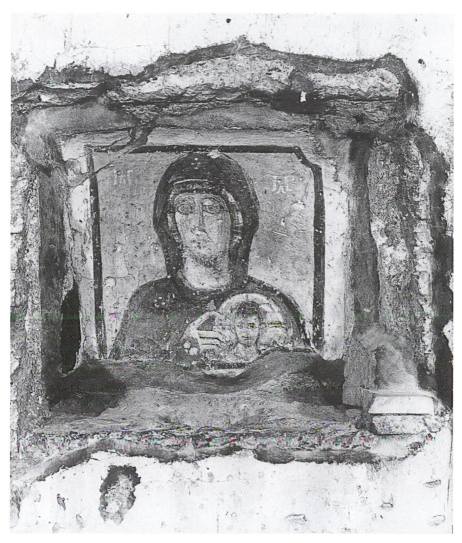

10.4 Niche with Madonna and Child, 705-707 CE. S. Maria Antiqua, Rome (Istituto Centrale per il Catalogo e la Documentazione, Rome).

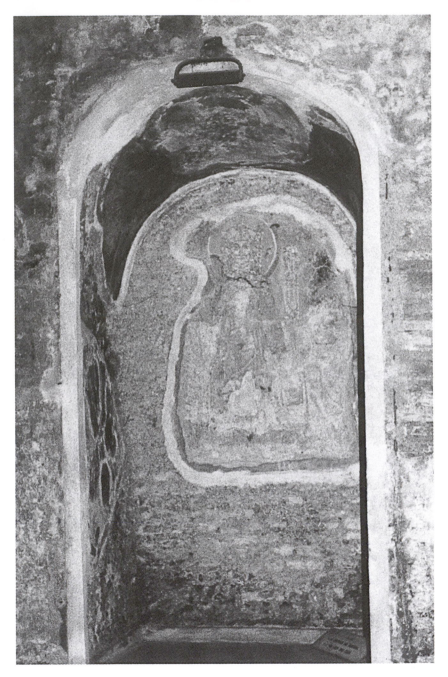

10.5 Niche with Madonna and Child, 8th century. San Clemente, Rome
(John Osborne).

Chapter 11

# Iconic Images of Children in the Church of St Demetrios, Thessaloniki

Cecily Hennessy

Among the known early mosaics in the church of St Demetrios in Thessaloniki, three show children protected by saints, and in all these the children are a central feature.[1] This raises questions about why images of children were so prevalent and the significance behind their depiction in the church. Because images dated prior to iconoclasm are scant, the mosaics provide important evidence regarding the visual representation of children, the function of early imagery, and the relation of images to the cult of St Demetrios. The portrayals do not seem to be depicting saints in their childhood, but rather children who lived at the time. While not icons in the strictest sense, the saints with whom the children appear do take the form of iconic figures, depicted with their hands raised in prayer or resting on the shoulders of the young they protect. To what extent were these children sanctified with the saints and may themselves have been objects of devotion, and in what ways may the images have been dedicated to children and viewed by both adults and children? Certainly very accessible, a child in close proximity to the saints would be easy to recognize and to identify with. To an adult, the image acts as a reminder of one's own childhood, one's own child, a grandchild, or friend, and to a child, it functions as a reflection of oneself. For children, a young boy or girl portrayed in the church is perhaps an emblem of youthful sanctity, a hero or heroine, exemplar to emulate or aspire to. The visual messages demonstrate clearly the view held in Thessaloniki that Demetrios was a saint of the city, who dwelled in the church and in heaven and might appear at any moment. He was accessible to little children who could approach him and be protected by him.[2]

The most elaborate of the mosaics, a series of scenes depicting a young girl

From *Icon and Word: the power of images in Byzantium. Studies presented to Robin Cormack*, eds Antony Eastmond and Liz James. © 2003 by contributors. Published by Ashgate Publishing Ltd, Gower House, Croft Road, Aldershot, Hampshire, GU11 3HR, England, pp. 157-172.

on the arcade of the north inner aisle, is lost and now known only from watercolours and photographs. These mosaics can probably be dated to the sixth century. Two other panels portraying children survive in their original positions in the church, one from the earlier and one from the later part of the seventh century. St Demetrios was intimately attached to Thessaloniki, the community was strongly dependent on his guardianship, and the church was a centre of pilgrimage. The city had localized lore in the form of the *Miracles of St Demetrios*, a collection of accounts of the Saint's miraculous deeds in Thessaloniki, written by two authors in the seventh century.[3] However, the images cannot be specifically linked with any narrative and do not commemorate events that merited a place within the written record. Therefore they inform about an aspect of the cult of St Demetrios that is not apparent from the contemporary accounts. The mosaics portraying the young girl may well be associated with a miraculous occurrence and do have a certain narrative element. However, they, like the two other panels showing children, may equally be viewed as votive offerings, marking spiritual devotion and societal position.

The series of mosaics depicting the little girl was destroyed in 1917, but various records made just prior give us a clear indication of its appearance. Of the early-twentieth-century photographs and watercolours, the paintings by W.S. George provide the most useful record of the mosaics (Figs. 11.1-11.4).[4] Although partially damaged by a fire c.620 and again later, the restored mosaics were visible in the church and functioned as votive imagery until 1492, when the building became a mosque and the mosaics were covered over. The records show that the mosaics extended over seven of the twelve arches of the arcade. Scenes are depicted in eight spandrels. Four scenes featuring the child are the central focus of the arcade and are framed by the orant Demetrios, on the first two spandrels and on the eighth, and by the Virgin, on the third. An inscription beneath the final spandrel reads, 'And you, my Lord St Demetrios, aid us your servants and your servant Maria, whom you gave to us'.[5] Since the child is the focus of the images, she must be the one referred to as Maria.[6] The images appear to be contemporaneous, and certainly the Maria scenes were created together as they are bordered by a consistent frame.[7]

Throughout the length of the mosaics, images show donors being led or protected by Demetrios or by the Virgin, indicating the links between the divine, the saintly, and the laity. They portray an integrated, caring and tactile relation between all elements in the human and divine hierarchy. In the other spandrels the donors are subsidiary, but in Maria's scenes the relationship between worshipper and saint is developed so that the child is the focus, first presented, then supplicating herself to the sacred. The mosaics are in a primary area of the church, situated near to St Demetrios's ciborion in which

he was thought to live, and in the first of Maria's scenes he is shown seated by his dwelling place. In the *Miracles*, he is described here, ever-present in the church, ready to receive prayers and to act on behalf of his people.[8] However, Demetrios is not necessarily depicted as living, since after his death he was believed to appear both in dreams and in the body and to intervene actively in people's lives. Maria is singled out as favoured since Demetrios appears to receive her from a young woman who, it is generally agreed, is her mother. Maria sits up and gazes out at the viewer with a mop of brown hair and a bright face. She has a cross on her forehead, which may well signify her baptism, since a story tells of a boy who is marked by a cross at his baptism when an icon of St Demetrios becomes his godfather.[9] Demetrios places his right hand on the child's shoulder, giving a sense of his familiarity and fleshly reality, while he points with his left to a lost medallion, probably of Christ. This indicates his act of linking mother, child, and God.

The second scene shows Maria, attended by members of her family, being presented to the Virgin and blessed by her. The Virgin, flanked by angels, points to the right, probably towards another lost image of Christ, and so she too intercedes on behalf of the child. Maria, now apparently older, is carried facing forward as if being offered to both the Virgin and to the viewer. The mother's sanctity is inferred through the protection of an angel who places a hand on her shoulder. In the following scene, Maria is old enough to walk and comes, with her mother and another woman, bearing gifts of candles for Demetrios. In the final episode, dressed in a white robe with a red and olive-green shawl over her head, a possible sign of increasing maturity, she steps forward on her own and gives him a bird. Accompanying her are two women, one of whom is her mother, and a man. Since the male figure is not only smaller than the mother but also beardless, he presumably is not the father, as mature men are generally shown with facial hair. It follows that Maria was either fatherless or her father had little role to play in her spiritual upbringing. Males are of little significance in these scenes, and particularly in this final image, women are shown to have a dominant role, apparently lauded for their piety. Maria's mother is her human protector and nurturer and it is through the mother's guidance that Maria is taking her own steps towards the saint.

Throughout the mosaics, the setting is one of natural vegetation, and in this final episode it is elaborated with flowers, leaves, a stream, and a fountain on a stone base. André Grabar suggested that Maria has died and that this setting represents paradise.[10] Yet this scene is not so very distinct from the others, and it would be perplexing if a dead infant were shown to age and mature. It is more likely that this is an idealized representation of the church and its environment. Eustathios, writing in the twelfth century, described the building as set amongst large trees and surrounded by greenery and running water, like a paradise.[11] The mosaic also includes a marble font and fountains,

as existed in the atrium.[12] The church itself was the scene of many of Demetrios' miracles: in times of trouble, the city's inhabitants fled there for protection, and during a plague, those who sought refuge in the church were miraculously saved.[13] The portrayal of Maria in this setting suggests such connotations. She, located in the church enclave and not in paradise, is a living person, portrayed in the idealized world of the saint's domain.

Although apparently dedicated to the saint, Maria does not forsake her relations. Not dressed as an oblate, she wears bright and rich clothes that suggest worldly wealth rather than asceticism. Comparable imagery often occurs in scenes where children are presented to religious authorities, such as in the dedication of the child Samuel and in the presentation of Christ in the temple. These portrayals therefore evoke a series of associations and references to holy biblical children.

Maria is blessed from childhood in the same way that certain hagiographies portray saints as marked out from other children, often by extreme piety and behaviour beyond their years. The inscription suggests intervention by Demetrios in Maria's life, and it may be that her birth was exceptional. Saints' vitae often depict a holy child as the much longed-for offspring of a barren woman or as a long-awaited son. Since having children was the main goal of marriage, infertility was viewed as a social disgrace, but also as evidence of God withholding his blessing.[14] Miraculous intervention, often induced by ritual practices, could result in a birth. Both male and female saints, such as St Stephen and St Elisabeth the Wonderworker, were born to women thought to be sterile or too old for childbirth.[15] The *Life of Saint Stephen*, who was born in 713, was written by Stephen the Deacon forty-two years after the saint's death and therefore some time later than our mosaics, and it was clearly intended to serve iconophilic purposes. However, Stephen's early life corresponds in several ways to the images of Maria.[16] Stephen's parents, Anne and Gregory, desperately wanted a son. Since Anne was growing old, she prayed repeatedly to the icon of the Virgin at Blachernai, saying that if she were blessed with a boy she would give him as a gift to Christ and God. On one occasion, the Virgin visited her in a dream and promised to fulfil her wish. Anne conceived, and forty days after the birth, she and her husband took the child, Stephen, to Blachernai and gave thanks to the icon, asking the Virgin to receive the boy whom she had created. Anne emphatically pointed out to her husband that the holy effigy was the guarantor, patron, and protector of Stephen's birth.[17]

This story contains many features that may be present in the Maria cycle: the close bond between mother and blessed child, the ambivalent role of a father, the series of rituals dedicated in thanks to the Virgin, the belief in the sanctity of the child, and the apparent deep gratitude for a longed-for infant. The author of Stephen's vita emphasizes that the patriarch Germanos names

the child before his birth, implying that Stephen's name is written in heaven and his life is pre-ordained by God.[18] Similarly, Maria must have been named after the Virgin and this gives her a particular bond with the Mother of God. Maria's life is depicted as blessed from babyhood, and her birth may well have been deemed to be miraculous. Women were seen to be primarily responsible for infertility or for not producing a son; and so, in Stephen's story, the child is not only blessed, but also the mother: Anne's great faith is rewarded and she too becomes saintly. In Maria's images, the mother shares in the closeness with the holy. She repeatedly protects and promotes the young child and builds the affiliation between Maria and the saints. Just as Maria and her mother are seen in repeated acts of devotion, Stephen's mother takes the child with her to give thanks to the Virgin, to offer him to the church, and to proffer night-time prayers at the monastery, presumably all designed both to make the child aware of his special connections and to give due thanks for his life. The four recurrent scenes in the Maria cycle bear a close resemblance to the series of events on which Stephen's faith is built. Moreover, the repetitive imagery of the orant St Demetrios seems appropriate to the successive rituals of prayer, marks of a blessed child being raised in the faith. Stephen's mother performs all the necessary acts to ensure the continued beneficence of the saint. Maria and her mother likewise are pictured in formal and ceremonial devotion to Demetrios and to the Virgin. Their ongoing protection is needed in a world of plague and high child mortality, where the only real insurance comes from God, mediated through saints and holy images.

The low profile of any male characters in Maria's mosaics, other than Demetrios, is also a feature of Stephen's story, and this also highlights the ambivalent role of men in the birth of holy children. A miraculous birth places women in an unusual position of power in the home and in the community. The mosaics portray a female-dominated world of supplication. Only one male figure is depicted, apart from Demetrios, and it is unlikely that he is the father. Similarly, Stephen's conception came not by man's doing but by the intercession of the icon in Anne's life, and it is through the mother's faith that the child is conceived. The father is a secondary figure, who merely witnesses the woman's rapport with the icon, is impressed by the emotion and power of her supplications and is firmly told who is responsible for the child – the Virgin. Therefore, the imagery chosen to depict Maria's early life may well be based on conventionalized attitudes and behaviour regarding blessed children.

The mosaics have a visual unity, but one in which the single images of Demetrios and the Virgin can be isolated, suggesting that worshippers could approach them individually for prayer. They appear to function as icons rather than as narrative elements, for the figures face forward and invite interpersonal contact. However, repetition of frontal imagery also within the Maria cycle suggests that these figures too were akin to the devotional images

at each end of the sequence. Perhaps Maria and her mother were likewise potential intermediaries through whom worshippers could communicate with the saints.

Although Maria was probably a local child, her images conceivably had both specific and universally understood meanings that were legible and significant to both local people and to pilgrims. In anthropological terms, such a symbol, the act of its viewing, or the relations it suggests, may provide a concept of the general order of existence.[19] The images of Maria, and the events surrounding the viewing of the images, are thus signs used to formulate concepts about life and belief. Religious symbols both shape and express the world, being both active and passive. Therefore the images articulate attitudes of belief, while at the same time this viewing influences and moulds faith and the context within which it operates. These symbols, in answering the human need to explain the unexplainable, may blur the lines between corporeal and spiritual reality, as in the treatment of miraculous relics and images. If we see the image of Maria as such a symbol, then her depiction may be slightly ambiguous. She appears in an intermediary state, neither little girl nor saint, presented by her mother to the holy, but always positioned between the spheres of family and of saints, between a physical reality and a conceptual reality of spiritual presences. A viewer may have registered this state of transition, a moment captured between two actualities. Pilgrimage has been defined as the transitional phase between segregation and aggregation, a liminal period separating people from normal life.[20] Can we see Maria's images reflecting or stimulating the pilgrims' sense of difference and a receptivity to growth and to transition in life?

The visitor to St Demetrios would perhaps identify with the child depicted in the image and self-referentially experience a like dedication to the holy. Simon Coleman and Jaś Elsner have suggested the physical characteristics of pilgrimage sites may lead to 'behavioural and ideological conformity', whereby movement through and actions within a site have theological significance.[21] The location controls the believer, and the peripatetical space and the visible imagery mould the pilgrim's experience. In our context, the imagery of Maria's devotion, set behind the ciborion housing the saint and clearly evoking the site of the church, would be read by the pilgrim along the length of the arcade. Thus each scene shows the passage of time with the child increasing in devotion, surrounded by an increasing number of family or friends. The imagery shapes the pilgrim's experience at the site, forming a visual analogy to his or her own supplication to the divine.

Yet the image functioning in this way is that of a child, which visually articulates the idea of spiritual growth through growing up. It has wide appeal to both the mature and the immature. Maria, though likely representing an individual, may also stand for little children in general, and her mother for any

maternal figure. This is perhaps why the scenes are not highly specialized, but rather suggest a universal devotion and benediction, which is immediately recognizable and with which worshippers can identify. The Maria cycle implies that children can be blessed and holy, that they owe that blessedness to the saint and to the Virgin, that mothers are instrumental in their lives, and that faith and obedience bring rewards.

Imagery can rewrite the past and can inspire new chapters or new readings of old chapters in the lore associated with a holy site. The rereading of fresh experiences within the existing visual formula and the creation of innovative texts or images leads to a complex layering of interpretation, whereby the original impetus for the imagery, whether an individualized event or a generalized symbol of faith, may spawn later histories or narratives, invented and reinvented by pilgrims and believers whose experience is formulated by the site. The Maria cycle demonstrates the spiritual life of a child, the important role children may have in the community and the perception that they can be inherently blessed. The presentation of the images and their context suggest ways they might affect the religious understanding and experience of worshippers, so a child may function as a transmitter of faith, an avenue that offers access to the divine for both adults and children.

Turning to the two extant mosaics in the church depicting children: the first, thought to be made prior to a fire c.620, is situated on an elevated wall in the south aisle, and so is viewed as one walks from the sanctuary towards the back of the church (Fig. 11.5). Demetrios stands to the left in the orant position, while an older and a younger boy, brothers perhaps, move forward in tandem towards the saint with their arms reaching out and their faces turned towards the viewer. The taller figure is still a youth, with the lack of a beard giving him a look of immaturity.[22] Both he and the smaller boy have short dark hair and covered hands. A further figure formerly stood to the left of the saint, although only the lower legs and bottom half of the robe remain. From the size of the feet, it seems this also represented a child. The setting is verdant with trees and shrubs, but with a mark of civilization given by a vase on top of a column. Demetrios is apparently positioned outside his ciborion, and the scene could represent him in a heavenly garden of paradise, or at home in his church, or a combination of the two.[23] The boys are not marked by haloes or by any sign of sanctity, but approach the saint with veiled hands to honour him. They have individualized faces and it seems likely that their identity, although there are no inscriptions, would have been recognizable at the time the mosaic was created. The children are not with their parents; together, as siblings or as associated young people, they honour the saint. One can speculate that parents of the children paid for the panel, yet it is intriguing that they are not represented, although of course they could have been depicted in an adjacent image, now lost. If the boys are living, possibly,

Demetrios was seen to have helped them, perhaps through an illness, and they are portrayed giving thanks. Alternatively, the boys may have died and be shown in paradise. In either case, as this panel stands, it visualizes a child's and a youth's connection with the saint as an independent relationship, apart from that of their parents.

This may also be the case in the other extant portrayal of children in the church, which is positioned on the west facing side of the north pier at the entrance to the chancel (Fig. 11.6). This mosaic is slightly later in date, being made after the c.620 fire during the reconstruction of the church. Near here in the crypt was, at least from the ninth century, a reliquary containing earth and miraculous oil, and the site may have been of particular importance earlier.[24] The mosaic is also close to the sanctuary and highly visible. In this image a youthful saint is shown standing between two children, with his right hand raised as if praying or blessing. Since his hair is longer and curlier than that of Demetrios as depicted elsewhere in the church, it is likely that he is St Bakchos, since St Sergios is shown as a pendant on the pier on the other side of the chancel.[25] Although the saint is the central and the largest figure, the magnetism of the image lies in the children at his side. To the left stands a small boy, perhaps about five years old, with short dark hair and veiled hands. To the right is another child with lighter hair, slightly older, with Bakchos's hand resting on his or her shoulder. This is a distinctly intimate construct, the three figures standing close together and the children safe under the saint's protection. Each faces frontally, with large almond-shaped eyes gazing steadfastly and directly. There is no evidence that the children are related, and it is perhaps incorrect to make that assumption. If they were brothers, one might imagine that the eldest and more important would be on the saint's right, but in fact the younger child takes that place. Perhaps the taller one is a girl, since she might well, although older, take second place to her brother.

It is possible that in this case the fathers of the children are shown in nearby mosaics. On the north-facing side of the pier, St Demetrios is portrayed with the bishop and the eparch. An inscription below names the men as founders (probably restorers) of the church and records the miraculous protection of the city from barbarians. The bishop is depicted in a reconstructed roundel on the north aisle along with a deacon.[26] This deacon also appears on the east-facing wall of the south pier next to Demetrios. Since bishops were not allowed to marry, one could argue that the children on the pier are most likely those of the deacon or eparch, who was a civil governor with jurisdiction over the diocese. Ernst Kitzinger suggested that the children are the sons of the eparch and that a portrait of the wife of the eparch, the mother of the children, might have been on the south-facing wall of the north pier, where there is now a later mosaic showing the Virgin and a saint, yet there is no evidence to substantiate this.[27] Like priests, deacons were

permitted to marry before they were ordained; but the bishop cannot be entirely excluded as a possible parent, since a bishop could have had children before reaching higher orders.[28] Although we cannot prove that the children are the offspring of any of the officials portrayed on the piers, it seems quite probable. The attire of these adults clearly articulates their place in society. Demetrios wears the robe of an aristocratic member of the senate, and the bishop and governor hold their attributes of office, which may suggest that the children are also depicted in a way that refers their place in society. They look well dressed, wearing long robes. If the children were intended to represent the concept of childhood or children in general, they might well have been depicted in more humble attire. Furthermore, they are placed on the same footing in relation to the saints as the church and civic leaders. The dominant presence of the bishop and dignitaries, displaying their religiosity and their generosity to the church and its congregation, and the presence of the children emphasizes the role of patrons in religious and community life. The children's mosaic is in a highly visible part of the church, near to the sanctuary. This is not a private setting, tucked away in an intimate chapel, but one that the congregation would face during the liturgy. Did the people of the city and the visiting pilgrims look upon the children as an inspiration to faith, as the prided descendants of city magnates, or as a combination of the two? In what sense were the children seen to inherit the familial piety and largesse? The image suggests that they were closely associated with both.

It might have been more customary, and certainly following in the tradition of imperial dynastic portraiture, to present a family portrait with parents and offspring together. The absence of direct association with the parents in these extant examples at St Demetrios shows both the respect and consideration granted to children as individual subjects and recognition of their spiritual independence, since they are portrayed with their own relationships to the saints. In this case, children's bonds are not necessarily primarily with the human family, but, within the context of the church, with a protector saint and the sacred.

The images of children in the church indicate a difference between the visual and the literary records. In the *Miracles*, there are no accounts of Demetrios curing children or having them dedicated to him. The author of the first book of miracles, written in the first half of the seventh century, notes that he gives a representative selection of recent examples of miracles, yet none of these centres on a child. Children are mentioned as being aware of the saint's powers and having learnt about them from their parents.[29] They are hit by plague, harmed in civil war, and present at the burning of the ciborion: when the population rush to the church, the young people get there quicker as they wake up faster.[30] Yet none of this is concerned with specific children and the accounts do not indicate a particular rapport between the saint and

individual boys and girls. In contrast, in these mosaics, Demetrios and Bakchos, young and gentle, invite children to accept and to revere them. The images of the saints with children promote a sense of guardianship, where the holy figures intercede with God on their behalf or stand with them in solidarity and protection. The children, chief participants, are clearly an important part of the relationships between the viewer, the child supplicant, Demetrios or Bakchos, the Virgin, Christ, and God.

It is evident, but not widely discussed, that Byzantine children were integrated into church practice. Infant baptism and confirmation were the norm by the sixth century, after having become widespread in the fourth and fifth centuries. Infants were generally baptized after their fortieth day. Children would therefore have had access to the main part of the church, even when catechumens were restricted to the narthex.[31] Presumably, when young, the children were with the women, often in one of the aisles or in the gallery.[32] It is not clear at what age male children would accompany the men rather than the women. St Stephen's *vita* recounts that he accompanied his mother at night vigils and went up close to the chancel to hear better. Either she was allowed in this area or the boy was permitted to enter the male areas of the church on his own.[33]

Thus children were on hand in the main body of the church from a very young age and were present at the liturgy. The images of children in St Demetrios, therefore, would have been viewed by children and may well have been intended primarily, if not exclusively, for their eyes. This includes children from all layers of society – those of the city leaders and of the general townsfolk as well as young pilgrims. While men in authority were held up as exemplars of piety, so perhaps were their children. As the relation of the men on the piers to the saints represents divine protection of the city and its inhabitants, so does the children's, seemingly intentionally implying that devout children both promote safety and are safeguarded. Likewise, the Maria cycle portrays Demetrios's guardianship of a child, and her role, in turn, evokes the perception of a child's efficacy and predominance in religious practice. These examples suggest that images of children were very much part of seventh-century visual culture.

## Notes

1.  This article was initially researched as part of my doctoral thesis written at the Courtauld Institute under the supervision of Robin Cormack. I am indebted to him and to generous funding from the Arts and Humanities Research Board. On the mosaics, see R. Cormack 'The Mosaic Decoration of S. Demetrios, Thessaloniki: A Re-examination in the Light of the Drawings of W.S. George', *Annual of the British School of Archaeology at Athens* 64 (1969), reprinted in R. Cormack, *The Byzantine Eye: Studies in Art and Patronage* (London, 1989), study

I, 17-52; R. Cormack, *The Church of St Demetrios: The Watercolours and Drawings of W.S. George* (Thessaloniki, 1985), esp. nos. 30-39, pls. 74-77, with extensive bibliography, 121-122; and R. Cormack, *Writing in Gold. Byzantine Society and its Icons* (London, 1985), 50-94, esp. 80-83, 86-93, figs 27-30.

2. For a bibliography on Byzantine children: C. Hennessy, *Imagery of Children in Byzantium* (unpublished PhD thesis, Courtauld Institute of Art, University of London, 2001).

3. For the text and commentary, see P. Lemerle, *Les plus anciens receuils des miracles de Saint Démétrios. I Texte. II Commentaire* (Paris, 1979-81).

4. Discovered between December 1907 and February 1908, while the mosque was undergoing repairs, the mosaics were photographed and copied in watercolour by Russian, French, and British scholars, before their destruction by fire. For a summary of the visual records, see Cormack, *Church of St Demetrios*, 47-52, 58.

5. Text: Καὶ σὺ Δέσποτά μο[υ] ῞Αγιε Διμήτ[ρ]ι [β]οήθι ἡμῖν τοῖς δούλοις σου καὶ τῇ δούλῃ σου Μαρίᾳ ἣ ἔδωκες ἡμῖν; Cormack, 'Mosaic Decoration', 31; Cormack, *Church of St Demetrios*, 43, 71.

6. As noted by Cormack, *Church of St Demetrios*, 70-71.

7. Observed by Cormack, 'Mosaic Decoration', 23; on this, viewed differently, see A. Grabar, 'Notes sur les mosaïques de Saint-Démétrios à Salonique', *Byz* 48 (1978), 67-71; A. Grabar, *L'iconoclasme byzantin: dossier archéologique* (Paris, 1957), 86; Grabar seems to have thought that the scenes represented different children, one a boy, and had different patrons. See also C. Diehl, M. Le Tourneau, and H. Saladin, *Les monuments chrétiens de Salonique*, 2 vols (Paris, 1918), I, 95, and on the church in general, see I, 61-114, II, pls. XXVII-XXIV.

8. See Lemerle, *Plus anciens,* I, sections 87-91.

9. See Grabar, *L'iconoclasme byzantin*, 86-87; mentioned by Theodore the Stoudite, letter 17, *PG* 99, 961.

10. Grabar, 'Notes sur les mosaïques', 72.

11. *PG* 136, 213, 164; in Diehl, *Monuments*, 73; for a more contemporary description of a church given similar attributes, see Procopius' *Buildings*, I, iii, 6-7, giving a description of the church of the Pegê or Spring in Constantinople.

12. The fountain may refer to an ancient nymphaeum in the crypt; see Lemerle, *Plus anciens,* II, appendix II, 207-8; also see R. Krautheimer, *Early Christian and Byzantine Architecture* (Harmondsworth, 1965, 1975 ed.), 474, n. 49; A. Grabar, *Martyrium: recherches sur le culte des reliques et l'art chrétien*, 2 vols. (Paris, 1946), I, 450-457.

13. Lemerle, *Plus anciens,* I, sections 18-20, 39.

14. For the raison d'être of marriage, see A.E. Laiou, *Mariage, amour et parenté à Byzance aux XIe-XIIIe siècles* (Paris, 1992), esp. 10-11.

15. For Stephen, see *BHG* II, 1666; for text and French translation, see M.-F. Auzépy, *La vie d'Etienne le Jeune par Etienne le Diacre* (Aldershot, 1997); for Elisabeth, see *BHG* III, Supplementum, 2121-2122a; F. Halkin, 'Sainte Elisabeth d'Héraclée, abesse à Constantinople', *Analecta Bollandiana* 91 (1973), 249-264; for translation, see *Holy Women of Byzantium: Ten Saints' Lives in English Translation*, ed. A.M. Talbot (Washington, DC, 1996), 122-135.

16. As with many hagiographies, the story is fabricated and adapted from other texts, particularly the *Life of Saint Euthymios*, and therefore serves as an exemplar of a type.

17. Auzépy, *Vie d'Etienne le Jeune*, sections 3-6.

18. Auzépy, *Vie d'Etienne le Jeune*, section 5.

19. As argued in C. Geertz, 'Religion as a cultural system', in *Anthropological Approaches to the Study of Religion: Conference on New Approaches in Social Anthropology, 1963*, ed. M. Banton (London, 1966), 3-5.

20. See, for instance, V. Turner and E. Turner, *Image and Pilgrimage in Christian Culture* (New York, 1978), 34; for earlier and related thinking, see A. van Gennep, *Les rites de passage* (Paris, 1909).

21. S. Coleman and J. Elsner, 'The Pilgrim's Progress: Art, Architecture and Ritual Movement at Sinai', *World Archaeology* 26 (1994), 74. For a summary of alternative views, see *Contesting the Sacred: The Anthropology of Christian Pilgrimage*, eds J. Eade and S. Sallnow (London, 1991), 2-3, and, for a critique of the Turners, 4-5.

22. Diehl, *Monuments*, II, title to pl. XXXII.2, influentially described the figure as a woman; however his hair is similar to that of Demetrios and his fine features connote youth.

23. Cormack, *Writing in Gold*, 80-83 suggests the former.

24. Grabar, *Martyrium*, I, 455, II, 119.

25. E. Kitzinger, 'The Cult of Images in the Age before Iconoclasm', *DOP* 8 (1954), 181; for style and dating issues, also 176-185, fig. 22; repr. in *The Art of Byzantium and the Medieval West: Selected Studies by Ernst Kitzinger*, ed. W.E. Kleinbauer (Bloomington and London, 1976), no. V.

26. Cormack, *Writing in Gold*, 90-91.

27. Kitzinger, 'Cult of Images', 181.

28. See M. Duchesne, *Christian Worship: Its Origin and Evolution* (London, 1903, 1923 ed.), 342.

29. Lemerle, *Plus anciens,* I, sections 7-9.

30. Lemerle, *Plus anciens,* I, sections 32, 82, 103.

31. A. Kazhdan and A. Wharton, *Change in Byzantine Culture in the Eleventh and Twelfth Centuries* (Berkeley, Los Angeles, London, 1985, 1990 ed.), 137 and 191 for ns. 116-117, 81 and 181 for n. 43; R. Taft, 'Women at Church in Byzantium', *DOP* 52 (1998), 62-63, with references. The use of the narthex for catechumens fell into disuse some time after the late seventh century, despite mention of the dismissal of the novices being kept in the liturgy. However, there was, as Taft terms it, 'a vestigial catechumenate for children of Orthodox parents and for converts' as late as the tenth century; see Taft, 'Women at Church', 61.

32. On this, see T. F. Mathews, *The Early Churches of Constantinople: Architecture and Liturgy* (University Park, PA, and London, 1971), 129-133; Taft, 'Women at Church', 27-87; Gerstel, 'Painted Sources for Female Piety in Medieval Byzantium', *DOP* 52 (1998), 89-111; N. Teteriatnikov, 'For Whom is Theodotus Praying? An Interpretation of the Program of the Private Chapel in S. Maria Antiqua', *CahArch* 41 (1993), 44 and fn. 45.

33. Auzépy, *Vie d'Etienne le Jeune,* 97, 188-199, section 8; in Taft (1998) 31.

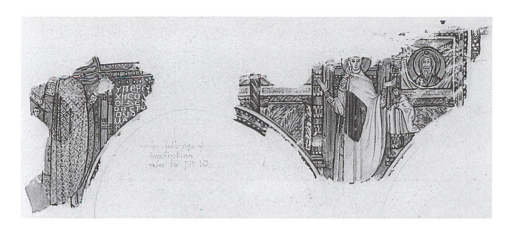

11.1 Mosaics of north inner aisle, 6th century. Thessaloniki, St Demetrios, W.S. George, watercolour, B26, sheet no. 1 (British School at Athens).

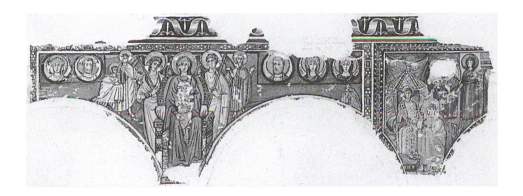

11.2 Mosaics of north inner aisle, 6th century. Thessaloniki, St Demetrios, W.S. George, watercolour, no. 2 (British School at Athens).

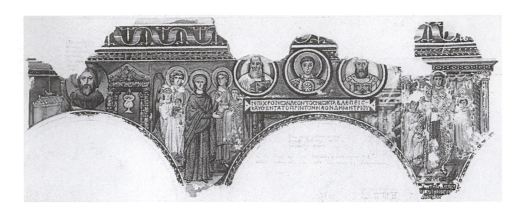

11.3 Mosaics of north inner aisle, 6<sup>th</sup> century. Thessaloniki, St Demetrios,
W.S. George, watercolour, no. 3 (British School at Athens).

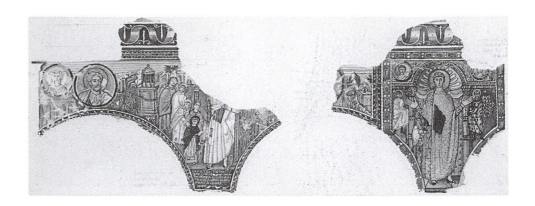

11.4 Mosaics of north inner aisle, 6<sup>th</sup> century. Thessaloniki, St Demetrios,
W.S. George, watercolour, no. 4 (British School at Athens).

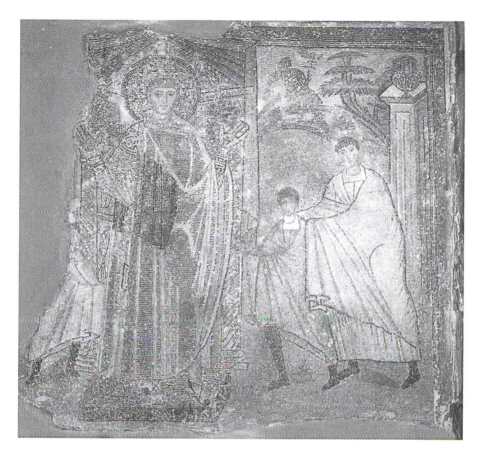

11.5 St Demetrios with two boys, before 620. Thessaloniki, St Demetrios, south aisle, mosaic, (Conway Library, Courtauld Institute of Art).

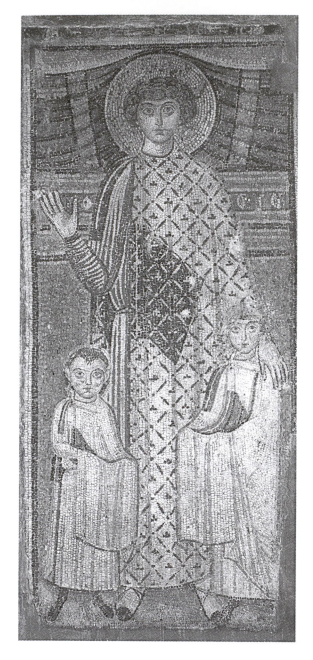

11.6 Mosaic of saint with two children, after 620. Thessaloniki, St Demetrios, north
pier, west face (Conway Library, Courtauld Institute of Art).

Chapter 12

# The 'Statuesque Hodegetria' and the Limitations of the Sculpted Icon

John Hanson

Among the most admired of Byzantine art objects are the carved ivory icons, normally associated with the reign of Constantine VII Porphyrogennetos in the mid-tenth century. One of the most striking of these is the statuette of the Theotokos Hodegetria now in the Victoria and Albert Museum in London.[1] (Fig. 12.1) It has drawn admiration partly on account of its impression of monumentality, achieved by the balanced poise of the figure and subtle modeling of the draperies, qualities which give it a statuesque character. It is a startling object because it is the only surviving example of a Byzantine icon sculpted in the round.[2] How are we to explain the appearance of such an object in the context of the Middle Byzantine period, a time after the attempted banishment of religious images from the Byzantine Church, by people who characterized them as idols? In one sense, this question is easily answered by observing that the particular worry about sculpted imagery in the Church is in fact a modern, post-Reformation worry.[3] The Byzantine literature on iconoclasm that has survived reveals no such medium-specific attention. However much we may expect iconoclastic writers to target the medium of sculpture as the successor to both the golden calf and Olympian idols, they do not. Their disapproval, when it suggests any medium at all, falls on paintings, not sculptures. Their indifference on the topic must be explained, at least in part, by the fact that they were not, as the Reformers in Western Europe were, surrounded by statuary depicting God and the saints. Apart from this historical circumstance, there may be confessional and societal differences between the Roman west and the Orthodox east which condition attitudes towards sculpture. Alternately, we could approach the question from the opposite direction. That is, if we simply accept the objects as evidence that

From *Icon and Word: the Power of Images in Byzantium. Studies presented to Robin Cormack*, eds Antony Eastmond and Liz James. © 2003 by contributors. Published by Ashgate Publishing Ltd, Gower House, Croft Road, Aldershot, Hampshire, GU11 3HR, England, pp. 173-184.

Orthodox worship did accommodate the veneration of sculpted images in relief, and at least in one case, in the round, the question then becomes, why have sculpted images not survived in greater numbers?

The statuesque character of the London Hodegetria consists in more than simply the fact that she is sculpted in the round. The fact that she is a full-length figure is also remarkable. The prototype for all Hodegetria icons, the famous icon in the Hodegon Monastery, supposed to have been painted by St Luke, must have been a half-length version, seeing as almost all versions of the Hodegetria image, including the icon-within-the-icon of the Triumph of Orthodoxy in the British Museum, are likewise half-length.[4] Exceptions among painted icons are exceedingly rare.[5] However, among ivory icons of the Hodegetria, while half-length versions are still in the majority, there is a considerable number of full-length versions. Just over one third of the Hodegetria icons in the ivories corpus are full-length images.[6] Most of these show the Theotokos standing, while the others show her enthroned. Even within the medium of ivory sculpture, the full-length Hodegetria is more specifically concentrated in terms of style. It occurs most frequently among the most classicizing, or hellenizing ivories in the Byzantine corpus, those given the label 'The Romanos Group' by Kurt Weitzmann.[7] Out of seven icons of the Hodegetria in this group, five are full-length.

The Hodegetria does not stand alone in this category. An analogous survey of the images of Christ Pantokrator reveals the same tendency. While in two-dimensional images, the Pantokrator is almost always a half figure, there is a large number of full-length standing figures among ivory icons. Again, as with the Hodegetria, the tendency is clearest among works of the Romanos Group, which includes fourteen full-length versions, (six standing and eight enthroned) and only one half-figure.[8] What was there about the medium of ivory sculpture, and more specifically about the classicism of the Romanos Group that made it particularly appropriate for the statuesque versions of the Hodegetria and the Pantokrator?

It is tempting to jump to one particular art historical conclusion on the basis of this census, namely that what we may interpret as the classicizing character of the statuesque Hodegetria testifies to the existence of a renaissance in tenth-century Byzantine culture.[9] There is more than one obstacle, however, to crediting the notion of a 'Macedonian Renaissance'. One is that we would need to see Byzantine artists and/or patrons as having a degree of consciousness of style that verges on academic. The belief in savvy stylistic judgement on the part of the medieval viewer, as Robin Cormack has argued, may be at best optimistic.[10] That is, while twenty-first-century art historians, with shelves of well-illustrated chronological surveys at their disposal, may clearly see a revival of Classical values in tenth-century art products, it is not clear that the artisans themselves did. In the study of

Byzantine ivory carving, the issue has been further muddied by the related notion of imperial quality. Scholars who single out certain objects as exemplars of high quality have often associated them with the Byzantine emperor. Specifically, the hellenizing manuscripts and ivory carvings of the tenth century have been associated with the reign of Constantine VII Porphyrogennetos, the scholar/artist Emperor.[11] The problem here is that, even if we were to accept the picture of Byzantine emperors interfering in artisans' studios, there is no clear reason to think that they would impose personal individual preferences. Emperors' tastes and visual needs were dictated by the same cultural matrix as their subjects'.[12] So, when we seek to explain the appearance of the statuesque Hodegetria, the idea of a renaissance under Constantine VII's sponsorship may create more problems than it solves.

One problem is that, when we discuss the Romanos Group, we are looking at a small group of objects. Whatever our modern admiration may be for these objects, we need to come to terms with the fact that they are a distinct minority in their class. The flatter, more graphic, and more hieratic ivories of other groups are far more numerous, and as such more representative of Byzantine taste. When we regard the statuesque Hodegetria images of the Romanos Group, instead of asking, 'What led the artists to such heights of humanism?', we should be asking, 'What is it about this style that made it a minority interest?'

The problem surfaces in another way in a medieval text that speaks directly to this discussion, that is, to the issue of full- versus half-length versions of the Pantokrator. Leo VI addresses the choice of the bust format directly in one of his sermons. While describing the church built by his father-in-law, Stylianos Zaoutas, he comes to the image of Christ Pantokrator in the dome:

> In the centre [of the church], i.e. in the segment of a sphere that rises at the summit, is an image that lacks the lower part of the body. I think that the artist wished, by means of this treatment of the picture, to offer a mystical suggestion of the eternal greatness inherent in the One represented, i.e. that His incarnation on earth did not detract from His sublimity, and even when He submitted to the ultimate humiliation, he retained the majesty He had previously enjoyed with His Father…This is how I understand the artist's intention, namely why he excised from the image the lower members of the body.[13]

Leo's comments expose the inadequacy of a Macedonian Renaissance as a framework for understanding the monumentality of the statuesque Pantokrator or Hodegetria, because his interpretation, from a ninth-century Byzantine point of view, is exactly the reverse. The image in front of him

possesses greatness and majesty not in spite of, but exactly because of its truncation. Our modern perception of dignity and monumentality in full-length sculptures may depend on our modern education, including, for example, having classical Greek sculptures rammed down our throats from an early age. Leo, unencumbered by such a prejudice, sees the half-length image as monumentalizing. Why he should make this connection is not immediately apparent, but further inquiry into matters of Byzantine visuality may enlighten us.

The existence of these statuesque carvings suggests, minimally, a refreshing willingness among Byzantine ivory carvers to experiment. The small numbers in which they survive, however, would seem to indicate that the experiment was not a success. Whatever may have been the conditions for the creation of the London statuette, judging from the lack of progeny, it failed to excite the eyes of future Byzantines in the way that painted icons did.

This suggestion is supported by the evidence of a later but analogous development, the carving of stone icons in the eleventh century and later.[14] These icons are on a much larger scale than the ivories, some as large as three-quarters life size. The preference for monumentality is here even more pronounced, with full-length versions of the Hodegetria out-numbering half-length versions by a ratio of four to one. This fact lends credence to the idea that the statuesque version was specifically appropriate to the three-dimensional medium. Apart from the Hodegetria, there is a preference for themes that, even in painting, tend to be full-length types, namely the Theotokos Orans and the Deesis. These praying, interceding images are eminently appropriate, given the intended locations of these icons. They were mostly immured in sanctuaries, where the Theotokos and the Baptist could join the faithful in their prayers. These icons are, in a sense, the successors of the London statuette, in as much as they combine plastic monumentality with a three-dimensional medium. Once again, however, as accomplished as some of these carvings are, we must see them as something of a failed experiment. The category of monumental stone sculpture is still not a large one, and, apart from some isolated examples, it does not carry over into the late or post-Byzantine periods. The objects suggest a narrative similar to the rise and fall of ivory icons. Their existence proves the legitimacy of sculpture as a medium, but their small numbers and sterility suggest that the icons did not meet the needs of the users as well as painted ones did.

This narrative only becomes more emphatic when we consider the progress of sculpture in other Christian countries in the eleventh and twelfth centuries. In western Europe, the rise of monumental sculpture as a medium is so dramatic that it practically defines the Romanesque period. While the art fizzles and dies in Constantinople in the twelfth and thirteenth centuries, it becomes the most visible art form in the west, with schools and programs of

sculpture spreading like a prairie fire. These contrary developments are remarkable, given that the time is one of demonstrable cultural contact between east and west. Many other developments of the twelfth century, such as the medieval novel and sacred drama, do run parallel. In the past, such parallelisms have been interpreted in terms of influence. For example, Byzantine prototypes have been cited for the genesis of Romanesque sculpture, but this simplifies the situation.[15] The role played by Byzantine sculpted icons in the west merits further investigation, as scholars continue to revise the traditional view of Byzantium as the teacher of the west.

There may be an as yet hidden dynamic at work with these objects anyway. So many of them made their way into Italian buildings, notably San Marco in Venice, that one is bound to ask how best to frame their pedigree as Byzantine products. Were they carved in Byzantium for export to an Italian market? Many of them resemble Italian sculptures in a Byzantinizing style in Tuscany, such as the lintel on the Pisa Baptistery. These sculptures may tell us more about medieval Italian art than Byzantine art.

That is another story, though. Whatever the success of sculpture was in the west, how do we explain the existence and poverty of both ivory and stone icons in the Byzantine middle ages? I propose to take as a starting point an idea expressed by a historian of modern sculpture. Fred Licht, in his introductory essay to a picture book of modern sculpture, notes the basic difference between sculpture on the one hand, and painting and architecture on the other in these terms: 'Painting and architecture require a certain degree of abstract thinking. Sculpture is immediately, sensually perceived, and exists fully in the world of our own direct experience since it exists corporeally'.[16] That is, the making and viewing of sculpture does not require abstraction, since the sculpture is a reality in the artist's or viewer's presence. Licht's insight could have lively implications for the discussion of Byzantine icons, seeing as the Orthodox veneration of images depends on an understanding of the process of veneration as reverencing, not the icon, but the remote reality represented by it. For John of Damascus, the legitimacy of icons is not an issue of medium. Both painted and carved images could theoretically be consistent with the notion of venerating the One represented, rather than the material.

> …what is the purpose of an image? Every image is declarative and indicative of something hidden. I mean the following: inasmuch as a man has no direct knowledge of the invisible (his soul being covered with a body), or of the future, or of things that are severed and distant from him in space, being as he is circumscribed by place and time, the image has been invented for the sake of guiding knowledge and manifesting publicly that which is concealed.[17]

Does Licht's dichotomy between the abstraction of painting and the concreteness of sculpture shed any light on how an orthodox viewer might approach the visual?

One of Cormack's most important contributions to Byzantine art history has been to study icons, not as straightforward products of painting, nor even as products of specific collaborations between individual artists and patrons, but as documents of a broad and complex matrix involving all elements of Byzantine society. He has drawn our attention in important ways to contemporary texts which illustrate, not just the original appearance of things, but the very functioning of the visual. One text he has used to illustrate the conscious manipulation of the visual environment by the Byzantine court is the Russian Primary Chronicle.[18] The stories surrounding the conversion of Vladimir in 988 are particularly suggestive in discussing the functioning of the visual in an orthodox culture.[19] The author presents Vladimir and the people of Rus' as inquirers into Greek faith, but this should not prevent us from seeing them as representing an orthodox position. The history was compiled over a hundred years later, and so presents the story from the point of view of tenth-century orthodox Kiev. It begins with Vladimir interviewing representatives from various religions for potential adoption. While he easily dismisses the Bulgarian Muslim and the Roman Catholics, the Greek visitors enter into a lengthy summary of the entire Biblical narrative and the Councils. Vladimir asks clever and apt questions to which the monks give equally apt answers. As if words begin to fail, the process culminates with one of the Greek scholars producing an icon:

> As he spoke thus, he exhibited to Vladimir a canvas on which was depicted the Judgement Day of the Lord, and showed him, on the right, the righteous going to their bliss in Paradise, and on the left the sinners on their way to torment. Then Vladimir sighed and said, 'Happy are they upon the right but woe to those upon the left!'

The scholars, knowing when to 'ask for the sale' now recommend baptism. Vladimir is deeply impressed at this point, but nevertheless puts them off in order to continue with his research.

He subsequently sends out envoys to examine the religions in their natural habitats. When they return, they describe their reaction to the carefully orchestrated visual demonstration in terms of religious wonder. They bring persuasive endorsements of the beauty of the Greek religion. 'Then we went to Greece and the Greeks led us to the edifices where they worship their God, and we knew not whether we were in heaven or on earth. For on earth there is no such splendour or such beauty and we are at a loss how to describe it.' Vladimir continues to resist baptism, until he has an experience apparently

based on the conversion of Saul. After Vladimir procures an engagement to Anna, the sister of Constantine and Basil, God blinds him, only restoring his sight after he is baptized. The restoration of his sight coincides with the consumption of his peace treaty with Byzantium, and symbolizes his reunion with God.

The Biblical and mystical character of the end of the story helps us to interpret the role of the painting at the beginning. Given the decisive role of the visual in allowing both the envoys and Vladimir to come to the point of perceiving the transcendent truths of God, it may not suffice to understand the Last Judgement painting as a simple illustration of a narrative, along the lines of the Gregorian idea of the 'Biblia Pauperum';[20] or as a scare tactic along the lines of Romanesque portal imagery. The image allows Vladimir to perceive events that are far removed from him, both in time and in spiritual plane. At the conclusion of the story, seeing and believing become almost synonymous. For Vladimir, visuality is a form of intuition that allows him access to a world beyond the reach of his senses.

This function of the visual as a way of making the absent present aligns with iconophile theology of the icon, as has been noted. It also blends with the medieval practice of *ekphrasis*. As Liz James and Ruth Webb have argued, scholars have misconstrued the *ekphrasis* of a work of art as a means of recording it for posterity.[21] In fact, the explicit goals of *ekphrasis* are not to describe, but to interpret; not to focus on the image, but to focus on the One represented. In the words of Nikolaos Mesarites in the twelfth century, his purpose in writing an *ekphrasis* of the architecture and mosaics of the Church of the Holy Apostles in Constantinople is to 'understand ultimate things and to enter secret places'.[22] If we want to understand Byzantine reactions to images, we need to take this process in earnest. James and Webb's framework for reading *ekphraseis* is an important background for reading Leo VI's description of the half-length image of the Pantokrator noted above. Leo is speculating on the spiritual significance of the truncation. For him it expresses the greatness and majesty of God in a way that a full-length image would not. It is as if the partial nature of the image is not an obstacle, but rather a positive aid to its understanding. Within this framework, the role of the visual in Orthodox spirituality is to reveal the spiritual, in part by concealing the material. The statuesque types of the Pantokrator or the Hodegetria may have revealed too well the corporeality of the persons represented to offer an effective window into the sacred.

This manner of digesting images is not, of course the only one. Another option is to see images as somewhat more mundane devices. That is, even when images inspire awe, the awe can centre on the beauty or cleverness of the image itself, rather than on what it represents. For orthodox viewers, the bitter experience of the iconoclastic controversy promoted the solution of

looking beyond the image at the prototype, and rendered any less complicated examination of the object pointless, if not, religiously suspect. In the Roman west, the controversy over images, such as it existed at all, was on very different grounds. The Church in the west, while it engaged in its own discussion on the sacred image, continued as ever to sanction images as illustration. This pragmatic approach has its purest expression in Gregory the Great's dictum that 'What Scripture is to the educated, images are to the ignorant…'[23] This equation of images with text is behind many western artistic conventions such as the decorating of churches with paired Old and New Testament stories in a *historia salvationis*, and elaborate educational picture books such as the Bibles Moralisées and Concordantiae Caritatis.

Further insight into the modes of perception of westerners relative to Byzantines might be gleaned from observing the much-quoted report of Liudprand, the bishop of Cremona, of his diplomatic visit to the court of Constantine VII in 949-950. In the *Antipodosis*, Liudprand describes the automated gilded bronze trees, birds and lions in the throne room at the Manganaura palace.[24] Liudprand must have seen the Great Church and the same liturgy as the Russian envoys, but does not record these. Instead, he chooses to describe for posterity this sculptural group in the palace. Admittedly, his story is not an absolute counterpart to Vladimir's, as the one describes a diplomatic mission, and the other a religious search. Nevertheless, Liudprand does give us some insight into the particular nature of his perception of these three-dimensional images. Like the story of the Russian envoys, Liudprand's narrative depicts a Byzantine emperor using the visual environment as a powerful public relations machine. Also, like the Russian envoys before him, Liudprand is suitably astonished by what he sees. His astonishment is quite clearly, though, of a different nature. The images of tweeting birds, roaring lions, and rising thrones do not astonish Liudprand because they provide a window into the transcendent beauty of the true religion, or even of the glory of the Imperial person. He understands the sculptures as present realities, and, like a cynic at a magician's show, only marvels at the 'cunning manner' in which they were made, and speculates that the elevator system might be the same as the one used in a wine press. His thoughts are of mechanics, rather than of transcendence. That this is the exact nature of Liudprand's wonderment is made explicit later, when he is marvelling at some acrobatic entertainment at a dinner.[25] The object of his contemplation then is the physics question of how one person could climb a pole without causing it to waver. Constantine cleverly apprehends what Liudprand is thinking, and uses it to his advantage. Liudprand's wonderment is on the concrete problems of representation, not on any mystical connection to the unseen. Appropriately, Liudprand's amazement centres on a three-dimensional, rather than a two-dimensional image. This affinity for sculpture

may have been shared by his compatriots in Lombard Italy, and by people in western Europe generally speaking, and may explain in part the subsequent success of sculpture there.

Again, compare Liudprand's reaction to these wonders with Prokopios' reaction to the dome of Hagia Sophia. When trying to express the profound impression made by the dome, he says that it appears to 'hang from heaven by a golden chain'.[26] He is obviously not, as Liudprand is with the automata, making a guess at how the effect is achieved. He is finding a way to interpret the imagery in front of him in transcendent terms. The dome is patently supported on the surrounding piers. His literary allusion is intended to convey to the reader the fact that the building is mystically the Kingdom of Heaven. Liudprand is much more pragmatic in his speculations, and comments, appropriately enough on a sculpture, rather than a painting. A painted image of singing birds or roaring lions would not have drawn attention, as he would have understood them immediately as illusions, representing birds that existed elsewhere, if only in the artist's imagination. The sculpted birds cannot be thus explained, as they are not images at all, but realities in the viewer's world, and therefore awesome. It is just this direct and concrete apprehension of imagery that iconoclasm had made redundant for orthodox believers.

By looking at these varieties of ways of seeing, we can develop more nuanced readings on two specific issues. One is the issue of the failure of sculpted icons. It is now easy to see why sculpted icons did not sell well in medieval Byzantium. They are, by their very nature, less functional than painted icons. The corporeal character of sculpture that may have tempted artists to produce full-length statuesque figures, failed to speak eloquently of the other world that is the object of the Byzantine icon. The other issue is the appearance of sculpture at a time when the religious image had been under attack as an idol. When we take on board the possibility that sculpture did not 'scratch where the Byzantine eye itched', the question of censure evaporates. As long as iconophiles preferred paintings, iconoclasts had no call to target other forms. The statuesque Hodegetria did not, it seems, slip through the cracks of post-iconoclastic scrutiny. It was more of a failed experiment.

## Notes

1.  A. Goldschmidt and K. Weitzmann, *Die byzantinischen Elfenbeinskulpturen des X. – XIII. Jahrhunderts.* vol II: *Reliefs* (Berlin, 1934), 40, No. 51, pl. XXI. See also J. Beckwith, '"Mother of God Showing the Way": a Byzantine ivory statuette of the Theotokos Hodegetria', *Connoisseur* CL (1962), 2-7; P. Williamson, *An Introduction to Medieval Ivory Carvings* (London, 1982), 28, 29; A. Eastmond, 'Ivory Statuette of the Mother of God', in *Byzantium: Treasures of Byzantine Art from British Collections*, ed. D. Buckton (London, 1994), 145; and A. Cutler,

*The Hand of the Master, Craftsmanship, Ivory and Society in Byzantium (9th-11th centuries)* (Princeton, 1994), 54, 55.

2.  Other free-standing icons such as those in Liverpool, New York and Hamburg are actually relief icons that have been cut away from their grounds at some later date, (Goldschmidt and Weitzmann, *Die byzantinischen Elfenbeinskulpturen* II, nos 48, 49, and 52, pp. 40, 41, pls. XX, XXII).

3.  See C.M.N. Eire, *The War Against the Idols: The Reformation of Worship from Erasmus to Calvin* (Cambridge and New York, 1986).

4.  See R. Cormack, 'The Icon of the Triumph of Orthodoxy' in *Byzantium*, ed. Buckton, 62-3.

5.  One such exception is the Hodegetria on the diptych of Toma Preljubović in Cuenca Cathedral, see K. Weitzmann, M. Chatzidakis, and S. Radojčić, *Icons*, (New York, [1980]), 188, 229.

6.  In Goldschmidt and Weitzmann, *Die byzantinischen Elfenbeinskulpturen* II, the full-length Hodegetrias are catalogued as (standing) nos 46, 48, 49, 51, 73, 78, 86, 142-5; and (enthroned) nos 29, 79, 82; The half-figure versions are nos 50, 76, 80, 81, 84, 87, 98, 124-6, 131-4, 138-41. To the list of standing figures could be added relief icons in precious metals, such as the gold and silver icon of the Hodegetria in the Georgian State Art Museum in Tbilisi, (K. Weitzmann, G. Alibegasvili, A. Volskaja, M. Chatzidakis, G. Babić, M. Alpatov, and T. Voinescu, *The Icon* (New York, 1982), 86-7; 99).

7.  Goldschmidt and Weitzmann, *Die byzantinischen Elfenbeinskulpturen* II, 6-17; Pl. X-XXIX. For a critique of Goldschmidt and Weitzmann's taxonomy see Cutler, *The Hand of the Master*, 185-97.

8.  Goldschmidt and Weitzmann, *Die byzantinische Elfenbeinskulpturen* II, (standing) nos 53, 56, 64, 65, 69, and 70; (enthroned) nos 31, 32, 33, 54, 55, 61, 62, and 63; and (half-length) no. 68.

9.  The term 'Macedonian Renaissance' was first used by Kurt Weitzmann in *The Joshua Roll; a Work of the Macedonian Renaissance*, Studies in Manuscript Illumination III (Princeton, 1948). For alternate readings of the classicism of the tenth century, see I. Kalavrezou-Maxeiner, 'The Cup of San Marco and the "Classical" in Byzantium', in *Studien zur mittelalterlichen Kunst 800-1250: Festschrift für Florentine Mütherich zum 70. Geburtstag*, eds K. Bierbauer, P.K. Klein, and W. Sauerländer (Munich, 1985), 167-174; and R. Cormack, *Byzantine Art* (Oxford, 2000), 129-142.

10. R. Cormack, *Painting the Soul: Icons, Death Masks, and Shrouds* (London, 1997), 156-157.

11. The connection of the Romanos Group of ivories with Constantine VII, and of the Nikephoros Group with Nikephoros I Phocas was first made by Hayford Pierce and Royall Tyler in 'Deux movements dans l'art byzantin du Xe siècle', *Aréthuse* 4 (1927), 129-135; followed by Goldschmidt and Weitzmann et al.

12. See R. Cormack, 'Patronage and New Programs of Byzantine Iconography' in *Seventeenth International Byzantine Studies Conference: major Papers (Washington, D.C., August, 1986)* (New Rochelle, 1986), 609-638, repr. in R. Cormack, *The Byzantine Eye: Studies in Art and Patronage* (London, 1989).

13. Leo VI, *Sermons*, in *Leontos tou Sophou panégurikoi logoi*, ed. Akakios Hieromonachos (Athens, 1868), 275ff. The translation is by C. Mango, *Art of the Byzantine Empire 312-1453* (Englewood Cliffs, NJ, 1972), 203.

14. On sculpted icons, see R. Lange, *Die byzantinische Reliefikone* (Recklinghausen, 1964) and, more recently, K. Loverdou-Tsigarida, 'The Mother of God in Sculpture', in *Mother of God: Representations of the Virgin in Byzantine Art*, ed. M. Vassilaki (Milan, 2000), 237-249.

15. On the general question of Byzantine sources for Romanesque sculpture, see M.F. Hearn, *Romanesque Sculpture: The Revival of Monumental Stone Sculpture in the Eleventh and Twelfth Centuries* (Ithaca, NY, 1981), 60.

16. F. Licht, *Sculpture, 19th & 20th Centuries* (New York, 1967), 13.

17. John of Damascus, *De imagine Oratio* III, 16 ff. in *PG* 94, 1337. The translation is by Mango, *Art of the Byzantine Empire*, 171.

18. Cormack, *Painting the Soul*, 151-152.

19. 'The Russian Primary Chronicle' trans. S.H. Cross, *Harvard Studies in Philology and Literature* XII (Cambridge, MA, 1930), 75-370. On the conversion of Vladimir, see 183-201.

20. See the letter of Pope Gregory I 'the Great' to Bishop Serenus of Marseilles: *Sancti Gregorii Magni Epistolarum* Lib. XI, Epist. 13; *PL* 77, 1128-30; trans. C. Davis-Weyer, *Early Medieval Art 300-1150* (Toronto, 1986), 47-49.

21. L. James and R. Webb, '"To understand Ultimate Things and Enter Secret Places": Ekphrasis and Art in Byzantium', *ArtH* 14 (1991), 1-17. On this particular aspect of Byzantine perception, see esp. 11-14.

22. 'Description of the Church of the Holy Apostles', ed. G. Downey in *Transactions of the American Philosophical Society* 47 (1957), 855-924; as quoted in James and Webb, 'To Understand Ultimate Things', 11.

23. This phrase comes from his letter to Bishop Serenus of Marseille (see above n.20). See *Early Medieval Art*, ed. Davis-Weyer,, 47-49.

24. *The Works of Liudprand of Cremona: Antipodosis, Liber de Rebus Gestis Ottonis, Relatio de Legatione Constantinopolitana*, trans. F.A. Wright (New York, 1930), 207, 208; reproduced in Mango, *Art of the Byzantine Empire*, 209, 210.

25. *The Works of Liudprand*, trans. Wright, 210-211.

26. *De Aedificii*, I, I, 23ff. in *Procopius* VIII, ed. and trans. H.B. Dewing and G. Downey (London and New York, 1940), and Mango, *Art of the Byzantine Empire*, 75.

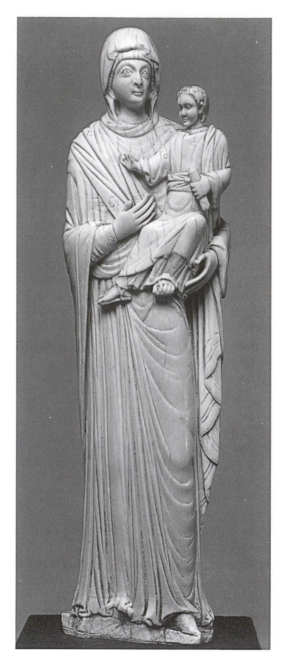

12.1 Ivory statuette of the Theotokos Hodegetria, 10th century. Victoria and Albert
Museum, London (V&A Picture Library; Mus no. 702-1884).

# The Migrating Image: Uses and abuses of Byzantine icons in Western Europe

Barbara Zeitler

What other innovations have they [the Latins] introduced contrary to the tradition of the church? Whereas the holy icons have been piously established in honour of their divine prototypes and for their relative worship by the faithful ... and they instruct us pictorially by means of colours and other material (which serve as a kind of alphabet) – these men, who subvert everything, as has been said, often confect holy images in a different manner and one that is contrary to custom. For instead of painted garments and hair, they adorn them with human hair and clothes which is not the image of hair and of a garment, but the [actual] hair and garment of a man, and hence is not an image and a symbol of the prototype. These they confect and adorn in an irreverent spirit, which is indeed opposed to the holy icons.

Symeon of Thessaloniki, *Contra Haereses*[1]

Byzantine ivory icons form an integral part of the cultural and artistic relationship between Byzantium and the medieval West. This paper discusses a selection of Byzantine ivories that were re-used in the medieval West, mostly in the eleventh century. Its aim is to add some observations to the complex relationship between two related, but in many respects – culturally, artistically and theologically – very different cultures.

Symeon of Thessaloniki's characterization of the differences between Byzantine and western religious images may, at first blush, not appear germane to the re-use of Byzantine ivories in the West. Symeon's polemical statement reflects the opposition of a Byzantine bishop against proposals to unite the Latin and Orthodox churches in the fifteenth century. However,

From *Icon and Word: the Power of Images in Byzantium. Studies presented to Robin Cormack*, eds Antony Eastmond and Liz James. © 2003 by contributors. Published by Ashgate Publishing Ltd, Gower House, Croft Road, Aldershot, Hampshire, GU11 3HR, England, pp. 185-204.

despite being rooted in a specific historical situation and a particular milieu, Symeon's polemical statement can be seen as a comment by someone versed in icon theology on both the differences in the function and appearance of religious imagery used in Latin-rite and Eastern-rite Christianity. His remark that westerners 'often confect holy images in a different manner and one that is contrary to custom' thus represents a *leitmotif* for this brief study investigating how some Byzantine ivories were transformed on being re-used in a western context.

Byzantine ivory icons document the relationship between East and West on at least two levels. Firstly, many Byzantine ivory icons have survived precisely because they reached medieval western Europe where they were treasured as precious and exotic objects. On reaching the West, these objects were often incorporated into the covers of manuscripts. The holes in the corners of many Byzantine ivory panels testify to this particular episode in the panels' viewing history. In the case of one tenth- to eleventh-century ivory, it is not merely holes but also an inscription that documents its incorporation into the decoration of a manuscript cover. This is a tenth- or eleventh-century panel showing the Hodegetria surrounded by the Evangelists (Berlin, Staatliche Museen, Inv. Nr. 2394). Its frame is inscribed with a Latin inscription in an eleventh century script, which proclaims that a certain Bishop Bertold used the ivory to decorate the covers of his Gospel book.[2] It is likely that metalwork, enamels and semi-precious stones formed a splendid surround for the ivory placed on Bertold's Gospel Book. Possibly, this book was used at the cathedral where Bertold held office. Church inventories indicate that most major churches in western Europe possessed books decorated with ivories and precious metals.[3] Perhaps the most spectacular example of a book cover if this kind is the Munich Gospel Book of Otto III (Munich, Bayerische Staatsbibliothek, clm 4453), which incorporates a tenth-century Byzantine ivory of the Koimesis and which Otto's successor, Henry II (1002-1024) gave to Bamberg Cathedral.[4]

In their Byzantine context, both the Hodegetria image formerly on the covers of Bishop Bertold's Gospels and the Koimesis decorating the Gospels of Otto III formed the central panels of ivory triptychs. Many Byzantine ivory triptychs probably reached the West in their entirety, but as is clear from examples with which this paper is concerned, on reaching the West at least some were dismantled before being incorporated into the decorative scheme of a book cover. Other ivories to be discussed in this paper demonstrate that individual panels were cut into smaller pieces and reassembled. This fact highlights the second way in which such ivories document the relationship between East and West: Byzantine ivories were put to uses by western artists and patrons in a way that would have been considered unusual by Byzantine viewers. The re-employment of Byzantine ivories in a western context resulted

in a profound change in the manner in which these objects were viewed and used.

This paper charts the transformation of selected examples of Byzantine ivories once they had reached the West. Foremost among this investigation are ways of interpreting the transformation of Byzantine ivories from triptychs or diptychs into entirely different objects that were incorporated into the covers of manuscript or the exterior of reliquaries. Anthony Cutler has argued that the transformation of these objects does not fit with the prevailing view of the relationship between East and West: rather than representing a crude response to exotic treasures from Byzantium, the way in which at least some Byzantine ivory triptychs were re-used in the West is a reflection of a considered response to objects from another culture.[5]

An example is a triptych which showed the Deesis and the archangels Michael and Gabriel on the central panel, St Peter with the archangel Uriel and St Basil on the left wing and St Paul with the archangel Raphael and St Nicholas on the right wing. Some time between 1022 and 1036, the triptych was carefully taken apart at its joints and its constituent parts were re-used to decorate the covers of two manuscripts, a Lectionary and an Epistolary, made for Bishop Sigebert of Minden (1022-1036). The person responsible for the design of the covers took the decision to place the panel showing Christ on the cover of the manuscript containing a selection of His words, while the wings showing Sts Peter and Paul were attached to the manuscript containing the Apostles' words.[6]

Unfortunately, the book cover that once enclosed the Epistolary no longer survives and it is unclear how the two wings were attached to the cover. Did the wings touch one another at their short sides, the two Apostles facing one another, or did the designer of the manuscript cover, perhaps under the instructions of his episcopal patron, decide that the two wings were to be juxtaposed at their long ends, thus creating a round-headed plaque similar to that showing Christ? The effect of this would have been that there was a formal resemblance between the ivories decorating the two manuscripts. However, if this was the case, the two figures would have faced away from one another. While the original display on the Epistolary must remain unknown, such hypotheses indicate that a western aesthetic appreciation of Byzantine ivories may have been limited.

Any aesthetic attitude that did exist on the part of those western viewers who re-used Byzantine ivory triptychs (or indeed lack thereof) is only documented in the objects themselves and in the way in which they are re-employed in a western context. There are no primary texts from western Europe which help us in investigating this issue. Equally, from a Byzantine perspective, there is no evidence how hypothetical Byzantine viewers might have reacted if they had seen Byzantine ivories re-used in a western context.

However, the passage from Symeon of Thessaloniki's *Contra Haereses,* quoted earlier, may represent a faint echo of how some Byzantine viewers might have reacted when confronted with parts of Byzantine ivory icons re-used on the covers of western manuscripts.

To some extent at least, westerners' aesthetic appreciation of a Byzantine ivory or its constituent parts were limited by the objects themselves: the discussion of how the wings might have been combined on the cover of Bishop Sigebert's Epistolary has highlighted that the shape and subject-matter of the wings were not easily reconcilable when re-used in a western context. However, even if the re-used objects allowed for the expression of an aesthetic attitude, the western designer of the manuscript cover may not have responded to such possibilities. A particular aesthetic response to an exotic artefact may underlie the re-use of one Byzantine artefact in a western context, but not that of another. It is an inescapable fact that Byzantine ivory triptychs were dismantled in order to be re-used, suggesting that even in those cases where the particular way in which they were re-employed may be indicative of an aesthetic attitude, in the first instance the physical integrity and the programmatic coherence the object possessed in Byzantium were destroyed.

The provenance of Byzantine ivory icons that found themselves in the West in the Middle Ages is manifold: some may have been brought home by pilgrims returning from a pilgrimage to the holy sites in the eastern Mediterranean, others were objects traded by merchants or booty, yet others formed part of diplomatic exchanges or were part of the dowry of a Byzantine nobleman or, more usually noblewoman, who married into a western ruling family.

Although Byzantine objects in ivory found their way into western Europe at different times, a significant number of ivories are documented in Ottonian and Salian Germany, many being associated with members of the imperial family and bishops, such as Sigebert of Minden or the anonymous bishop Bertold.[7]

It is tempting to link the prevalence of such objects in Germany in the second half of the tenth century and the first half of the eleventh century with the marriage of the Byzantine princess Theophano and the future Otto II in 972. Although the possibility cannot be excluded that some Byzantine ivory icons (and indeed icons in other artistic mediums) formed part of Theophano's trousseau – the Koimesis image on the cover of the Gospels made for Theophano's son, Otto III, mentioned earlier, being a probable candidate – Theophano and her entourage are unlikely to have had sole responsibility for the Byzantine ivories that found their way into Ottonian Germany in the second half of the tenth century.[8] More likely, the marriage of Theophano and the future Otto III stimulated a demand for Byzantine ivories in imperial circles and triggered a fashion that lasted into the eleventh century.

With one significant exception, all the Byzantine ivories that once formed or still form part of the decoration of western medieval book covers were originally part of triptychs.[9] The exception is the covers of the so-called Prayer Books of Emperor Henry II and Empress Kunigunde (Bamberg, Staatsbibliothek, Msc. Lit. 7 and Msc. Lit. 8).[10] While most re-used Byzantine ivories form part of a larger ensemble, frequently being incorporated into a larger figurative and decorative arrangement consisting of metal and enamel work, the four panels from Bamberg alone make up the covers of two manuscripts. As such, the ivories of the Bamberg *cantatoria* are unique among Byzantine ivories re-used on western manuscripts.[11] Because they are devoid of any frame, the round-headed shape of these panels by necessity dictated the format of the parchment folios, creating codices of an unusual format.

Msc. Lit. 7 is decorated with the patron saints of Bamberg cathedral founded by Henry II.[12] St Peter appears on the back cover and St Paul on the front (Fig. 13.1). The front of Msc. Lit. 8 shows an ivory panel decorated with Christ on the front, while Mary appears on the back (Fig. 13.2).

Strictly speaking, these manuscripts are not prayer books but graduals or *cantatoria* made for use in Bamberg Cathedral.[13] The link with the imperial couple is perhaps not as close as the titles commonly given to these books suggest. Reference to Henry and Kunigunde is made only in Msc. Lit. 7,[14] but this does not preclude the possibility that either manuscript was associated with the imperial couple and made for use by them, if only occasionally.

These codices pose some intriguing questions. As the covers are the focus of our investigation, questions relating to the date and place of the manuscripts' manufacture need not concern us here.[15] The covers of the Bamberg *cantatoria* consist of what at first glance appear to be two tenth-century Byzantine ivory diptychs. However, as Kurt Weitzmann has suggested, these ivories once formed part of an iconostasis beam, depicting an extended Deesis with Christ surrounded by Mary and John the Baptist at its centre followed by an archangel and six Apostles on each side.[16] In a later article Weitzmann went even further and suggested that two panels in the Hermitage in St Petersburg, showing the Presentation in the Temple, came from the same iconostasis beam, probably belonging to Theophano and dismantled after her death.[17]

It is perhaps not fruitful to speculate about the precise appearance of the iconostasis beam and the circumstances leading to its dismantling, or indeed about the time and place of its dismantling. What can be said perhaps with a greater degree of certainty is that two of the four Bamberg panels, namely Mary and Christ decorating the exterior of Msc. Lit. 8, once formed two of the three central panels of a Byzantine ivory iconostasis. The other two panels in Bamberg, Peter and Paul on the exterior of Msc. Lit. 7, were likely to have been quite close to the three central panels of that iconostasis but on opposite

sides. In that iconostasis, Peter would have appeared somewhere to the right of Christ, and Paul somewhere to the left of Christ and Mary.

The transformation of the panels from constituent parts of an iconostasis to book covers highlights a fundamental change in their viewing conditions. In their Byzantine context, these four panels formed part of a much larger visual ensemble. As such, they were likely to have been displayed at some remove from its viewers. That the panels were meant to be viewed from a distance is certainly indicated by the lack of detail in the drapery folds of the figures, which is particularly pronounced in the case of the Apostles. In their western context, by contrast, the panels become portable items and could be viewed at close quarters. In their role as covers of Ottonian manuscripts, these images were viewed in a way which accords much greater emphasis to the individual image than would have been the case in Byzantium.

In this regard, it is important to consider how these two *cantatoria* might have been displayed and viewed. It is not impossible that the books would have been open and that the ivories faced the viewers, while the manuscript folios were not visible to anyone but the user of the text. At others times, when not used as liturgical manuscripts, their covers may well have been intended to be viewed as diptychs. As such, they may have been placed on or near an altar, the ivories being displayed as objects in their own right not as book covers.[18]

The change of the viewing conditions of these panels, however, is not merely a question of position and distance. Even a cursory glance at the exterior of the two Bamberg *cantatoria* indicates that the re-used of these panels in their western context has resulted in a pictorial combination that is very different from the way in which these panels would originally have appeared. The covers of Msc. Lit. 8 represent two-thirds of the core of a Deesis. In its original context, the ivory of Christ would have been surrounded by figures on either side: Mary appearing to Christ's right (the viewer's left) and St John the Baptist on Christ's left (the viewer's right). Ironically, perhaps, the pairing that was created by turning the panels of Mary and Christ into the covers of Msc. Lit. 8 created a pairing of figures that would not have been unusual to Byzantine viewers: Mary standing with a supplicatory gesture to the left of Christ can be found in numerous examples in Byzantine church decoration.[19] However, it was only when being re-used in the West that this particular pairing was created out of an ensemble that, in its Byzantine context, included the figure of St John the Baptist and several other holy figures.

Turning to the covers of Msc. Lit. 7, which show Sts Peter and Paul, the arrangement and sequence of figures is striking, especially when viewing the book open. On viewing the two ivories when the book is open, the visual experience immediately strikes a discordant note as the saints are facing away

from one another. As mentioned earlier, in their original context, a Byzantine iconostasis, St Peter would have been placed somewhere to the right and St Paul somewhere to the left of the Deesis.[20] Yet, although visually discordant, the arrangement on the exterior of the *cantatorium* is quite coherent in the context in which they were seen, bearing in mind that Henry's foundation at Bamberg was dedicated to Sts Peter and Paul. Peter was given precedence over Paul in that the church was dedicated to 'Peter with Paul'. This particular order of precedence is reflected in the fact that the ivory showing Peter is to the left of Paul when the book is open.[21]

There may even be greater visual coherence in the arrangement than at first meets the eye. Paul, who is holding the book, is shown in the same position as Christ, who, as usual, is shown holding the Gospels. If the two open books were intended to be displayed in vicinity to one another, the particular sequence of Sts Peter and Paul, with the figure holding the book appearing on the left, would echo the composition on the covers of the other *cantatorium*.

Still assuming that the book covers were originally displayed in close vicinity to one another, a further possibility poses itself: Peter may be facing away from Paul, but if this book cover is placed next to Msc. Lit. 8, Peter is facing Christ and forms the counterpart to Mary. This combination would result in an ensemble of two figures turned towards Christ in adoration. Thus, if in the early eleventh century the *cantatoria* were indeed displayed in an open state on an altar or some other position in Bamberg cathedral, their ivory covers facing the viewer, a sequence of images representing holy figures would have been created. Such a sequence echoed the arrangement of figures on a Byzantine iconostasis, but to a Byzantine viewer, such a sequence would not have made much sense as John the Baptist was absent. Thus, in turning iconostasis panels into book covers, the programmatic coherence of a feast cycle was destroyed. At the same time, however, a pairing of figures was created that reflected, at least in the case of the panels of Sts Peter and Paul, the particular concerns of Bamberg Cathedral.

The re-employment of these panels, however, can be considered from yet another angle. The preceding discussion has shown that in their Byzantine context these panels never functioned as diptychs. Being re-used as manuscript covers, however, they were transformed into diptychs. This transformation was not merely physical. The panels were also given a meaning and historical resonance which they did not possess in Byzantium. As newly fashioned ivory diptychs, they were assimilated to a western tradition of manuscript decoration that harks back to the decoration of Carolingian manuscripts and specifically liturgical manuscripts. An example is the late ninth-century antiphonary of St Gregory (Monza, Tesoro del Duomo, MS IX), the covers of which consist of a late antique consular diptych.[22]

Undoubtedly, the late antique diptych was turned into the cover of the Monza manuscript to evoke the early Christian period. The Monza antiphonary is not a unique example of a late antique diptych being re-used as a cover for a liturgical manuscript in the Carolingian period.[23] It is probable that the re-use of the Byzantine panels as covers for the Bamberg *cantatoria* is an explicit reference to a Carolingian tradition. This thematic reference has implications for the way in which the significance of the panels from a tenth-century Byzantine iconostasis changed on being re-used in a western context: they were used to evoke a past (or pasts) and a culture (or cultures) of which they did not form part.

The Bamberg covers, of course, occupy a unique position among Byzantine ivories re-used in the West. It is time, therefore, to examine how triptychs were transformed on being re-used in a western context.

In Byzantium, a triptych would have been used in private devotion. It is in the nature of a triptych to allow for a variety of viewing experiences, depending on whether the object was open or shut. The changes made to a Byzantine triptych in the West had profound effects on the object: it was physically altered, its iconographic programme was changed and it was put to uses without parallel in Byzantium. The re-use of three different Byzantine triptychs as covers of western manuscripts allows us to follow this transformation in more detail.

The parts of the first triptych to be discussed were until recently the respective front covers to two different manuscripts. However, it is thought that the two covers originally may have formed the exterior decoration of one manuscript. One of the covers belongs to the ninth-century Aachen Coronation Gospels, the second adorned the Aachen Gospels of Otto III until the early 1970s.[24] The centrepiece of the book covers of the Aachen Coronation Gospels is a tenth-century Byzantine ivory showing the Virgin Hodegetria with Christ. The centrepiece of the second cover consists of two wings of a Byzantine triptych, the left wing showing St John the Evangelist with a martyr saint below, possibly St Theodore Stratelates, while St John the Baptist appears with an another martyr saint below, possibly St George or St Demetrios, on the right wing. Although the two wings are somewhat smaller than the central panel, stylistic similarities between the wings and the central panel strongly suggest that they once formed part of the same triptych.[25]

Although very different in appearance, both book covers date from the early eleventh century. The gold repoussé metalwork that encloses the Virgin Hodegetria is closely related to the golden altar front commissioned by Henry II for Aachen. The date of the silver repoussé work on the covers formerly adorning the front of the Otto III's Gospels is uncertain,[26] even though an early-eleventh-century date is not beyond the bounds of possibility. There is some debate whether in the early eleventh century the two covers formed part

of the same manuscript and, if so, which manuscript the covers adorned. In 1870, both covers were attached to the Carolingian manuscript. Originally, however, the two covers probably adorned the Gospel Book of Otto III, having been fashioned either during the reign of Otto III or Henry II.[27]

Turning to the cover incorporating the Hodegetria icon, it is immediately apparent that the re-use of the ivory at Aachen create a viewing experience that was entirely different from that open to a Byzantine viewer. Whereas a Byzantine viewer would have seen an object which by virtue of its wings had a sculptural and three-dimensional quality in which the Hodgetria was either surrounded by an assembly of saints or hidden from view if the wings were closed, in its western re-use the image becomes part of a surface that – the depth of the carving and the repoussé metalwork aside – is a two-dimensional and static image.

In addition, the Hodegetria has become part of a narrative of the life of Christ, being surrounded by scenes in repoussé metal showing the Nativity (top left), the Crucifixion (bottom left), the Maries at the Tomb (bottom right) and the Ascension (top right), as well as being accompanied by the symbols of the Evangelists. Thus, the programmatic context of the image has changed entirely.

The changed setting also resulted in a completely different visual effect. Being part of the decoration of a western manuscript, the ivory is now combined with semi-precious stones, cloisonné enamel and an expanse of gold. While it is possible that this ivory was at very least partially coloured when in Byzantium,[28] its colouristic effect would have been more restrained. It has been suggested that the covers of western manuscripts decorated with gold and ivory referred to chryselephantine works of antiquity.[29] Whatever allusion was intended, if any, the combination of gold and ivory creates a visually overwhelming artefact, consisting of the most precious materials available to craftsmen and creating a combination of materials on a flat surface unparalleled in Byzantium.

The analysis of the silver covers is more difficult, bearing in mind that combination of the silver frame and the two ivory wings may not be the original appearance of the cover. It has been suggested that the presence of the angels on either side of the central image indicates that the original image represented either Christ in Majesty or an Agnus Dei.[30] Certainly, the gestures of the angels presuppose a hieratic image in the centre. The question, however, arises when the ivories were incorporated into the silver frame. Although heavily restored,[31] it is not immediately apparent that the ivories were inserted into the frame at a later date. Indeed, it would appear that they fit perfectly into the metal frame, suggesting that the present appearance of the cover is the original one. While it is not impossible that the metal frame was designed to accommodate an image of Christ, perhaps even in an artistic

medium other than ivory, and endowed with images to complement a depiction of Christ, it may well be that the decision was taken to incorporate the two wings while the frame was still being executed.

In discussing the original appearance of the silver cover, another consideration needs to be taken into account. The two wings are shorter than the Hodegetria panel. This might suggest that the wings were from a different triptych, but this need not be so. It is possible that the two wings were cut. However, any cutting that did take place only affected the frame, not the figures themselves. The fact that the wings are shorter than the central panel, however, do not necessarily indicate that they once formed part of a different triptych. Arguably, the discrepancies in size between the central panel and the wings were intentional. Certainly, the facial features of the saints are similar to the faces of the figures on the central panel, suggesting that at the very least the panels emanated from the same workshop.

Turning to the silver book cover in its totality, the question arises what medieval western viewers would have made of the assembly of figures shown on the cover (assuming, of course, that the cover would have been looked at closely). It is immediately apparent that the subject matter and programmatic content of the panel are unusual. St John the Evangelist is shown twice, appearing in the top right of the silver frame and the top of the left wing of the triptych. To Byzantine viewers, the juxtaposition of the four saints in the centre would have looked odd. This is indeed a strange combination of images. Perhaps what underlies it, is the wish to incorporate two Byzantine ivories in a frame originally designed to incorporate another image. Paramount in the decision to use the ivories was their preciousness and their Byzantine, or at least perceived exotic origin, not the creation of a programmatically coherent image.

We can gain further insight into the fate of Byzantine ivory triptychs from another set of book covers. The front covers of two eleventh-century manuscripts associated with Bishop Ellenhard of Freising (1052-78) – a Lectionary and a Gospel Book (Munich, Bayerische Staatsbibliothek, clm 6831 and 6832) – incorporate the three segments of a tenth-century Byzantine triptych.[32] The cover of the lectionary incorporates the central panel showing the Crucifixion and the Deposition. (Fig. 13.3) On the cover of the Gospel book (Fig. 13.4) are the wings, showing on the left the Annunciation, Nativity and Baptism and, on the right, the Visitation, Presentation and Anastasis. The ivories are surrounded by the strips of gilded copper with niello inlay, datable to the middle of the eleventh century. It is not known whether the both manuscripts originally had covers or whether only one of the manuscripts was decorated with covers at the front and back.[33]

In the original state of the ivories, the double image of the Crucifixion and Deposition dominated the triptych; the scenes from the early life of Christ and

the Anastasis were subsidiary to the depiction of Christ suffering. By being dismantled, different weight was given to the images, not least because they were deployed on two manuscripts.

Turning to the cover of the Gospel Book, which incorporates the two wings, it is apparent that the designer of the cover preserved the chronological sequence of the scenes from the life of Christ. The maker of the cover was clearly aware of the significance of the scenes and combined them in a chronologically coherent fashion. Perhaps more so than in their Byzantine context, the chronological progression of the life of Christ is emphasized by dint of combining the two wings on the cover. The life of Christ now unfolds from left to right, starting with the Annunciation and the Visitation on the top row, followed by the Nativity and the Presentation in the middle row. It is only in the bottom row that, to a western viewer, the chronological coherence existing in the preceding two rows is absent as there is a wide narrative gap between the Baptism and the Anastasis. When the object still functioned as a triptych, the gap was filled by the Cruxifixion and Deposition shown on the central panel. Perhaps what was unusual to western viewers of this cover was the depiction of the Anastasis, an image which in the Europe north of the Alps is likely to have been virtually unknown.[34]

Thus, in dismantling the triptych the narrative coherence of the ivory triptych was fundamentally changed. The Crucifixion/Deposition panel was removed from its narrative context and the scenes on the wings, although still forming a chronologically coherent sequence, are now devoid of the narrative's pivotal image.

Another example of this type is the cover of a ninth-century Gospel Book from Wessobrun (Munich, Bayerische Staatsbibliothek, clm 22 021).[35] In this instance, the entire tenth-century Byzantine triptych is incorporated into the front cover of the manuscript. Here, however, the triptych has not only been dismantled, the wings have been cut into three pieces each.

The central panel of the triptych and the dismembered wings are incorporated into a decorative ensemble consisting of niello enamel plaques and gold filigree work, dating from the late eleventh or early twelfth century. Christ is embedded in the centre of the decoration. (Perhaps the silver cover of the Aachen Gospel Book of Otto III was once intended to contain a similar ivory of Christ.) Above Christ, two symbols of the Evangelists and a depiction of the Holy Spirit are shown on a niello plaque. Below Him, a second niello plaque shows two further symbols of the Evangelists together with the hand of God.

The three segments of the left wing of the triptych, placed to the left of Christ, show, in descending order, an angel, Mary and St Paul. The ivories to his right show, again in descending order, St Peter, an angel and St John the Baptist. If the wings were combined in the order on which they are displayed

on the book cover, the arrangement, at least from a Byzantine perspective, does not make sense. The original sequence of the figures on the left wing of the triptych would have been, in descending order, an angel, Mary and St Paul. The sequence on the right wing would have been, again in descending order, an angel, St John the Baptist and St Peter. Thus, in its original state the tripytch showed a Deesis, with Mary and St John the Baptist appearing at the central figures on each of the wings. In the current arrangement, which presumably reflects the arrangement intended by the makers of the manuscript cover, Mary is paired with an angel and St John the Baptist is paired with St Paul at the bottom of the cover, while an angel appears with St Peter at the top.

Thus, an essentially new assembly of holy figures is created. Whereas in its Byzantine context, the triptych depicted a Deesis, with Mary and John the Baptist occupying, respectively, the central position in each wing, the programmatic emphasis of the image as displayed on the cover is different. Here, the central image is the Trinity, represented by the Hand of God and the Trinity shown in the enamels and the image of Christ in ivory, surrounded by the symbols of the Evangelists. The dismembered sections of the wings are secondary to that image, being separated from the image of the Trinity and the Evangelists by the gold filigree frame that surrounded the pieces.

The three manuscript covers discussed provide instances of what, at least superficially, may be considered a 'crude' response to the Byzantine object: the triptychs were dismantled and in some instances dismembered. The two final examples discussed in this paper show how a Byzantine triptych could be recreated or turned into an altogether new image.

The lower cover of a thirteenth-century book binding (Paris, Musée de Cluny, Cl. 1399) contains what at first sight appears to be a Byzantine ivory triptych showing a standing Hodegetria surrounded on either side by three busts of saints (Fig. 13.5).[36] It is thought that the triptych comes from an earlier binding.[37] The wings have been dated to the second half of the tenth century.[38] The figures on the two wings share many similarities, suggesting a common origin somewhere in Byzantium.[39] At a later stage the wings were recut. Even at a fleeting glance it is clear that the standing Hodegetria has a different origin. The plaque is less tall than the two wings, necessitating the addition of a small ivory strip at the bottom to create an impression of uniform size. The width of the plaque showing the Hodegetria is very similar to the width of the two wings, indicating that, whatever its origin, it could not have formed the central plaque of the triptych to which the two plaques showing saints were originally attached. Stylistically, the Hodegetria looks very different from the saints. It is likely that the plaque is a western pastiche of a Byzantine ivory showing the Hodegetria. It has been suggested that this plaque dates to the end of the tenth or beginning of the eleventh century,[40]

even though a later date is not impossible.

Regardless of whether the triptych was created for the thirteenth-century binding or originally adorned another binding, it is a western recreation of Byzantine triptych. Whereas the preceding examples discussed in this paper show that triptychs were dismantled and at times even dismember, here the parts of the a Byzantine triptych were combined with a western recreation of a Byzantine image to create a semblance of a Byzantine triptych and create an image which is not paralleled by any surviving Byzantine ivories.

The re-use of Byzantine triptychs in the last example to be discussed has parallels both with the covers of the manuscripts now in Munich and that of Cluny codex. This is the portable altar of St Willibord (Trier, Church of Sts Mary and Lawrence).[41] According to an inscription, it contains a fragment from the True Cross and and a piece from Christ's sudarium. Other relics are contained in the altar, among them a part of Mary's robe. Individual sections of the altar date from eighth, eleventh, twelfth and fourteenth centuries.

Some time in the twelfth century, two eleventh-century Byzantine triptych were attached to the long sides of the reliquary, but not before they were dismantled. The long sides are divided into three squares of roughly equal size divided by enamel strips. On one long side the ivory of the Koimesis appears in the centre. On the opposite side, the central panel depicts the Hodegetria. On both long sides of the altar the two wings, each of which shows two Byzantine bishop saints, appear in the compartment on either side of the central panel. They are surrounded by repoussé metalwork showing bishops associated with Trier. Two are shown on a strip of metal on each side of the ivory panels.

It has been suggested that the two triptychs were incorporated into the decorative scheme of the altar precisely because of their Marian subject matter.[42] It is clear, however, that in the process of doing so, the bishop saints on the wings were not only physically removed from the central wings, but also incorporated into a new pictorial programme.

Although some of the metal strips on either side of the ivories have disappeared, it is clear that the bishops shown on the metal strips are turned towards the saints shown in the ivories. What has been created is a community of bishop saints, four western ones and two Byzantine ones in each compartment. Clearly, this is an instance where the designer created a new pictorial programme by removing the wings from the image of the Koimesis and incorporating them into a new ensemble of figures. At the same time, the panels of the Hodegetria and the Koimesis have become self-contained images, which refer to the relics of the Mary contained inside the reliquary.

This survey has considered selected examples of Byzantine ivory icons that were re-used in a western context. On being re-used in a western context, Byzantine ivory icons were not only removed from their original context and

displayed in a way which bore no resemblance to the narrative ensemble to which they initially belonged, but they were also transformed into all together different religious images that had no parallel in Byzantium. Such images were carefully designed by the western creators of manuscript covers of reliquaries, at times probably reflecting an aesthetic appreciation of objects from a distant and different culture. In their re-use the ivory icons were turned into radically different images which Symeon of Thessaloniki would have considered 'confections ... contrary to custom'. The question remains, however, whether an imaginary Byzantine viewer transported into Ottonian or Salian Germany and confronted with the objects discussed in this paper would have concurred with Symeon's views.

## Notes

1.  Symeon of Thessaloniki, *Contra Haereses*, PG 155, 112; trans. C. Mango, *The Art of the Byzantine Empire, 312-1453* (Englewood Cliffs, NJ, 1972), 253-4.

2.  PRESULIS IMPERIIS BERTOLDI CLAUDITUR OMNIS TEXTUS EVANGELII REDIMITUS HONORE DECENTI. See A. Effenberger et al., *Museum für Spätantike und Byzantinische Kunst* (Mainz, 1992), 220-21.

3.  R. Kahsnitz, 'Byzantinische Kunst in mittelalterlichen Kirchenschätzen: Franken, Schwaben und Altbayern', in *Rom und Byzanz. Schatzkammerstücke aus bayerischen Sammlungen*, ed. R. Baumstark (Munich, 1998), 47.

4.  Kahsnitz, Entry on ivory panel in Baumstark, *Rom und Byzanz*, 154.

5.  A. Cutler, 'A Byzantine Triptych in Medieval Germany and Its Modern Recovery', *Gesta* 37/1 (1998), 3-12.

6.  Cutler, 'Byzantine Triptych'.

7.  A. Effenberger, 'Byzantinische Kunstwerke im Besitz deutscher Kaiser, Bischöfe und Klöster im Zeitalter der Ottonen', in *Bernward von Hildesheim und das Zeitalter der Ottonen*, eds. M. Brandt and A. Eggebrecht (Hildesheim, 1993), I, 145-59; Cutler, 'Byzantine Triptych'. See also the Gospel Book of Bishop Bernward (Hildesheim, Dom-Museum, Inv. Nr. DS 18), the front cover of which is decorated with a tenth-century Byzantine ivory of the Deesis. See *Byzanz. Die Macht der Bilder*, eds M. Brandt and A. Effenberger (Hildesheim, 1998), fig. 127, cat. no. 69; also H. Klein, 'Aspekte der Byzanz-Rezeption im Abendland', in *Byzanz*, 122-53, esp. 131-33.

8.  R. McKitterick, 'Ottonian intellectual culture in the tenth century and the role of Theophano', in *The Empress Theophano. Byzantium and the West at the Turn of the First Millennium*, ed. A. Davids (Cambridge, 1995), 53-74 [first published in *Early Medieval Europe* 2 (1993)].

9.  K. Weitzmann, 'Die byzantinischen Elfenbeine eines Bamberger Graduale und ihre ursprüngliche Verwendung', *Studien zur Buchmalerei und Goldschmiedekunst des Mittelalters. Festschrift für Karl Hermann Usener* (Marburg, 1967), 11-20, esp. 11; repr. in K. Weitzmann, *Byzantine Book Illumination and Ivories* (London, 1980).

10.  *Rom und Byzanz*, ed. Baumstark, 167-70, cat. no. 44, with earlier literature.

11.  Weitzmann, 'Die byzantinischen Elfenbeine', 11.

12. On Henry's foundation see A. von Reitzenstein, *Die Geschichte des Bamberger Domes* (Munich, 1984).

13. J. Lowden, 'The Royal/Imperial Book and the Image or Self-Image of the Medieval Ruler', in *Kings and Kingship in Medieval Europe*, ed. A. Duggan (London, 1993), 213-40, esp. 228-32, with earlier literature.

14. The laudes of the Easter mass in Msc. Lit. 7 are offered to *Henrico imperatori et Chunigunde reginae*.

15. For instance, despite their identical appearance, the manuscripts have been attributed to different centres of production. See H. Hoffmann, *Buchkunst und Königtum im ottonischen und frühsalischen Reich*, MGH 30/1, 281 and 406 and idem, *Bamberger Handschriften des 10. und des 11. Jahrhunderts*, MGH 39 (Hanover, 1995), 94-5, 144-45, suggests that Msc. Lit. 7 was made at Seeon between 1014 and 1024, while Msc. Lit. 8 is thought to have been made in Regensburg between c.1015 and 1030.

16. Weitzmann, 'Die byzantinischen Elfenbeine', 13. A fragment of the Archangel Gabriel thought to have come from the same iconostasis beam as the Bamberg ivories survives in the Royall Tyler Collection in Paris. See Weitzmann, 'Die byzantinischen Elfenbeine', 12.

17. K. Weitzmann, 'An Ivory Diptych of the Romanos Group in the Hermitage', *VizVrem* 32, 142-55. Reprinted in Weitzmann, *Byzantine Book Illumination*, 1-11. According to Weitzmann, the extended Deesis formed the second row of this iconostasis beam while the Twelve Feasts appeared on the first and third rows. The figures of St Symeon and Mary and Christ in the Hermitage panels are accompanied by a fifteenth-century inscription in Latin from the Second Chapter of the Gospel of Luke.

18. Lowden, 'Royal/Imperial Book', 231-32.

19. For instance among the decoration of the Kariye Camii in Istanbul.

20. See, for instance, the Deesis with Sts Peter and Paul on the Harbaville Triptych in the Musée du Louvre, Paris: *Byzance. L'art byzantin dans les collections publiques françaises*, ed. J. Durand (Paris, 1992), 233-36.

21. Lowden, 'Royal/Imperial Book', 231.

22. F. Steenbock, *Der kirchliche Prachteinband im frühen Mittelalter: von den Anfängen bis zum Beginn der Gotik* (Berlin, 1965), 72-3; cat. no. 7, fig. 9; Lowden, 'Royal/Imperial Book', 229-30.

23. Steenbock, *Prachteinband*, 73 refers to other diptychs in Monza that appear to have been used as covers of liturgical manuscripts.

24. Steenbock, *Prachteinband*, nos. 51 and 52, 133-37; E. G. Grimme, *Das Evangeliar Kaiser Otto III. im Domschatz zu Aachen* (Freiburg, 1984), 85-88. On the Carolingian manuscript see *Kunst und Kultur der Karolingerzeit*, eds C. Stiegemann and M. Wemhoff (Mainz, 1999), 706-10.

25. Grimme, *Evangeliar*, 85.

26. Steenbock, *Prachteinband*, 135-37 suggests a date in the early eleventh century.

27. Grimme, *Evangeliar*, 85.

28. For a discussion of coloured ivories in Byzantium see C. Connor, *The Color of Ivory* (Princeton, 1998).

29. Kahsnitz, 'Byzantinische Kunst in mittelalterlichen Kirchenschätzen', 48.

30. Steenback, *Prachteinband*, 136; Grimme, *Evangeliar*, 88.

31. Grimme, *Evangeliar*, 8 and 88.

32. *Rom und Byzanz*, ed. Baumstark, cat. no. 53, 85-90. The lectionary was written at Tegernsee in the second quarter of the eleventh century. It was given to Freising by Bishop Ellenhard

to St Andrew, a collegiate church founded by him in 1062. The Gospel book was written for the church of St Andrew.

33. Until 1965, the cover incorporating the two wings decorated the back cover of the Gospel book. On rebinding, the cover was placed on the front. See *Rom und Byzanz*, ed. Baumstark, 190.

34. A. Kartsonis, *Anastasis: the Making of an Image* (Princeton, 1986).

35. *Rom und Byzanz*, ed. Baumstark, cat. no. 52, 181-85.

36. J.-P. Caillet, *L'antiquité classique, le haut moyen âge et Byzance au musée de Cluny* (Paris, 1985), 134-37. The front cover of the binding incorporates a Carolingian ivory of the Crucifixion.

37. Caillet, *L'antiquité classique*, 137.

38. The saints have not been conclusively identified. The left wings shows from top to bottom what appear to be two military saints and an apostle. On the right wing a saintly bishop, a military saint and an apostle appear in descending order.

39. The wings have been linked to the fragment of triptych now in the Museum Mayer van den Bergh in Antwerp. See A. Cutler, *The Hand of the Master. Craftsmanship, Ivory and Society in Byzantium (9th-11th centuries)* (Princeton, 1984), 193-94, figs 214 and 215.

40. Caillet, *L'antiquité classique*, 134-37.

41. *Schatzkunst Trier*, ed. F. J. Ronig (Trier, 1984); 110-11, cat. no. 40; M. von Vlierden, *Willibrord en het begin van Nederland* (Utrecht, 1995), 84-5; cat. no. 55; H. van Os, *De Weg naar de Hemel* (Baarn, 2000), 162-63. The reliquary was kept at the convent of St Mary until 1794.

42. Klein, 'Byzanz-Rezeption', in Brandt and Effenberger, *Byzanz*, 141-42.

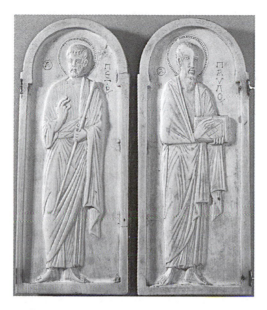

13.1 Ivory plaques of St Peter and St Paul, 10th century. Used as cover of Bamberg, Staatsbibliothek, Msc. Lit. 7 (courtesy of the library).

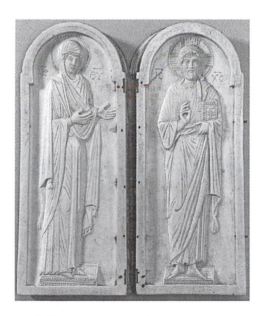

13.2 Ivory plaques of Christ and Mary, 10th century. Used as cover of Bamberg, Staatsbibliothek, Msc. Lit. 8 (courtesy of the library).

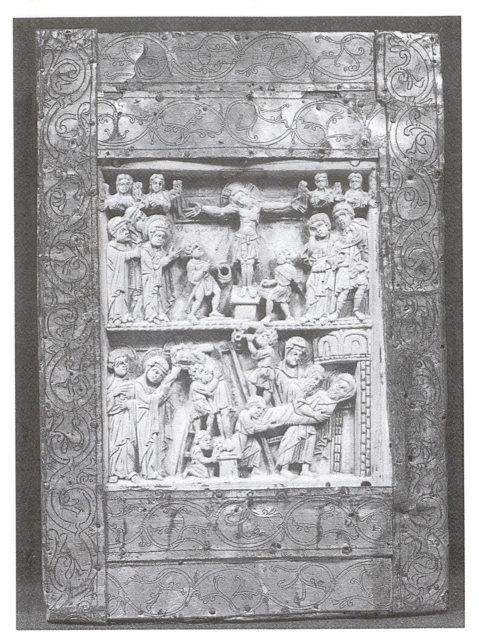

13.3 Ivory of the Crucifixion and the Deposition, 10th century. Used as cover of Munich, Bayerische Staatsbibliothek, clm 6831 (Lectionary) (courtesy of the library).

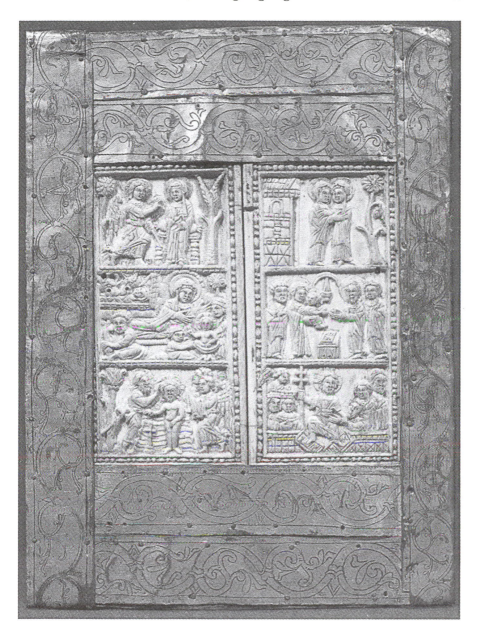

13.4 Ivories of the Annunciation, Nativity and Baptism (left) and the Visitation, Presentation and Anastasis (right), 10th century. Used as cover of Munich, Bayerische Staatsbibliothek, clm 6832 (Gospel Book) (courtesy of the library).

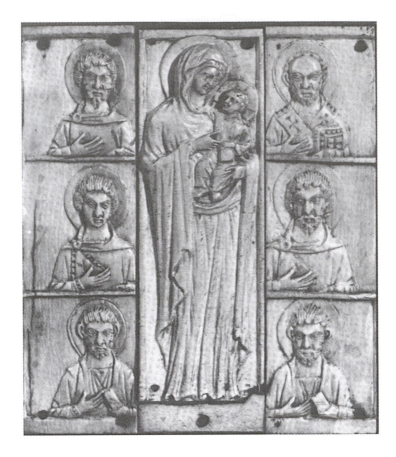

13.5 Ivory triptych of the standing Hodegetria accompanied on either side by three busts of saints, 10th century. The lower cover of Paris, Musée de Cluny, Cl. 1399 (Réunion des Musées Nationaux).

Chapter 14

# For the Salvation of a Woman's Soul: An icon of St Michael described within a medieval Coptic context

Lucy-Anne Hunt

## Introduction

Robin Cormack has remarked that 'icons remain among the most elusive subjects in the history of art ... one challenge of the icon at this time is to react to a whole new range of material and find and justify new ways of approach'.[1] Developing the approach of considering icons from the perspective of the viewer, or 'audience'. I propose to discuss a description of an icon in an encomium of the archangel Michael, hitherto unnoticed by art historians, as a case study in the commissioning, appearance, purpose and subsequent use and re-use of a particular icon. My intention here is to examine this literary reference to St Michael, his icon and his miracles, both for its contribution to the broader study of the icon and its relevance in its specific Coptic context. The description of the icon of St Michael forms part of an encomium on the archangel dating from the early seventh century but best preserved in a manuscript made in Cairo in the early thirteenth century. My approach is to consider the text in its early thirteenth-century version, with related visual imagery, in the light of its arguably predominantly female audience. This narrative of an icon of St Michael belonging to a woman (hitherto neglected by art historians), presents a case study of the reliance on icons by women in the medieval eastern Mediterranean world and their instrumental role within a particular, thriving, popular culture.

## The Encomium of Eustathius of Thrace (Trakê)

The description comes within an Encomium on St Michael the Archangel,

From *Icon and Word: the Power of Images in Byzantium. Studies presented to Robin Cormack*, eds Antony Eastmond and Liz James. © 2003 by contributors. Published by Ashgate Publishing Ltd, Gower House, Croft Road, Aldershot, Hampshire, GU11 3HR, England, pp. 205-232.

attributed to an otherwise unknown author, Eustathius, bishop of Thrace (Trakê). It was written to be read during the church service for the feast of St Michael on the twelfth day of the Coptic month Athôr. The most complete version of the encomium, and the one referred to here, occurs in an early thirteenth-century Bohairic (Northern dialect) Coptic-Arabic manuscript in the British Library (MS Or. 8784) which was edited and translated by E.A. Wallis Budge in 1894.[2] The encomium is also known in its shorter Sahidic Coptic version.[3] It was probably written in the early seventh century, as were the two other encomia to St Michael in the London manuscript, written by the eastern Christian writers Abba Theodosius Archbishop of Alexandria and Severus, Patriarch of Antioch.[4] Eustathius' text, according to Michel van Esbroeck, displays an 'anti-Chalcedonian tendency' with a mass of detail not included in the synaxary.[5] According to its author, Trakê was the island to which the Empress (Eudokia) banished St John Chrysostom and this has been assumed to be to the north-east of the Black Sea.[6] The whole narrative takes place here with the author conflating the place of St John Chrysostom's last exile with that of his death.[7] The author also recounts that the encomium was recited by St John Chrysostom before his death, and that the endpiece to the encomium is written in his honour.

*The Manuscript in the Context of a Female Audience in early thirteenth-century Cairo*

The British Library manuscript comes from a specifically Cairene context. It was bought in Cairo by Robert Curzon (fourteenth Baron Zouche) during the travels in the Middle East that he described in his *Visits to the Monasteries of the Levant* published in 1849.[8] It came into the possession of the British Library in October 1917.[9] Although the manuscript's own colophon is lost, a leaf from another manuscript in the same scribe's hand is attached to it (fol. 188r), which gives a date of AD 1210 and the scribe's name, appropriately, as Michael.[10] Since the binding is modern it is not known when this leaf came to be attached to the encomium. However, assuming the scribe wrote both manuscripts within the space of a decade, this gives an early thirteenth-century date for the British Library encomium. But it provides much more than just a date. It reveals that the scribe wrote this other manuscript for a charitable 'God-loving' woman, Melokh, for donation to the church of St Michael (Râ's al-Khalîj), south of Old Cairo (Babylon), as 'a memorial for her for the salvation of her soul'.[11] This came about 'through the command and foresight of the venerable and holy Patriarch Apa John'.[12] This means that official patriarchal sanction and encouragement for such female veneration of St Michael was forthcoming in early thirteenth-century Cairo. While it cannot, of course, be said for sure which texts Melokh's book contained, these were likely to have been connected with St Michael. This is supported by the existence of yet another manuscript written by the same scribe, which is also

in the British Library. It has been suggested that this third manuscript, a Biblical Lectionary, could have been written for the concluding lesson for 12 Hathôr for the feast of St Michael.[13] The Encomium was, then, written by a scribe called Michael who not unnaturally favoured texts relating to his namesake and included female donors among his patrons. Equally naturally, a female donor such as Melokh would have identified with Euphemia, the charitable, God-loving woman in the Encomium, whose icon of St Michael supported her throughout her widowhood. This prompts a gendered reading of the text in the light of the significance of the icon to Euphemia's widowed state.

*Summary of the narrative of Euphemia's icon of St Michael in Eustathius' encomium*

The narrative is structured in sections. First is the process whereby the icon comes to be commissioned, as a result of the pact between husband and wife, Aristarchus and Euphemia, as the husband lies dying. Next, three different visits to Euphemia by the devil are foiled through her faith in the icon. Then comes the role of the icon at Euphemia's own death. Finally, the changes to the icon and its miracle-working activities after Euphemia's death are described.

1. The circumstances of the commissioning of the icon

On his deathbed Aristarchus, the governor of Trakê, begs his wife Euphemia to continue to give the monthly donations and offerings to the Church at the appropriate days commemorating St Michael, the Virgin Mary, and the Nativity that he had been giving since the time of his baptism by St John Chrysostom. He asks her to pay particular attention to the offerings given in the name of St Michael on the twelfth day of each month. He is concerned about this, as it is St Michael who will intercede with God to receive his soul. His wife Euphemia agrees, and says she will increase the sums of money given to charity. In turn she makes a request to her husband that he have an icon of St Michael made for her to keep in her bedroom. She wills her husband to 'commit' her to the saint 'as an object of trust' so that when he is gone, St Michael will become her guardian and protect her against evil. She points out how sorrowful and without hope she will be as a widow, like a body without a head and 'the body without a head is without a soul'. She cites St Paul (Ephesians 5.23) as saying that 'the head of a woman is her husband' and she also uses the analogy of being like a ship without a rudder. Aristarchus immediately has an artist paint an icon of St Michael, with a cover of gold inlaid with precious stones. Euphemia presses him to commit her into the hands of St Michael to make him her guardian for the rest of her life. This Aristarchus does, by taking her hand and laying it on the figure of the saint and calling on St Michael to answer her prayers and protect her. Euphemia

puts the icon in her bedroom and offers up incense to it. A lamp burns continually by it and she prays to it three times a day, asking it to help her. Her husband dies and Euphemia continues to make the charitable donations, as she promised.[14]

2. The devil's tormenting of Euphemia three times and the role of the icon in deflecting him
i) The devil wants to destroy the reward of eternal life that Euphemia would gain by her worthy behaviour. His first visit to her is in the guise of a nun, accompanied by other devils also disguised as nuns. Euphemia invites the devil-as-nun to enter her bedroom to pray before the icon but the devil is afraid to enter. He starts to harangue Euphemia saying that, since all women except Mary the Mother of God live with their husbands, he advises her to remarry the wealthy and well-connected widower Hilarchius, and offers her gold and silver gifts. Euphemia says she will have to ask her (male) guardian's advice, whereupon the devil accuses her of impropriety. Euphemia agrees to show the devil her guardian 'face to face' on condition that he turns to the east and prays for forgiveness for his evil thoughts. When the devil refuses, Euphemia continues to try to convince him to pray after which she says she will bring out the guardian for the 'nun' to kiss, if she is worthy to look on his face. Seeing himself beaten, the devil starts to change shape, taking varied forms. Euphemia then calls on St Michael and makes the sign of the cross over herself, wherupon the devil disappears 'like a spider's web'.[15]

ii) The devil's next appearance is in the form of a very tall Ethiopian who has the head of a goat with blood-shot eyes, hair like a boar's bristles, holds a two-edged sword, and he smells. At his appearance Euphemia rushes into the bedroom, grabs the icon and calls on St Michael. The devil threatens her from outside the door, making gutteral noises and declaring that he wants to seduce her. He particularly curses St Michael as the one who expelled him and his companions from heaven. He admits that it is St Michael's appearance in the coloured icon that defeats him: the saint's face terrifies him and his garments painted in different colours 'by sorcery' overcomes the devil's power. The icon is made of wood, the same material substance as the cross which hindered him in the past. He knows that as long as Euphemia puts her trust in the little icon in her hands he will not prevail. So he threatens to return on a particular day, the twelfth of the month of Paôni (6 June), when he surmises that Euphemia will be vulnerable. It is at this time that St Michael and his angels will be occupied for three days and nights praying continuously, entreating God to make the Nile rise during the innundation and make the rain and the dew fall. The devil threatenes that when he returns he will smash the icon over Euphemia's head. Having had enough of all this, Euphemia

rushes at him with the icon and he disappears.[16]

iii) While Euphemia is praying on the morning of the feast of St Michael, preparing herself to give her gifts, the devil duly appears, this time in the form of the archangel himself. He has mighty wings and wears a golden girdle inlaid with precious stones and a crown set with pearls on his head. In his right hand he holds a golden sceptre, but this is without the sign of the cross. He says he had been sent by God and that her prayers have been efficacious, sending forth light brighter that the sun. His advice now is that since her husband has already gained eternal life there is no point in squandering her husband's possessions by continuing to give alms. She may as well keep some of these, in case she runs low, and in any case her charity may attract the attention of the devil. Furthermore, if she remarries she can bear a son to inherit her possessions and perform commemorations for her when she dies. Since Hilarichus is about to declare war on the emperor Honorius he will be wealthier than ever once he gains control of the Byzantine empire.

While Euphemia had initially been taken in by the devil's appearance as St Michael, she is not fooled for long. She challenges the devil to show her scriptural texts directing her to cease alms-giving, desist from prayer, or remarry, least of all to someone who is a heretic and disloyal to the emperor. Instead she backs up her points with Psalm and New Testament references. Concerning remarriage, she refers to the *Physiologus*. When the turtledove loses its mate, rather than taking another, it goes into the wilderness until its own death. Similarly, the raven only takes one mate. When the male raven dies, the female tears out her tongue with her claws so that other ravens will recognize her situation by the sound she makes and will, furthermore, come to her rescue if another tries to molest her. Her final argument stems from St Michael's appearance on her icon. She recognizes St Michael by the cross on his sceptre, but this the devil lacks. He retorts that 'Painters wish to decorate their pictures in order that their art may be more glorified' and angels do not bear the sign of the cross. But Euphemia is quick to point out that envoys of the emperor carry imperial tokens to be recognized, and that their authority is endorsed by documents bearing the emperor's seal. If angels do not carry the sign of the cross they will not be believed, and this is especially true of the archangel Michael. When she declares that she is going to fetch her icon for her visitor to acknowledge, the devil changes into a lion and starts to savage her at the neck. When she was nearly dead from strangulation Euphemia cries out to St Michael who appears 'bearing upon himself royal rank and dignity', with a golden sceptre, duly bearing a cross, in his right hand, and everywhere is illuminated a thousand times more than the sun. The terrified devil pleads with St Michael, confessing that he had dared to come into a place with St Michael's image and promises not to do so again. St Michael meanwhile is

gripping him hard 'like a bird in the hand of a little child' before letting him go in disgrace.[17]

3. The role of the icon at the time of Euphemia's death

St Michael assures Euphemia that the devil will not now have the power to return to her. He asserts that he was present when Euphemia asked for her icon to be painted as a protector and that he will be there with his angels to take her to heaven to rejoin her husband when she dies. Euphemia takes the sacrament at the church of Abba Anthimus from the bishop (appointed by St John Chrysostom), and goes home to give her alms to the poor and feed them. After this she sends for the bishop. He comes and tells her that God has accepted her sacrifice, as he accepted those of Abel and Melchisedec. She takes the bishop to her bedroom, where the icon is, and places a throne of ivory for him to sit on, with the priests and deacons on a bench of silver. Then she brings out all her possessions for the bishop to distribute to the poor in the name of the archangel Michael so that he might pray for her and her husband before God, that God might show mercy to her soul. After this, the bishop has her possessions taken to the church and Euphemia releases her servants. The writer of the encomium records that as he witnessed this scene – he was a priest at the time – he was struck by the sudden strong smell of incense which accompanied the scene. Euphemia proceeds to beseech the bishop to pray for her as she is dying; St Michael is coming for her, with his angels and with her husband. After the bishop's prayers Euphemia requests that she may kiss her icon. When Euphemia calls upon St Michael 'to stand by me in this terrible hour' there is a mighty gushing sound and the archangel appears shining like the sun, with feet like brass pouring out flames of fire, holding a harp in his right hand and in his left a wheel (or disk) with a cross. His clothing is finer than any earthly king. Standing, he spreads out his garment of light to envelop Euphemia's soul. Thus 'she gave up the ghost with the picture of the Archangel Michael laid upon her eyes before she departed from the body', accompanied by angelic psalm singing which seals her redemption.[18]

4. The icon's activities after Euphemia's death

After her death the icon immediately 'flew away', nobody knew where to. But after Euphemia had been buried alongside her husband in his tomb, the bishop re-entered the church to find the icon hanging, immovable and without support, in the apse. The writer recounts that news of the miracle reached the emperor Arcadius and empress Eudoxia in Constantinople and Honorius in Rome, who all three together came to see it, and bowed down at the miracle-working site of the deathbed of St John Chrysostom.

Subsequently, on the twelfth day of each month, at the feast of St Michael,

the icon puts out olive leaves at its four corners, together with fine fresh fruit. It does this because it is made of olive wood, and it performs miracles. Two are recited, one of a woman with stomach abscesses who was cured by eating the fruit and another of a man whose pain at the side of his head was cured when he took oil from the lamp, made the sign of the cross on his face and took one of the leaves. Here the writer concludes the main body of the encomium by summing up the attributes of the archangel Michael as 'master and lord after God' describing him as 'the governor of all men and of all animals, and ... the steward of them all before God'. St Michael is chief general of the hosts of heaven, and stands before God. Having direct access to God, it is he who entreats God on mankind's behalf and acts as the messenger or steward and angel of God.[19]

5. Endpiece
The encomium concludes with a short section praising St John Chrysostom before a final prayer to St Michael.[20]

*The text as popular literature*
The text itself is written in an approachable way for a lay, including or especially, female audience. It is designed to appeal to the popular imagination, with the events narrated as if enacted in a play. There is the drama of Euphemia being rescued by St Michael and the bathos, comedy even, of the devil's exploits, as he changes guises and is evocatively brought to heel by the archangel, like a bird in the hand of a child (Section 2 (iii) above) in one case. The devil's appearance as a nun (Section 2(i)) introduces a note of irreverent ludicrousness. There is a sense of immediacy about the proceedings. Even the sense of smell is evocative, with the devil's bad odour pervading his second appearance to Euphemia (Section 2(ii)) juxtaposed with the smell of incense at Euphemia's death (Section 3).

References to animals touch on the popular. The devil in one appearance has the head of a goat and, in a later appearance, changes into a lion. This would have been familiar in popular culture of the time. It is reminiscent of the mimicry of animals by entertainers in the medieval Arab world, in which the entertainers not only used voice to imitate, but also costume and gesture.[21] Such mimicry of animals in entertainment was found in Egypt up until the beginning of the twentieth century.[22] This occurred in the shadow plays (khayâl) commonly found in the Arab world as well as Turkey (the karagoz). Gesture and dialogue were also fundamental to the shadow play and both are found in highly developed form in the encounters described between Euphemia and the devil in the encomium.[23] The devil's inconsistency contrasts with Euphemia's constancy during these encounters; when he feels himself to be vanquished he starts changing shape.

Visual parallels endorse the suggestion that the devil's animal-antics are in line with popular theatre. The devil is described (section 2(ii)) as having a goat's head, bloodshot eyes and boar's bristles for hair. He can be imagined as wearing a mask. The devil – or the tormented soul of Judas – is depicted as a composite creature in the Coptic Gospels in Paris (Bibliothèque Nationale Copte 13) in the scene of the suicide of Judas (fol. 81r) (Fig. 14.1).[24] Although the figure is now damaged and difficult to make out, it apparently has two horned heads with a mouse at the end of his nose, wings, a pair of elephant's heads for a body, with snakes writhing up his legs and rodents' heads on his feet. This is reminiscent of masquerading that took place during three days on the streets of Cairo in AD 975, which included the parading of mock elephants.[25] Representations of human dancers wearing animal masks were evinced by Richard Ettinghausen in arguing for the rise in middle-class entertainment in the thirteenth century in particular from the merger of popular and royal cultures from the Fatimid period into the Seljuk/Ayyubid period.[26] Dancers with goat headgear appear notably in mid-sixteenth- to early seventeenth-century Safavid painting.[27] But the tradition can be traced earlier. Dancing figures wearing animal masks in metalwork from mid-thirteenth-century Syria, including the decorated inscriptions of the Freer Canteen in the Freer Gallery of Art in Washington, and an inlaid tray in Cleveland.[28] The Blacas ewer in the British Museum displays entertainers as monkeys with castanets.[29] These are evocative of a thirteenth-century Egyptian shadow play by Ibn Dânîyâl with dancing monkeys at a fair.[30] Such play-acting, alongside singing and other forms of entertainment, are likely to have formed part of Coptic pilgrims' celebrations at the time of church feasts.[31]

The magical and the miraculous coincide in the encomium, which goes beyond viewing the icon as a form of talisman. The unexpected occurs, such as the moment when the icon is found to have a life if its own once it is released from its duties on the death of Euphemia and flies to the church to levitate above the altar. The lively, popular, element of the text was not lost on E.A. Wallis Budge, the editor and translator of this and the other encomiums of the London manuscript, who summarized its appeal in this way in 1894:

> The most ardent lover of Coptic literature must confess that the lives of Coptic saints and the Encomiums upon them are generally too full of miracles and somewhat monotonous exhortations to the listener and reader, but [these] Encomiums... are interesting exceptions to the rule, for they contain narratives which are full of importance, not only for the philologist and antiquary, but also for the student of comparative folk-lore and demonology.[32]

One may also add those interested in art history to the list.

*Euphemia's commissioned icon in the light of her status as a widow*

One of the most interesting aspects of the icon story is the insight it gives into Euphemia's relationship to, and with, the icon at the onset of widowhood. The icon both replaces her husband, even to the extent that it occupies her bedroom, and invokes her male protector, St Michael. It is the product of a pact between a childless husband and wife for the mutual attainment of the afterlife. Following the demise of the male head of the household, the icon stands proxy, as guardian of the widow, to ensure the transfer of the property to the Church. Euphemia acts as a role model for others, offering a way to negotiate widowhood, church authorities and the transfer of property.

Sandra Cavallo and Lyndan Warner have pointed to the necessity of studying the 'self construction' of widowhood in the medieval and early modern period, whereby the widowed 'negotiated the ideals and social practices associated with their condition'.[33] The icon story here portrays a model example of the chaste, virtuous and charitable widow, a type associated with hagiographical texts and sermons throughout the Middle Ages.[34] As a widow, her legal and patrimonial position was no longer 'covered' by her husband.[35] The fact that she is childless simplifies the story, and enables the emphasis to focus on the mutual pact for redemption. As it is, Euphemia inherits all of Aristarchus' wealth and so the narrative can be focused on her dilemmas and temptations and how she overcomes these, with the aid of the icon, to fulfil her destiny as the dutiful widow who garners her final reward. In reality, widows were 'both vulnerable and resourceful, and in some cases exploited their vulnerability to advantage'.[36] In the present case Euphemia used her vulnerable position to argue her case for having an icon made for her, as a strategy for empowerment. The icon became an enabling agent, permitting her to go about her own life and fulfil her responsibilities. As such, her strategy in the encomium, read on St Michael's main winter feast day, would have provided a model for others. She is saved from herself, her own temptations, and corralled into the stereotype of the dutiful widow. The intellect triumphs over desire. From her starting point in the narrative as a headless, and therefore soul-less, being (Section 1) with the aid of St Michael, evoked by the icon, Euphemia can muster the intellectual arguments to outwit the devil himself.

The icon acts as a proxy for Euphemia's husband in providing both protection after his death and in being the object of intimacy. Euphemia's husband puts her hand on the icon almost like a betrothal (Section 1 above). The state of marriage is seen as the natural one, hence the reference to the loyalty of the turtledove and the female raven in the *Physiologus*, representing thinking common to Islam as well as Christianity.[37] Physical contact with the icon as part of icon worship is exemplified in the narrative here, with the emphasis on seeing and touching. When the devil-as-nun appears (Section (i)),

Euphemia naturally assumes 'she' will want to kiss the icon which Euphemia keeps in her bedroom. On her deathbed Euphemia asks to kiss the icon after the bishop has said prayers and she dies with the icon laid upon her eyes (Section 3). This intimacy is reminiscent of the depiction of a woman supplicating the equestrian St Sergios on a thirteenth-century icon made in Latin Syria in which the kneeling, veiled, woman embraces the right foot of the equestrian saint in her hands while pressing her face against it.[38]

*Image recognition and the visual evidence: St Michael's appearance in the Icon*
As Gilbert Dagron has pointed out, images played an important part in the recognition of particular saints in miracle stories, with the image authenticating the vision.[39] The thirteenth-century manuscript in London is headed by a cross frontispiece (fol. 1r) which reinforces the power of the cross asserted several times in the text of Eustathius' encomium. As the devil points out (Section 2 (ii)), it is the fact that Euphemia's panel shares the same physical property – wood – as Christ's cross that makes it so feared by the devil. But other manuscripts with encomia of St Michael display portraits of the saint. These, with other visual material from Coptic Egypt, notably on a shroud and in wallpainting, demonstrate the imagery available to the audience of the encomium to assist its members in visualizing St Michael.

St Michael's physical appearance on the icon, or his actual appearance, is referred to several times in the description. It is the saint's face on the icon that most terrifies the devil and his garments painted in different colours 'by sorcery' that overpowers him (Section 2 (ii)). This introduces the magical aspect to St Michael's image. The next section 2 (iii) describes the appearance of the devil masquerading as St Michael as having mighty wings, wearing a golden and bejewelled girdle with a pearled crown and carrying a golden sceptre in his right hand, which should have had a cross on it. When St Michael himself appears this is rectified. The real St Michael is dressed royally, carries a golden cross-bearing sceptre, and he suffuses light. This is evocative of manuscript and wallpainting in Egypt which likely extended to icon painting. It is only at the end of the encomium that St Michael's appearance evolves, to receive Euphemia's soul (Section 3). Here the imagery of light is retained, but fire issues from his feet, he holds a harp in his right hand, with a wheel (or more likely, disk) with a cross in his left. With clothing finer than a king, he spreads his garment of light out for Euphemia's soul to enter.

Two surviving tenth-century manuscript portraits of St Michael conform to several elements of the encomium description. They also endorse both the God-given power of the archangel and the magical associations which are characterized as sorcery by the devil in the encomium. One is the portrait in a manuscript in the Pierpont Morgan Library in New York (M603) (Fig. 14.2).[40] The text is a Sahidic version of the same Encomium of Severus, Patriarch of

Antioch, which also appears in the London manuscript accompanying the one under discussion here. The New York manuscript was written by Deacon Gabriel (Gabri) and his son Mercurius (Merkoure) from Theogenidos (Perpnoute) in the Fayoum. It was given by a woman, the sister Thanasia, daughter of Anastasia, to the church of St Michael in her native village and then to the monastery of St Michael near present-day Hamouli, thus providing a link with a female donor.[41] The main elements of the description are present, including the mighty wings, belt and cross-sceptre. The authority of the imposing figure, frontally facing with piercing eyes, is endorsed by the text immediately following the portrait, which refers to the power bestowed on the archangel Michael by God.[42] His tunic is white with the folds emphasized in green. He wears purple shoes and a purple mantle, suggestive of royal might, with disks prominently painted on them similar to magical signs.

A similar portrait of St Michael, also dedicated by a private individual, is that heading a London manuscript, BL Or. 7021, fol. 1r (Fig. 14.3) with the text of Apa Theodosius of Alexandria's encomium on St Michael the archangel composed for the feast of the archangel.[43] The manuscript, dated 13 July, AD 987, was written by the scribe Biktor, son of Merkurios, at Esna for a named male donor for the church of the Archangel Michael at Edfu. The illustration would have provided a kind of icon at the start of the book, a paper manuscript, measuring 29.5 x 20.0 cm. The standing St Michael, with his head given prominence, is drawn in a black outlining with his hair and mantle filled in with dark red. Henry Maguire has pointed to the 'binary system' depiction of the immateriality of angels as a foil for the mundane, corporeal depiction of saints.[44] This holds true here, with the archangel's tunic left blank, mirroring the white of the tunic in the New York portrait, to indicate the lack of physical, corporal, substance. By contrast the material substance of the archangel's tunic in both portraits is given tangible form and colour. In the encomium description such garments both frighten the devil and have a protective function in enveloping Euphemia's soul at her death.

A prominent feature of this portrait, in BL Or. 7021 (Fig. 14.3), are the eyes of the angel's peacock's wings, which, with the loops suspended from the archangel's belt, are suggestive of the magical, apotropaic signs and charms on early Christian and Byzantine clothing and textiles.[45] The eyes of the peacock wings in particular are reminiscent of the protective eyes sewn into clothing.[46] A manuscript in London, written in AD 982 or AD 992 at Esna by a named scribe, which includes the oration of St Timothy, archbishop of Alexandria, on St Michael the Archangel, even has instructions for the making of apotropaic charms illustrated with the magical signs decorated with large red capitals.[47] Angels too benefited from apotropaic signs on their garments in Coptic thinking, as a passage in the apocryphal work *The Mysteries of Saint John the Apostle and the Holy Virgin* demonstrates.[48] Here St John converses with a

cherubim (whose body was 'filled with eyes') having been taken up to heaven from the Mount of Olives after Christ's resurrection. One of the questions St John asks is: why do the angels wear the name of Michael written on their garments and why do they always cry his name out? The cherubim answers that 'no angel is allowed to come upon the earth unless the name of Michael is written upon his garments, for otherwise the Devil would lead them astray'.[49]

At St Michael's appearance to assist Euphemia on the morning of his feast day, the encomium specifies that St Michael appeared displaying his royal rank and dignity (Section 2(iii)). As well as the red and purple for his garments as described in the portraits thus far, the archangel appears in more conventional imperial costume in an early thirteenth-century portrait in a Coptic Gospel book as well as manuscript wallpainting of the thirteenth century in Egypt.

The portrait of St Michael accompanying St Mark in the Coptic Gospel Book Vatican Copto 9 of 1204/5 shows the archangel, in imperial dress (Fig. 14.4).[50] He is standing, wearing a golden *loros*, studied with blue jewels, over a red garment with a golden, decorated, hem. He wears red imperial buskins on his feet, which are ornamented with pearls. He carries a staff, from which white cross-stars emanate, this time in his left hand, as his right is occupied indicating to the seated, writing evangelist. He wears a white fillet in his hair. The portrait is predominantly frontal, with only the head tilted in the direction of Mark, his hands indicating and the weight of the figure on the right foot. The image of light and brightness evident in the encomium is visible not only in the bright gold and red of his garments and his twinkling staff but also his golden halo and golden wings, with red tips. This portrait is exactly contemporary with the encomium in the London manuscript version, from the first decade of the thirteenth century. Quite possibly this image was disseminated in icon form. It marries the Byzantine tradition of the imperially dressed archangel, as exemplified in a late-twelfth-century carved slab from Constantinople in the Staatliche Museen zu Berlin, with the earlier Coptic portraits of St Michael in 'antique' dress (Figs 14.2, 14.3).[51]

St Michael is shown in imperial dress on the north side, opposite the archangel Gabriel on the now restored and repainted entrados of the arch dividing the nave from the khurus (the enclosed space between the sanctuary and the nave) in the monastery church of St Antony at the Red Sea (Fig. 14.5).[52] Painted shortly after 1232/3, the two archangels are identically depicted, but for different coloured tunics, winged, in imperial garb, green, red and yellow, with a fillet in their hair. They wear belts as specified in the homily. They each hold a staff in their right hand and off-white disk in their left. Michael's bears a cross in red, while Gabriel's bears the letters ιc xc νικα, Jesus Christ is victorious. The cross and inscription-charged orbs here – as those held by angels elsewhere in the church - have been likened to eucharistic loaves.[53] But a close reading of the encomium allows further interpretation of

the wallpainting here. The encomium refers to the light emanated by the archangel Michael (sections 2(iii) and 3 above). The circular shape is also suggestive of the light of the sun. This originates in the sun symbolism of white bread offerings to ancient Egyptian gods which the feast of St Michael conserved in the Coptic church.[54] Instead of literally depicting the sun's illumination through bright tints, the light of the sun is here inferred by the eucharistic orb-disk. In other respects, Coptic interpretation is not so different from Byzantine. In Byzantine thought, the orb represents the consecration of the host. The cross on it shows Christ's unending power over the universe, or cosmos, and demonstrates the delegation of that power to the angels. This interpretation appears, for example, at the end of a fourteenth-century Byzantine *ekphrasis* in which it is also explained that the angels' wearing of the fillet around the head circumscribes the place of the intellect and replaces the crown as a sign of heavenly virtue. The nimbus signals grace and radiance.[55]

St Michael is again represented in imperial dress on the first pier to the west in the south nave arcade of the monastery church of the Virgin (al 'Adra) at Dayr al-Baramus in the Wadi Natrun (Figs 14.6, 14.7) which came to light while work was being undertaken on the church in 1989.[56] Inscribed with his name in red, the image of Michael occupies the west face of the pier, so that the worshipper looks towards it as s/he faces the sanctuaries to the east. St Michael is standing against a mid-blue ground, haloed and wearing a diadem. He holds a cross staff in his right hand, and while his left hand is now indistinct, he apparently holds a disk or orb on this side. He has black hair and eyebrows and his eyes, nose and mouth are outlined in red. His facial features are carefully delineated. While his overgarment is greenish in colour, his undergarment is imperial red, with the hem lined with a decorative patterned border on yellow. His shoes are also red. This imperial dress is similar to that worn by Michael who, with Gabriel, flanks in the Virgin and Child in a slightly earlier phase of painting in the main apse of the church.[57] The painting is dateable in the thirteenth century, alongside the cycles of wallpainting that were discovered under plaster in 1986.[58] By comparison with the St Antony examples this painting is likely to date to the first half of the thirteenth century. Between the three they give a clear image of the appearance of the icon envisaged in the encomium.

*The role of the icon before and during Euphemia's death*

Several significant features of the veneration of St Michael emerge from the encomium and works of art which can be interpreted in the light of it. The archangel's role as the angel of death and personal salvation, as well as that of the angel of nature, are apparent through his appearances before and at Euphemia's death in the encomium.

The icon invokes St Michael through the agency of the individual,

Euphemia in the present case. The onus, then, is on the individual to make the icon 'work' for them through their prayers to and service of the archangel. After his final dismissal of the devil and as the prelude to Euphemia's death (Section 3), St Michael explains how this works. He asserts his own position as the one who looks after her and abides by his part of the contract between them. It is he, Michael, whom she serves and he who takes her prayers before God. He was present when she entreated her husband to have the icon made. St Michael listens to all who prays to God in his name. He alludes to Euphemia's service done in his name. Having completed that service, St Michael and a multitude of angels will appear at her death and take her up into God's rest where her husband is already. An example of an individual addressing prayers through an image and an inscription to an archangel, possibly St Michael, is to be found on the north wall of the upper gallery of the monastery church at Dayr Abu Sayfayn in Old Cairo. This is inscribed with the commemorative prayer of a deacon, Abû'l Fadâ'il, and his family, with the added date of 1174-75.[59] St Michael's role as the angel of death, judgement and resurrection is further demonstrated in the Coptic context by his invariable appearance in the scene of the Three Hebrews in the Fiery Furnace.[60] St Michael's God-given power and special authority is frequently emphasized, for example his appearance with Gabriel, flanking the Virgin and Child below Christ in Majesty in the northern of the two eastern apses of the Northern church at the monastery of the Martyrs (Dayr al-Chohada') at Esna (Fig. 14.8).[61]

Euphemia has the picture of St Michael placed over her face at the time of her death. The role of icons of St Michael and the Virgin are documented in an eleventh-century Byzantine text.[62] But here in a Coptic context this most intimate contact with the saint's icon is also continuation of the ancient Egyptian and Graeco-Roman funerary practice of covering the corpse with a decorated shroud. A rare survival of such a linen funerary shroud, painted with a portrait of St Michael, is that from Antinoë, in Upper Egypt, preserved in the Coptic Museum in Old Cairo (Figs 14.9, 14.10).[63] It is likely that the shroud came from a funerary chapel in which the dead were interred, their bodies bandaged and tied to sycamore planks and covered with shrouds.[64] Although damaged, the inscription down the archangel's lower right side (Fig. 14.10) gives some useful indicators, with the date at the bottom. Dated to AD 928, it makes it clear that the shroud was commissioned for the dead person by a particular artist, whose name is also now lost:

(Right side) ⲡ̄ⲟ̄ⲥ̄ ⲧⲥ̄ ⲡⲉ / ⲭ̄ⲥ̄ ⲡ̇ⲓ̇ⲁ̇ⲧⲙ / ⲏⲓⲟⲟⲥ ⲛⲙⲟⲩ / ⲧⲉ ⳇ ⲛ̄ⲟⲩⲙⲉ / ⲉⳇ⳩ ⲉ̣.̣.̣ / ⲡⲱ̄ⲛⲙ /
ⲛⲟⲩⲧⲉ / ⲁⲅⲁⲡⲏ ⲁ̇ⲙ̣ / ⳇ ⲏⲕⲉ ⲙⲙⲏⲓ / ⲕ̄ / ⲙ / ⲙ / Ⳳⲭⲏ ⲧⲁ̣ⲓ / ⲡ / ⲏⲟⲩ / ⳇ ⲏ̄ⲡ̣ⳡ̄ / ⲙⲛ̄
ⲡⲉⳡⲁⲣ / ⲭⲁⲅⲅⲉⲗⲟ[ⲥ / ⲉⲧⲟⲩⲁⲁⲃ ⲙ̣ⲓ / ⲭⲁⲗⲁ ⲟⳇⲩ / ⲣⲟⲟⲩⳳ / ⲙ̣ⲙⲟ̣ⳡ ⲛⳤⲉ / ⲕⲁⲥ ⲉⳡⲉⳡ /
ⲉⳭⲩⳡ / ⲡⲓⲧⲏⲣ̄ⳡ / ⳇ �l ⲟ̣ⲩⲛ̣ / ⳇ �l ⲃⲥⲧ / ⲁⲗⳡ / [Fibres gone] ⲙⲏ ⲉⲧⲙⲉ̣ ⲛⲛ̄ / ⳧ⲁⳭⲉ
ⲁⲙⲏⲓⲧⲏ̣ⳳ.̣.̣ / .̣.̣.̣.̣ⲉⲧⲥⲙⲁⲙⲁⲁⲧ ⲥⲉ̣ⲡ / ⲛ̄ⲧⲉ̣ ⲛⲁⲛⲱ ⲧⲁⲣⲉⲕ ⲧⲏⲣ̣ / ⲛⲟⲙ ⲓ̣ ⲧⲱⲛ ⳇ ⲱ̣ⲛ.̣.̣.̣
(Bottom) ⲁⲛⲟⲕ ⲡⲉ̣ⳇ ⲛⲧⲉ / ⲃ �l ⳇ ⲟ�ⳡⲉⲟ̣ⲥ̣ ⲡⲉ̄ⲛ / ⲧⲁⳡⳤⲉⲕ .̣.̣ ⳡⲉ ⲓ ⳥ⳡ̄ / ⲛⲁ �l ⲛⲁⳡ ⲁⲙⲏⲛ /
Ⳡⲉ̄⁰ (ⲧⲟⲩⲥ) ⳡ (ⲁⲣⲧⲩⲣⲱⲛ) ⳃⲭⲙⲁ

'O Lord Jesus Christ who rose (?) from the dead in truth ... this soul ... with his holy archangel Michael (to) look after him ... everything ... blessed ... I am the poor (?) N. who (made?) this, God have mercy on him, Amen. Year of the Martyrs 644 (=A.D. 928)'.[65]

Painted in tempera in dark red, yellow and green, the image (Fig. 14.9) shows Michael seated on a throne, with two high side arms. He is haloed and wears a diadem encrusted with precious jewels and holds a staff in his right hand. The remains of a circular object are visible which he originally held in his now-lost left hand. His garments are patterned with the design accentuated with dots and bordered with braided panels.

In Section 3 of the encomium, St Michael's appearance at Euphemia's death is described thus: he is shining like the sun with feet like brass pouring out flames holding a harp in his right hand and wheel or, more likely, a disk with cross in his left. Standing, he spreads out a garment of light to envelop Euphemia's soul.

A gushing sound is reported in the encomium as St Michael appears to Euphemia at the time of death (section 3). This endorses the association of Michael with water and the other elements. Particularly significant in the Coptic context was St Michael's role in the raising the waters of the Nile. The devil refers to this in section 2 (ii) when he thinks St Michael will be too busy to come and rescue Euphemia as he will be praying incessantly for three days and nights to God to raise the waters of the Nile and make the rain and dew fall. This is a key function of the archangel. In the apocryphal text, *The Mysteries of St John the Apostle and Holy Virgin*, St John asks the cherubim about the vagaries of the source of water in Egypt. He is especially curious to know why when water is scarce the harvest may be good while another year water is plentiful and yet there is a famine. The cherubim answers that 'the water is under the feet of the Father'. God keeps the water under his feet, controlling the water on the earth and regulating it according to the level of sin committed by humans. Water complete with fish is depicted in this way, literally below Christ's feet, in a wallpainting of Christ in Majesty flanked by archangels in the southern of the two eastern apses in the north church at the monastery at Dayr al-Chohada' near Esna (Fig. 14.11).[66] If humans are watchful and contain their sinning, God releases water through the supplications of St Michael: 'If only men were to know of the supplications of

Michael at the time when the water should come upon the earth, they would never commit sin at all'.[67] Dew comes into the same category, as part of St Michael's remit on behalf of mankind. According to the cherubim in the same homily, dew falls onto the earth at the sound of Michael's trumpet, the seventh in heaven. This comes from a fountain at which an angel sits. When a trumpet sounds the angel shakes his wings, opening the seven heavens, each at the sound of a trumpet. Dew falls on the earth when Michael sounds the seventh trumpet and causes 'all the fruits to swell (or, increase)'.[68] This identification of St Michael as 'nature angel' is common also to Byzantine culture, as exemplified by the miracle at Chonae.[69] But it is, of course, the Nile association which is specific to Egypt.

*Conclusion*

The encomium narrative about a charitable God-loving woman and her icon offers new evidence about the veneration of icons and their functions in an eastern Mediterranean medieval society. Its valuable insight into an early-thirteenth-century Cairene audience which included women prompts a gendered approach which takes account of the contemporary state of widowhood and the ways that the Church reacted to its needs. The fragment bound into the London manuscript pointing to the commissioning of a manuscript by the woman named Melokh, together with the ownership of a manuscript with an encomium text from Esna in the Pierpont Morgan Library (M603) by a nun suggests that veneration to St Michael was important to women. It is likely, then, that women played a role in the commissioning of icons as well as contributing to the donations and celebrations that accompanied the feast of St Michael. Euphemia's story in the encomium of Eustathius provides a kind of blueprint of this activity. With the assistance of St Michael, with whom she has contact through her icon, she was able to resist the temptation to remarry and to keep her promise to her husband to maintain the family donations so that both attain eternal life. The icon provides comfort and assistance at her death, with the reassurance that St Michael is at hand. Euphemia as a widow with no heirs is reliant on the Church for the maintenance of her social standing in life, as well as for the last rites. But she does not represent an entirely dependent stereotype. She wins her own intellectual arguments against the devil and has control over her final hours and the disposal of her property in a dignified way. This is not to imply that Euphemia's position is treated with utter solemnity. On the contrary, the description occupies the interface between religion and popular culture with its references to popular theatre and masquerading. Far more detailed than official saint's lives and miracles, it would have touched ordinary people's lives, especially those of women.

The icon narrative also prompts further exploration of the issue of the

visualization of the holy person and their intervention within the lives of the individual, through the interplay of the literary and the visual. As one would expect of a eulogy, when looked at in the light of the visual evidence, the account offers a broad sweep, rather than being associated with any unique visual image of St Michael. Thus the early magical associations are incorporated as well as the later, Byzantine-style, depiction of the archangel in imperial ceremonial dress as well as his attributes as intercessor and nature angel. The early thirteenth-century date of the text, which is more expansive in its Bohairic (northern Coptic) version than the early surviving Sahidic one, does, however, assist in interpreting contemporary imagery of St Michael. The luminous quality attributed to the archangel in the text enables the image in the Gospel book Vatican Copto 9 of St Michael accompanying St Mark (Fig. 14.4) to be looked at with fresh eyes. The use of gold on the garments, wings and halo, as well as the sparkling staff held in the archangel's right hand, takes on a quality beyond luxury. An image of the standing St Michael such as this, with a cover of gold inlaid with precious stones as specified in the encomium (Section 1), can be envisaged in icon form. But the encomium is not about any one single object but more to do with the expectations of the owner/viewer of an icon. It is through the mutual reading of text and image that nuances emerge which are not immediately apparent to the modern eye. This approach, applied to material not hitherto drawn into the debate about icons is of value in rendering icons less elusive subjects.

## Notes

1.  R. Cormack, *Painting the Soul: Icons, Death Masks and Shrouds* (London, 1977), 20.

2.  The manuscript is described by B. Layton, *Catalogue of Coptic Literary Manuscripts in the British Library acquired since the year 1906* (London, 1987) 395-97, no. 251-1. E. A. Wallis Budge, *Saint Michael the Archangel: Three Encomiums* (London, 1894), 93-135 (Coptic text), 170-194 (a Specimen of the Arabic version), 74*-108* (English translation). A French version, 'Légende de la sainte Euphémie', published by E. Amélineau, *Contes et Romans de L'Egypte Chrétienne* tom 1, 21-68 does not identify its source, but is based on a different manuscript according to Budge, *Saint Michael*, xxvii, note 1. Further manuscripts are cited by G. Graf, *Geschichte der Christlichen Arabischen Literatur* 1, Studi e testi 118 (Vatican, 1944), 543, no. e.

3.  W.E. Crum, *Catalogue of the Coptic Manuscripts in the British Museum* (London, 1905), 134-36. For its presence in a collection of homilies of St Michael written for the monastery of St Michael near present-day Hamuli in the Faiyum in the Pierpont Morgan Library in New York, see L. Depuydt, *Catalogue of Coptic Manuscripts in the Pierpont Morgan Library* (Louvain, 1993), 233-34, no. M592 (8) of c. AD 822/23-913/4; ed. and trans. into Italian by A. Campagnano, in *Quattro Omelie Copte*, eds. A. Campagnano, A. Maresca and T. Orlandi, Testi e documenti per lo studio dell'antichità serie copta 60 (Milan, 1977), 105-72.

4.  Budge, *Saint Michael*, Preface, v-vi: 'There is no reason for doubting that the three Encomiums were written about the beginning of the VIIth century of our era, and in them

we see some of the earliest specimens of this class of Coptic literature in existence'. The Coptic text of the Encomium of Eustathius is given, 93-135, with a specimen of the Arabic version, 170-194, and English translation, 74\*-108\*.

5. M. van Esbroeck, 'Michael, the Archangel, Saint', in *The Coptic Encyclopedia* 5, ed. A.S. Atiya (New York, Toronto, Oxford), 1618.

6. In Armenia. This is assumed by Budge, *Saint Michael*, xxvii, note 3.

7. E.A. Wallis Budge, in Crum, *Coptic Manuscripts*, 136 note 1, pointed out that the fact that Seleucia in Cilicia was also called τραξεῖα has contributed to the confusion.

8. The manuscript was brought from Cairo by Curzon according to Budge, *Saint Michael*, Introduction, ix. Budge was uncertain as to whether the inscription pasted onto the front cover of the manuscript was in Curzon's hand, reading 'History of the wonders produced by the cabalistic use of the name of the Archangel Michael. A very early, and fine Coptic Manuscript, with the Arabic translation on the margin. It came from Cairo, and is the finest Coptic manuscript on Paper I have seen'. Layton, *Catalogue of the Coptic Literary Manuscripts*, 397, suggests that the inscription was probably written by Henry Tattan. He states that the manuscript was bought by Curzon 'from a source in Cairo' between 1833-c.1839 and could have been seen in Cairo in 1839 by Tatton before it was shipped to Curzon. Layton noted that Curzon later described the manuscript in very similar terms in a different context. For the most recent edition of Curzon's account of his travels, see R. Curzon, *Visits to the Monasteries of the Levant*, presented by J. Hogg (Lewiston, New York-Salzburg), 1995. There is currently considerable interest in Lord Curzon and the manuscripts he and others brought from Egypt in the nineteenth century: see S. Jeffries, 'Desert Songs', *The Guardian Saturday Review* (13April, 2002), 1-2, which describes how the Coptic and Syriac manuscripts of the Monastery of the Syrians (Dayr al-Suryān) in the Wadi Natrun are being restored and reunited as a virtual, digitized, collection to be made available online.

9. The manuscript was donated to the British Library by Darea, Baroness Zouche of Haryngworth, on 10 October 1917: see Layton, *Coptic Literary Manuscripts*, 397. When Budge studied the manuscript it was still in Lord Curzon's collection: Budge, *Saint Michael*, Introduction, ix.

10. For the colophon, dated 1 June 1210, see Budge, *Saint Michael*, Introduction, x-xii (Coptic) with English translation, xii-xiv; Layton, *Coptic Literary Manuscripts*, 396, no. 251-2.

11. Budge, *Saint Michael*, xii-xiii. For the church of St Michael see C. Coquin, *Les Édifices Chrétiennes du Vieux-Caire* Vol.1 *Bibliographie et Topographie Historiques*, Institut français d'archéologie orientale de Caire, Bibliothèques d'études coptes, 11 (Cairo, 1974), 203-14.

12. Layton, *Catalogue of the Coptic Literary Manuscripts*, 396.

13. This suggestion was made by Layton, *Catalogue of Coptic Literary Manuscripts*, 329-330, no. 212. This encomium provides evidence for the consecration of the twelfth day of each month to St Michael with the major winter feast falling on twelfth Paôni. The main summer feast was celebrated on twelfth Hathôr. For the development of this system see Y. Nessim Youssef, 'De Nouveau, la Christianisation de dates de fêtes de l'ancienne religion Égyptienne', *Bulletin de la societé copte* 31 (1992), 109-113.

14. This summarizes pp. 96-101 of the London manuscript, trans. Budge, *Saint Michael*, 76\*-80\*.

15. This summarizes pp. 101 (end) -110 of the manuscript, trans. Budge, *Saint Michael*, 81\*-87\*.

16. This summarizes pp. 110-114 of the manuscript, trans. Budge, *Saint Michael*, 87\*-90\*.

17. This summarizes pp. 114-124 of the manuscript, trans. Budge, *Saint Michael*, 91\*-99\*.

18. This summarizes pp. 124-129 of the manuscript, trans. Budge, *Saint Michael*, 99\*-103\*.

19. This summarizes pp. 129-132 of the manuscript, trans. Budge, *Saint Michael*, 103\*-105\*.

20. Pp. 132 (end) -135, trans.Budge, *Saint Michael*, 106\*-108\*.

21. Ch. Pellat, 'Ḥikâya', *Encyclopaedia of Islam* New Edition, eds B. Lewis, V.L. Ménage, Ch. Pellat, J. Schacht, Vol. III (Leiden and London, 1971), 367-68.

22. Pellat, 'Ḥikâya' 368.

23. See M. Nicolas, 'La comédie humaine dans le *karagöz*' in *l'humor en orient*, *Revue du Monde Musulmane et de la Méditerranée* 77-78 (1995), 77, 79 on dialogue.

24. J. Leroy, *Manuscrits Coptes et Coptes-Arabes Illustrés* (Paris, 1974), 129, with pl. 56 (3).

25. B. Shoshan, *Popular culture in medieval Cairo* (Cambridge, 1993), 43 with 113 notes 30-32.

26. R. Ettinghausen, 'The Dance with Zoomorphic Masks and other Forms of Entertainment seen in Islamic Art', in *Arabic and Islamic Studies in Honor of Hamilton A.R. Gibb*, ed. G. Makdisi (Cambridge, 1965), 211-224, with pls. 1-XXV.

27. Ettinghausen, 'Dance with Zoomorphic Masks', 212-4, with pls. III-IV.

28. Ettinghausen, 'Dance with Zoomorphic Masks', 217 with Pl. X, 1-2.

29. Ettinghausen, 'Dance with Zoomorphic Masks', 217-18, with Pl. XII.

30. Ettinghausen, 'Dance with Zoomorphic Masks', 223, referring back to 218 n.2.

31. C.D.G. Müller, 'Gab es ein koptisches Theater?', *Bulletin de la société d'archeologie copte* 29 (1990), 9-22, esp. 17-22. The motif of the heroine pursued by a lion, as Euphemia is in Section 2(iii) is reminiscent of plays in other cultures, for example the play within a play in Shakespeare's *A Midsummer Night's Dream* with Thisbe pursued by a lion as she waits for Pyramus.

32. Budge, *Saint Michael*, Preface, viii.

33. *Widowhood in Medieval and Early Modern Europe*, eds S. Cavallo and L. Warner (Harlow, 1999), foreword, xii.

34. J. Bilinkoff, 'Elite widows and religious expression in early modern Spain: the view from Avila', in *Widowhood*, eds Cavallo and Warner, 189. See also the comments of Cavallo and Warner in the same volume, 5 with note 6 and 7 on chastity and the continuing obedience of the perpetual wife stereotype.

35. *Widowhood*, eds Cavallo and Warner, Introduction, 3.

36. *Widowhood*, eds Cavallo and Warner, Introduction, 3.

37. The Kur'ân states that of everything God created a pair (Kur'an LI, 49): Ch. Pellat, J. Sourdel-Thomine, P. Naili Boratav, 'Hayawân' *Encyclopaedia of Islam* III, 306. The reference to the *Physiologus* in the encomium was the only one in Coptic literature known to Wallis Budge: see Budge, *Saint Michael*, Preface, viii. For the manuscript tradition of the *Physiologus* in the Christian east see Graf, *Geschichte* 1, 548-59. A Syriac version of the *Physiologus* is edited and translated into German by K. Ahrens, *Das Buch der Naturgegenstände* (Kiel, 1892).

38. L.-A. Hunt, 'A Woman's Prayer to St Sergios in Latin Syria: Interpreting a Thirteenth-Century Icon at Mount Sinai', *BMGS* 15 (1991), 96-145, reprinted in L.-A. Hunt, *Byzantium, Eastern Christendom and Islam: Art at the Crossroads of the Medieval Mediterranean* Vol. II (London, 2000), 78-126.

39. G. Dagron, 'Holy Images and Likeness', *DOP* 45 (1991), 30-31. A frequently-cited example is that of St Irene, abbess of Chrysobalaton recognising St Basil when he appears to her in a dream because of the features she had previously seen on his icons; referred to by Dagron, 30; Cormack, *Painting the Soul*, 136.

40. Depuydt, *Coptic Manuscripts in the Pierpont Morgan Library*, 219-221, no. 113. Depuyt (219) gives the full title of the encomium as 'Homily on the Mercifulness of God and the Freedom of Speech of St Michael Archangel'. For the frontispiece, see J. Leroy, *Manuscrits Coptes et Coptes-Arabes Illustrés*, Institut français d'archéologie de Beyrouth, Bibliothèque archéologique et historique 91 (Paris, 1974), 99-100 with pl. 30 (2). For the Bohairic version in the London manuscript see Budge, *Saint Michael*, 63-91 (text), 51*-93* (trans.) with intro., xxii-xxvi.

41. This may only indicate a change in name: Depuydt, *Coptic manuscripts in the Pierpont Morgan Library*, 220, note 2.

42. M. Cramer, *Koptische Buchmalerei: Illuminationem in Manuskripten des christlich-koptischen Ägypten vom 4. bis 19. Jahrhundert* (Recklinghausen, 1964), 66 with Abb. 77.

43. Layton, *Catalogue of the Coptic Literary Manuscripts*, 133, no. 20, which contains other fragments. The colophon is on fol. 49r. The version of the text of this homily in MS London, BL Or. 8784 is edited and translated by Budge, *Saint Michael*, 1-61 (Coptic), 1*-50* (English). For the frontispiece see Leroy, *Manuscrits Coptes-Arabes*, 186-87 with pl. 30 (1).

44. H. Maguire, *The Icons of their Bodies: Saints and their Images in Byzantium* (Princeton, 1996), 70.

45. H. Maguire, 'Magic and the Christian Image', in *Byzantine Magic*, ed. H. Maguire (Washington, DC, 1995), 60-66.

46. Maguire, *The Icons of their Bodies*, 106-7.

47. BL Or. 7029, fol. 73v: Layton, *Coptic Literary Manuscripts*, 198 no. 163.

48. E.A. Wallis Budge, *Coptic Apocrypha in the Dialect of Upper Egypt* (London, 1913), text, 59-74, trans. 241-57 of MS BL Or. 7026 of AD 1006 produced at Esna by Victor, the deacon of the church of St Mercurius (Intro. xxxii-xli).

49. Budge, *Coptic Apocrypha*, 246. The name of Michael on amulets and rolls is one aspect of Coptic veneration to St Michael; see C.D.G. Müller, *Die Engellehre der koptischen Kirche* (Wiesbaden, 1959), 33-34.

50. Cramer, *Koptische Buchmalerei*, 84 with Abb. XII in colour; Leroy, *Manuscrits Coptes-Arabes*, 150-51, with pl. 102 and pl. H in colour. L.-A. Hunt, 'Christian-Muslim Relations in Painting in Egypt of the Twelfth to mid-Thirteenth Centuries: Sources of Wallpainting at Deir es-Suriani and the illustration of the New Testament MS Paris, Copte-Arabe 1/Cairo Bibl. 94', *CahArch* 33 (1985), reprinted in Hunt, *Byzantium, Eastern Christendom and Islam*: Vol. II, 217.

51. The marble panel, Staatliche Museen zu Berlin-Preussischer Kulturbesitz, Museum für Spätantike und Byzantinische Kunst, inv. 2429A) is conveniently reproduced in *Monastic Visions: Wall Paintings in the Monastery of St Antony at the Red Sea*, ed. E.S. Bolman, with photography by P. Godeau, American Research Centre in Egypt (New Haven and London, 2002), 134, fig. 8.13.

52. P. van Moorsel et al., *Les Peintures du Monastère de Saint-Antoine près de la Mer Rouge*, Institut français d'archéologie orientale, Mémoires, 112/1-2, (Cairo, 1995/97), 110-12 with Pls. 55-57 (55 in colour); van Loon, *The Gate of Heaven*, 89 with note 89. Post-restoration, see *Monastic Visions*, ed. Bolman, 127-129 with figs 8.1-4 (in colour). For the Byzantine character of the imperial ceremonial dress of the archangels see 134, note 22.

53. E.S. Bolman and W. Lyster, 'The Khurus Vault: An Eastern Mediterranean Synthesis', in *Monastic Visions*, ed. Bolman, 134 with figs 8.14-15, and figs 4.35, 6.17. Bolman reproduces an icon of St Michael of c.1474, from the Church of Archangelos Pedoulas, Cyprus, in which the medallion carried by the archangel Michael bears the bust portrait of Christ, the Synaxis of the Archangels, found in the later wallpainting of St Gabriel occupying, with St

Michael, the annexe archway at the monastery church of St Antony: see 140, figs 8.23 and 8.24.

54. E. Stroot-Kiraly, 'L'offrande du Pain Blanc,' *Bulletin de la Societé d'Egyptologie de Genève* 13 (1989), 157-60; Youssef, 'La christianisation de dates des fêtes', 113 suggests that this is adapted from the white bread offerings to ancient Egyptian gods Thot and Serapis.

55. G. Peers, *Subtle Bodies: Representing Angels in Byzantium* (Berkeley, Los Angeles and London, 2001), 203-4, note 14, quoting an *ekphrasis* of Symeon of Thessaloniki (died 1429) composed before an icon of St Michael.

56. G.J.M. van Loon, *The Gate of Heaven: Wall Paintings with Old Testament Scenes in the Altar Room and the Hurûs of Coptic Churches* (Istanbul, 1999), 62 with note 270.

57. The apse image is reproduced in N.S. Atalla, *Coptic Art:Wall-paintings/ l'Art Copte: Peintures Murales*, (Cairo, n.d), 59.

58. Van Loon, *Gate of Heaven*, 61-74.

59. Van Loon, *Gate of Heaven*, 29-30, with pls. 30-31

60. Van Loon, *Gate of Heaven*, 173.

61. J. Leroy, *Les peintures des couvents du désert d'Esna*, l'Institut français d'archéologie orientale du Caire, Mémoires t. 94 (Cairo, 1975), 6-10 with Fig. 3 (drawing of whole) and pls. 13-15 Christ) and pls. 36-38 (St Michael). For comment on the angels here and elsewhere see 54-56.

62. The narrative of the monk Nikon in the eleventh-century life of Lazarus Galesiotes lying dying in the refectory 'in the place in which there are holy images of the Theotokos and St Michael stretching out [their arms] in supplication (εἰς δέησιν) to the Saviour surrendering his soul to God through the hands of the angels' is cited in A. Kazhdan and H. Maguire, 'Hagiographical Texts as Sources on Art', *DOP* 45 (1991), 17 with note 149.

63. C.M. Kaufmann, 'Ein spätkoptisches bemaltes Grabtuch aus Antinoupolis in Oberägypten', *Oriens Christianus* N.S. Vols 7-8 (1918), 128-32, gives the original measurement of the shroud as 150 x 250cm.

64. Kaufmann, 'Ein spätkoptisches bemaltes Grabtuch' 128-29.

65. I owe my thanks to Dr Leslie MacCoull for this transcription and translation.

66. Leroy, *Peintures des Couvents du désert d'Esna*, 10-11 with pls. 29, 30, 31.

67. Budge, *Coptic Apocrypha*, 243. So many centuries later, Curzon, *Visits to the Monasteries of the Levant*, presented by James Hogg, 27-30 was struck by the significance of the rising of the Nile to Egyptian society.

68. Budge, *Coptic Apocrypha*, 247-48.

69. Peers, *Subtle Bodies*, 6-8, for St Michael as the nature angel; 143-51, and Chapter 5, 157-93, concerning miracle stories and hagiographical writing on the miracle at Chonae.

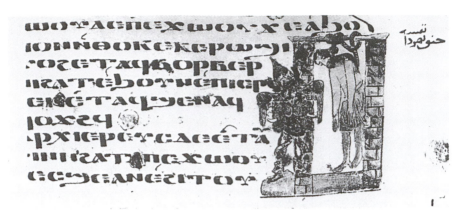

14.1 Suicide of Judas, 1178-80. MS Paris, Bibl. Nat. Copte 13 fol. 81r. (after J. Leroy, *Manuscrits Coptes et Coptes-Arabes Illustrés* (Paris, 1974), pl. 56.)

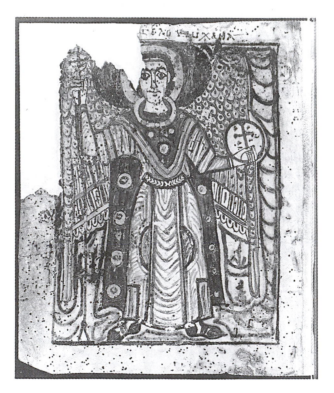

14.2 St Michael, 902-903. New York, Pierpont Morgan Library, MS M603 fol. 1v (courtesy of the trustees of the Pierpont Morgan Library, New York).

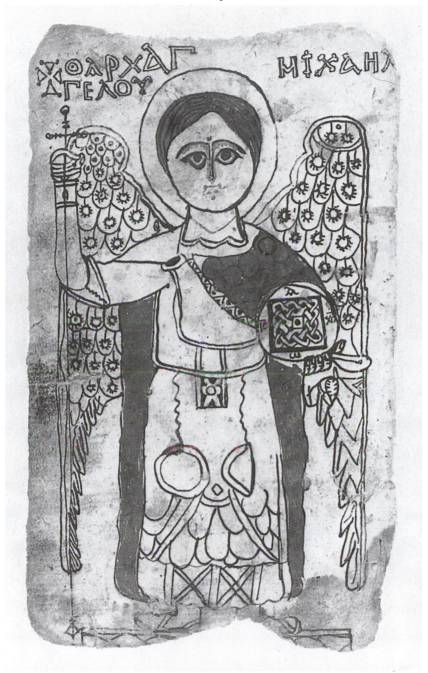

14.3 St Michael, 987. London, British Library MS Or. 7021, fol. 1r
(by permission of the British Library).

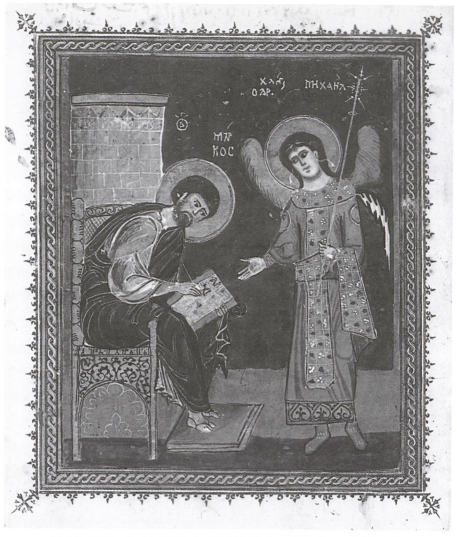

14.4 St Michael with St Mark, 1204/5. Vatican MS Copto 9 fol. 145v
(© Biblioteca Apostolica Vaticana).

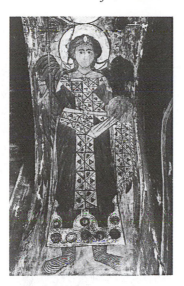

14.5 St Michael, 1232/3. Wallpainting, khurus arch, monastery church of St Antony at the Red Sea (after J. Leroy, 'Le programme decorative de l'église de Saint-Antoine du désert de la mer Rouge', *Bulletin de l'institut français d'archáeologie orientale* 76 (1976), 347-79).

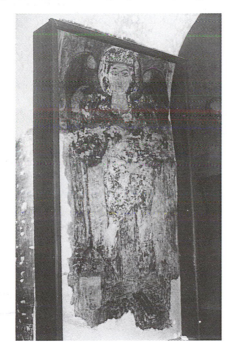

14.6 St Michael, 13th century. Nave pier, Church of al 'Adra, Dayr al-Baramus, Wadi Natrun (L.-A. Hunt).

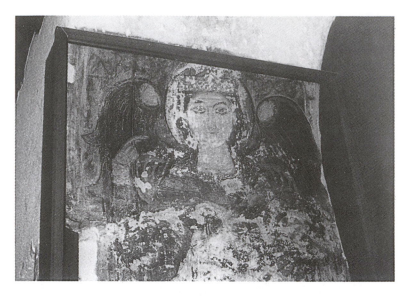

14.7 St Michael, detail, 13ᵗʰ century. Nave pier, Church of al 'Adra, Dayr al-Baramus, Wadi Natrun. (L.-A. Hunt).

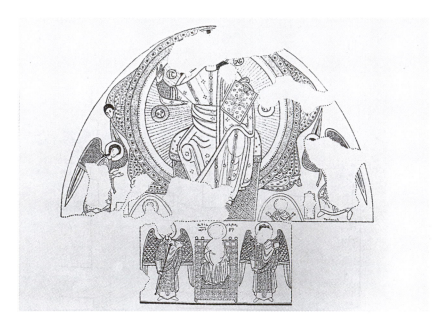

14.8 Christ in Majesty. Drawing of wallpainting, eastern apse (north) of north church, Dayr al-Chohada', Esna (after drawing by P.-H. Lafferière in J. Leroy, *Les peintures des couvents du désert d'Esna* (Cairo, 1975), Fig. 3).

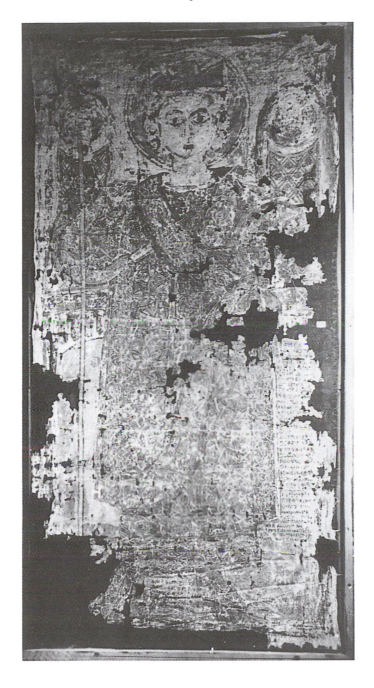

14.9 St Michael, AD 928. Funerary shroud from Antinoë. Coptic Museum, Old Cairo, no. 8452 (courtesy of the Coptic Musuem, Old Cairo).

14.10 St Michael, inscription of AD 928. Funerary shroud from Antinoupolis. Coptic Museum, Old Cairo (courtesy of the Coptic Museum, Old Cairo).

14.11 Christ in Majesty. Drawing of wallpainting, eastern apse (south) of north church, Dayr al-Chohada', Esna (after drawing by P.-H. Lafferière in J. Leroy, *Les peintures des couvents du désert d'Esna* (Cairo, 1975), pl. 31).

# Chapter 15

# Archimedes into Icon:
# Forging an image of Byzantium[1]

John Lowden

On 29 October 1998 a manuscript known as the Archimedes Palimpsest was sold at auction by Christie's, New York, for a hammer price of $2 million. The previous and indeed the subsequent history of the Archimedes Palimpsest provides an extraordinary insight into attitudes to the past – to its preservation, transmission, communication, and abuse – over more than a millennium. One of the strangest and most revealing aspects of the tale concerns four images, in which, in a manner of speaking, Archimedes became a series of icons. More generally, current interest in the manuscript reflects the 'iconic' status of the ancient mathematician, a point to which we shall return briefly. None of the attitudes we shall encounter, however, are straightforward, for the objects of study and discussion are not what they seem to be; they resist easy definition.

*The Manuscript: Archimedes into Prayerbook*
Because the Archimedes manuscript is at the centre of discussion, it is essential to give an introductory account of this complex and only partially preserved document, and in particular of its images.[2] The manuscript, now the property of an anonymous private collector, is currently deposited at the Walters Art Museum, Baltimore, where it is the subject of long-term conservation and study by an international team co-ordinated by the curator of manuscripts, Dr William Noel, and funded by the anonymous purchaser of the volume. It is a damaged and incomplete book, now consisting of 174 parchment folios, numbered 1-177 (folios 104, 123, and 170 are lacking), each about 195 x 150 mm, but buckled by humidity, their edges blackened by fire. At the time of writing the book is partially disassembled. Its binding, to be

From *Icon and Word: the Power of Images in Byzantium. Studies presented to Robin Cormack*, eds Antony Eastmond and Liz James. © 2003 by contributors. Published by Ashgate Publishing Ltd, Gower House, Croft Road, Aldershot, Hampshire, GU11 3HR, England, pp. 233-260.

discussed below, has been removed.

The book contains a Euchologion, that is a selection of prayers to be used by the celebrant in various liturgical and para-liturgical contexts. It is thought that as many as sixty leaves may be missing from the Euchologion (in addition to the three lost since they were foliated),[3] a point which further study will need to clarify. The book commences on folio 1r-v with a prefatory text of some sort, very blackened and thus far illegible, which is followed by the end of a table of contents on folio 2r-v, listing the volume's separate prayers. The numbering of the contents runs from 94-117 on the recto, and 118-123 on the verso. Since the layout is ruled for 24 lines per page, the earlier part of the list of contents was probably contained on a lost bifolio (i.e. 4 pages of 24 lines each to accommodate numbers 1-93 plus two or three lines for a title) between what are now folios 1 and 2.

At the bottom of folio 1v a date, presumably recording the donation of the manuscript – and hence a terminus for the palimpsest – can now be deciphered for the first time: Saturday 14 April, 6737 (i.e. 1229 CE).[4] Since Easter fell on 15 April in 1229, 14 April that year was Holy Saturday. The name of the donor in the line above ought to be recoverable. The Euchologion is carefully written in a standard calligraphic hand of the period, and there are rubricated titles and an enlarged decorated initial to each prayer, and some decorative headbands, all primarily using red pigment, with some blue in the decoration.[5] The style of the decoration is typical of generically 'provincial' work throughout the Byzantine world in the decades around 1200, from Sicily and South Italy to Palestine.

In order to produce the Euchologion in or more probably before 1229, the scribe, or rather scribes – there were at least two – supplied themselves with parchment that had been recycled from two or more (perhaps several) much earlier books. For example, scribe B, who wrote what is now the second quire of the Euchologion, folios 7-12, re-used parchment from a carefully written book, with a text in a single column, on ruled lines, in a calligraphic script perhaps of the *bouletée* type characteristic of the middle decades of the tenth century. The content of this recycled parchment has yet to be established.[6] Most of the Euchologion, however, was written on parchment recycled from a less carefully written manuscript, with a text in two columns without horizontal ruling. This book contained works by Archimedes, probably also written in the tenth century. These texts were first identified in 1906 by the Danish Archimedes scholar J.L. Heiberg, and subsequently transcribed and published by him.[7] At that time the manuscript was at Istanbul in the library of the Metochion (dependency) of the Monastery of the Holy Sepulchre at Jerusalem. Heiberg identified substantial parts of the following Archimedean texts: *On the Equilibrium of Planes, On Floating Bodies, The Method of Mechanical Theorems, On Spiral Lines, On the Sphere and the Cylinder, On the Measurement of the*

*Circle*, and a fragment of a text known as '*Stomachion*'. The palimpsest is particularly famed for preserving the unique text of Archimedes's *Method* (hence unknown before 1906), and the only Greek text of *Floating Bodies*. Heiberg's remarkable discovery made the front page of the *New York Times* on 16 July 1907.[8]

As was generally the practice with palimpsests, the scribe(s) of the Euchologion first cut the bifolios (the double-page spreads) of his source in half, vertically, before folding them in half again to make bifolios for his own book, thus doubling the number of pages available, and leaving the under script running vertically in a way that made it less likely to distract the reader of the new text. (In modern terms he took the A3 sheet which when folded made two A4 pages in his source, cut it into two A4 sheets, and then folded each A4 sheet to make two A5 pages.) Because the brown oak-gall ink used by the tenth-century scribes was very hard to remove in its entirety, on many pages the underlying text remains clearly legible. The main thrust of research into the manuscript has been concentrated thus far on recovering as much as possible of the text of Archimedes.[9]

Because of the way the pages of the Archimedes manuscript were folded for reuse in the Euchologion, there are passages in the gutter, on both sides of the sheet, that were invisible to Heiberg. These can be recovered by the relatively simple process of disbinding the book and hence revealing the areas in question. In addition, whereas Heiberg worked from the book with the help of nothing more sophisticated than a magnifying glass and an incomplete set of black-and-white photographs (together with an exceptional acuity and knowledge, based on his long study of the text of Archimedes), current research is able to correct and supplement his readings at various points with the help of examination under ultra-violet (UV) light, and various types of high-technology digital imaging.[10] Most regrettably, although when Heiberg studied the book it was in relatively good condition, as his photographs confirm, by the end of the twentieth century its condition had deteriorated markedly, partly as a result of damage by mould – the result of storage in an area of high humidity. This has rendered a programme of conservation imperative, and has made the study of Archimedes's text significantly more difficult than it was in 1906-8. It is largely because the images in the Archimedes palimpsest obscure (except occasionally where the pigment is flaked) the reading of the Archimedes text that interest and attention is now focused upon them. They raise a number of basic questions. Why were the images inserted? What can they reveal of the book's history? Should they now be removed to aid recovery of the words of Archimedes?

*The Images: Prayerbook into Evangelist Portrait*
When in 1899 Papadopoulos-Kerameus published his catalogue description of

the Euchologion, as Metochion MS 355, the book had no images.[11] When Heiberg examined it in 1906 and again in 1908 it had no images. That the lack of specific mention does indeed mean a lack of images, and is not merely to be attributed to a surprising oversight (a point we shall need to reconsider below in a different context), is confirmed by two points. First, Heiberg transcribed Archimedean texts from the pages in question (i.e. folios 21r, 57r, 64v, and 81r). Second, he also photographed folio 57r (Fig. 15.3), and included a print of it in his album, showing that at the time this was a 'normal' text page, without any image (compare Fig. 15.2).[12] In terms of the text beneath the images, therefore, we can be certain that folio 21r contains part of *Floating Bodies*, folios 57r and 64v preserve part of the unique text of the *Method*, and folio 81r has part of the *Equilibrium of Planes*.[13]

When the manuscript was sold at Christie's, the catalogue illustrated one of the four images in colour, and described them as 'presumably the result of a misguided attempt at the Metochion to embellish the manuscript and enhance its value in the eyes of a prospective purchaser'.[14] This was a strongly tendentious statement, the significance of which will be considered below. Nigel Wilson (author of the 'analysis and description' in the catalogue),[15] when he discussed the manuscript in 1999, dropped the reference to the Metochion, but otherwise reiterated the statement: the images were 'a disastrously misguided attempt to embellish the manuscript, presumably to enhance its value in the eyes of a prospective purchaser'.[16] Who made the misguided attempt, when, and where, and who the prospective purchaser was, are all questions we shall need to consider. Wilson went on to say 'It will be interesting to see if any art historian can recognize the model on which they are based.'[17] Here at last we are on firm ground. The models of the images can indeed be very readily identified. But the significance of the identification goes well beyond what might be anticipated: it calls into question the accepted history of the Archimedes manuscript in the twentieth century.

The four images, although they do not have inscriptions (as they would in a Byzantine work), will here be given titles for convenience. The forgeries (I will justify the use of the term in due course) are based on the black-and-white reproductions of the set of four evangelists from the eleventh-century Gospel Book in Paris, Bibliothèque nationale de France, MS grec 64, as found together on plate LXXXIV of Henri Omont's *Miniatures des plus anciens manuscrits grecs de la Bibliothèque Nationale du VIe au XIVe siècle*, which was published in Paris in 1929 (Fig. 15.6). On folio 21r of the Archimedes Palimpsest is a St Luke, approximately 152 x 105 mm (Fig. 15.1). Folio 57r has a St John, roughly 150 x 105 mm (Fig. 15.2). Folio 64v has a St Matthew, roughly 152 x 104 mm (Fig. 15.4). Folio 81r has a St Mark, roughly 151 x 101 mm (Fig. 15.5). Also added at the same time (I would suggest) is the illuminated headpiece, used in an un-Byzantine fashion as a tail-piece, found

in a blank space in the Euchologion text at the bottom of folio 116v, and measuring 18 x 65 mm (Fig. 15.7). It is based on a decoration from MS Paris gr. 550, reproduced in Omont's book as plate CIV.7 (Fig. 15.8).

The location and/or order – as suggested by the folio numbers – of the four evangelists within the text of any Euchologion makes no sense, and hence requires explanation. They are in fact all now single leaves, cut or broken away from their cognate halves (each was once part of the outer bifolio of a quire, folios 21 and 81 were the opening leaves of quires, and folios 57 and 64 were originally conjoint).[18] Folio 116, with the decoration, was the last leaf of a quire. There is plentiful evidence, however, which will be considered shortly, to demonstrate that at one stage the four folios, and possibly the fifth, led an existence separated from their 'parent' manuscript.

In working from Omont's plates, the forger in each case traced the main lines of the evangelist, his seat, stool and desk. Some form of intermediate tracing paper was used, and by shifting the paper a slightly more compressed figure was created.[19] Microscopic examination has revealed minute pricked holes under the pigment (especially clear in the Matthew), linked by indented lines which define the main outlines of the design (notably in the John and Matthew). The forger also traced the headpiece in a similar fashion.[20] The writing tools on the desks he also copied, but the complex architectural backgrounds, clearly visible in Omont's reproduction of Paris gr. 64 (Fig. 15.6), he ignored, substituting an arch decorated with a Byzantine-derived flower-petal pattern, supported on marbled columns. He added as his own contribution a wavy, partly gold line in the foreground of each image. Because of the presence of the arch, in each case he had to narrow the composition at the right, moving the right edge of the desk a little inwards, and the lectern on the desk a little to the left, vis-à-vis the images in Omont. Seemingly ignorant of the colour scheme of Paris gr. 64, the forger employed a strange (by Byzantine standards) palette. In each case he painted the ornament of the frame, the arch, and the evangelist's drapery all in similar tones: for Luke the dominant tone is a mid-blue, for John it is a mid-green, for Matthew it is a strange purple, and for Mark a pale creamy brown. Meanwhile for the illuminated headpiece on folio 116r he used tones of red and blue, with white highlighting, in a somewhat more Byzantine manner than seen in the evangelists.

In order to work on the evangelists, the forger certainly removed the requisite folios from the Euchologion. He then sought to erase the text(s) on both sides of the leaves, presumably washing them with some solution,[21] but this he did relatively inefficiently, to the extent that surviving text, notably in the St Luke and St John (Figs 15.1, 15.2), sometimes even shows through the thin gilding (applied with a brush as a suspension, not as gold leaf). This is true of the brown ink of the Euchologion, as well as the more intensely

pigmented red of its rubrics. (The forger may have felt the gold and pigments would cover any traces of the text.)

Once the images were completed they were at some point provided with paper guards, toned to resemble the parchment, to enable the separate leaves to be resewn into the manuscript. Later these guards were cut and at some stage the images were re-mounted with a modern synthetic (PVAC) glue on guards of different paper. However for much of their subsequent history the images seem to have been separated from the book, and mounted as single leaves. Rusty traces of paper-clips show that each was at some stage attached to another sheet, perhaps a supporting card. Extensive traces of adhesive on the backs of the leaves (overlying the rust stains), together with small blue scraps of paper, show they were at some later time crudely mounted on blue paper, with their versos obscured. Blobs of Blu-Tack (first commercially available in Europe in 1970),[22] which overlie the adhesive, imply another even cruder method of display or mounting. Pencil numbering from 1-4 in the top right corner of the leaves (in the order Mark, John, Matthew, Luke), together with a similar 7(?) on the headpiece leaf further imply a separate existence for the decorated pages.

At this point we need to question the motive for the execution of these images. Were they merely, for the sake of argument, the (relatively) harmless activities of a private owner, indulging his enthusiasm for Byzantine art by copying some images from Omont on pages that happened to have come loose in an old book in his possession? Or were they executed by or for someone who intended to deceive a potential purchaser, either of the book, or of the leaves – singly or together – or of both? There are two aspects of the evidence, not yet considered, which point to deception. The first is to be found in the Archimedes Palimpsest itself. The second requires comparison with another (genuine) Byzantine manuscript containing loose folios on which images copied from the plates of Omont were executed.

First, the internal evidence. The binding of the Euchologion when it was studied by Heiberg in 1906 is partly visible in some of his photographs. It was of Byzantine type, with characteristic raised endbands. That this binding might have dated from the sixteenth century or so is suggested by the evidence for a 'restoration' at that period, which included the supply of texts on two quires of watermarked paper, one of which was loosely inserted in the book (between folios 28 and 29 when catalogued by Papadopoulos-Kerameus), and not foliated (it has survived), while the other was catalogued as folios '177'-185 (most probably 178-185, since folio 177 is a surviving parchment leaf).[23] The edges of the book's leaves are charred by fire, and we might imagine that a grave misfortune befell the Euchologion at some point between 1229 and the sixteenth century, leaving it in need of attention. It may have been at the Palestinian Monastery of Mar Saba at this time, as Papadopoulos-Kerameus

recorded a Mar Saba ex-libris in the lost paper quire at the end.[24] By 1906, therefore, the book's rebinding and restoration were already centuries old.

The current binding (now removed) certainly looks old, but it must in fact postdate the binding visible in Heiberg's photographs of 1906-8. It consists of plain dark leather (re-used, perhaps nineteenth century) over wooden boards, the latter recycled from a binding sewn not in the Byzantine but in the Western fashion.[25] Most bizarrely, onto the inside faces of the boards of the current binding are glued two pages from a set of decorated Canon Tables, originally significantly larger than the present maxima of about 197 x 140 mm, but carefully cut to size (Fig. 15.11).[26] They must have been extracted from a Byzantine Gospel Book of the late twelfth or early thirteenth century, to judge by the style. These Canon Tables were certainly not part of the book according to Papadopoulos-Kerameus' catalogue entry (Heiberg's silence is less telling, given the focus of his researches). No Byzantine manuscript, in fact, uses decoration, let alone Canon Tables, as paste-downs in this way. A bizarre element is that the binding was later adapted to enclose only folios 1-96 (out of 174).[27]

To rebind the book (or part of it) in this extraordinary fashion does not look like the actions of an amateur of Byzantine art. Recycling old material to make such a binding has the hallmarks of fakery. When it is also noted that the evangelists all come from the re-bound section, folios 1-96, we appear to have evidence of a complex attempt to 'improve' an old liturgical book, presumably in two distinct phases (to judge from the two different types of paper guard mentioned above), so as to make it more interesting to a potential buyer by adding a 'decorated' binding and four 'Byzantine' images. We have to accept that at this point (or points) in its history the presence of Archimedes in the palimpsested leaves appears to have been unknown (or perhaps considered irrelevant), since the text was both obscured by images, and later divided into two sections.

The second and parallel case to the Euchologion concerns a twelfth-century Gospel Book from the Hagop Kevorkian collection, also decorated with a set of four evangelist portraits and some decoration based on the plates (but not the same plates) of Omont's publication of 1929. It was purchased at Sotheby's in London in 1982 by the dealer Alan Thomas for £2000,[28] and sold by him, shortly after, to Duke University, for £2200.[29] (The low price is explained mainly by the lack of an 'Archimedes factor', partly by changes in the market between 1982 and 1998 [including general inflation], and partly, perhaps, by the unambiguous identification of the images in the sale catalogue as 'copied from plates in Omont'.) Having identified the forged images in the sale catalogue in 1982, I discussed them in a publication of 1994, at which point the method of using Omont's plates as a source was unique.[30] But it was on the basis of familiarity with what is now Duke University Greek MS 84

that I was able to point at once to Omont as the source when shown photocopies of the images in the Archimedes Palimpsest by William Noel in December 1999. Recently it has been possible at the Walters Art Gallery to place the two manuscripts side by side, and to examine the pages of both under the microscope: the results are instructive. It has also recently become clear that Duke Gk. 84 was, like the Archimedes Palimpsest, once in the library of the Metochion, where it too was catalogued by Papadopoulos-Kerameus,[31] a point which will be relevant in the following discussion.

The pages of Duke Gk. 84 are only slightly larger than those of the Euchologion, some 210 x 166 mm, as compared to 195 x 150 mm, but by leaving much narrower margins on the pages the forger was able to work at significantly larger scale. The images in Duke Gk. 84 average around 190 x 150 mm, those in the Euchologion around 150 x 105 mm. The contrast between the figures is even more striking, for those in the Duke manuscript dominate their setting, and are some 105 mm tall (Matthew and Luke), whereas those in the Euchologion are only some 55-65 mm tall (measuring vertically from top of head to lower hem of drapery). Indeed the forgeries, like the manuscripts they are based on, look like the works of two entirely different artists. Pigment analysis could provide a valuable insight into how they were executed, but certainly the tonal range in the two manuscripts also appears quite different. As mentioned above, the images in the Archimedes manuscript use tones in a notably un-Byzantine manner. In contrast, the pale pinks and blues of the Mark and Luke (Fig. 15.9) of the Duke MS (both based on Omont's plate LXXXIX [compare Fig. 15.10]) are almost completely convincing in their Byzantinism. (The Matthew and John, based on Omont's plate LXXXVIII, are more garish in tone.) As in the Archimedes, the forger also introduced some ornamental elements into the Duke MS, a headpiece used inappropriately (for a Byzantine manuscript) as a marginal ornament, and two ornaments including a historiated initial (misunderstood), based on part of Omont's plate CXIII (reproducing a different page of the same manuscript as used for the Archimedes headpiece).

As in the Archimedes, all these images in Duke Gk. 84 were painted on single leaves taken from various points in the book (mostly originally the first leaves of quires), leaves that had previously been washed more or less clean of their text. There are some traces that suggest they were mounted at some date, but not with the crude adhesives used in the Euchologion. The four evangelist portraits have traces of paper guards.[32] (The two leaves with marginal decoration also have rusty traces of paperclips, like the Archimedes leaves.) One leaf, the incipit of Luke's gospel, which was already decorated in the original manuscript, was also subjected to an 'improvement' that left it with most of the parchment surface eaten away into a headpiece-shaped hole.[33] That the images of the Duke MS are knowing forgeries is suggested in

particular by the treatment of the scroll in the Luke: it was shortened in comparison with the original (cf. Figs 15.9 and 15.10), and its surface partly rubbed and abraded, deliberately, it would seem, so as to make the task of transcribing the lengthy text seen in Omont less difficult.[34]

Although the general appearance of the forged images in the two manuscripts is thus very different, one aspect of both, visible under the microscope, is identical. In both cases the intial underdrawing of the figures and setting was executed, at least in part, with red lines. These are the compositional outlines based on the tracings from Omont's plates. The recurrence of the red line in both is sufficiently unexpected to appear distinctive, and to suggest a single artist's practice. It may be possible at some future date to confirm the similarity by pigment analysis. The other element that becomes apparent under magnification is that the artist of the Euchologion evangelists, albeit seemingly less comfortable at working at such small scale, was skilled. The face of St John, in particular, is remarkably fine, and the fist on which Mark rests his chin is carefully foreshortened. The artist was no mere weekend dauber.

In one important respect, however, the story of the forgeries in the Duke MS differs from that in the Archimedes palimpsest. When Papadopoulos-Kerameus catalogued Metochion MS 490, it already had four evangelist portraits (on what were then folios 11v, 60r, 95v, 173v), as well as Canon Tables (on folios 3-7), and illuminated headpieces (on folios 61r, 96r, 174r; the opening of Matthew to face folio 11v was missing).[35] The only part of this decorative scheme that has survived is the headpiece to Luke (originally folio 96r, now an unnumbered leaf that should precede the current 'folio 83'). That is to say Metochion MS 490 was a Gospel Book with (presumably) original Byzantine decoration, but at some date after c.1900 this was removed. It would seem likely that the (original) evangelist portraits were detached so as to be sold separately from the book, possibly, but not necessarily, by the forger in Paris. (I considered the possibility that the Canon Tables recycled as paste-downs in the binding of the Archimedes palimpsest could have come from the Duke MS, but they must have been made for a notably larger book.[36])

Comparison of the Archimedes palimpsest and the Duke MS indicates that there was a skilled artist – albeit a forger – at work, quite possibly in Paris, conceivably as early as 1929, but more probably in the years shortly thereafter, perhaps in the early 1930s. His method was to remove single leaves from Byzantine manuscripts (in this case both coming from the library of the Metochion of the Holy Sepulchre in Istanbul). He then painted on those leaves Byzantine-style images after first washing off the text, or occasionally he filled a blank space with Byzantine-style ornament. He based himself in either instance primarily on models in Omont's publication of 1929. The resulting images, while they might circulate individually, on occasions

remained with their parent manuscript. Since both manuscripts have lost additional leaves (in the case of Archimedes three leaves, as mentioned above, since it was studied by Heiberg; thirty or more leaves in Duke Gk. 84) there remains a real possibility that other forgeries have become separated from one or both of them (not to mention the missing original evangelist portraits of Metochion MS 490). Indeed, recent examination by Abigail Quandt has revealed traces of pigment transferred onto the facing pages from the three lost leaves of the Archimedes (folios 104, 123, 170), presumably from (missing) forged images. This distasteful scenario is likely to remain murky as far as Duke Gk. 84 (*olim* Metochion MS 490) is concerned, since (disappointingly), so far as I can establish there is no surviving record of how, when, or where Hagop Kevorkian acquired the book. The position with the Archimedes Palimpsest is very different, however, since its history and ownership since 1908 were explicitly contested in a New York law-court immediately before and for some eighteen months after the auction (the case was finally closed on 25 February 2000). With the benefit of hindsight it can be said that the discussions in court, if not the outcome of the case, might have been quite different had the focus been less exclusively on Archimedes, and more on the 'Byzantine' images.

*Archimedes on Trial: the New York Court Case*
The case, heard before Judge Kimba M. Wood in the US District Court, Southern District of New York, was brought by the Greek Orthodox Patriarchate of Jerusalem, represented by attorney Simos Dimas, initially (at 5 p.m. on 28 October 1998) seeking a restraining order on Christie's to prevent the auction of the manuscript at 2 p.m. on 29 October. This was unsuccessful, but the case against Christie's, Anne Guersan (the consignor), and the anonymous buyer ('John/Jane Doe') was pursued. The court records, affidavits, exhibits, and other documents run to some 500 pages.[37] Much of the material, however, is repetitive, and for present purposes only a few issues can be highlighted.

The Patriarchate's case was, in large part, that the owners had no right to sell the Archimedes Palimpsest since it had been stolen from the Patriarchate's Metochion at Istanbul at some point after 1910. They were able to produce a letter in connection with Heiberg's work in 1908, permitting him to study MS 355,[38] but they were not able to produce any direct evidence of theft. It was unfortunate for their case that when the Metochion manuscripts were transferred from Istanbul to the National Library of Greece (at an unknown date, said to be in the 1930s by Metropolitan Timothy of Bostra, secretary of the Jerusalem Patriarchate),[39] no inventory was taken, so that there was no knowledge that the manuscript was (presumably) missing. It also weakened their case as custodians of their manuscripts (even without citing former

Metochion MS 490/Duke Gk. 84) that the former Metochion MS 370 was acquired from a dealer in Paris in 1905 by the Bibliothèque nationale (now MS suppl. gr. 1317), the former Metochion MS 767 was acquired by the University of Chicago Library (now MS 129) in 1929, and the former Metochion MS 634 was in the hands of the New York- and Paris-based dealer Dikran Kelekian by 1931 (earlier he had maintained an office in Istanbul).[40] Tischendorf had even succeeded in acquiring a leaf of the Archimedes palimpsest itself on his first visit to Istanbul as long ago as 1844 (it is now Cambridge University Library, add. MS 1879.23), but he was unaware of its full significance.[41] The Jerusalem Patriarchate had not contested any of these acquisitions, either at the time, or at any subsequent point until 22 October 1998 (and only then in response to publicity in Greece).

The defence suffered the same lack of documentation, although it did less to weaken their position. According to Mme Guersan, her father, Marie Louis Sirieix, after World War I 'traveled extensively throughout Greece and Turkey and purchased many objects in these countries. I believe that he bought the Palimpsest in the course of his travels, probably in 1920 or 1921.'[42] Mme Guersan was married in 1946, and in 1947, in the words of her affidavit, her father left her and her family part of his collection, including the Palimpsest, when he moved from their Parisian apartment[43] to live in the South of France. Mme Guersan was unable to offer any proof of purchase.

As it happened, this lack of documentation from the 1920s made little difference to the result, because the case was heard under French law (a point hotly contested by Dimas), according to which after thirty years 'continuous and uninterrupted, peaceful, public and unequivocal possession' the Guersan family had acquired ownership ('prescription') of the object.[44] Yet surprisingly, in view of the narrative sketched out above, even in 1998 the Guersan family had some difficulty providing the necessary independent evidence of thirty years possession,[45] although this was not highlighted by the plaintiff.

The first dated document in the affidavit of Mme Guersan was a letter from [Professor] A[braham] Wasserstein at the Hebrew University, Jerusalem, dated 25 August 1970, in which he provided a short but detailed and precise account of 2 bifolios (folios 91-94) that he was shown, identifying them as part of Metochion MS 355 (a remarkable feat, it would seem).[46] In her affidavit there is then plenty of subsequent evidence of the family's attempts to sell the book to private collectors/dealers or to scholarly institutions (H.P. Kraus, or the Beinecke Library at Yale, for example) in full knowledge of its importance. This activity was supported by a bilingual French/English advertising brochure of 'the early 1970s'.[47] To demonstrate their ownership at an earlier date, however, that is to say thirty or more years before the sale, the Guersans were able to produce only a letter dated 2 November 1998 (i.e. after the sale) from their neighbour in the apartment above, the distinguished

scholar of Greek texts, Prof Jean Bollack.[48] In the letter he recalls for Mme
Guersan how he was shown (once) in 1960 (an approximate date [*à-peu-près la
date que je reconstitue*], almost forty years before) '*le palimpseste de Constantinople*'.
The significance that attaches to the Bollack letter is two-fold: it demonstrates
possession of the manuscript, and it indicates that the Guersan family were
fully aware of both its contents and provenance.

The Wasserstein letter of 1970, however, implies a very different scenario.
Wasserstein never mentions Archimedes (surely a vital omission), clearly has
no knowledge of the work of Heiberg, and describes the palimpsest text only
in the terms of Papadopoulos-Kerameus's catalogue description as consisting
of 'mathematical material'.[49] Furthermore, he goes on to say 'If I am right in
thinking that these pages belong to codex 355 of the library of the *Panaghios
Taphos* in Constantinople...'. It is thus clear, I suggest, that Wasserstein was
given the pages of the manuscript by the Guersans with a request to identify
what they were, which he went some way to doing. Now it would make no
sense for the owners in 1970 to have hidden from Wasserstein that they
already knew they possessed Metochion MS 355, and that they knew in
addition that it was the (famous) Archimedes palimpsest. If this point is
accepted, the recognition of the Guersan's text as containing Archimedes
must have postdated 25 August 1970. My guess is that the identification was
first made at the Institut de Recherche et d'Histoire des Textes in Paris (to
which Wasserstein in a postscript to his letter specifically recommended the
Guersans for advice on the conservation of the book). There the pages were
studied by Joseph Paramelle (perhaps later in 1970 or in 1971) 'for several
weeks with the aid of several of his colleagues [who] verified their historical
provenance, contents, and scholarly importance.'[50] The IRHT, however, kept
no record of this activity. In the present context, therefore, the statement of
Bollack that he saw the 'Constantinopolitan Archimedes' (that is to say he had
full knowledge of its provenance and significance) 'around 1960' would be
easier to square with the evidence had he said either that he had seen it around
1970, or that he had seen it around 1960 but without knowing exactly what it
was.[51]

### The Moral Dimension in the Court Case

Much of the plaintiff's case, as presented by Simos Dimas, sought to open up
a moral debate about cultural property (it focused on 'public policy arguments'
in the words of Judge Wood).[52] This undoubtedly reflected the views and
desires of the Jerusalem Patriarchate and the Greek Government. Indeed, the
issues surrounding the sale were hotly discussed at the time in Greece, and the
Minister of Culture, Evangelos Venizelos, made a series of confident public
statements (but he responded to journalists' subsequent questions with some
truculence).[53] Speaking on 23 October 1998 he declared 'the acquisition of the

manuscript is an obligation upon us [Greece], not only a historic obligation and thus a moral one but also a scientific one... [It] is ...an object of our universal cultural legacy.'[54] He talked of 'the moral and historical obligations of the State', and 'the legacy of mankind'.[55]

In view of the perceived importance of the book, a Greek consortium was organized and the State of Greece 'orally submitted an offer for approximately $1 million' for the manuscript before the sale (an offer that was declined).[56] In the auction the Greek Consul-General in New York was the underbidder at $1.9 million (by this time Greece was prepared to increase its offer to $2 million, but not beyond). Speaking after the sale, on 30 October, Venizelos clearly felt that legal argument in the continuing court case could still win the day and see the Archimedes deposited in Athens, but at the same time (speaking as a politician) he sought to downplay the importance of the manuscript – which his government had failed to acquire – citing in particular its poor condition.[57]

The issue of the condition of the Archimedes manuscript is indeed important to the moral, if not to the legal debate. The defence claimed that the French owners had carefully preserved the manuscript, and made its existence known to scholars.[58] This the owners could demonstrate from 1970.[59] Christie's further implied the venality and cunning of the monks of the Metochion by attributing to them 'presumably' the decision to add the images to 'enhance [the book's] value in the eyes of a prospective purchaser'.[60] According to this version, the Western purchaser was by implication the innocent dupe, the monks by implication the vandalous (because they obscured Archimedes) perpetrators of a crime against the cultural legacy of mankind. By overlooking the Byzantine element of their cultural heritage and tradition, the Greek Government, however, found no material with which to rebut this view. By focusing their attention exclusively on Archimedes they missed the opportunity to identify the presence of the forged Byzantine images in the book, and as a result were unable to call into question the whole notion of crafty monks and the careful preservation of the book in France since 1921-22 by a single family. Ironically, by overlooking their Byzantine heritage, they lost their link to their classical past.

*Reconstructing the circumstances of the forgeries and the provenance of the Archimedes Palimpsest*

Is it then possible to reconstruct, albeit speculatively, the provenance of the Archimedes Palimpsest? Fortunately, a strong sidelight on its otherwise obscure history after 1910 appears to be cast not just by Duke Gk. 84, but also by two important illuminated manuscripts which also made the journey (in whole or in part) from Istanbul to the Paris art market, one of them certainly in the 1920s. The first book was the so-called Phanar Gospels,

catalogued as MS 2 of the Megale tou Genous Schole by Papadopoulos-Kerameus in 1909.[61] It was seen by Charles Diehl at the School in the Phanar district of Istanbul around the turn of 1921-22, and subsequently discussed by him in publications of 1922 and 1927 (with illustrations).[62] Of this magnificent book, given to the Holy Trinity Monastery of Chalki in 1063 by the Empress Catherine Komnene, and still complete in 1921-22, until very recently only four leaves were known to have survived: the evangelist portraits of Matthew, Mark (Fig. 15.12), and Luke, and the incipit page of Matthew's Gospel.[63] The portraits of Matthew and Luke were in the hands of the dealer Dikran Kelekian – whom we have already encountered – by 1931 (or 1930),[64] and were sold by him to the Cleveland Museum of Art in 1942.[65] The portrait of Mark was acquired by Dumbarton Oaks from a Dutch dealer (Robert Roozemond) in 1979 along with the Matthew incipit page. The fourth evangelist portrait, that of John, which Diehl's plate shows to have been in poor condition,[66] is still missing. But most remarkably, Georgi Parpulov has recently confirmed that all the rest of the manuscript, long believed lost without trace, is in fact preserved in the National Library of Greece (still under the shelfmark Constantinople, Megale tou Genous Schole MS 2) among the books transferred at an unknown date from Istanbul to Athens.[67]

Most important in the present context are two points. First, when the Mark page of the Phanar Gospels was exhibited, as a single leaf, at the great Parisian exhibition of Byzantine Art in 1931, it was catalogued as property of the 'Collection Guerson' (*sic*).[68] Second, the Matthew and Luke images of the Phanar Gospels, when sold by Kelekian to Cleveland in 1942, were bound into a different manuscript, into which they had already been inserted in 1931 (they were subsequently detached).[69] This fine Gospel book with commentary, said by Kelekian to have come from Trebizond, was in fact the former MS 634 from the Metochion in Istanbul.[70] We thus have a documented pattern by which manuscripts from Istanbul were brought to Paris between c.1910 and 1930, went on to the art market, and might be 'enhanced' by the addition of images. Involved in this trade were (amongst others) Kelekian, a dealer of the first importance, who had a Metochion manuscript and some of the decorated pages of an imperial Gospel Book, and Guerson, a much less important dealer, who nonetheless had another of that same imperial Gospel book's leaves (possibly two, if the Matthew incipit page has the same twentieth-century history as the Mark miniature). The dealers Kelekian and Guerson were certainly known to one another, for Kelekian bought two Persian textiles from Guerson in Paris in December 1929.[71] Their acquaintance may well have been a long one, for in 1892 the Victoria and Albert Museum purchased ceramics and other near-eastern materials from each of them, separately, and both had addresses at that time in Istanbul.[72]

There may, I think, even be a direct connection between the Mark leaf of

the Phanar Gospels in the Guerson Collection and the images in the Guersan family's Archimedes palimpsest. It will be recalled that the Archimedes evangelists differ from those on plate LXXXIV of Omont most notably by omitting the background architecture and by placing the figure under an arch (compare Figs 15.1-2 and 15.4-5 with Fig. 15.6). Oddly (in Byzantine terms) this arch is then set within a rectangular frame. The pattern of the ornamented arch framing the evangelist, however, is precisely the formula adopted in the Mark leaf from the Guerson collection (Fig. 15.12). The colours are not at all similar, however. I propose that it was knowledge of the Guerson leaf that suggested to the forger of the Archimedes evangelists how he might frame the images he copied from Omont.

The reconstruction I propose (it is not a legal argument) is thus the following. The Euchologion, Metochion MS 355, was acquired in Istanbul by or for a dealer between 1910 and 1930, quite likely in the chaotic period after 1922. It was brought to Paris. In the enthusiasm for Byzantine art that gripped the city in and after 1931, and using Omont's publication of 1929, forged images were painted on folios removed from the book. The book was later in two parts, one bound, the other loose, a form it had when first offered for sale by the Guersan family in the early 1970s.[73]

The status of the pages with images even in recent times remains puzzling. The book now has 174 folios. In the first sale brochure (presumably of the early 1970s) it is described as having 171 'pages' (doubtless folios).[74] In the documentation of the French Ministry of Culture of 1996, in connection with the granting of an export licence (overturning the denial of such a licence in 1993), it is documented as having 170 folios.[75] Neither brochure nor certificate mentions the presence of images. Most likely, therefore, the folios with images were indeed separate from the book at the time (because mounted for display), and were only returned to it relatively recently (they were certainly there when the MS was examined at the British Library in 1996).[76] The traces of Blu-Tack on the backs of the images is direct evidence of a post-1970 history separated from the rest of the book.

Our perception of the role of the Sirieix/Guersan family in this story will depend to a considerable extent on whether we think they were merely the (innocent) purchasers of the already 'improved' manuscript in Paris, say in the early 1930s (leaving aside the question of how and by whom the manuscript was brought from Istanbul), or whether we think they were responsible in some form for the forging of the images, with the intention that they would sell the book, and/or the images, sooner or later. (If they did indeed own the book without interruption, as claimed, since acquiring it 'probably in 1920 or 1921', then the evidence of the forgeries as to their role is damning.) They were certainly interested in selling from the early 1970s onwards, as Mme Guersan's affidavit makes clear, and they had sufficient nerve to hang on for

almost thirty years until they were able to realize an exceptional price. Finally, it also remains unclear whether the Guerson/Guersan 'connection' could be merely a remarkable (near) coincidence of nomenclature among Paris-based dealers/collectors of Byzantine manuscripts and images, or whether there is some direct link. Further research in France could probably clarify at least this last point.

### The future of the forgeries

What should happen to the forgeries now? It has been suggested in some quarters that they should be removed, that is to say destroyed, in order to reveal the Archimedes text. I would argue most strongly against such a course. As they are, they already stand as an object lesson in the disheartening destruction of cultural property that is often the result of forgery. They are also a valuable reminder in our too easily prejudiced world that such forgeries are quite as likely, one could say more likely, to come out of an 'enlightened' Western as opposed to a 'mysterious', 'devious' Eastern context. The forgeries also have the power to serve as a constant reminder of how, in the enthusiastic, even headlong pursuit of one aspect of heritage and tradition, other aspects are overlooked, and an understanding of the past thus becomes seriously distorted.

The Archimedes Manuscript has been the focus of quite extraordinary publicity since the autumn of 1998. During a well-attended exhibition at the Walters Art Museum in 1999 it was the subject of a lengthy discussion in the columns of the *Baltimore Sun*, a story which was followed up by the *Washington Post*, and thence via the Associated Press wire service was syndicated in innumerable North American newspapers. It took a while for the story to cross the Atlantic, but when it did the effect was remarkable. The *Sunday Times* colour magazine ran an article on the manuscript as their cover feature on 17 June 2001, and it was followed more or less immediately by enquiries to the Walters Art Museum from half a dozen British-based television production companies wishing to tell the manuscript's story. When BBC Science emerged successful, and the resulting *Horizon* documentary was aired on 14 March 2002, it attracted 2.9 million viewers (13.1% of the UK viewing audience that evening).

Yet in all these varied very public contexts there is one element that is consistent: the words Byzantium, or its cognates, are never mentioned. Who copied this Archimedean manuscript in the tenth century if not a Byzantine scribe? Who wanted to read and study the Archimedean texts if not a tenth-century Byzantine mathematician? Who then preserved the parchment in or before 1229 by recycling it, if not another Byzantine scribe? And when the book was preserved in Paris after 1929 was it not at least in part due to the addition to it of (forged) Byzantine images? In the crucial years between 1910

and 1970 when the knowledge of its Archimedean text hung by a slender perhaps invisible thread, it was the presence of images – less than worthless in our current view as ignorant forgeries – that made the book something to save. Let the forged Byzantine images survive as a lesson about abuse of the past.

## Notes

1. This paper would have been impossible without the generous help and hospitality of the Walters Art Museum at Baltimore, and in particular its Director Dr Gary Vikan, Curator of Manuscripts Dr William Noel, and Senior Conservator Abigail Quandt. I am also grateful to the following for answering specific enquiries and/or commenting on a draft of this paper: Susan Boyd, William Carrick, Dr Christopher de Hamel, Dr Christian Förstel, Sam Fogg, Dr Paul Géhin, Dr Marie-Odile Germain, Nanette Kelekian, Dr Charles Little, Prof. Timothy Mitchell, Prof. Reviel Netz, Georgi Parpulov, Camilla Previté, B.W. Robinson, Nabil Saidi, Dr Patricia Stirnemann, Alicky Sussman, Liz Tucker, Dr Rowan Watson, Nigel Wilson. It is offered to Robin Cormack in gratitude for many indispensable lessons, not least the first 'How to Date a Dated Inscription', without which the Archimedes palimpsest might still be undated.

2. A basic source is the sale catalogue: *The Archimedes Palimpsest, Thursday 29 October 1998*, Christie's, New York (New York, 1998). Useful introductions are 'The Archimedes Palimpsest' [video, 20 mins.], Walters Art Museum (Baltimore, 1999); 'Archimedes' Secret', [video, 49 mins.] BBC Science (London, 2002). The manuscript has a website: http://www.thewalters.org/archimedes/index.html.

3. *Archimedes Palimpsest*, 15.

4. ...μ[ηνὶ] ἀπ[ριλλίου] ιδ' ἡμέρ[α] σα[ββάτω] ἔτ[ους] ͵ςψλζ' ἰνδ[ικτιῶνος]...

5. Some examples reproduced in *Archimedes Palimpsest*, 2, 21, 23, 29, 37, 44, 47.

6. A small UV-image of part of folio 76v is reproduced in *Archimedes Palimpsest*, 47.

7. J.L. Heiberg, 'Eine neue Archimedeshandschrift', *Hermes* 42 (1907), 235-303; J.L. Heiberg, *Archimedis opera omnia cum commentariis Eutochii* 2nd ed., Bibliotheca Teubneriana, 3 vols. (Leipzig, 1910-15).

8. It failed, however, to receive any mention in *The Times* of London.

9. For example, R. Netz, 'The Origins of Mathematical Physics: New Light on an Old Question', *Physics Today* (June 2000), 32-37; R. Netz, K. Saito and N. Tchernetska: 'A New Reading of *Method* Proposition 14: Preliminary Evidence from the Archimedes Palimpsest', *SCIAMVS* 2 (2001), 9-29.

10. Some examples in *Archimedes Palimpsest*, 2, 14, 15, 21, 44-45.

11. A. Papadopoulos-Kerameus, *Ierosolymitike Bibliotheke etoi katalagos ton en tais bibliothekais tou agiotatou apostolikou te kai katholikou orthodoxou patriarchikou thronou ton Ierosolymon kai pases Palaistines apokeimenon ellenikon kodikon*, vol. 4 (Peterburg, 1899), 329-31.

12. The album of Heiberg's photographs from the Kongelige Bibliotek, Copenhagen, is currently on loan to the Walters Art Musem where I was able to examine it. The photographs were made with the support of the Carlsbergstiftung: Heiberg, 'Archimedeshandschrift', 236 n. 1.

13. See also the diagrams in *Archimedes Palimpsest*, 30-33.

14. *Archimedes Palimpsest*, 25 (includes image of f. 21r).

15. *Archimedes Palimpsest*, 4.

16. N.G. Wilson, 'Archimedes: the Palimpsest and the Tradition', *BZ* 92 (1999), 89-101, plates IV-IX, esp. p. 92. For the most part this article summarizes and/or repeats the content of *Archimedes Palimpsest*.

17. Wilson, 'Archimedes'.

18. Remarks on codicology and condition depend heavily on the research in progress of Abigail Quandt, which she generously made available to me.

19. Based on experiments by Abigail Quandt.

20. Tracings by Abigail Quandt confirm the point.

21. See the general remarks in R. Reed, *Ancient Skins, Parchments and Leathers* (London, 1972), 154-59.

22. Information kindly supplied by Bostik Europe.

23. Papadopoulos-Kerameus, *Ierosolymitike Bibliotheke*, vol. 4, 329-31.

24. Papadopoulos-Kerameus, *Ierosolymitike Bibliotheke*, vol. 4, 329. See further R. Netz, 'Archimedes in Mar Saba: a Preliminary Notice', in *The Sabaite Heritage. The Sabaite Factor in the Orthodox Church: Monastic Life, Liturgy, Theology, Literature, Art and Archaeology*, ed. J. Patrich (in press). I am grateful to Prof. Netz for sending me a copy of this paper, which appeared too late to be considered in detail here.

25. Current binding is shown in *Archimedes Palimpsest*, 24. I owe the detail in this discussion of the leather, sewing, and boards of the binding to the informal comments of Abigail Quandt and John Sharpe.

26. The Canon Table reused in the front cover was illustrated in colour in *Archimedes Palimpsest*, 24.

27. Again, Abigail Quandt is the source of this unpublished information.

28. Sotheby's, *Catalogue of Western Manuscripts and Miniatures*, 22 June 1982 (London, 1982), no. 37.

29. Information on the purchase price was provided by John Sharpe, who is preparing a catalogue of the Greek manuscripts at Duke University.

30. J. Lowden, 'Some Forged Byzantine Miniatures', in Benaki Museum, *Thymiama ste mneme tes Laskarinas Boura*, 2 vols. (Athens, 1994) I, 165-67; II, pls. XIX, 88-94 (figs 1-13). Note that the captions to Figs 5 and 6 should read 'St John', and those to Figs 7 and 8 should read 'St Matthew'. At the time I was unaware that the manuscript had gone to Duke University.

31. Papadopoulos-Kerameus, *Ierosolymitike Bibliotheke*, vol. 5, 50 (no. 490). See further discussion below.

32. Noted by Abigail Quandt.

33. Lowden, 'Forged Byzantine Miniatures', fig. 12.

34. Deliberate abrasion of the paint surface in the borders was confirmed microscopically by Abigail Quandt (vertical scratch marks in the vertical borders, horizontal in the horizontal borders).

35. It was the presence of these 'original' images that suggested to me that Duke Gk. 84 could not be the former Metochion MS 490. The fact that both manuscripts begin Matthew imperfectly in Mt 1:19 (παραδειγματίσαι) however, is proof of their identity, and overrules the minor differences of page size (about 5 mm), and the obvious differences in foliation

between the two. Note that possible identification marks on the spine of the binding have been removed. I am grateful to Georgi Parpulov whose proposed identification of the Duke MS as Metochion MS 490 (e-mail message) encouraged me to check my notes.

36. Metochion MS 490 as measured by Papadopoulos-Kerameus, *Ierosolymitike Bibliotheke*, 50, was 215 x 172 mm, the Canon Tables (see above) must have been significantly larger than 197 x140 mm, the folios which they decorated larger still.

37. The case reference is United States District Court, Southern District of New York, 98 CIV 7664 (KMW).

38. 98 CIV 7664 (KMW), Affidavit of Simos C. Dimas, Exhibit E.

39. A supplementary catalogue of Metochion manuscipts by K. Moraïtikis was being published serially in the periodical *Orthodoxia* 10 (1935) - 15 (1940).

40. M. Richard, *Répertoire des bibliothèques et des catalogues de manuscrits grecs*, 2nd ed. (Paris, 1958), 114-5; see also *Répertoire des bibliothèques et des catalogues de manuscrits grecs de Marcel Richard*, 3rd ed. J.-M. Olivier, Corpus Christianorum (Turnhout, 1995), 387. Note that Richard's 2nd edition (1958) and the *Supplément I* (1964), do not mention Metochion MS 355. See also Victoria and Albert Museum, Registry, nominal file: Kelekian, Dikran. In 1892 Kelekian's letterhead gave addresses in Paris and Istanbul ('Indjidjiler, Constantinople'). By 1919 his near eastern operations were from an office in Cairo. By 1921 his letterhead included 'MSS' among his specialities. To the total of dispersed Metochion MSS, Georgi Parpulov has recently added Metochion MS 275, now Baltimore, Walters Art Museum, MS 529 (e-mail communication of 21 November 2002).

41. P. Easterling, 'Library Hand-List of the Additional Greek Manuscripts in the University Library, Cambridge', *Scriptorium* 16 (1962), 302-23 at p. 307; first identified by N.G. Wilson, *Scholars of Byzantium* (London, 1983), 139.

42. 98 Civ. 7664 (KMW), Affidavit of Anne Guersan, 12 February 1999, p. 1-2 for this and what follows.

43. 54 rue de Bourgogne, Paris 7e, not far from the Musée Rodin.

44. In his Opinion and Order of 18 August 1999 (98 Civ. 7664), 10-15, Judge Wood concluded that the outcome of the case would have been the same whether it had been tried under French or New York law.

45. 98 CIV 7664 (KMW), Conference, 27 January 1999, p. 16 lines 4-5, James Benkard (attorney for the defendant): 'I don't have a specific document dated 30 years prior to today'.

46. Copy attached to Anne Guersan's affidavit, as above.

47. 'Archimède et le Codex C ou Eurêka/Archimedes and Codex C or Eureka', (n.p., n.d.). Copy submitted as Exhibit A, Affidavit of Anne Guersan .

48. Affidavit of Anne Guersan, Exhibit B.

49. Affidavit of Anne Guersan, Exhibit C.

50. Affidavit of Anne Guersan, p. 8.

51. Note that Judge Wood concluded: 'it is unlikely that even a "reconstructed" recollection would be inaccurate by a decade': Opinion and Order, 18 August 1999 (98 Civ. 7664), 17. Attorney Dimas had characterized the letter as 'not very convincing: it is rather vague about the date': Plaintiff's Memorandum of Law in Opposition to Motion for Summary Judgement, p. 16.

52. 98 Civ. 7664 (KMW), Opinion and Order, 18 August 1999, 12.

53. 98 Civ. 7664 (KMW), Transcript attached to plaintiff's documents.

54. [Greek] Ministry of Culture, Press Office, Press Conference, Evangelos Venizelos, Minister of Culture, Friday, 23 October 1998, p. 1.

55. [Greek] Ministry of Culture, Press Office, Press Conference, p. 3.

56. 98 Civ. 7664 (KMW), Affidavit of Felix de Marez Oyens, 28 October 1998, p. 5.

57. 98 Civ. 7664 (KMW), Transcript of Press Conference attached to plaintiff's documents; discussion of Prof. S. Kotsambassis' report (illegible photocopy included as Exhibit G, Affidavit of Costas S. Dimas) on the condition of the manuscript on p. 3.

58. 98 Civ. 7664 (KMW), for example Affidavit of Anne Guersan, 2-5 (paras. 6-13). One 'unofficial' indication of scholarly interest, not cited in her affidavit is demonstrated by D. Harflinger, *Die Wiedergeburt der Antike und die Auffindung Amerikas*, exhibition catalogue, Hamburg Staats- und Universitätsbibliothek (Hamburg, 1992), no. 20, p. 44.

59. But the manuscript was not available even in this period for scholarly study: see the remarks by Wilson, 'Archimedes', 100.

60. *Archimedes Palimpsest*, 25. Even less guarded statements were made by Christie's in a statement released in Athens, 26 October 1998: Affidavit of Simos C. Dimas, Exhibit C, 98 Civ. 7664 (KMW).

61. A. Papadopoulos-Kerameus, 'Dyo Katalogio Ellenikon Kodikon en Konstantinoupolei, tes Megales tou Genous Scholes kai tou Zographeiou', *IRAIK* 14 (1909), 101-53, at pp. 106-7 (also numbered as pp. 38-9). The MS was erroneously described by Vikan, 'Gifts', 6 as seen by Papadopoulos-Kerameus in the Kamariotissa Monastery on the island of Chalke.

62. Ch. Diehl, 'L'Évangéliaire de l'impératrice Cathérine Comnène', *Comptes rendus des séances de l'Académie des Inscriptions et Belles-lettres* (1922) 243-48 (séance du 12 juillet); Ch. Diehl, 'Monuments inédits du onzième siècle', *Art Sudies* 5 (1927), 3-9, esp. p. 9, pls. 3-7. Diehl appears to have been unaware of Papadopoulos-Kerameus' catalogue description of the MS (as above n. 61), which thus was overlooked by subsequent writers.

63. G. Vikan, *Gifts from the Byzantine Court* (Washington, DC, 1980), 1-8. See also the colour reproductions of the Cleveland Matthew and Luke in *The Glory of Byzantium*, eds H.C. Evans and W.D. Wixom (New York, 1997), no. 58, pp. 103-4 (surprisingly, the author of the catalogue entry did not know of the Dumbarton Oaks leaves). Still useful is *Illuminated Greek Manuscripts from American Collections*, ed. G. Vikan (Princeton, 1973), nos. 12-14, pp. 82-87.

64. K.W. Clark, *A Descriptive Catalogue of Greek New Testament Manuscripts in America*, (Chicago, 1937), 122-23. He states that the manuscript was acquired by Kelekian in 1931, but records that he (KWC) examined it on 5 September 1930. It is not clear how this was possible.

65. W.M. Milliken, 'Byzantine Manuscript Illumination', *Bulletin of the Cleveland Museum of Art* 34 (1947), 50-56. Note that when Wilhelm Koehler, 'Byzantine Art and the West', *DOP* [Inaugural Lectures] 1 (1940 [publ. 1941]), 61-87, esp. fig. 16 and p. 77, cited and reproduced the Matthew portrait it was as 'Istanbul, Phanar School Gospels'.

66. Diehl, 'Monuments', pl. 6, and see the remark on p. 9: 'fort abîmée'.

67. E-mail message of 21 November 2002. I am most grateful to Mr Parpulov, currently a curatorial fellow at the Department of Manuscripts of the Walters Art Museum, for this very important information, which he has kindly permitted me to mention.

68. *Exposition internationale d'art byzantin*, Musée des Arts Décoratifs (Paris, 1931), no. 653. On display at the exhibition were sixteen manuscripts from a variety of international collections, and twenty-seven manuscipts from the Bibliothèque Nationale, including BN gr. 64 (cat. no. 666), the source, via Omont, of the Archimedes evangelists, and BN gr. 550 (cat. no. 668), the source of the ornament, again via Omont, in both the Archimedes and Duke manuscripts.

69. Clark, *Greek Manuscripts*, 122. The miniatures had already been identified at this date by A.M. Friend as coming from the Phanar Gospels (122 n.1). This was hardly surprising since Diehl's photos of the manuscript had appeared in *Art Studies* 5 (1927) alongside Friend's first article on 'The Portraits of the Evangelists in Greek and Latin Manuscripts', 115-49. A puzzle is that Vikan, *Gifts*, 5, states that 'that Gospel book, those portraits, and our [Dumbarton Oaks] leaves were [all] in Paris for the huge exhibition of Byzantine art staged at the Musée des Arts Décoratifs'. It seems very possible that there were additional uncatalogued items on display, but I have not thus far been able to find confirmation.

70. Papadopoulos-Kerameus, *Ierosolymitike Bibliotheke*, vol. 5, 190-93.

71. Information from Nanette Kelekian, kindly communicated by Charles Little.

72. Victoria and Albert Museum, Registry, nominal file: Guerson, Samuel Moses, agenda nos. 3669, 3654.

73. 'Archimède et le Codex C', [unpaginated, 'p. 6'], 'Une partie est reliée à la couverture originale, l'autre est détachée'.

74. 'Archimède et le Codex C', [unpaginated, 'p. 6'].

75. 98 Civ. 7664 (KMW), Affidavit of Anne Guersan, Exhibit K (see also Exhibits I and J).

76. Copy of the report on temporary deposit in the Department of Manuscripts, Walters Art Museum.

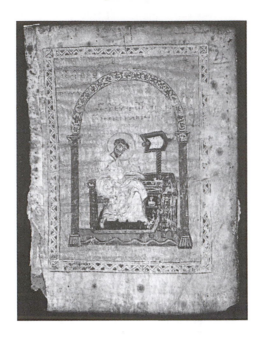

15.1 St Luke. Archimedes Palimpsest, fol. 21r.

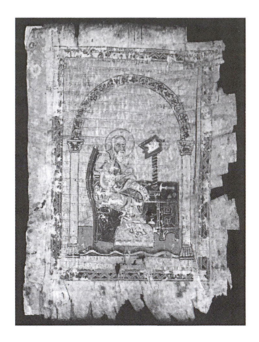

15.2 St John. Archimedes Palimpsest, fol. 57r.

15.3 Archimedes Palimpsest, fol. 56v-57r, showing condition when photographed for Heiberg in 1906-8.

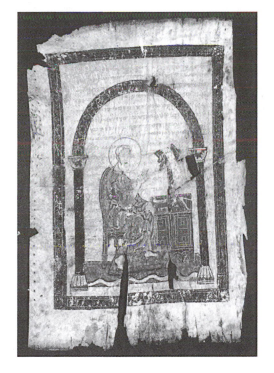

15.4 St Matthew. Archimedes Palimpsest, fol. 64v.

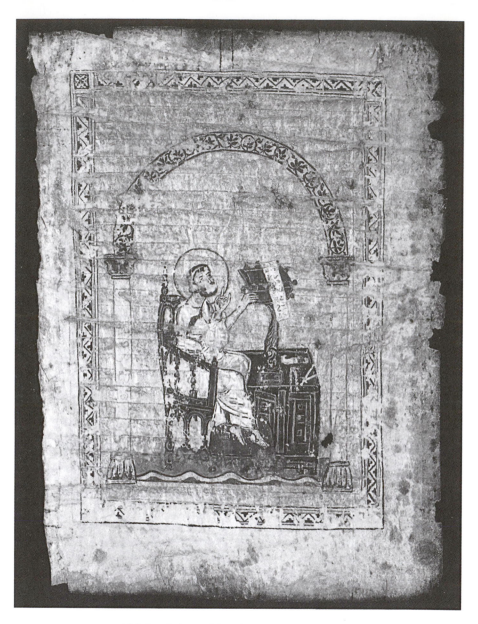

15.5 St Mark. Archimedes Palimpsest, fol. 81r.

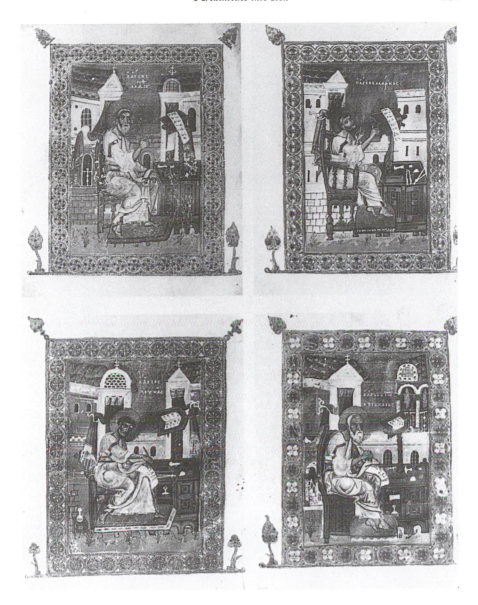

15.6 H. Omont, *Miniatures des plus anciens manuscrits grecs de la Bibliothèque Nationale du VIe au XIVe siècle* (Paris, 1929), pl. LXXXIV.

15.7 Tailpiece. Archimedes Palimpsest, fol. 116v.

15.8 MS Paris gr. 550, fol. 116v, headpiece: H. Omont, *Miniatures des plus anciens manuscrits grecs de la Bibliothèque Nationale du VIe au XIVe siècle* (Paris, 1929), pl. CIV.7.

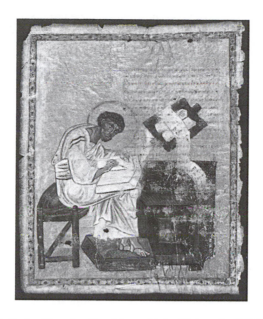

15.9 St Luke. Detached leaf from Duke University, MS Gk. 84.

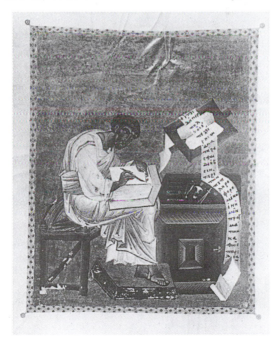

15.10 H. Omont, *Miniatures des plus anciens manuscrits grecs de la Bibliothèque Nationale du VIe au XIVe siècle* (Paris, 1929), pl. LXXXIX.

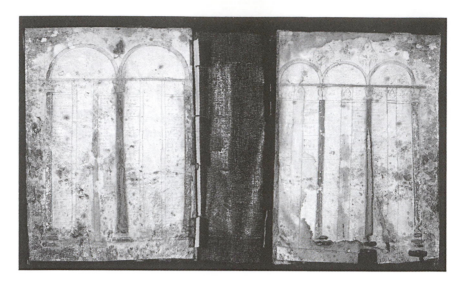

15.11 Archimedes Palimpsest, interior of binding (removed from book) showing Canon Tables re-used as pastedowns.

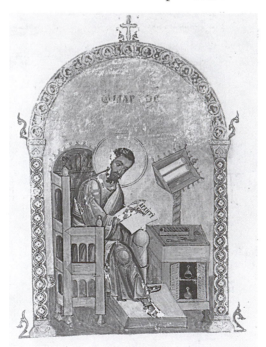

15.12 St Mark. Dumbarton Oaks MS acc. 79.31.1 (Dumbarton Oaks, Byzantine collection, Washington, DC).

Chapter 16

# The Purple Thread of the Flesh: The theological connotations of a narrative iconographic element in Byzantine images of the Annunciation[1]

Maria Evangelatou

In many representations of the Annunciation in Byzantine art, the Virgin is shown spinning the purple thread destined for the new Temple veil, as narrated in the apocryphal *Protevangelion* of James.[2] In this paper, I will argue that a significant reason for the popularity of this iconographic detail was its symbolic reference to the Incarnation of the Logos – the main event of the Annunciation, the central dogma of the Christian Church and the base of the economy of Salvation. This interpretation is based on apostolic and patristic exegeses that take the Temple veil as a type of Christ's body; on the clothing metaphors frequently used in Byzantine hymns and homilies referring to the Incarnation; and on the iconographic peculiarities in a small number of Byzantine images, monumental paintings and icons, where the symbolic function of the purple yarn spun by the Virgin appears accentuated.

The following chapter is a preliminary report on research that I hope to develop further in the future. My intention was to present Robin Cormack with a small tribute for teaching me the importance of asking questions, even when the answer is not at hand, and instructing me to be aware of the dangers of over-interpretation.

The spinning of the purple thread appears in scenes of the Annunciation from the fifth century onwards. It soon became a standard iconographic element, present in most depictions of the event in Byzantine art. Up to the ninth century, a basket that contains the purple skein was frequently depicted next to the Virgin, who usually holds a spindle with yarn or one end of the

From *Icon and Word: the Power of Images in Byzantium. Studies presented to Robin Cormack*, eds Antony Eastmond and Liz James. © 2003 by contributors. Published by Ashgate Publishing Ltd, Gower House, Croft Road, Aldershot, Hampshire, GU11 3HR, England, pp. 261-279.

spun thread.[3] From the Middle Byzantine period onwards, however, the basket was usually omitted from the composition. In most cases, Mary holds the spindle, whether she is shown seated or standing before the heavenly messenger who approaches her.[4] As is well known, the theme of the spun purple skein in Annunciation scenes is inspired by chapters 10-11 in the apocryphal *Protevangelion* of James:

> Now there was a council of the priests, and they said: Let us make a *veil for the temple of the Lord*. And the priest said: Call unto me pure virgins of the tribe of David. And the officers departed and sought and found seven virgins. And the priests called to mind the child Mary, *that she was of the tribe of David and was undefiled before God*: and the officers went and fetched her. And they brought them into the temple of the Lord, and the priest said: Cast me lots, which of you shall weave the gold and the undefiled (the white) and the fine linen and the silk and the hyacinthine, and the scarlet and the true purple. *And the lot of the true purple and the scarlet fell unto Mary*, and she took them and went unto her house...[5]

According to the *Protevangelion*, when Gabriel entered Mary's house to announce the joyous news of the Incarnation of the Logos, she was spinning the purple skein.[6]

When scholars comment upon this story, they emphasize the fact that Mary's involvement in the spinning of the threads for the Temple veil proves two fundamental 'truths' of the Christian dogma: Mary's virginity at the time of the Annunciation, and her descent from the house of David. The scarlet and especially the purple colour of the skeins entrusted to the Virgin are also seen as alluding to the royal status of Mary and her son.[7]

A number of scholars have also considered the purple yarn as a symbol of the Incarnation in the case of one particular image of the Annunciation: the late twelfth-century icon at St Catherine's Monastery, Mt Sinai (Fig. 16.1). The elaborate iconographic details of this painting are frequently mentioned in scholarly literature for some details are rare or unique in the surviving corpus of Byzantine art. They are interpreted as reflecting expressions often employed in Byzantine hymns and homilies dedicated to the Virgin.[8] The warm, golden light that suffuses the whole composition, comprising the incorporeal angel, is taken to signify the supernatural light of the divinity descending on earth at the time of the Incarnation. As Hans Belting observes of the icon: 'Only Mary, who is to give a body to the "incorporeal Word", has a solid blue and a deep purple-brown on her garments. She is weaving the temple curtain in the colour of blood like a garment for the Logos, who took on "fleshy existence from the Holy Spirit and from her blood".'[9] Likewise, Annemarie Weyl Carr writes that, in this icon, Mary is 'fingering the blood red

fabric of the temple veil, symbol of the veil of mortal flesh that she will cast over God's divinity'.[10]

In the case of this particular painting, scholars have been induced to interpret the purple thread symbolically, not only because of the elaborate symbolic character of the other iconographic details of the icon, but also through the presence of the infant (or, rather, embryo) Christ in a mandorla, depicted in grisaille on the Virgin's chest.[11] This rare iconographic element visualizes the moment of Christ's conception – when the Logos is being dressed in the veil of the flesh – and creates a telling analogy with Mary's spinning the thread for the veil of the Temple. A similar iconographic solution appears on a twelfth-century icon from Novgorod, now in the Tretiakov Gallery, Moscow (inv. no. 4), where the Child is painted in colour, and his skin is rendered in a crimson red similar to the hue of the purple thread held by the Virgin.[12] Bissera Pentcheva observes that, in both icons, the analogy between the 'weaving' of Christ's body and the spinning of the thread for the Temple veil is emphasized by the gesture of the Virgin. On the Sinai icon, Mary seems to hold the infant's mandorla with her left hand, with which she is also grasping the skein and the spun thread. On the Novgorod icon, she seems to touch the infant's shoulder with her right hand holding the yarn.[13] In both cases, the purple thread gives the impression of an umbilical cord connecting the mother and her child.

Patristic exegeses on the Temple veil as a type of Christ's body offer a strong argument in support of the hypothesis that the purple thread was symbol of the Incarnation in all Byzantine Annunciation images. The veil (κατaπέτασμα) for which the Theotokos was spinning the purple thread at the time of her Annunciation can be identified, according to the description in the *Protevangelion*, with the veil that closed the entrance to the Holy of Holies in the Jewish Temple. This curtain was also made of purple in Solomon's Temple (II Chron. 3.14) and in Moses' Tabernacle (Exod. 37.3-5), where it concealed the most holy space of Jewish religion. Only the high priest could enter that place once a year to offer a propitiatory sacrifice of blood, so that the sins of his people could be forgiven (Lev. 16.29-34, cf. Hebrews 9.6-7).[14] In the New Testament, the veil of the Temple is used as a type of Christ's body. This exegesis originates in Christ's description of his Passion and Resurrection as a destruction and three-day rebuilding of the Temple (Mark 14.58, 15.29; John 2.19-22). The veil of the Temple enters the picture when the gospels report that it was torn asunder at the time of Christ's death on the Cross (Matt. 27.51; Mark 15.38; Luke 23.45). In Paul's Epistle to the Hebrews, the exegesis of the Temple veil as a type of Christ's body is fully developed, and it becomes a key element in the Pauline concept of the transition from the Old to the New Covenant and the identity of the Christian religion. According to Paul, Christ is the new high priest who, through the sacrificial offering of

his own blood on the Cross, washes away the sins of mankind, and lifts the veil of the Temple so that everyone can enter in the true Holy of Holies and see God (esp. Hebrews 6.19-20 and Hebrews 9-10).[15]

Paul specifically mentions that the way to the Holy of Holies was opened to all Christians 'through the veil (καταπέτασμα), that is, Christ's body' (Hebrews 10.20). This concept was repeated and further elaborated, by, among others, John Chrysostom, Kosmas Indikopleustes, John of Damascus, and patriarch Photios.[16] They saw the Temple veil as a type of the human nature Christ took from his mother in order to dress his divinity and become known to the world.[17] Thus the veil of Christ's flesh was the vehicle of the Incarnation through which God revealed himself to all mankind, and through which he could die and rise again to offer his salvation to all who believed in him. As the Acts of the Seventh Ecumenical Council put it, 'The name "Christ" implies two natures, the one being visible and the other invisible. Thus this Christ, while visible to men by means of the veil (καταπέτασμα), that is his flesh, made the divine nature – even though this remained concealed – manifest through signs'.[18]

Inherent in this symbolism of divine revelation through the veil-flesh of Christ is the tradition found in various ancient and medieval cultures of the concealment or revelation of God, the emperor, or sacred objects behind curtains.[19] This tradition lived on in Byzantium as part of state and church ceremonial, in imperial audiences, in the liturgy, and in the case of miraculous images.[20] One of the most famous examples of this kind is the 'usual miracle' that was expected to take place every Friday in the church of the Blachernai in Constantinople.[21] Here the veil hanging in front of a venerable icon of the Virgin and Child miraculously lifted itself to reveal the sacred image. Intrinsic to this miracle seems to be the idea of the Temple veil being lifted to reveal the truth of the Incarnation.[22] In this respect, it was probably indicative of the significance of the miracle that it occurred on Friday, the day the Temple veil was torn asunder at the time of Christ's death on the Cross.[23]

In medieval art, both in Byzantium and the West, the motif of curtains drawn aside is frequently used to symbolize the revelation of God through the Incarnation of the Logos in Christ. Open curtains or a spread veil are often employed as symbols of the Incarnation in various scenes related to the Annunciation, the Conception and the Nativity, and in representations of the Virgin and Child, or the Evangelists who announced the Incarnation of the Saviour to the world.[24] For example, in the iconographic type of the *kykkotissa*, documented in Byzantine art from the twelfth century onwards, the Christ Child holds tightly the veil covering Mary's head. This has been interpreted by Hans Belting as symbolizing the Incarnation in relation to the Temple veil and the 'veil of the flesh' that the Theotokos cast on Christ's divinity.[25] In some icons of the *kykkotissa*,[26] the veil is decorated with the

diapered pattern that at times appears in depictions of the Temple veil itself.[27] Moreover, in Byzantine homilies and hymns the Temple veil is used not only as a type of Christ's flesh taken from his mother, but also directly as a type of the Theotokos who provides her flesh to veil the divinity of the Logos. In these texts the Virgin is called either καταπέτασμα or παραπέτασμα (curtain, veil).[28] One of the commonest biblical prefigurations of the Theotokos in Byzantine hymns and homilies, the Tabernacle, also visualizes her as a veil enclosing the divinity.[29]

The veil of the Temple as a symbol of the Incarnation was employed in several different ways in Byzantine art and culture, attesting to, and further enhancing, the familiarity of the public with its theological significance. It is therefore plausible that the purple thread spun by the Virgin for the Temple veil in images of her Annunciation was also interpreted in this light, as a symbol of the sacred purple of the flesh prepared for Christ in the womb of his mother. This is apparent in the frequent use of relevant metaphoric expressions in Byzantine hymns and homilies, especially those dedicated to the Theotokos. In the Marian homilies of Proklos of Constantinople the image of Mary as weaver of Christ's human nature appears in elaborate variations.[30] In his homilies, Mary's womb is seen as the virginal workshop in which Wisdom set up a loom for the Holy Spirit to weave Christ a robe, using Mary's pure flesh.[31] Proklos also perceives the Incarnation in terms of the Logos putting on the garment of human nature: As the high priest who must propitiate God on behalf of all mankind, he puts on the priestly robe of purity, and as the king who must defeat the devil, he wears the robe of royal dignity.[32] Here, Proklos specifically mentions that both garments are made of purple. Such clothing metaphors draw their origins in biblical scripture, where the most crucial moments in the sacred history are expressed in terms of putting on or putting off a number of symbolic garments:[33] Adam and Eve were dressed in robes of glory before the Fall, and in garments of skin after their sin. Christ clothed himself with Adam's human nature in the Virgin's womb, so that Adam could be reclothed in the robe of glory. This is achieved through Christian baptism, when the initiate takes off the garment of his or her previous sinful existence and is 'dressed in Christ' (Romans 13.14; Galatians 3.27).

In Byzantine hymns and homilies, both the Incarnation of the Logos and the Salvation of man are frequently described in clothing metaphors, in which the Theotokos is often mentioned as the one who provided Christ with the robe of human nature.[34] Various authors place particular emphasis on the purple of the flesh as the royal textile with which the Theotokos dressed Christ. For example, Andrew of Crete exalts Mary as the one who clothed the incarnated Logos in the purple mantle of her flesh;[35] and John of Damascus hails her for weaving Christ's purple robe with her virginal blood.[36] All of this

suggests that in Byzantine culture, the public was familiar with the idea of the Incarnation as the clothing of the Logos in the purple garment of the Virgin's flesh, and that Mary's spinning the purple thread in images of the Annunciation was probably seen as a visual expression of this idea. According to the textual evidence presented here, the purple thread spun by the Theotokos not only symbolizes the Incarnation, but places emphasis on a basic dogma of the Orthodox Church, the union of Christ's two natures in one hypostasis.[37] In this context the purple colour of the thread/cloth mentioned in the literature (or the red colour of the yarn shown in the pictorial representations) is a reference both to the flesh (human nature) and to the royal dignity (divine nature) of Christ.[38]

A small number of Annunciation images place particular emphasis to the purple thread in the Virgin's hands, further sustaining the hypothesis that this object had symbolic meaning in the eyes of Byzantine viewers. In these images, the Virgin points her spindle towards a small container that rests on her lap, just in front of her womb. These images include the early twelfth-century wall-painting of the Annunciation in the church of the Theotokos in Trikomo, Cyprus (Fig. 16.2);[39] the mosaic of the same subject in St Mary of the Admiral (Martorana) in Palermo, c.1146-51 (Fig. 16.3);[40] the late twelfth-century Sinai icon mentioned above (Figs. 16.1); and a double-sided fourteenth-century icon with the Hodegetria and the Annunciation from the church of the Virgin Peribleptos in Ohrid (Fig. 16.4), now in the National Museum in Belgrade (inv. no. 2316).[41] Little has been said about this container. In the case of the Sinai icon it is rarely mentioned. In the other cases, the object on the Virgin's lap is considered a basket (or more vaguely a 'container') for yarn.[42] However, in these images, the vessel shown has nothing to do with the big basket that in earlier representations of the Annunciation was often depicted next to Mary. In those cases the object shown was clearly a basket made of reed or other interwoven material, and it contained the skein and sometimes even the Virgin's spinning instruments.[43] In the middle- and late-Byzantine images discussed here, the container is much smaller and seems to be made of metal.[44] In the Sinai icon, the vessel has a rather peculiar shape, resembling a scalloped shell. In the Trikomo wall-painting and the icon from Peribleptos, the container looks like a cup.

In these four images, the object has a symbolic meaning that can be understood if we take into account its relation to the Virgin's body and the purple thread she is holding. In all four cases, the vessel rests on Mary's lap just in front of her womb. In the Martorana mosaic (Fig. 16.3) the spindle hanging from the thread which the Theotokos is holding in her right hand is shown suspended diagonally in mid-air, pointing towards the opening of the vessel that stands further to the right of the composition. In the other three images, the Virgin herself points the spindle towards the opening of the

vessel. I would suggest that we are dealing with a symbol of the virginal womb in which Christ will wear the robe of human nature without the intervention of man. The 'seedless conception' seems alluded to by the combination of Mary's gesture, pointing the spindle with the purple thread downwards into the vessel, and the descent of the Holy Ghost, pointing to the pure body of the Virgin with rays of divine light.[45] In the two icons, the rays of light fall upon the same diagonal axis with Mary's hands and the direction of her gesture (Figs 16.1, 16.4). In the Martorana mosaic (Fig. 16.3), the suspension of the spindle in the air, pointing towards the vessel, cannot be explained by physical laws, but does make sense as a manifestation of the miraculous event of the Incarnation through the grace of the Holy Ghost, shown as a dove descending upon the Virgin. The robe of human nature Christ took from his mother is indeed considered symbolic of the immaculate conception in a number of Byzantine hymns and homilies.[46]

This interpretation of the vessel finds ample support in the patristic literature of Byzantium dedicated to the Mother of God. It is a *topos* in homiletic and hymnographic texts to describe the Theotokos as a container of the incarnate Logos. Some of the most commonly used types of the Virgin are the Tabernacle which housed the sacred objects of the Jewish religion, the ark which contained the tablets of the law, the golden jar of the manna, and the golden censer of perfumed incense.[47] All these types are based on the idea of the Theotokos as container of Christ the true ark, the living law, the heavenly manna, the incense that purifies the world. In all of them, the age-old perception of the fertile female body as container of life is apparent. One of the commonest characterizations of Mary in Byzantine hymns and homilies is 'the one who in her womb contained the uncontainable'.[48] Additionally, the Theotokos is regularly called σκεύος 'vessel' or δοχεῖον 'container/receptacle' of the incarnate Logos. She is the 'receptacle of the wisdom of God',[49] 'the mortal vessel of the immortal God',[50] and 'the container… in essence of the hypostasis of the Son and God',[51] to cite three examples from many.[52] The frequency with which such expressions appear in Byzantine homilies and hymns dedicated to the Virgin, texts that were regularly read or chanted in the church, suggests that the concept of the Theotokos as vessel and container of the incarnate Logos was another well-known one. Thus it is plausible that a Byzantine viewer would recognize the object on Mary's lap in these four images as a symbol of the virginal body, the instrument of the Incarnation.

The particular way in which the vessel is shown in each of these images deserves further comment. Its golden colour in the two icons and the Martorana mosaic may be related to the precious and pure material of which the sacred vessels of the Jewish Temple, types of the Theotokos, were also made. In the Martorana mosaic, the rounded container is rendered gold on the outside and red on the inside, the same blood red of the purple thread in the

Virgin's hands. The impression is of a vessel containing a red liquid, which may be identified with the eucharistic wine, Christ's blood taken up in Mary's womb to be spilt on the cross for the salvation of the world. This may be relevant to the positioning of the scene of the Annunciation, not only in the Martorana but also in a great number of middle- and late-Byzantine monuments, in the eastern part of the church, flanking or surmounting the area of the bema, or in the bema itself, and on the two wings of the sanctuary door leading into the bema, where the eucharistic re-enactment of Christ's Incarnation and Sacrifice was regularly performed.[53] This placement emphasizes the relation of the Annunciation, the first stage in the history of the Incarnation, with Christ's mission on earth and its continuation through the mysteries of the Church. It also underlines the analogy between the descent of the Holy Ghost to transform Mary's virginal womb into the dwelling of the incarnate Logos, and the descent of the Holy Ghost to transubstantiate the bread and wine of the eucharist into Christ's flesh and blood.[54]

Writing about the Sinai and the Novgorod icons, Pentcheva observes that the combination of the image of the infant Christ and the purple thread of the Temple veil as metaphor of the cloth of human nature connects the Annunciation to the Crucifixion, the Incarnation to the Sacrifice. This is because the Byzantine viewer would recall that the Temple veil, the type of Christ's body, was torn asunder at the time of his human death on the cross.[55] A similar recollection might cross the mind of Byzantine viewers looking at the purple thread in Mary's hands. This would be especially true of Annunciation scenes depicted near the bema, where the connection between Christ's Incarnation and Sacrifice was inherent in the symbolism of the space.

In the Trikomo Annunciation,[56] and in the icon from Peribleptos, an emphatic reference to Christ's Sacrifice may be made through the shape of the vessel on the Virgin's lap, which is reminiscent of a eucharistic chalice. As the one who gave flesh and blood to the sacrificial lamb, the Theotokos is called 'cup of salvation', an obvious reference to the eucharistic chalice.[57] In Byzantine homilies and hymns, she is also compared to a krater,[58] a vessel in which wine is mixed with water (likewise the eucharistic chalice also contains wine and water). In the relevant texts this krater is said to provide bliss, rejoicing and everlasting life, or to contain the wine of salvation and remission of sins – Christ's eucharistic blood. It is evident that in these cases the Theotokos is described as the eucharistic chalice. This is clearly spelt out in the fourth homily on the Annunciation by Andrew of Crete, where the Virgin is 'the fruit from which the living bread, the Lord's body, is brought forth; and the krater of immortality, which shows forth the drink of salvation'.[59] The exaltation of Mary's role in the Incarnation through a more or less explicit reference to the mystery of the eucharist appears in a number of Byzantine

homilies on the Annunciation.[60] The commonplace descriptions in Byzantine hymnography and homiletics of the Theotokos as the holy altar/receptacle of the heavenly bread, or the golden jar of the manna have similar eucharistic connotations.[61]

On the Sinai icon, the shape of the golden vessel on Mary's lap appears more enigmatic. The object has a perfectly circular rim, inside which two groups of curved lines, the one at the lower part and the other in the rest of the vessel, are reminiscent of the undulated surface of a scalloped shell.[62] This peculiar and possibly unique iconographic element may be interpreted in the light of those poetic expressions of Byzantine homilies and hymns that describe Mary as the sea, the shell, or other receptacle bearing the 'divine' or 'heavenly' pearl, Christ. This metaphor is related to the ancient myth of Eastern origin that explains the birth of the pearl as the result of the union of fire and water when lightning penetrates a mussel. The myth was employed by St Ephrem as a symbol of the immaculate conception of Christ, whose two natures were united in one hypostasis in the virginal womb of the Theotokos.[63] The metaphor lived on in various Byzantine homilies and hymns dedicated to the Mother of God.[64]

In these texts, the theme of Mary as the pearl-bearing shell is sometimes combined with her characterization as the purple cloth of Christ's divinity.[65] Likewise, in the Sinai icon, the Virgin points her spindle with the purple thread into the golden shell-vessel, probable symbol of her womb as birthplace of the divine pearl. Despite the fact that the shell which produces the purple dye is of a very different morphology (and name) from the oyster that bears pearls, in Byzantine literature Mary is usually called simply 'shell' both as bearer of Christ the pearl and as producer of the purple dye with which the royal cloth of the incarnate Logos was coloured.[66] It is obvious that both in literature and in art, the Byzantines were not interested in the scientific precision of Mary's characterizations taken from nature, but in the potential of these characterizations to function as vivid and clearly comprehensible images of the Theotokos as instrument of the Incarnation. In the Sinai icon, the shell-like vessel on Mary's lap fulfils exactly such a function. Moreover, given that fish are shown in the aquatic landscape in the foreground of the icon, it may be possible that one meaning of this iconographic theme is the sea, as a metaphor of the world,[67] where the virginal shell conceives and delivers the divine pearl. Generally speaking, this interpretation of the vessel in the Sinai icon is in accordance with the sophisticated character of the whole painting's iconography, thriving with rare or unique motifs that seem inspired by the rich Marian literature of Byzantium.

In the four images discussed above, the most important element that makes probable the interpretation of the vessel on Mary's lap as symbol of her womb is the spindle with the purple thread pointed towards the opening of

the vessel. It is this detail that seems to make reference to the body of the Theotokos as the container of the royal purple of the flesh, the material of the Incarnation. The same detail indicates that the Byzantine audience was familiar not only with the textual but also with the pictorial function of the purple thread as symbol of the human body Christ took from his mother, and that this symbolic connotation would be attributed to the yarn held by the Virgin in Annunciation scenes, even when the vessel was not shown on her lap. Moreover, although the iconographic element of the vessel remains very rare in the surviving corpus of Byzantine art, the geographic and chronological provenance of the four works under discussion may suggest that initially this iconography was more widely known, and that it probably originated from Constantinople. The Trikomo wall-painting, the Martorana mosaics, and the Sinai icon, have been assigned to Constantinopolitan artists of the twelfth century.[68] The icon from Peribleptos has been attributed to a fourteenth-century workshop in Thessaloniki.[69] Further, with the exception of the Sinai icon for which we do not have secure evidence, the other three paintings were made for churches dedicated to the Virgin – a fitting environment for iconographic solutions emphasizing Mary's role in the Incarnation.

But to what extent would the 'average' Byzantine viewer invest with symbolic meaning iconographic details that can be also explained only as narrative elements of the composition? It is the simplicity of these images, taken from nature or from every-day life, that makes us wonder whether we should interpret them symbolically or not; but again it is their simplicity that makes them successful symbols, clearly comprehensible signs of complex theological ideas or dogmas unexplainable through logic. The exact relation of Christ's two unconfused and undivided natures united in one hypostasis, and the role of the Virgin in the miracle of the Incarnation, were the subjects of long disputes among the Fathers of the Church, gradually clarified by a number of Ecumenical Councils and patristic treatises. Such disputes were far beyond the grasp of most people. But the main dogma of Orthodox Christianity that the Logos was incarnated in Mary's womb, taking from his mother the human nature that would be sacrificed for the salvation of mankind, was an idea every Christian could recognize as a foundation of his or her faith. The comparison of the Theotokos to the receptacle of the Logos, the weaver of the human nature with which Christ would dress his divinity, the shell that through lightning and the union of fire and water would bear the heavenly pearl, and so on, were all images that both in their textual and their visual form expressed in simple terms understandable to the public the most basic aspects of the Incarnation.[70] The frequent use of such metaphors in Byzantine hymns and homilies suggests that people were familiar with them and would recognize them in their visual form as well, not simply because the images illustrated the texts, but because both illustrated their epoch.[71]

# Notes

1. I would like to thank Liz James for making valuable suggestions and correcting my English; and Patricia Skotti for her insightful comments and indispensable help in abbreviating the first version of this article. It goes without saying that responsibility for all mistakes and shortcomings lies entirely with me.

2. G. Schiller, *Ikonographie der christlichen Kunst* (Gütersloh, 1966), I, 44-47; K.D. Kalokyris, *'H Θεοτόκος είς τὴν είκονογραφίαν 'Ανατολῆς καὶ Δύσεως* (Thessaloniki, 1972), 115-16.

3. For examples see Schiller, *Ikonographie*, 45-47, figs 66, 68, 70-73, 156; *Age of Spirituality, Late Antique and Early Christian Art, Third to Seventh Century*, ed. K. Weitzmann (New York, 1979), 498-99, cat. no. 448; *Mother of God. Representations of the Virgin in Byzantium*, ed. M. Vassilaki (Athens and Milan, 2000), 269, cat. no. 5, and 290-91, cat. no. 10.

4. Kalokyris, *Θεοτόκος*, 115-16.

5. Chapter 10. Greek text ed. C. Tischendorf, *Evangelia Apocrypha* (Lipsiae, 1876), 20-21. English translation taken from *The Kariye Djami*, Bollingen Series 70, ed. P.A. Underwood (Princeton, 1975), I, 76-77 [italics are mine]. (When not mentioned otherwise, translations of Greek texts are mine. In these cases my intention is only to render the content of the translated passages with the maximum precision and minimum pretensions to literary style.)

6. Chapter 11, Tischendorf, *Apocrypha*, 22.

7. *Kariye Djami*, ed. Underwood, 94.

8. K. Weitzmann, 'Eine spätkomnenische Verkündigungsikone des Sinai und die zweite byzantinische Welle des 12. Jahrhunderts', in *Festschrift für Herbert von Einem*, eds G. von der Osten and G. Kauffmann (Berlin, 1965), 299-312, esp. 302; repr. in *Studies in the Arts at Sinai. Essays by K. Weitzmann* (Princeton, 1982), X [271-83, esp. 274]; H. Maguire, *Art and Eloquence in Byzantium* (Princeton, 1981), 49-51; H. Belting, *Likeness and Presence. A History of the Image before the Era of Art* (Chicago and London, 1994), 278; A. Weyl-Carr in *The Glory of Byzantium. Art and Culture of the Middle Byzantine Era, A.D. 843-1261*, eds H.C. Evans and W. Wixom (New York, 1997), 374, cat. no. 246.

9. Belting, *Likeness and Presence*, 278.

10. *The Glory of Byzantium*, eds Evans and Wixom, 374.

11. For a good colour photograph of this detail, see P.L. Vokotopoulos, *Ελλενική Τέχνη. Βυζαντινές Εικόνες* (Athens, 1995), fig. 50.

12. *Gosudarstvenaia Tretiakovskaia Galereia, Katalog sobrania, I-III, Drevnorusskoe iskusstvo X – nachala XV veka* (Moscow, 1995), I, 47-50, coloured photo p. 49.

13. B.V. Pentcheva, 'Rhetorical images of the Virgin: the icon of the 'usual miracle' at the Blachernai', *Res* 38 (2000), 44-45.

14. Old Testament quotations are made according to *The Septuagint with apocrypha, Greek and English*, ed. Sir L.C.L. Brenton (London, 1997); and New Testament quotations according to *Interlinear Greek-English New Testament*, ed. A. Marshall (Grand Rapids, 1976).

15. Cf. H. Kessler, 'Through the Temple Veil: The Holy Image in Judaism and Christianity', *Kairos* 32-33 (1990-91), 53-77, esp. 67f.; and 'Medieval Art as Argument', in *Iconography at the Crossroads. Papers from the Colloquium sponsored by the index of Christian Art, Princeton University, 23-24 March 1990*, ed. B. Cassidy (Princeton, 1993), 59-70. See also O. Hofius, *Der Vorhang vor dem Thron Gottes. Eine exegetisch-religiongeschichtliche Untersuchung zu Hebräer 6,19f. und 10,19f.* (Tübingen, 1972).

16. John Chrysostom, *In epistolam ad Hebraeos*, PG 63, 27, 229; *In memoriam martyrum (spuria)*, PG 52, 829-31; Kosmas Indikopelustes, *Christian Topography*, ed. W. Wolska-Conus, *Topograhpie chrétienne*, I-III (Paris, 1968-73), II, 47; John of Damascus, *Expositio fidei*, ed. B. Kotter, *Die Schriften des Johannes von Damaskos*, II (Berlin, New York, 1973), 226 (96, IV.23.61-64); Photios, *Epistulae*, eds B. Laourdas and L. Westerink, *Photii patriarchae constatninopolitani Epistulae et Amphilochia*, I-III (Leipzig, 1983-85), I, 163-64 (epistle 125:21-48), *Fragmenta in Lucam*, PG 101, 1226. Kessler, 'Art as Argument', 64-65, mentions some of the above texts.

17. Besides the texts mentioned above, see also Theodoret, *In psalmos*, PG 89, 1193AB (Psalm 44:9-10); Basil of Seleukia, *In Annuntiationem*, PG 85, 433B. See also G.W. Lampe, *A Patristic Greek Lexicon* (Oxford, 1961), 714: καταπέτασμα, 3.e; H. Papastavrou, 'Le voile, symbole de l'Incarnation. Contribution à une étude sémantique', *CahArch* 41 (1993), 41-43, esp. the texts mentioned in n.12.

18. Mansi, 13, 340D; trans. D. J. Sahas, *Icon and Logos: Sources in Eighth-Century Iconoclasm. An annotated translation of the Sixth Session of the Seventh Ecumenical Council* (Toronto, 1986), 156-57.

19. A. Grabar, 'Un fresque visigothique et l'iconographie du silence', *CahArch* 1 (1945), 125-28; repr. in *L'art de la fin de l'antiquité et du moyen age* (Paris, 1968), 583-88; compare B.A. Siegerl, *Der Vorhang der Sixtinischen Madonna. Herkunft und Beduteung eines Motivs der Marienkikonographie* (Zurich, 1977), on the iconography of the veil from Antiquity until the Renaissance; J.K. Eberlein, 'The Curtain in Raphael's Sistine Madonna', *ArtB* 65 (1983), 61-77, figs 10-11.

20. T.F. Mathews, *The Early Churches of Constantinople, Architecture and Liturgy* (University Park, London, 1971), 162-71, and R.F. Taft, *A History of the Liturgy of St John Chrysostom*, II, *The Great Entrance, A History of the Transfer of Gifts and other Pre-anaphoral Rites* (Rome, 1978), 209-10, 244-49, for the use of veils to conceal the holy gifts or the altar in the liturgy. (Cf. Germanos of Constantinople, *Ecclesiastical History*, ed. and trans. P. Meyendorff, *St Germanus of Constantinople. On the Divine Liturgy* (New York, 1984), 88-91 [§41]. He relates the *aer*, the liturgical veil covering the eucharistic bread and wine, to the Temple veil – by quoting Hebrews 10.19-21.) For the use of curtains in Byzantine imperial ceremonials see Mathews, *Early Churches*, 164. On the veils of icons, see V. Nunn, 'The Encheirion as an Adjunct to the icon in the Middle Byzantine Period', *BMGS* 10 (1986), 73-102.

21. See Pentcheva, 'Rhetorical images', 45f., with previous bibliography.

22. Cf. Pentcheva, 'Rhetorical images', 50.

23. Cf. Michael Psellos' reference to the miracle in connection to *Hebrews* (Greek text and English translation in Pentcheva, 'Rhetorical images', 46).

24. For examples see Eberlein, 'Curtain'; Papastavrou, 'Le voile'.

25. Belting, *Likeness and Presence*, 291. See also Papastavrou, 'Le voile', 156-61.

26. As, for example, a thirteenth-century icon now in the Byzantine Museum of the Holy Bishopric of Paphos: *Mother of God*, ed. Vassilaki, 350-51, cat. no. 36.

27. For representations of the Temple veil, or of images related to it, where the diapered pattern appears, see Kessler, 'Art as Argument', 63-66, figs 2, 4-8.

28. Examples by Andrew of Crete, *In nativitatem B. Mariae*, PG 877D, 879A; Theodore Stoudite, *In dormitionem Deiparae*, PG 99, 721D; Leo VI, *In B. Mariae annuntiationem*, PG 107, 25D; James of Kokkinobaphos, *In praesentationem SS. Deiparae*, PG 127, 608D. See also S. Eustratiades, *Ἡ Θεοτόκος ἐν τῇ ὑμνογραφίᾳ* (Paris, 1930), 33: καταπέτασμα.

29. See, for example, Eustratiades, *Θεοτόκος*, 71-72, σκηνή; J. Ledit, *Marie dans la liturgie de Byzance* (Paris, 1976), 77-78.

30. N. P. Constas, 'Weaving the Body of God: Proclus of Constantinople, the Theotokos, and the Loom of the Flesh', *Journal of Early Christian Studies* 3/2 (1995), 164-194.

31. See especially his *Oratio I, De laudibus S. Mariae, PG* 65, 681B, and his *Oratio IV, In natalem diem domini, PG* 65, 712C (English translation by Constas, 'Proclos', 182-83).

32. *Oration VI, De laudibus S. Mariae, PG* 65, 724A-C.

33. M. Aubineau, 'La tunique sans couture du Christ. Exégèse patristique de *Jean* 19, 23-24', in *Kyriakon. Festschrift Johannes Quasten,* I-II, eds P. Granfield and J. A. Jungmann (Münster, 1970), I, 111-16; S. Brock, 'Clothing metaphors as a means of theological expression in Syriac tradition', in *Typus, Symbol, Allegorie bei den östlichen Vätern und ihren Parallelen im Mittelalter*, ed. M. Schmidt (Regensburg, 1982); repr. in his *Studies in Syriac Christianity. History, Literature and Theology* (Aldershot, 1992), XI; Papastavrou, 'Le voile', 142; Constas, 'Proclos', 181-85 (where various aspects of the tradition of weaving and clothing metaphors in the Greco-Roman culture are also discussed).

34. For some examples, see the Akathistos Hymn, *oikos* 7 and 13 (*PG* 92, 1339C, 1341D); John Chrysostom, *In incarnationem domini (spuria), PG* 59, 695; Proklos of Contantinople, *Oratio I, De laudibus S. Mariae, PG* 65,688D, *Oratio II, De incarnatione domini, PG* 65, 708A, *Oratio IV, In natalem diem domini, PG* 65, 712A, *Oratio VI, De laudibus S. Mariae, PG* 65, 733A, 741A, 748A, 756B; Basil of Seleukia, *In SS. Deiparae annuntiationem, PG* 85, 432C, 433B, 437C, 445C; Antipatros of Bostra, *In S. Joannem Baptistam, PG* 85, 1765B, 1772C, 1776A, *In SS. Deiparae Annuntiationem, PG* 85, 1781B, 1789B, 1789C; John of Damascus, *In nativitatem B.V. Mariae II, PG* 96, 681A; Andrew of Crete, *Canon in B. Mariae nativitatem, PG* 97, 1320A, *Magnus Canon, PG* 97, 1357B; Germanos of Constantinople, *In S. Mariae zonam, PG* 98, 373C; Cosmas the Hymnographer, *Hymni, PG* 98, 493B; George of Nikomedeia, *In SS. Mariae praesentationem, PG* 100, 1416BC, 1417B; Photios of Constantinople, *On the Annunciation* (I, §7), ed. B. Laourdas, Φωτίου Ὁμιλίαι (Thessaloniki, 1959), 61:10-11, trans. C. Mango, *The Homilies of Photius, Patriarch of Constantinople* (Cambridge, MA, 1958), 121; Joseph the Hymnographer, *Mariale, PG* 105, 1005A, 1045C, 1100D-1101A, 1109CD, 1133C, 1144C, among others; Leo VI, *In B. Mariae assumptionem, PG* 107, 164A; James of Kokkinobaphos, *In conceptionem SS. Deiparae, PG* 127, 573A, *In nativitatem SS. Deiparae, PG* 127, 576C, 593CD, *In praesentationem SS. Deiparae, PG* 127, 600C-601A; Isidoros of Thessaloniki, *In dormitionem B.V. Mariae, PG* 139, 149AB. See also Eustratiades, Θεοτόκος, 22, ἔνδυμα; 30, ἱστός; 82, ὑφανασα; 85, χλαμύς.

35. *In nativitatem B. Mariae I, II, IV, PG* 97, 812B, 838B-D, 880CD; *Canon in B. Annae conceptionem, PG* 97, 1316B; *Magnus Canon, PG* 97, 1377D.

36. *In nativitatem B.V. Mariae, II, PG* 97, 693C. Other examples by: Epiphanios of Cyprus, *Oratio V, In laudes S. Mariae Deiparae, PG* 43, 496B; Photios of Constantinople, *On the Annunciation* (II, §7), and *On the Nativity of the Virgin* (§10), ed. Laourdas, Ὁμιλίαι, 81.33-82:3, 97.29-31, trans. Mango, *Homilies,* 148, 175; George of Nikomedeia, *In SS. Deiparae conceptionem, PG* 100, 1384C; Joseph the Hymnographer, *Mariale, PG* 105, 988A, 1021B; James of Kokkonibaphos, *In conceptionem SS. Deiparae, PG* 127, 545D, 584C, *In SS. Deiparae visitationem, PG* 127, 664B, 669BC. See also Eustratiades, Θεοτόκος, 3-4, ἀλουργὶς; 37, κογχύλη; 38, κόχλος; 64, πορφύρα, πορφυρίς. Ledit, *Marie,* 76-77.

37. Cf. Aubineau, 'La tunique', esp. 11-16, for the patristic exegesis on *John* 19:23-4, interpreting Christ's 'seamless robe, woven in one piece form top to bottom', as a symbol of his two undivided and unconfused natures.

38. The textual references both to the purple spun by the Virgin during the Annunciation and to the purple woven in her womb for the Incarnation leave no doubt that the thread held in her hands in images of the Annunciation is the purple (and not the scarlet material) for the Temple veil, despite the fact that it is often rendered in bright red rather than dark purplish

colour. The intense bright colour of the thread may have been used to draw attention to the object, especially against the dark purple and blue cloths of the Virgin.

39. E. Kitzinger, *The mosaics of St Mary of the Admiral in Palermo*, Dumbarton Oaks Studies 27 (Washington, DC, 1990), 174, fig. 189; A. and J. Stylianou, *The Painted Churches of Cyprus. Treasures of Byzantine Art* (London, 1985), 486-88, fig. 296.

40. Kitzinger, *St Mary*, 172-75, 307-9, plates XIV-XV, figs 98-101.

41. *Mother of God*, ed. Vassilaki, 402-405, cat. no. 61.

42. Kitzinger, *St Mary*, 174; *Mother of God*, ed. Vassilaki, 402.

43. See note 2, above, for examples.

44. In the Trikomo image the vessel is certainly not a basket, since such an object is shown on the wall behind the Theotokos.

45. For the probable inclusion of the Holy Ghost in the Trikomo Annunciation in its original state see Kitzinger, *St Mary*, 172, n.254.

46. For examples see Aubineau, 'La tunique', 112-24.

47. For examples see Ledit, *Marie*, 73-78; Eustratiades, *Θεοτόκος*, 29, *θυμιατήριον*, 35, *κιβωτός*, 71-72, *σκηνή*, 73, *στάμνος*.

48. For examples see Eustratiades, *Θεοτόκος*, 85-86, *χώρα, χωρήσασα, χωρίον*.

49. *Hymn Akathistos, oikos 17* (PG 92, 1344C).

50. Proklos of Constantinople, *Oratio VI, Laudatio Mariae*, PG 65, 745C.

51. John of Damascus, *In nativitatem B.V. Mariae*, PG 96, 672A, *Sermo in B.V. Mariae*, PG 96, 816B.

52. For more examples see: John of Euboia, *In conceptionem Deiparae*, PG 96, 1465A; George of Nikomedeia, *In SS. Mariae praesentationem*, PG 100, 1417B/D, *In SS. Deiparae ingressum in templum*, PG 100, 1444A; Joseph the Hymnographer, *Ad Hymnum Acathiston*, PG 105, 1020A, *Mariale*, PG 105, 1072A, 1117C, 1148D, 1208A, 1253D, 1348D; James of Kokkinobaphos, *In praesentationem SS. Deiparae*, PG 127, 609B, 620A; Isidoros of Thessaloniki, *In nativitatem B.V. Mariae*, PG 139, 17C, *In praesentationem B.V. Mariae*, PG 139, 44C, 57B, *In dormitionem B.V. Mariae*, PG 139, 141B, 153C, 156B.

53. I.D. Varalis, 'Παρατηρήσεις για τη θέση του Ευαγγελισμού στη μνημειακή ζωγραφική κατά τη μεσοβυζαντινή περίοδο', DChAE, 4th period, 19 (1996-97), 201-19; A. Mandas, *Το εικονογραφικό πρόγραμμα του ιερού βήματος των μεσοβυζαντινών ναών της Ελλάδας (843-1204)* (Ph.D. dissertation, University of Athens, 2001), 175-83; Schiller, *Ikonographie*, I, 48 (for the Annunciation on the sanctuary door of Byzantine churches). In the Martorana the two protagonists of the Annunciation, Mary and Gabriel, appear on the right- and left-hand spandrels of the bema arch respectively: Kitzinger, *St Mary*, 172.

54. See Mandas, *Εικονογραφικό πρόγραμμα*, 177-80.

55. Pentcheva, 'Rhetorical images', 45.

56. Mary and Gabriel are painted on the east side of the recesses in the south and north walls of the church respectively: Stylianou, *Churches of Cyprus*, 487-88.

57. Varalis, 'Παρατηρήσεις', 203, n.21.

58. Hymn Akathistos, oikos 21 (PG 92, 1345C); Andrew of Crete, *In dormitionem S. Mariae III*, PG 97, 1092D; see also Eustratiades, *Θεοτόκος*, 'κρατήρ', 38.

59. *In annuntiationem B. Mariae IV*, PG 97, 901A.

60. John of Damascus, *In annuntiationem B.V. Mariae*, PG 96, 656D-657A; Photios of Constantinople, *Homily on the Annunciation* I.7, ed. Laourdas, Ὁμιλίαι, 60.33ff., trans. Mango, *Homilies*, 121; James of Kokkinobaphos, *In annuntiationem SS. Deiparae*, PG 127, 657D.

61. See, for example, Eustratiades, Θεοτόκος, 73, 'στάμνος'; 79, 'τράπεζα'; Ledit, *Marie*, 73-4.

62. Weitzmann, 'Verkündigungsikone des Sinai', 300, describes the vessel as a 'muschelförmigen Schale' (shell-shaped bowl). For a good coloured photograph of this detail see the reference in note 10 above.

63. M. Eliade, *Images and Symbols. Studies in Religious Symbolism*, trans. P. Mairet (Princeton, 1991), 148; *Dictionnaire d'archéologie chrétienne et de liturgie*, XIV₁, 'Perle', I; *Lexikon der christlichen Ikonographie*, III, 300, 'Muschel'; 393, 'Perle'.

64. Examples by: Epiphanios of Cyprus, *Homilia V, In laudes S. Mariae Deiparae (dubia aut spuria)*, PG 43, 489A/D, 496B/C; Proklos of Constantinople, *Oratio VI, De laudibus S. Mariae*, PG 65, 753A, *Oratio V, De laudibus S. Mariae*, PG 65, 720C; Basil of Seleukeia, *In SS. Deiparae annuntiationem*, PG 85, 436A; Pseudo-Modestos of Jerusalem, *Encomium in B. Virginem*, PG 86 II, 3289C-3292A (for the false attribution of this homily to Modestos see M. Jugie, *La morte et l'assomption de la Sainte Vierge. Etude historico-doctrinal*, (Vatican City, 1944), 214-17.); Chrysipos presbyter of Jerusalem, *Oratio in sanctam Mariam Deiparam*, PO 19₃, [219:5-6]; John of Damascus, *In nativitatem B.V. Mariae, I*, PG 96, 665D-668A, 677A, *In nativitatem B. V. Mariae, II*, PG 96, 684B, *Sermo in B. V. Mariae*, PG 96, 816B; John of Euboia, *In conceptionem Deiparae*, PG 96, 1465A; Photios of Constantinople, *On the annunciation* (I, §7), ed. Laourdas, Ὁμιλίαι, 61:3-5, trans. Mango, *Homilies*, 121; Joseph the Hymnographer, *Marialae*, PG 105, 1021D; John Geometres, *Hymni in S. Deiparae*, PG 106, 857A; Leo VI, *In B. Mariae annuntiationem*, PG 107, 24D-25A, *In Christi nativitatem, I*, PG 107, 36D; Symeon Metaphrastes, *In lamentationem SS. Deiparae*, PG 114, 213D.

65. See, for example, Epiphanios of Cyprus, *Homilia V, In laudibus S. Mariae Deiparae (dubia aut spuria)*, PG 43, 496B; John of Damascus, *In nativitatme B.V. Mariae*, PG 96, 665D-668A.

66. In Greek, the shell that produces the purple dye is called 'πορφύρα' (the same word is used for the dye and for textiles coloured with it), and the oyster that bears pearls 'ὄστρειον/ὄστρεον': H.G. Liddell and R. Scott, *A Greek-English Lexicon. A New Edition Revised and Augmented throughout by Sir H. Stuart Jones* (Oxford, 1948), 1451, 1264.

67. Epiphanios of Cyprus, *Homilia V, In laudibus S. Mariae Deiparae (dubia aut spuria)*, PG 43, 489A; Pseudo-Modestos of Jerusalem, *Encomium in B. Virginem*, PG 86 II, 3289C-3292A.

68. Trikomo: D. Winfield, 'Hagios Chrysostomos, Trikomo, Asinou. Byzantine Painters at Work', Πρακτικὰ Πρώτου Διεθνοῦς Κυπρολογικοῦ Συνεδρίου (Nicosia, 1972), II, 285f.; Stylianou, *Churches of Cyprus*, 124-26, 486; Martorana: Kitzinger, *St Mary*, 242-45; Sinai: P. Vokotopoulos, *Mystery Great and Wondrous* (Athens, 2002), 114, no. 17; A. Weyl-Carr in *The Glory of Byzantium*, eds Evans and Wixom, 375.

69. *Mother of God*, ed. Vassilaki, 402.

70. Cf. Constas, 'Proclos', 193, (and n.79, referring to John Chrysostom's observation that he uses comparisons from everyday life, so that when his hearers go home, everything around them will remind them of what he said – PG 51, 358). See also Brock, 'clothing metaphors', 22; B.E. Daley, 'Late Medieval Iconography of Mary', in *Medieval Gardens* (Washington, DC, 1983), 255-78, esp. 277-78.

71. For a review of current approaches to the major issues of the relationship between texts and images and the capacity of art not only to reflect but also to constitute ideology see *Iconography at the Crossroads*, ed. B. Cassidy, (as in n.14) esp. B. Cassidy, 'Iconography, Texts, and Audience', 3-16, and M.A. Holly, 'Unwriting Iconology', 17-26.

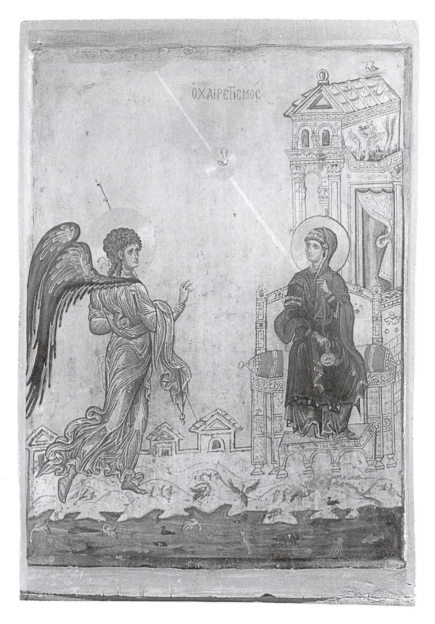

16.1 Icon of the Annunciation, late 12th century. St Catherine's monastery, Mt Sinai
(courtesy of the Byzantine and Christian Museum, Athens, Greece).

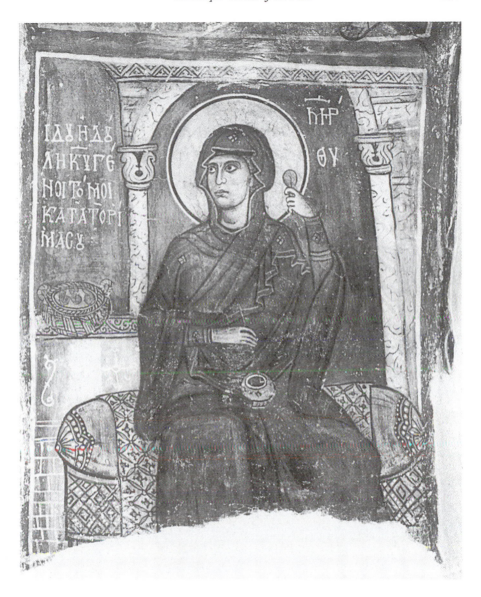

16.2 Wall-painting of the Virgin Mary from the Annunciation, early 12th century. Church of the Virgin, Trikomo, Cyprus (after E. Kitzinger, *The Mosaics of St Mary of the Admiral in Palermo*, Dumbarton Oaks Studies 27 (Washington, DC, 1990), fig. 189).

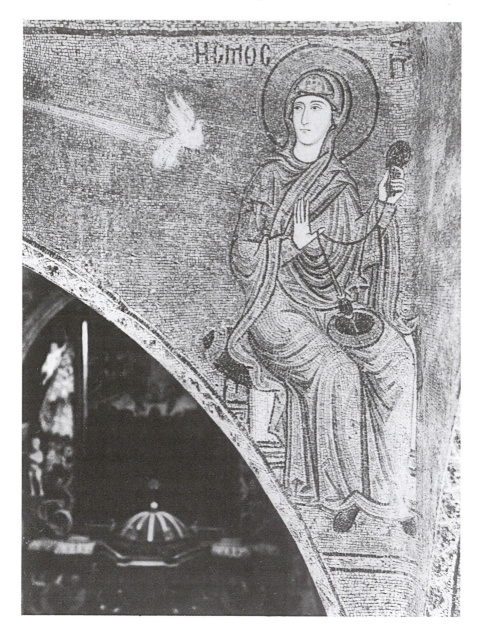

16.3 Mosaic of the Virgin Mary from the Annunciation, c.1146-51. Church of St Mary of the Admiral (Martorana), Palermo, Sicily (after E. Kitzinger, *The Mosaics of St Mary of the Admiral in Palermo*, Dumbarton Oaks Studies 27 (Washington, DC, 1990), fig. 99).

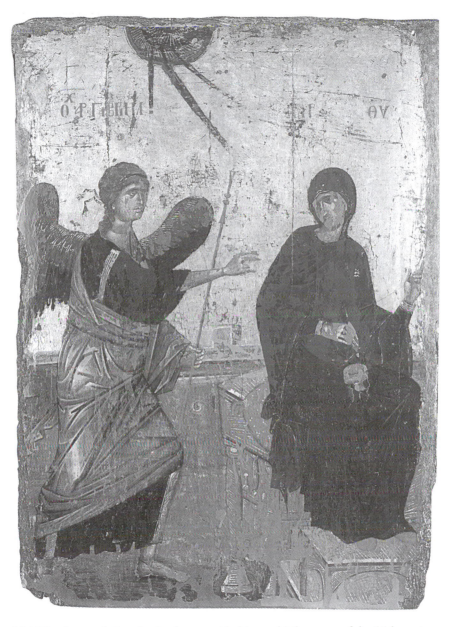

16.4 The Annunciation, back of a two-sided icon, third quarter of the 14th century.
From the church of the Virgin Peribleptos, Ohrid, now at the National Museum,
Belgrade (courtesy of the museum).

# Select Bibliography

Acres, A., 'The Columba Altarpiece and the Time of the World', *ArtB* 80 (1998), 422-51

Alpers, S., *Rembrandt's Enterprise* (London, 1988)

Amato, P., *De Vera Effigie Mariae: Antiche Icone Romane* (Rome, 1988)

Andaloro, M., 'I mosaici parietali di Durazzo o dell'origine costantinopolitana del tema iconografica di Maria Regina', in *Studien zur spätantiken und byzantinischen Kunst*, eds O. Feld and U. Peschlow (Bonn, 1986), III, 103-112

-- 'S. Susanna. Gli affreschi frammentati', in *Roma dall'Antichità al Medioevo: Archeologia e Storia*, eds M. Arena et al. (Milan, 2001), 643-645

-- 'La datazione della tavola di S. Maria in Trastevere', *Rivista dell'Istituto Nazionale d'Archeologia e Storia dell'Arte* 19-20 (1972-73), 139-215

-- 'Le icone a Roma in età preiconoclasta', *Roma fra Oriente e Occidente*, Settimane di Studio del Centro Italiano di Studi sull'Alto Medioevo XLIX (Spoleto, 2002), 719-753

Anderson, J.C., 'The Byzantine portrait panel before and after Iconoclasm', in *The sacred image east and west*, eds R. Ousterhout and L. Brubaker (Urbana and Chicago, 1995), 25-44

Andrieu, M., *Les 'Ordines Romani' du Haut Moyen Ages. II: Les Textes (Ordines I-XIII)* (Louvain, 1971)

Anton, J., 'The Aristotelian Doctrine of Homonyma in the *Categories* and its Platonic Antecedents', *Journal of the History of Philosophy* 6 (1968), 315-326

-- 'Ancient Interpretations of Aristotle's Doctrine of Homonyma', *Journal of the History of Philosophy* 7 (1969), 1-18

Apter E. and W. Pietz, eds, *Fetishism as Cultural Discourse*, (Ithaca, 1993)

Arena, M., et al., eds, *Roma dall'Antichità al Medioevo: Archeologia e Storia*, (Milan, 2001)

St Artemios, *The Miracles of St Artemios*, ed. and trans. V.S. Crisafulli and J.W. Nesbitt (Leiden, 1997)

Atalla, N.S., *Coptic Art:Wall-paintings/ l'Art Copte: Peintures Murales*, (Cairo, n.d)

Athanasios, *Oratorio contra Arianos, PG* 26; Mansi 13; trans. A. Robertson, *Select Library of Nicene and Post-Nicene Fathers*: 2nd series, IV (London, 1896)

Attavanti, P., *Dialogus de origine Ordinis Servorum ad Petrum Cosmae* published in *Monumenta Ordinis Servorum sanctae Mariae* 11 (1910), 88-113

Aubineau, M., 'La tunique sans couture du Christ. Exégèse patristique de *Jean* 19,23-24', in *Kyriakon. Festschrift Johannes Quasten*, eds P. Granfield and J. A. Jungmann (Münster, 1970), I, 111-16

Augenti, A., 'Continuity and Discontinuity of a Seat of Power: the Palatine Hill from the Fifth to the Tenth Century', in *Early Medieval Rome and the Christian West: Essays in Honour of Donald A. Bullough*, ed. J. Smith (Leiden, 2000), 43-53

Bacci, M., *Il pennello dell'Evangelista. Storia delle immagini sacre attribuite a san Luca* (Pisa, 1998)

--   'The Berardegna Antependium and the *Passio Ymaginis* Office', *JWCI* 61(1998), 1-16

Barber, C., 'From Transformation to Desire: Art and Worship after Byzantine Iconoclasm', *ArtB* 75/1 (1993), 7-16

--   'The truth in painting: Iconoclasm and identity in early medieval art', *Speculum* 72 (1997), 1019-1036

--   'Early representations of the Mother of God', in *Mother of God*, ed. Vassilaki, 252-261

--   *Figure and Likeness: On the Limits of Representation in Byzantine Iconoclasm* (Princeton, 2002)

St Basil, *De Spiritu sancto Sur le Saint-esprit*, SC 17, ed. and trans. B. Pruche (Paris, 1968) and *Nicene and Post-Nicene Fathers*, trans. P. Schaff and H. Wace (Grand Rapids, 1955), VIII

Beani, G., *S. Maria delle Grazie volgarmente del Letto. Notizie storiche* (Prato, 1892)

Beckwith, J., '"Mother of God Showing the Way": a Byzantine ivory statuette of the Theotokos Hodegetria', *Connoisseur* CL (1962), 2-7

Belluzzi, A., *Giuliano da Sangallo e la chiesa della Madonna dell'Umiltà a Pistoia* (Florence, 1993)

Belting, H., 'Papal artistic commissions as definitions of the medieval church in Rome', *Light on the Eternal City: Observations and Discoveries in the Art and Architecture of Rome*, ed. H. Hager and S.S. Munshower, Papers in Art History from the Pennsylvania State University II (University Park, PA, 1987), 13-29

--   *Bild und Kult – Eine Geschichte des Bildes vor dem Zeitalter der Kunst* (Munich, 1990), trans. by E. Jephcott as *Likeness and Presence. A history of the image before the era of art* (Chicago, 1994)

--   and C. Kruse, *Die Erfindung des Gemäldes: Das erste Jahrhundert der niederländischen Malerei* (Munich, 1994)

Bertelli, C., *La Madonna di S Maria in Trastevere* (Rome, 1961)

--   *Gli affreschi nella torre di Torba* (Milan, 1988)

Bilinkoff, J., 'Elite widows and religious expression in early modern Spain: the view from Avila', in *Widowhood*, eds Cavallo and Warner, 181-92

Bisconti, F., 'La Madonna di Priscilla: interventi di restauro ed ipotesi sulla dinamica decorativa', *Rivista di Archeologia Cristiana* 72 (1996), 7-34

de Blaauw, S., *Cultus et Decor. Liturgia e architettura nella Roma tardoantica e medievale* (Vatican, 1994)

Blumenthal, H.J., *Aristotle and neoplatonism in Late Antiquity* (New York, 1996)

Bolman, E.S. ed., with photography by P. Godeau, *Monastic Visions: Wall Paintings in the Monastery of St. Antony at the Red Sea* (New Haven and London, 2002)

Bourdara, C.A., 'Quelques cas de *damnatio memoriae* à l'époque de la dynastie macédonienne', *JÖB* 32/2 (1982), 337-42

Brandt, M., and A. Effenberger, eds, *Byzanz. Die Macht der Bilder* (Hildesheim, 1998)

Brenk, B., *Die frühchristlichen Mosaiken in S. Maria Maggiore zu Rom* (Wiesbaden, 1975)

Brock, S., 'Clothing metaphors as a means of theological expression in Syriac tradition', in *Typus, Symbol, Allegorie bei den östlichen Vätern und ihren Parallelen im Mittelalter*, ed. M. Schmidt (Regensburg, 1982)

Brubaker, L., 'Conclusion: Image, audience and place: interaction and reproduction', in *The sacred image east and west*, eds R. Ousterhout and L. Brubaker (Urbana and Chicago, 1995), 204-220

--   'Icons before Iconoclasm?', *Morfologie sociali e culturali in europa fra tarda antichità e alto medioevo*, Settimane di Studio del Centro Italiano di Studi sull'Alto Medioevo 45 (1998), 1215-54

--   *Vision and Meaning. Image as Exegesis in the Homilies of Gregory of Nazianzos* (Cambridge, 1999)

--   and J. Haldon, *Byzantium in the Iconoclast Era (ca 680-850): The Sources* (Aldershot, 2001)

Buckton, D. ed., *Byzantium: Treasures of Byzantine Art from British Collections* (London, 1994)

Caillet, J.-P., *L'antiquité classique, le haut moyen âge et Byzance au musée de Cluny* (Paris, 1985)

Cameron, A.M., 'The Theotokos in sixth-century Constantinople', *Journal of Theological Studies* N.S. 29 (1978), 79-108

-- 'The Early Cult of the Virgin', in *Mother of God*, ed. Vassilaki, 3-15

Campbell, L., 'The Making of Early Netherlandish Portraits' in *The Image of the Individual: Portraits in the Renaissance*, eds N. Mann and L. Syson (London, 1998), 105-112

*Capitoli della compagnia della Madonna dell'Impruneta scritti nel buon secolo della lingua e citati dagli Accademici della Crusca*, a cura di C. G[uasti] (Florence, 1866)

Casotti, Giovanni Battista, *Memorie istoriche della miraculosa Imagine di Maria Vergine dell'Impruneta* (Florence, 1714)

Catlin, G., *Illustrations of the Manners, Customs, and Condition of the North American Indians, with Letters and Notes Written during Eight Years of Travel and Adventure among the Wildest and Most Remarkable Tribes Now Existing* (London, 1857)

Cavallo, G., *I Bizantini in Italia* (Milan, 1982)

Cavallo, S., and L. Warner, eds, *Widowhood in Medieval and Early Modern Europe* (Harlow, 1999)

Cecchelli, M., 'Dati da scavi recenti di monumenti cristiani. Sintesi relativa a diverse indagini in corso', *Mélanges de l'École Française de Rome: Moyen Âge* 111 (1999), 227-251

Chatzidakis, M., 'An Encaustic Icon of Christ at Sinai', *ArtB* 49/3 (1967), 197-208

Chatzidakis, M., ed., *Hosios Loukas: Mosaics and Wallpaintings* (Athens, 1997)

Niketas Choniates, *Historia*, ed. J.L. van Dieten, (Berlin, 1975), 151, 558; trans. H. Magoulias, *O City of Byzantium, the Annals of Niketas Choniates* (Detroit, 1984)

Cigaar, K.N., 'Une description de Constantinople traduite par un pèlerin anglais', *REB* 34 (1976), 211-267

-- 'Une description de Constantinople dans le *Tarragonensis* 55', *REB* 53 (1995), 117-140

Robert de Clari, *The Conquest of Constantinople*, trans. E.H. McNeal (Columbia, 1936)

Clark, K.W, *A Descriptive Catalogue of Greek New Testament Manuscripts in America*, (Chicago, 1937)

Coleman, S., and J. Elsner, 'The Pilgrim's Progress: Art, Architecture and Ritual Movement at Sinai', *World Archaeology* 26 (1994), 73-89

Comblen-Sonkes, M., and P. Lorentz, *Corpus de la Peinture des Anciens Pays-Bas Méridionaux et de la Principauté de Liège au Quinzième Siècle*, 17, *Musée du Louvre, Paris* II (Brussels, 1995)

Connor, C., *The Color of Ivory* (Princeton, 1998)

Constas, N.P., 'Weaving the Body of God: Proclus of Constantinople, the Theotokos, and the Loom of the Flesh', *Journal of Early Christian Studies* 3/2 (1995), 164-194

Coquin, C., *Les Édifices Chrétiennes du Vieux-Caire* Vol.1 *Bibliographie et Topographie Historiques*, Institut Français d'Archéologie Orientale de Caire, Bibliothèques d'Études Coptes, tom. XI (Cairo, 1974)

Cormack, R., 'The Mosaic Decoration of S. Demetrios, Thessaloniki: A Re-examination in the Light of the Drawings of W.S. George', *Annual of the British School of Archaeology at Athens* 64 (1969), 17-52

-- 'The Arts during the Age of Iconoclasm', in *Iconoclasm*, eds J. Herrin and A. Bryer (Birmingham, 1977), 35-44

-- 'Interpreting the Mosaics of S. Sophia at Istanbul', *ArtH* 4/2 (1981), 131-150

-- *The Church of St. Demetrios: The Watercolours and Drawings of W. S. George* (Thessaloniki, 1985)

-- *Writing in Gold. Byzantine Society and its Icons* (London, 1985)

-- '"New Art History" vs. "Old History": Writing art history,' *BMGS* 10 (1986), 223-31

-- 'Patronage and New Programs of Byzantine Iconography' in *Seventeenth International Byzantine Studies Conference: major Papers (Washington, D.C., August, 1986)* (New Rochelle, 1987), 609-638

-- *The Byzantine Eye: Studies in Art and Patronage* (London, 1989)

-- 'The Icon of the Triumph of Orthodoxy' in *Byzantium: Treasures of Byzantine Art from British Collections*, ed. D. Buckton (London, 1994), 62-3

-- 'The Emperor at Hagia Sophia: Viewer and Viewed', in *Byzance et les images*, ed. A. Guillou (Paris, 1994), 223-54

-- *Painting the Soul: Icons, Death Masks, and Shrouds* (London, 1997)

-- *Byzantine Art* (Oxford, 2000)

-- 'The Mother of God in Apse Mosaics', in *Mother of God*, ed. Vassilaki, 91-106

Flavius Cresconius Corippus, *In laudem Justini Augusti minoris*, ed. and trans. A. Cameron (London, 1976)

Cramer, M., *Koptische Buchmalerei: Illuminationem in Manuskripten des christlich-koptischen Ägypten vom 4. bis 19. Jahrhundert* (Recklinghausen, 1964)

Crum, W.E., *Catalogue of the Coptic Manuscripts in the British Museum* (London, 1905)

Curzon, R., *Visits to the Monasteries of the Levant* presented by J. Hogg (New York-Salzburg, 1995)

Cutler, A., 'The Psalter of Basil II', *Arte Veneta* 30 (1976), 9-19 and 31 (1977), 9-15

-- *The Hand of the Master, Craftsmanship, Ivory and Society in Byzantium (9th-11th centuries)* (Princeton, 1994)

-- 'A Byzantine Triptych in Medieval Germany and Its Modern Recovery', *Gesta* 37/1 (1998), 3-12

Dagron, G., *Constantinople imaginaire* (Paris, 1984)

-- 'Holy Images and Likeness', *DOP* 45 (1991), 23-33

-- *Empereur et prêtre: étude sur la 'césaropapisme' byzantin* (Paris, 1996)

Daley, B.E., 'Late Medieval Iconography of Mary', in *Medieval Gardens* (Washington, DC, 1983), 255-78

David, J., 'L'église Sainte-Marie-Antique dans son état originaire. Étude liturgique et hagiographique suivie d'un catalogue raisonné des saints de cette église', in W. de Grüneisen, *Sainte Marie Antique*, 449-559

Davies, P., 'Studies in the Quattrocento centrally planned church' (unpublished Ph.D. thesis, University of London, 1992)

Davis-Weyer, C., *Early Medieval Art 300-1150* (Toronto, 1986)

Deckers, J., G. Mietke and A. Weiland, *Der Katakombe 'Commodilla': Repertorium der Malereien*, IV (Vatican, 1994)

*Decrees of the Ecumenical Councils* vol. 1, *Nicaea I to Lateran V*, ed. N.P. Tanner (London and Washington, DC, 1990) and *Acts of the Seventh Ecumenical Council*, D. Sahas, *Icon and Logos: Sources in Eighth Century Iconoclasm* (Toronto and London, 1986)

St Demetrios, *Les plus anciens receuils des miracles de Saint Démétrios*, I *Texte*. II *Commentaire*, ed. and trans. P. Lemerle (Paris, 1979-81)

Depuydt, L., *Catalogue of Coptic Manuscripts in the Pierpont Morgan Library* (Louvain, 1993)

Der Nersessian, S., *L'Art Arménien* (Paris, 1977)

Deshman, R., 'Servants of the Mother of God in Byzantine and medieval art', *Word & Image* 5 (1989), 33-70

Dhanens, E., *Rogier van der Weyden. Revisie van de documenten* (Brussels, 1995)

*Dictionnaire d'Archéologie chrétienne et de Liturgie*, eds F. Cabrol and H. Leclercq, 15 vols (Paris, 1907-57)

Didi-Huberman, G., 'The Portrait, the Individual and the Singular: Remarks on the Legacy of Aby Warburg', in *The Image of the Individual*, eds Mann and Syson, 165-88

Diehl, C., 'L'Évangéliaire de l'impératrice Cathérine Comnène', *Comptes rendus des séances de l'Académie des Inscriptions et Belles-lettres*, (1922) 243-48

-- 'Monuments inédits du onzième siècle', *Art Sudies* 5 (1927), 3-9

Diehl, C., M. Le Tourneau, and H. Saladin, *Les monuments chrétiens de Salonique*, 2 vols. (Paris, 1918)

van Dijk, A., *The Oratory of Pope John VII (705-707) in Old St Peter's* (Ph.D. dissertation, The Johns Hopkins University, Baltimore, 1995)

von Dobschütz, E., *Christusbilder. Untersuchungen zur christlichen Legende* (Leipzig, 1899)

Duchesne, M., *Christian Worship: Its Origin and Evolution* (London, 1903, 1923 ed.)

Durand, J., ed., *Byzance: L'art byzantin dans les collections publiques françaises*, (Paris, 1992)

Durkheim, E., *The Elementary Forms of Religious Life*, trans. C. Cosman (1912; New York, 2001)

Eade, J., and S. Sallnow, eds, *Contesting the Sacred: The Anthropology of Christian Pilgrimage*, (London, 1991)

Easterling, P., 'Library Hand-List of the Additional Greek Manuscripts in the University Library, Cambridge', *Scriptorium* 16 (1962), 302-23

Eberlein, J.K., 'The Curtain in Raphael's Sistine Madonna', *ArtB* 65 (1983), 61-77

Effenberger, A., et al., *Museum für Spätantike und Byzantinische Kunst* (Mainz, 1992)

-- 'Byzantinische Kunstwerke im Besitz deutscher Kaiser, Bischöfe und Klöster im Zeitalter der Ottonen', in *Bernward von Hildesheim und das Zeitalter der Ottonen*, eds M. Brandt and A. Eggebrecht (Hildesheim, 1993), Vol.1, 145-59

Eire, C.M.N., *The War Against the Idols: The Reformation of Worship from Erasmus to Calvin* (Cambridge and New York, 1986)

Eisler, C., *Les Primitifs Flamands. I. Corpus de la Peinture des Anciens Pays-Bas Méridionaux au Quinzième Siècle* 4: *New England Museums* (Brussels, 1961)

Eliade, M., *Images and Symbols. Studies in Religious Symbolism*, trans. P. Mairet (Princeton, 991)

Epiphanios of Salamis, *Letter to the emperor Theodosios*, in *Studien zur Geschichte des byzantinisches Bilderstreites*, ed. G. Ostrogorsky (Breslau, 1929)

van Esbroeck, M., 'Michael, the Archangel, Saint', in *The Coptic Encyclopedia* 5, ed. A.S. Atiya (New York, Toronto, Oxford), 1618

Etinhof, O., 'I mosaici di Roma nella raccolta di P. Sevastjanov', *Bollettino d'Arte* 66 (March-April 1991), 29-38

Ettinghausen, R., 'The Dance with Zoomorphic Masks and other Forms of Entertainment seen in Islamic Art', in *Arabic and Islamic Studies in Honor of Hamilton A.R. Gibb* , ed. G. Makdisi (Cambridge, 1965), 211-224

St Euphemia, 'Légende de la sainte Euphémie', published by E. Amélineau, *Contes et Romans de L'Egypte Chrétienne*, ed. and trans. into Italian by A. Campagnano, in A. Campagnano, A. Maresca and T. Orlandi, *Quattro Omelie Copte*, Testi e documenti per lo studio dell'antichità serie copta 60 (Milan, 1977)

Evans, H.C., and W.D. Wixon, eds, *The Glory of Byzantium. Art and culture of the Middle Byzantine Era AD 843-1261* (New York, 1997)

*Exposition internationale d'art byzantin*, Musée des arts décoratifs (Paris, 1931)

Fassler, M., 'Mary's Nativity, Fulbert of Chartres, and the *Stirps Jesse*: liturgical innovation circa 1000 and its Afterlife', *Speculum* 75 (2000), 389-434

Filippini, A., *The eleventh-century frescoes of Clement and other saints in the Basilica of San Clemente in Rome* (Ph.D. dissertation, The Johns Hopkins University, Baltimore, 1999)

Frank, G., *The memory of the eyes* (Berkeley, 2000)

Franzoni, C., ed., *La Basilica di San Vitale a Ravenna* (Modena, 1997)

Frazer, J.G., *Totemism and Exogamy: A Treatise on Certain Early Forms of Superstition and Society*, 4 vols. (London, 1910)

Freud, S., 'Fetishism', in *Works*, ed. J. Strachey (London, 1953-1974), vol. 21

-- *Totem and Taboo: Resemblances between the Psychic Lives of Savages and Neurotics*, trans. A.A. Brill (1913; Amherst NY, 1999)

Friedländer, M.J., *Early Netherlandish Painting* (Leiden, 1967)

Friend, A.M., 'The Portraits of the Evangelists in Greek and Latin Manuscripts', *Art Studies* 5 (1927) 115-49

Gage, J., *Colour and Culture* (London, 1993)

Galavaris, G.P., 'The Mother of God "Stabbed with a knife"', *DOP* 13 (1959), 229-33

Gavrilović, Z.A., 'The Humiliation of Leo VI the Wise', *CahArch* 28 (1979), 87-94

Geertz, C., 'Religion as a cultural system', in *Anthropological Approaches to the Study of Religion: Conference on New Approaches in Social Anthropology, 1963*, ed. M. Banton (London, 1966), 1-46

van Gennep, A., *Les rites de passage* (Paris, 1909)

St George, *Miracula S. Georgii*, ed. J.B. Aufhauser (Leipzig, 1913)

Germanos of Constantinople, *Ecclesiastical History*, ed. and trans. P. Meyendorff, *St Germanus of Constantinople. On the Divine Liturgy*, (New York, 1984)

Gero, S., 'The Eucharistic Doctrine of the Byzantine Iconoclasts and Its Sources', *BZ* 68 (1975), 4-22

Giovammini, L., ed., *Arts de Cappadocia* (Geneva, 1971)

von Goethe, J.W., *Italian Journey (1786-1788)*, trans. W. H. Auden and E. Mayer (San Francisco, 1982)

Goldschmidt, A., and K. Weitzmann, *Die byzantinischen Elfenbeinskulpturen des X. – XIII. Jahrhunderts*. 2 vols (Berlin, 1934)

*Gosudarstvenaja Tretiakovskaja Galereja, Katalog sobraniia, I-III, Drevnorusskoe iskusstvo X – nachala XV veka* (Moscow, 1995)

Grabar, A., *L'empereur dans l'art byzantin* (Paris, 1936)

-- 'Un fresque visigothique et l'iconographie du silence', *CahArch* 1 (1945), 125-28

-- *Martyrium: recherches sur le culte des reliques et l'art chrétien*, 2 vols (Paris, 1946)

-- *L'iconoclasme byzantin: dossier archéologique* (Paris: 1957)

-- 'Notes sur les mosaïques de Saint-Démétrios à Salonique', *Byz* 48 (1978), 67-71

Graf, G., *Geschichte der Christlichen Arabischen Literatur*, Studi e Testi 118 (Vatican, 1944)

Gray, N., 'The paleography of Latin inscriptions in the eighth, ninth and tenth centuries in Italy', *Papers of the British School at Rome* 16 (1948), 38-162

Grimme, E. G., *Das Evangeliar Kaiser Otto III. im Domschatz zu Aachen* (Freiburg, 1984)

de Grüneisen, W., *Sainte Marie Antique* (Rome, 1911)

Guidobaldi, F., 'Gli scavi del 1993-95 nella basilica di S. Clemente a Roma e la scoperta del battistero paleocristiano. Nota preliminare', *Rivista di Archeologia Cristiana* 73 (1997), 459-491

Halbertal, M., and A. Margalit, *Idolatry*, trans. N. Goldblum (Cambridge, MA, 1992)

Halkin, F., 'Sainte Elisabeth d'Héraclée, abesse à Constantinople', *Analecta Bollandiana* 91 (1973), 249-264

Harbison, C., 'Visions and meditations in early Flemish painting', *Simiolus* 15 (1985), 87-118

Harflinger, B., *Die Wiedergeburt der Antike und die Auffindung Amerikas* (Hamburg, 1992)

Hawkins, E.J.W., 'Further Observations on the Narthex Mosaic in St. Sophia at Istanbul', *DOP* 22 (1968), 151-168

Hearn, M.F., *Romanesque Sculpture: The Revival of Monumental Stone Sculpture in the Eleventh and Twelfth Centuries* (Ithaca, NY, 1981)

Heiberg, J.L., 'Eine neue Archimedeshandschrift', *Hermes* 42 (1907), 235-303

-- *Archimedis opera omnia cum commentariis Eutochii* 2nd ed., 3 vols (Leipzig, 1910-15)

Hennessy, C., 'Imagery of Children in Byzantium' (unpublished Ph.D. thesis, Courtauld Institute of Art, University of London, 2001)

Hill, B., L. James, D.C. Smythe, 'Zoe: the rhythm method of imperial renewal', in *New Constantines. The Rhythm of Imperial Renewal in Byzantium*, ed. P. Magdalino, SPBS 2 (Aldershot, 1994), 223-25

Hoeniger, C., *The Renovation of Paintings in Tuscany, 1250-1500* (Cambridge, 1995)

Hoffmann, H., *Buchkunst und Königtum im ottonischen und frühsalischen Reich*, MGH 30/1 (Hanover, 1995)

Hofius, O., *Der Vorhang vor dem Thron Gottes. Eine exegetisch-religiongeschichtliche Untersuchung zu Hebräer 6,19f. und 10,19f.* (Tübingen, 1972)

-- *Bamberger Handschriften des 10. und des 11. Jahrhunderts*, MGH 39 (Hanover, 1995)

*Holy Women of Byzantium: Ten Saints' Lives in English Translation* ed. A. M. Talbot (Washington, DC, 1996)

Horner, S., *The Emperor's New Pose? Re-Reading the Narthex Mosaic at Hagia Sophia as a Liminal Image in Liminal Space* (unpublished MA thesis, Courtauld Institute of Art, University of London, 1994)

Huizinga, J., *The Autumn of the Middle Ages*, trans. R. J. Payton and U. Mammitzsch (Chicago, 1996)

Hunt, L.-A , 'Christian-Muslim Relations in Painting in Egypt of the Twelfth to mid-Thirteenth Centuries: Sources of Wallpainting at Deir es-Suriani and the illustration of the New Testament MS Paris, Copte-Arabe 1/Cairo Bibl. 94' *CahArch* 33 (1985), 111-155 reprinted in L.-A. Hunt, *Byzantium, Eastern Christendom and Islam: Art at the Crossroads of the Medieval Mediterranean* I (1998), 205-281

-- 'A Woman's Prayer to St. Sergios in Latin Syria: Interepreting a Thirteenth-Century Icon at Mount Sinai', *Byzantine and Modern Greek Studies* 15 (1991), 96-145, reprinted in L.-A. Hunt, *Byzantium, Eastern Christendom and Islam: Art at the Crossroads of the Medieval Mediterranean* II (London, 2000), 78-126

Ignatios the Deacon, *The Life of the Patriarch Tarasios (BHG 1698)*, ed. and trans. S. Efthymiadis, Birmingham Byzantine and Ottoman Monographs 4 (Aldershot, 1998)

*In August Company: The Collections of the Pierpont Morgan Library* (New York, 1993)

Jäggi, C., 'Graffiti as a Medium for Memoria in the Early and High Middle Ages', *Memory & Oblivion: Proceedings of the XXIXth International Congress of the History of Art*, eds W. Reinink and J. Stumpel (Dordrecht, 1999), 745-751

James, L. and R. Webb, '"To understand Ultimate Things and Enter Secret Places": Ekphrasis and Art in Byzantium', *ArtH* 14 (1991), 1-17

James, L., *Light and Colour in Byzantine Art* (Oxford, 1996).

-- '"Pray Not to Fall into Temptation and Be on Your Guard": Pagan Statues in Christian Constantinople', *Gesta* 35/1 (1996), 12-20

-- *Empresses and Power in Early Byzantium* (London, 2001)

Janes, D., *God and Gold* (Cambridge, 1998)

John of Damascus, *Die Schriften des Johannes von Damaskos*, ed. B. Kotter (Berlin, New York, 1973)

Jolivet-Lévy, C., *Les églises byzantines de Cappadoce* (Paris, 1991)

Justin Martyr, *II Apology*, PG 6, 453, trans. A. Roberts and J. Donaldson, *The Apostolic Fathers with Justin Martyr and Irenaeus* (New York, 1926)

Kahsnitz, R., 'Byzantinische Kunst in mittelalterlichen Kirchenschätzen: Franken, Schwaben und Altbayern', in *Rom und Byzanz. Schatzkammerstücke aus bayerischen Sammlungen*, ed. R. Baumstark (Munich, 1998), 47-69

Kalavrezou-Maxeiner, I, 'The Portraits of Basil I in Paris gr.510', *JÖB* 27 (1978), 19-24

-- 'The Cup of San Marco and the 'Classical' in Byzantium', in *Studien zur mittelalterlichen kunst 800-1250: Festschrift für Florentine Mütherich zum 70. Geburtstag*, eds K. Bierbauer, P.K. Klein, and W. Sauerländer (Munich, 1985), 167-174

-- 'Images of the Mother: When the Virgin Mary Became Meter Theou', *DOP* 44 (1990), 165-172

Kalokyris, K.D., *Ἡ Θεοτόκος εἰς τὴν εἰκονογραφίαν Ἀνατολῆς καὶ Δύσεως* (Thessaloniki, 1972)

Kann, A., 'Rogier's *St. Luke*: Portrait of the Artist or Portrait of the Historian?' in *St Luke Drawing the Virgin*, ed. Purtle, 15-22

Kantorowicz, E., *The King's Two Bodies: a study in medieval political theology* (Princeton, 1957)

Kazhdan, A., and A. Wharton, eds, *Change in Byzantine Culture in the Eleventh and Twelfth Centuries* (Berkeley, 1985)

-- and H. Maguire, 'Byzantine Hagiographical Texts as Sources on Art', *DOP* 45 (1991), 1-22

Kartsonis, A., *Anastasis: the Making of an Image* (Princeton, 1986)

-- 'The Emancipation of the Crucifixion', in *Byzance et les images*, ed. A. Guillou (Paris, 1994), 151-188

Kaufmann, C.M., 'Ein spätkoptisches bemaltes Grabtuch aus Antinoupolis in Oberägypten', *Oriens Christianus* N.S. 7-8 (1918), 128-32

Kessler, H.L., 'Through the Temple Veil: The Holy Image in Judaism and Christianity', *Kairos* 32-33 (1990-91), 53-77

-- 'Medieval Art as Argument', in *Iconography at the Crossroads. Papers from the Colloquium sponsored by the index of Christian Art, Princeton University, 23-24 March 1990*, ed. B. Cassidy (Princeton, 1993), 59-70

-- and G. Wolf, eds, *The Holy Face and the Paradox of Representation*, Villa Spelman Colloquia 6 (Bologna, 1998)

-- and J. Zacharias, *Rome 1300. On the path of the pilgrim* (New Haven, London, 2000)

Kitzinger, E., 'The Cult of Images in the age before Iconoclasm', *DOP* 8 (1954), 83-150 and repr. in *The Art of Byzantium and the Medieval West: Selected Studies*, ed. E. Kleinbauer (Bloomington, 1976), 90-150

-- *The mosaics of St Mary of the Admiral in Palermo*, Dumbarton Oaks Studies 27 (Washington DC, 1990)

Klauser, T., 'Rom und der Kult des Gottesmutter Maria', *Jahrbuch für Antike und Christentum* 15

(1972), 120-135

Klein, D., *St Lukas als Maler der Maria. Ikonographie der Lukas-Madonna* (Berlin, 1933)

Klein, H., 'Aspekte der Byzanz-Rezeption im Abendland', in *Byzanz*, ed. Brandt and Effenberger, 122-53

Koehler, W., 'Byzantine Art and the West', *DOP* 1 (1940 [publ. 1941]), 61-87

Koerner, J. L., *The Moment of Self-Portraiture in German Renaissance Art* (Chicago, 1993)

Kosmas Indikopelustes, *Christian Topography*, ed. W. Wolska-Conus, *Topograhpie chrétienne*, I-III (Paris, 1968-73)

Krautheimer, R., *Early Christian and Byzantine Architecture* (Harmondsworth, 1965)

Laiou, A.E., *Mariage, amour et parenté à Byzance aux XIe-XIIIe siècles* (Paris, 1992)

Lampe, G.H.W., *A Patristic Greek Lexicon* (Oxford, 1961)

Lange, G., *Bild und Wort: Die katechetischen Funktionen des Bildes in der griechischen Theologie des sechsten bis neunten Jahrhunderts* (Paderborn, 1999)

Lange, R., *Die byzantinische Reliefikone* (Recklinghausen, 1964)

Latour, B., 'A Few Steps Toward an Anthropology of the Iconoclastic Gesture', *Science in Context* 10/1 (Spring, 1997), 63-83

Lawrence, M., 'Maria Regina', *ArtB* 7 (1924-25), 150-161

Layton, B. *Catalogue of Coptic Literary Manuscripts in the British Library acquired since the year* 1906 (London, 1987)

Ledit, J., *Marie dans la liturgie de Byzance* (Paris, 1976)

Lefebvre, H., *The Social Production of Space*, trans. D. Nicholson-Smith (1974, Oxford, 1991)

Leo VI, *Sermons*, in *Leontos tou Sophou panêgurikoi logoi*, ed. Akakios Hieromonachos (Athens, 1868)

Leroy, J., *Manuscrits Coptes et Coptes-Arabes Illustrés*, Institut Français d'archéologie de Beyrouth, Bibliothèque archéologique et historique t. XCI (Paris, 1974)

-- *Les peintures des couvents du désert d'Esna*, l'Institut français d'archéologie orientale du Caire, Mémoires t. XCIV (Cairo, 1975)

*The Letter of the Three patriarchs to the Emperor Theophilos and Related Texts*, eds J.A. Munitiz, J. Chrysostomides, E. Harvalia-Crook and Ch. Dendrinos (Camberley, Surrey 1997)

Lévi-Strauss, C., *Totemism*, trans. R. Needham (Boston, 1963)

*Liber pontificalis*, ed. L. Duchesne, 2 vols (Paris, 1886-92); trans. R. Davis, *The Lives of the Ninth-Century Popes (Liber pontificalis)* (Liverpool, 1995)

Licht, F., *Sculpture, 19th & 20th Centuries* (New York, 1967)

Liddell, H.G., R. Scott, H.S. Jones, *A Greek-English Lexicon* (Ninth edition, Oxford, 1968)

Lidov, A.M. ed., *Chudotvornaia ikona v Vizantii i drevnei Rusi* (Moscow, 1996)

Liutprand of Cremona, *The Works of Liudprand of Cremona: Antipodosis, Liber de Rebus Gestis Ottonis, Relatio de Legatione Constantinopolitana*, trans. F.A. Wright (New York, 1930)

Loewinson-Lessing, W. and N. Nicouline, *Les Primitifs flamands. Le museé de l'Ermitage Leningrad* (Brussels, 1965)

Loon, G.J.M. van, *The Gate of Heaven: Wall Paintings with Old Testament Scenes in the Altar Room and the Hurûs of Coptic Churches* (Istanbul, 1999)

Lossky, V., *The Mystical Theology of the Eastern Church* (London, 1957)

Lotz, W., 'Notes on the Centralized Churches of the Renaissance', in *Studies in Italian Renaissance Architecture* (Cambridge, MA, 1977), 66-73

Louth, A., *St John Damascene. Tradition and originality in Byzantine theology* (Oxford, 2002)

Loverdou-Tsigarida, K., 'The Mother of God in Sculpture', in *Mother of God*, ed. Vassilaki, 237-249

Lowden, J., 'The Royal/Imperial Book and the Image or Self-Image of the Medieval Ruler', in *Kings and Kingship in Medieval Europe*, ed. A. Duggan (London, 1993), 213-40

-- 'Some Forged Byzantine Miniatures', in Benaki Museum, *Thymiama ste mneme tes Laskarinas Boura*, 2 vols (Athens, 1994) I, 165-67; II, pls XIX, 88-94 (figs 1-13)

MacBeth, R., and R. Spronck, 'A Material History of Rogier's *Saint Luke Drawing the Virgin*, Conservation Treatment and Findings from Technical Examinations' in *St Luke Drawing the Virgin*, ed. Purtle, 103-34

Macrides, R., 'Saints and Sainthood in the Early Palaiologan Period', in *The Byzantine Saint*, ed. S. Hackel (London, 1981), 83-86

Macrides, R., and P. Magdalino, 'The architecture of ekphrasis: construction and context of Paul the Silentiary's ekphrasis of Hagia Sophia', *BMGS* 12 (1988), 47-82

Mandas, A., *Το εικονογραφικό πρόγραμμα του ιερού βήματος των μεσοβυζαντινών ναών της Ελλάδας (843-1204)* (Ph.D. dissertation, University of Athens, 2001)

Maguire, H., *The Icons of their Bodies: Saints and their images in Byzantium* (Princeton, 1996)

-- ed., *Byzantine Magic* (Washington, DC, 1995)

Manafis, K., *Sinai: Treasure of the Monastery of St. Catherine* (Athens, 1990)

Mangia Renda, P., 'Il culto della Vergine nella basilica romana dei SS Cosma e Damiano dal X al XII sec.', *Rivista dell'Istituto Nazionale d'Archeologia e Storia dell'Arte* 8-9 (1985-86), 323-364

Mango, C., *The Brazen House. A Study of the Vestibule of the Imperial Palace of Constantinople* (Copenhagen, 1959)

-- *Art of the Byzantine Empire 312-1453* (Englewood Cliffs, NJ, 1972)

-- 'Constantinople as Theotokoupolis', in *Mother of God*, ed. Vassilaki, 16-25

Maniura, R., *Pilgrimage to Images in the Late Middle Ages: the Origins of the Cult of Our Lady of Czestochowa* (forthcoming)

Marrow, J. H., 'Artistic Identity in Early Netherlandish Painting: The Place of Rogier van der Weyden's *St. Luke Drawing the Virgin*', in *St. Luke Drawing the Virgin*, ed. Purtle, 53-59

Marx, K., *Capital*, ed. Frederick Engels (1867; New York, 1967)

Mathew, G., *Byzantine aesthetics* (Oxford, 1963)

Mathews, T.F., 'An early Roman chancel arrangement and its liturgical functions', *Rivista di Archeologia Cristiana* 38 (1962), 73-95

-- *The Early Churches of Constantinople: Architecture and Liturgy* (University Park, PA, and London, 1971)

McKitterick, R., 'Ottonian intellectual culture in the tenth century and the role of Theophano', in *The Empress Theophano. Byzantium and the West at the Turn of the First Millennium*, ed. A. Davids (Cambridge, 1995), 169-193

Megaw, A.H.S., and E.J.W. Hawkins, *The Church of the Panagia Kanakaria at Lythrankomi in Cyprus. Its Mosaics and Frescoes* (Washington, DC, 1977)

Nikolaos Mesarites, 'Description of the Church of the Holy Apostles', ed. G. Downey in *Transactions of the American Philosophical Society* 47 (1957), 855-924

Michael (Archangel), *Saint Michael the Archangel: Three Encomiums*, ed. and trans. E.A. Wallis Budge (London, 1894)

Milliken, W.M., 'Byzantine Manuscript Illumination', *Bulletin of the Cleveland Museum of Art* 34

(1947), 50-56

M.-J. Mondzain, *Image, Icon, Economy*, trans. R. Franses (Stanford, forthcoming)

van Moorsel, P., et al., *Les Peintures du Monastère de Saint-Antoine près de la Mer Rouge*, Institut Français d'archéologie Orientale, Mémoires, CXII/1-2, (Cairo, 1995/97)

Morey, C.R., 'The inscription on the enameled cross of Paschal I', *ArtB* 19 (1937), 595-596

Müller, C.D.G., *Die Engellehre der koptischen Kirche* (Wiesbaden, 1959)

--   'Gab es ein koptisches Theater?' *Bulletin de la Société d'archeologie Copte* 29 (1990), 9-22

Muñoz, A., *La basilica di S. Lorenzo fuori le mura, Roma* (Rome, 1944)

Nardi, C., 'La "Leggenda riccardiana" di Santa Maria all'Impruneta: un anonimo oppositore del pievano Stefano alla fine del Trecento?', *Archivio Storico Italiano* 149 (1991), 503-51

Nelson, R.S., 'To say and to see: ekphrasis and vision in Byzantium' in *Visuality before and beyond the Renaissance*, ed. R.S. Nelson (Cambridge, 2000), 143-168

Nesbitt, J., and N. Oikonomides, eds, *Catalogue of the Byzantine Seals at Dumbarton Oaks and in the Fogg Museum of Art* (Washington, DC, 1994)

Netz, R., 'The Origins of Mathematical Physics: New Light on an Old Question', *Physics Today* (June 2000), 32-37

--   'Archimedes in Mar Saba: a Preliminary Notice', in ed. J. Patrich, *The Sabaite Heritage. The Sabaite Factor in the Orthodox Church: Monastic Life, Liturgy, Theology, Literature, Art and Archaeology* (in press)

--   and K. Saito and N. Tchernetska: 'A New Reading of *Method* Proposition 14: Preliminary Evidence from the Archimedes Palimpsest', *SCIAMVS* 2 (2001), 9-29

Nicetas Stethatos, *Nicétas Stéthatos, Opuscules et lettres*, ed. J. Darrouzès, SC 81 (Paris, 1961)

Nicolas, M. 'La comédie humaine dans le *karagöz*' in *L'humor en orient, Revue du Monde Musulman et de la Méditerranée* 77-78 (1995)

Nikephoros (patriarch), *Nicéphore: Discours contre les iconoclasts*, ed. and trans. M-J. Mondazin-Baudinet (Paris, 1989)

St Nikon, *The Life of St Nikon*, ed. and trans. D.F. Sullivan (Brookline, MA, 1987)

Nilgen, U., 'Maria Regina – Ein politischer Kultbildtypus?', *Römisches Jahrbuch für Kunstgeschichte* 19 (1981), 1-33

Noble, T., 'Topography, celebration and power: the making of a papal Rome in the eighth and ninth centuries', in *Topographies of Power in the Early Middle Ages*, eds M. de Jong and F. Theuws (Leiden, 2001), 45-91

Nordhagen, Per J., 'The earliest decorations in Santa Maria Antiqua and their date', *Acta ad archaeologiam et artium historiam pertinentia* 1 (1962), 53-72

--   'The mosaics of John VII (A.D. 705-707)', *Acta ad archaeologiam et artium historiam pertinentia* 2 (1965), 121-166

--   'The Frescoes of John VII (A.D. 705-707) in S. Maria Antiqua in Rome', *Acta ad archaeologiam et artium historiam pertinentia* 3 (1968)

--   'Icons designed for the display of sumptuous votive gifts', *DOP* 41 (1987), 453-460

Noreen, K., *Sant'Urbano alla Caffarella: Eleventh-Century Roman Wall Painting and the Sanctity of Martyrdom* (Ph.D. dissertation, The Johns Hopkins University, Baltimore, 1998)

Nunn, V., 'The Encheirion as an Adjunct to the icon in the Middle Byzantine Period', *BMGS* 10 (1986), 73-102

Oakeshott, W., *The Mosaics of Rome* (Greenwich, CT, 1967)

Oikonomides, N., 'Leo VI and the Narthex Mosaic of Hagia Sophia', *DOP* 30 (1976), 151-172

Olivier, J.-M. , *Répertoire des bibliothèques et des catalogues de manuscrits grecs de Marcel Richard*, 3rd ed., Corpus Christianorum (Turnhout, 1995)

Omont, H., *Évangiles avec peintures byzantines du XIe siècle (Reproduction des 361 miniatures du manuscrit Grèc 73 de la Bibliothèque Nationale* (Paris, 1908)

van Os, H., *De Weg naar de Hemel* (Baarn, 2000)

Osborne, J., 'Early medieval wall-paintings in the Catacomb of San Valentino, Rome', *Papers of the British School at Rome* 49 (1981), 82-90

-- 'The atrium of S. Maria Antiqua, Rome: a history in art', *Papers of the British School at Rome* 55 (1987), 186-223

-- 'Early medieval painting in San Clemente, Rome: the Madonna and Child in the niche', *Gesta* 20 (1981), 299-310

Pace, V., 'Between East and West', in *Mother of God*, ed. Vassilaki, 424-433

Gregory Palamas, *Triad* II, in *Défense des Saints hésychastes*, ed. and French trans. J. Meyendorff (Louvain, 1959)

Panofsky, E., *Early Netherlandish Painting. Its Origins and Character* (Cambridge, MA, 1953)

Papadopoulos-Kerameus, A., *Ierosolymitike Bibliotheke etoi katalagos ton en tais bibliothekais tou agiotatou apostolikou te kai katholikou orthodoxou patriarchikou thronou ton Ierosolymon kai pases Palaistines apokeimenon ellenikon kodikon*, vol. 4 (Peterburg, 1899)

-- 'Dyo Katalogio Ellenikon Kodikon en Konstantinoupolei, tes Megales tou Genous Scholes kai tou Zographeiou', *IRAIK* 14 (1909), 101-53

Papastavrou, H., 'Le voile, symbole de l'Incarnation. Contribution à une étude sémantique', *CahArch* 41 (1993), 41-43

*Constantinople in the Early Eighth Century: The* Parastaseis syntomoi chronikai, eds A. Cameron and J. Herrin et al. (Leiden, 1984)

Parry, K., *Depicting the Word: Byzantine Iconophile Thought of the Eighth and Ninth Centuries* (Leiden, 1996)

-- 'Theodore Studites and the Patriarch Nicephoros on Image-Making as a Christian Imperative', *Byz* 59 (1989), 164-183

Paul the Silentiary, *Description of Hagia Sophia*, ed. P. Friedländer, *Johannes von Gaza und Paulus Silentarius* (Leipzig-Berlin, 1912)

Peers, G., *Subtle Bodies: Representing Angels in Byzantium* (Berkeley, Los Angeles and London, 2001)

Peirce, C.S., *The Collected Papers of Charles Sanders Peirce*, vols. I-VI, eds C. Hartshorne and P. Weiss (Cambridge, MA, 1931-1935)

Pelikan, J., *Christianity and Classical Culture* (New Haven and London, 1993)

Pellat, Ch., Ḥikâya', *Encyclopaedia of Islam* New Edition, eds B. Lewis, V.L. Ménage, Ch. Pellat, J. Schacht, Vol. III (Leiden and London, 1971), 367-68

Pellat, Ch.., J. Sourdel-Thomine, P. Naili Boratav, 'Hayawân' *Encyclopaedia of Islam* III, 306

Penna, V., 'The Mother of God on Coins and Lead Seals', in *Mother of God*, ed. Vassilaki, 209-218

Pentcheva, B.V., 'Rhetorical images of the Virgin: the icon of the 'usual miracle' at the Blachernai', *Res* 38 (2000), 44 –45

Photios, *Homilies*, ed. B. Laourdas, Φωτίου Ὁμιλίαι (Thessaloniki, 1959); trans. C. Mango, *The Homilies of Photius Patriarch of Constantinople* (Harvard, 1958)

-- *Epistulae*, eds B. Laourdas and L. Westerink, *Photii patriarchae constatninopolitani Epistulae et*

*Amphilochia*, I-III (Leipzig, 1983-85)

Pierce, H., and R. Tyler, 'Deux movements dans l'art byzantin du Xe siècle', *Aréthuse* 4 (1927), 129-135

Pietz, W., 'The Fetish of Civilization: Sacrificial Blood and Monetary Debt', in *Colonial Subjects*, eds P. Pels and O. Saleminck (Ann Arbor, 1999), 53-81

Price S.R.F., 'From noble funerals to divine cult: the consecration of Roman emperors', in *Rituals of Royalty. Power and ceremonial in traditional societies*, eds D. Cannadine and S.R.F. Price (Cambridge, 1987), 56-105

Privalova, E., *Rospis' Timotesubani* [The paintings of Timotesubani] (Tbilisi, 1980)

Procopios, *Buildings*, ed. and trans. H.B. Dewing and G. Downey (London and New York, 1940)

*Protoevangelium* of James, ed. C. Tischendorf, *Evangelia Apocrypha* (Lipsiae, 1876)

Michael Psellos, *Chronographia*, ed. and trans. E. Renaud (Paris, 1926)

Pseudo-Dionysios, *Pseudo-Dionysius. The Complete Works*, trans. C. Luibheid (Mahwah, NY, 1987)

Purtle, C.J., ed., *The Museum of Fine Arts in Boston. Rogier van der Weyden. St. Luke Drawing the Virgin. Selected Essays in Context* (Turnhout, 1997)

Rauty, N., 'Tracce archivistiche per l'antica chiesa di Santa Maria Forisportam', *Centenario del miracolo della Madonna dell'Umiltà a Pistoia* (Pistoia, 1992), 21-40

Reed, R., *Ancient Skins, Parchments and Leathers* (London, 1972)

von Reitzenstein, A. *Die Geschichte des Bamberger Domes* (Munich, 1984)

Resnick, I.M., 'Idols and Images: early definitions and controversies', *Sobornost* 7/2 (1985), 25-51

Restle, M., *Byzantine Wallpainting in Asia Minor* (Greenwich, CT, 1967)

Richa, G., *Notizie istoriche delle chiese Fiorentine divise ne' suoi Quartiere* 3 (Florence, 1755)

Richard, M., *Répertoire des bibliothèques et des catalogues de manuscrits grecs*, 2nd ed. (Paris, 1958)

Rodley, L., *Byzantine Art and Architecture* (Cambridge, 1994)

Ronig, F.J., ed., *Schatzkunst Trier*, (Trier, 1984)

Rotili, M., *Arte Bizantina in Calabria e in Basilicata* (Milan, 1980)

Rushforth, G., 'The Church of S. Maria Antiqua', *Papers of the British School at Rome* 1 (1902), 1-123

*The Russian Primary Chronicle* trans. S.H. Cross, *Harvard Studies in Philology and Literature* 12 (Cambridge, MA, 1930), 75-370

*Russian Travelers to Constantinople in the Fourteenth and Fifteenth Centuries*, ed. and trans. G. Majeska (Washington, DC, 1984)

Russo, E., 'L'affresco di Turtura nel cimitero di Commodilla, l'icona di S. Maria in Trastevere e le più antiche feste della Madonna a Roma', *Bullettino dell'Istituto Storico Italiano per il Medioevo e Archivio Muratoriano* 88 (1979), 35-85; 89 (1980-81), 71-150

Sansterre, J.-M., 'L'image blessée, l'image souffrante: quelques récits de miracles entre Orient et Occident (VIe-XIIe siècle)', in *Les images dans les sociétés médiévales: Pour une histoire comparée*, Actes du colloque international organisé par l'Institut Historique Belge de Rome en collaboration avec l'École Française de Rome et l'Université Libre de Bruxelles (Rome, Academia Belgica, 19-20 juin 1998), *Bulletin de l'Institut Historique Belge de Rome* 69 (1999)

-- 'Entre "Koinè méditerranéenne", influences byzantines et particularités locales: le culte des images et ses limites à Rome dans le haut Moyen Âge', *Europa medievale e mondo bizantino: contatti effettivi e possibilità di studi comparati*, eds G. Arnaldi and G. Cavallo, Istituto Storico Italiano per il Medio Evo: Nuovi Studi Storici 40 (Rome, 1997), 109-124

-- 'Entre deux mondes? La vénération des images à Rome et en Italie d'après les textes des VIe-XIe siècles', *Roma fra Oriente e Occidente*, 993-1050

*Scelta d'alcuni miracoli e Grazie della Santissima Nunziata di Firenze Descritti Dal P. F. Gio. Angiolo Lottini dell'Ord. de Servi* (Florence, 1619)

Schiller, G., *Ikonographie der christlichen Kunst* (Gütersloh, 1966)

Schofield, M., 'Aristotle on the imagination' in *Aristotle on mind and the senses*, eds G.E.R. Lloyd and G.E.L. Owen (Cambridge, 1978), 99-140

Shoshan, B., *Popular culture in medieval Cairo* (Cambridge, 1993)

Siegerl, B.A., *Der Vorhang der Sixtinischen Madonna. Herkunft und Beduteung eines Motivs der Marienkikonographie* (Zurich, 1977)

Sotheby's, *Catalogue of Western Manuscripts and Miniatures*, 22 June 1982 (London, 1982)

Smyrnakis, G., *To 'Αγιον 'Ορος* (Karyes, 1903, 1988(2))

Spatharakis, I., *The Portrait in Byzantine Illuminated Manuscripts* (Leiden, 1976)

Steenbock, F., *Der kirchliche Prachteinband im frühen Mittelalter: von den Anfängen bis zum Beginn der Gotik* (Berlin, 1965)

Stephen the Younger, *La vie d'Etienne le Jeune par Etienne le Diacre*, ed. and trans. M.-F. Auzépy (Aldershot, 1997)

Stewart, P., 'The destruction of statues in late antiquity', in *Constructing identities in late antiquity*, ed. R. Miles (London, New York, 1999), 159-89

Stiegemann, C., and M. Wemhoff, eds, *Kunst und Kultur der Karolingerzeit*, (Mainz, 1999)

Stroll, M., 'Maria Regina: Papal Symbol', in *Queens and Queenship in Medieval Europe*, ed. A. Duggan (Woodbridge, 1997), 173-203

Stroot-Kiraly, E., 'L'offrande du Pain Blanc', *Bulletin de la Societé d'Egyptologie de Genève* 13 (1989), 157-60

*Suida Lexicon*, ed. A. Adler (Leipzig, 1928-29)

Symeon the New Theologian, *Syméon le Studite, Discours Ascétique*, ed. and trans. H. Alfeyev, SC 460 (Paris, 2001). I. Hausherr, *Un grand mystique byzantin: Vie de Syméon le Nouveau Théologien (949-1022) par Nicétas Stethatos*, Orientalia Christiana Analecta 45 (Rome, 1928); A. Golitzin, *St. Symeon the New Theologian, On the Mystical Life: The Ethical Discourses*, Vol. 3: *Life, Times and Theology* (Crestwood, NY, 1997)

Taft, R.F., *A History of the Liturgy of St. John Chrysostom*, II, *The Great Entrance, A History of the Transfer of Gifts and other Pre-anaphoral Rites* (Rome, 1978)

-- 'Women at Church in Byzantium', *DOP* 52 (1998), 22-87

Talbot Rice, D. and T., *Icons and their dating* (London, 1974)

Tea, E., *La basilica di S. Maria Antiqua* (Milan, 1937)

Tedeschi, B., 'L'onciale usuale a Roma e nell'area Romana in alcune iscrizioni graffite', *Scrittura e Civiltà* 16 (1992), 313-329

-- , '"Scrivere i santi": epigrafia del pellegrinaggio a Roma nei secoli VII-IX', *Roma fra Oriente e Occidente*, 323-360

Teteriatnikov, N., 'For Whom is Theodotus Praying? An Interpretation of the Program of the Private Chapel in S. Maria Antiqua', *CahArch* 41 (1993), 37-46

Thayer, J.H., *A Greek-English Lexicon of the New Testament* (Grand Rapids, 1977)

Theodore the Stoudite, *Orations on the Holy Images* trans. C. Roth, *On the Holy Icons* (Crestwood, NY, 1981)

Theodoret, *Historia Ecclesiastica*, ed. L. Parmentier (Berlin, 1954); trans. B. Jackson in *The Writings*

*of the Nicene and Post-Nicene Fathers*, 2nd series III (Oxford, 1892)

Theophanes Confessor, *Chronographia*, ed. C. de Boor (Leipzig, 1883); *The Chronicle of Theophanes Confessor. Byzantine and Near Eastern History AD 284-813*, trans. C. Mango and R. Scott (Oxford, 1997)

Thierry, N., 'Une mosaïque à Dyrrachium', *CahArch* 18 (1968), 227-229

Tourta, A., 'The Virgin Dexiokratousa', cat. 78 in ed. Vassilaki, *Mother of God*, 474-5

Trexler, R., 'Florentine Religious Experience: the Sacred Image', *Studies in the Renaissance*, 19 (1972), 7-41

Tronzo, W., 'Setting and structure in two Roman wall decorations of the early Middle Ages', *DOP* 41 (1987), 477-492

Turner, V., and E. Turner, *Image and Pilgrimage in Christian Culture* (New York, 1978)

Tylor, E.B., *Researches into the Early History of Mankind and the Development of Civilization*, 3rd ed., intro., abridged by P. Bohannan (1st ed. 1865, 3rd ed. 1879, Chicago, 1964)

Underwood, P.A. ed., *The Kariye Djami*, Bollingen Series 70 (Princeton, 1975)

Varalis, I.D., 'Παρατηρήσεις για τη θέση του Ευαγγελισμού στη μνημειακή ζωγραφική κατά τη μεσοβυζαντινή περίοδο', *DChAE*, 4th period, 19 (1996-97), 201-19

Varchi, Benedetto, *Storia Fiorentina*, ed. L. Arbib, I, (Florence, 1843)

Vassilaki, M., ed., *Mother of God: Representations of the Virgin in Byzantine Art* (Milan, 2000)

Velmans, T., *Byzance: Fresken und Mosaic* (Zurich, 1999)

Veronée-Verhaegen, N., *Les Primitifs Flamands. I. Corpus de la Peinture des Anciens Pays-Bas Méridionaux au Quinzième Siècle* 13: *L'Hôtel-Dieu de Beaune* (Brussels, 1973)

Vikan, G., ed., *Illuminated Greek Manuscipts from American Collections*, exhibition catalogue, Art Museum, Princeton University (Princeton, 1973)

-- *Gifts from the Byzantine Court*, exhibition catalogue, Dumbarton Oaks (Washington, DC, 1980)

von Vlierden, M., *Willibord en het begin van Nederland* (Utrecht, 1995)

de Vos, D., *Bruges Musees Communaux. Catalogue des Tableaux du 15e et du 16e Siècle* (Bruges, 1982)

-- *Rogier van der Weyden. The Complete Works* (Antwerp, 1999)

Wallis Budge, E.A., *Coptic Apocrypha in the Dialect of Upper Egypt* (London, 1913)

Webb, R., 'Imagination and the arousal of the emotions in Greco-Roman rhetoric' in *The passions in Roman thought and literature*, eds S.M. Braund and C. Gill (Cambridge, 1997), 112-127

-- 'Mémoire et imagination: les limites de l'enargeia dans la théorie rhétorique grecque' in eds C. Levy and L. Pernot, *Dire l'évidence* (Paris, 1997), 229-248

-- 'The aesthetics of sacred space: narrative, metaphor and motion in *ekphraseis* of church buildings, *DOP* 53 (1999), 59-74

-- 'Ekphrasis ancient and modern: the invention of a genre', *Word & Image* 15 (1999), 11-15

-- 'Ekphrasis, amplification and persuasion in Procopius' *Buildings*', *Antiquité Tardive* 8 (2000), 67-71

Weitzmann, K., *The Joshua Roll; a Work of the Macedonian Renaissance*, Studies in Manuscript Illumination III (Princeton, 1948)

-- 'Eine spätkomnenische Verkündigungsikone des Sinai und die zweite byzantinische Welle des 12. Jahrhunderts', in *Festschrift für Herbert von Einem*, eds G. von der Osten and G. Kauffmann (Berlin, 1965), 299-312

-- 'Die byzantinischen Elfenbeine eines Bamberger Graduale und ihre ursprüngliche

Verwendung', *Studien zur Buchmalerei und Goldschmiedekunst des Mittelalters. Festschrift für Karl Hermann Usener* (Marburg, 1967), 11-20. Reprinted in *Byzantine Book Illumination and Ivories* (London, 1980)

-- 'An Ivory Diptych of the Romanos Group in the Hermitage', *VizVrem* 32 (1940), 142-55

-- *The Monastery of St. Catherine at Mount Sinai: The Icons from the Sixth to the Tenth Centuries* (Princeton, 1976)

-- ed., *The Age of Spirituality: Late Antique and Early Christian Art, Third to Seventh Century*, (New York, 1979)

-- and M. Chatzidakis, and S. Radojčić, *Icons*, (New York, n.d.)

-- and G. Alibegasvili, A. Volskaja, M. Chatzidakis, G. Babić, M. Alpatov, and T. Voinescu, *The Icon* (New York, 1982)

Wellesz, E., 'The "Akathistos": a study in Byzantine hymnography', *DOP* 9-10 (1956), 141-174

Wharton Epstein, A., *Tokalı Kilise: Tenth-Century Metropolitan Art in Byzantine Cappadocia* (Washington, DC, 1986)

White, E. M., 'Rogier van der Weyden, Hugo van der Goes, and the Making of the Netherlandish St. Luke Tradition' in ed. Purtle, *St. Luke Drawing the Virgin*, 39-48

White, N., and E. Willensky, *AIA Guide to New York City* (New York, 1978)

Whittemore, T., *The Mosaics of Haghia Sophia at Istanbul. Third Preliminary Report. Work Done in 1935-8. The Imperial Portraits of the South Gallery* (Boston, Oxford, 1942)

Williamson, P., *An Introduction to Medieval Ivory Carvings* (London, 1982)

Wilson, N.G., *Scholars of Byzantium* (London, 1983)

-- 'Archimedes: the Palimpsest and the Tradition', *BZ* 92 (1999), 89-101, pls IV-IX

Winfield, D., 'Hagios Chrysostomos, Trikomo, Asinou. Byzantine Painters at Work', Πρακτικὰ Πρώτου Διεθνοῦς Κυπρολογικοῦ Συνεδρίου (Nicosia, 1972), II, 285f

Wolf, G., *Salus Populi Romani: Die Geschichte römischer Kultbilder im Mittelalter* (Weinheim, 1990)

Yates, F., *The Art of Memory* (London, 1966)

Zacharias of Mitylene, *The Syriac Chronicle known as that of Zachariah of Mitylene*, trans. F.J. Hamilton and E.W. Brooks (London, 1899)

Zanker, P., *The Power of Images in the Age of Augustus* (Michigan, 1988)

# Index

THE ART INSTITUTE OF PORTLAND